GET YOUR CLAIM PAID

A Pro-Active Guide

for Handling

the Most Difficult

Part of Insurance

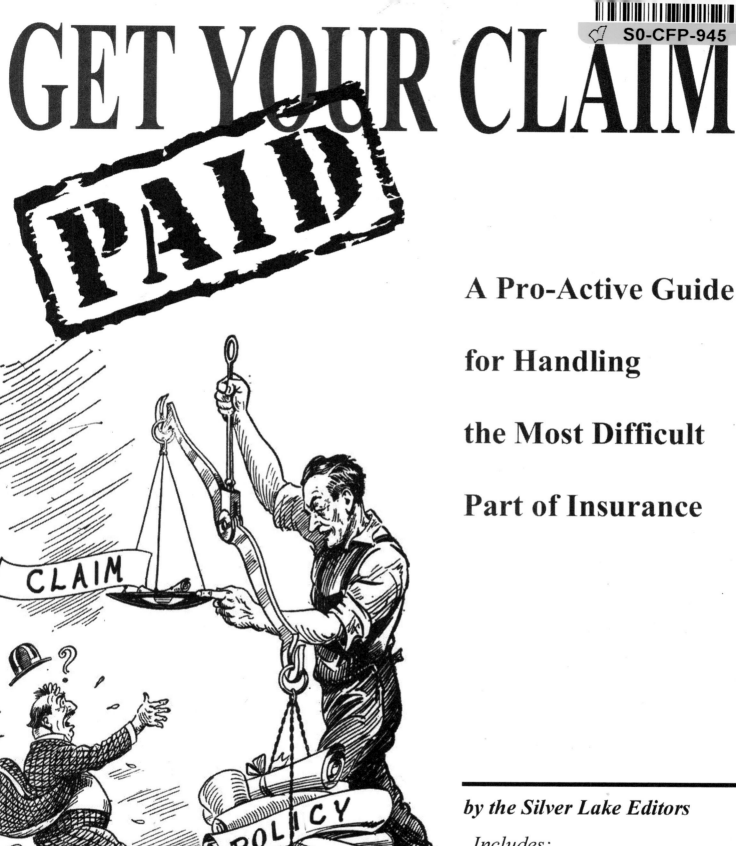

by the Silver Lake Editors

Includes:

standard policy language,

worksheets and

checklists

Get Your Claim Paid
A Pro-Active Guide for Handling the Most Difficult Part of Insurance
First edition, 1999
Copyright © 1999 by Silver Lake Publishing

Silver Lake Publishing
2025 Hyperion Avenue
Los Angeles, CA 90027

For a list of other publications or for more information from Silver Lake Publishing, please call (888) 663-3091.

Library of Congress Catalog Number: pending

The Silver Lake Editors
Get Your Claim Paid
A Pro-Active Guide to Handling the Most Difficult Part of Insurance
Includes index
Pages: 374

ISBN: 1-56343-168-8
Printed in the United States of America.

Acknowledgments

The Silver Lake Editors would like to thank the following organizations for assistance offered in researching information that appears this book: The Insurance Information Institute, the National Consumers' League, the Insurance Services Office and the Risk and Insurance Management Society. The Offices of Insurance Commissioner in several states—California, Connecticut, Indiana, Maryland, New Jersey, New York, Oregon, Texas and Washington—also helped considerably.

Get Your Claim Paid is part of Silver Lake Publishing's consumer insurance reference series. This book, used with *Insurance Buying Guide* and *"What Do You Mean It's Not Covered?"*, takes the smart consumer through the entire process of buying and using personal-lines insurance.

While the information and statistics in this book will help you understand how to buy personal-lines insurance in a cost-effective manner, no book can analyze a person's specific legal position and insurance needs. This book should not be used in place of qualified professional advice.

The Silver Lake Editors welcome feedback from our readers. If you have a comment or suggestion on the content and delivery you see in this book, please feel free to call Silver Lake Publishing at 888.663.3091 or e-mail us at editors@silverlakepub.com. We look forward to hearing from you.

James Walsh, Publisher
Silver Lake Publishing
June, 1999

Table of Contents

Introduction: Politics, Policies and Why Getting Your Claim Paid Is so Tough......1

Part One: Cars, Trucks and Things You Drive
Chapter 1: What Happens When Someone Hits You......5
Chapter 2: What Happens When You Hit Someone......37
Chapter 3: No-Fault Coverage Claims......63

Part Two: Houses, Apartments and Places You Live
Chapter 4: The Mechanics of Homeowners Coverage Disputes......77
Chapter 5: How Natural Disasters and Catastrophes Stir up Trouble......97
Chapter 6: Avoiding Common Homeowners Claims Problems......111
Chapter 7: Homeowners Liability and Related Claims......135
Chapter 8: Condos, Rentals and Other Specialty Claims......145

Part Three: Possessions, Property and Things You Own
Chapter 9: Making Claims for Damage to Things......169

Part Four: Your Life...and Everything That Means for Your Affairs
Chapter 10: Life Insurance as a Death Benefit......197
Chapter 11: Life Insurance as an Investment......217

Part Five: Your Ability to Earn a Living
Chapter 12: Disability Insurance Claims......239

Part Six: Medcial Care, Your Health and Well-Being
Chapter 13: The Mechanics of Health Insurance Claims......265
Chapter 14: HMO Coverage Disputes......281
Chapter 15: Medicare, Medicaid and Other Government Program Claims......291

Part Seven: Liability—Personal and Work-Related
Chapter 16: Workers' Compensation and Employers' Liability Claims......305
Chapter 17: Making Claims on Professional Liability Policies......325
Chapter 18: Umbrella Liability Claims......345

Conclusion: What to Do When all Else Fails......357
Appendix: Contacts for Consumers......365
Index......375

Introduction

Politics, Policies and Why Getting Your Claim Paid Is so Tough

You buy insurance so that you get paid when you make a claim. Whether the reason for the claim is that someone put a dent in your car, a fire destroyed the kitchen in your house, your dog bit your neighbor or you need your appendix taken out, you want one thing from your policy—the insurance company to cut a check quickly and without a lot of debate.

This is getting more difficult to accomplish with any kind of certainty. Insurance companies are more likely than ever to deny or delay paying claims. And, even when they finally do decide to pay, they will often only pay part of the money you need to resolve your problem.

Why has this happened?

Several different sets of issues during the late 1980s and 1990s have combined to put pressure on the claims process.

First, trends in the law have made it easier for people to sue insurance companies that don't pay claims in a timely manner. These laws—intended to make it easier for you to get your claim paid—have had unintended consequences. They have attracted a growing number of crooks and con artists to the insurance business; the bumbling insurance crook of movies and novels has become in real life a smooth criminal—often with ties to organized crime. As a result, insurance companies spend more time examining claims for fraud. This has a negative impact on all people making claims—most of whom are honest...and desperate.

Second, technology hasn't improved the claims process as much as it has other parts of the insurance industry. Computers and the Internet have made the process of applying for insurance easier and faster. They've made the

process of paying for insurance faster. They've given the actuaries better tools for pricing coverage that's just right for you. What they haven't done yet is make the claims process easy.

As a result, claims processing—the most critical part of the insurance business—has lagged behind the other parts in terms of customer service and ease-of-use.

This last point is important, as more and more insurance is being sold on-line. A lot of insurance industry types talk about how these computer-based changes will reduce the role of the agent in the application and administrative parts of the insurance cycle.

But if you think buying car insurance over the Internet is impersonal, wait until you have to file a claim by Internet.

The fact is that claim processing may be the one part of the insurance industry that won't work in an on-line format.

And another fact is that even the most expensive PR gurus in Manhattan and L.A. can't seem to talk fast enough to turn the tide of perception that the insurance industry rips off customers by denying legitimate claims.

Insurance companies make good punching bags for trial lawyers, politicians and politically-motivated consumer advocates.

There always has been a somewhat touchy relationship between insurance companies and customers. It's rooted in the inherent tensions between business and society.

People pay insurance premiums year after year—and believe that they are entitled to a fast, fair settlement when they make a claim. When an insurance company hesitates, delays or negotiates, the consumer is not happy.

But the insurance companies are often following the letter of their agreements. They write language into insurance policies limiting what is covered and how this will be paid. These terms help set the price of the policy, which the consumer usually wants to keep as low as possible.

But you get what you pay for. A cheap insurance policy is bound to be not-so-good when it comes time to pay a claim. And this is especially true if the claim involves complex issues like damages to third parties or loss of use of the insured item.

So, inherent tensions remain. Lawyers and advocates for policyholders argue that insurance companies have adopted aggressive strategies to deny valid claims; at the same time, the companies argue that they are victims of a legal system that often requires them to pay unjustified claims.

Who's Supposed to Resolve the Disputes?

If getting your claim paid is an inherently conflicted proposition, shouldn't some disinterested third party be available to resolve disputes? Yes. This party is usually your state's Insurance Commissioner—who doesn't always satisfy everyone.

One of the goals of insurance market regulation is to protect consumers from unfair practices in insurance claims settlement. Insurance contracts are complex legal documents which are often difficult for consumers to understand, and it is not uncommon that disputes over the existence or amounts of coverage arise during the claims settlement process.

Unlike most financial industries, insurance is regulated on a state-by-state level rather a national one. (This is a vestige of government policies of a hundred years ago. There was talk during the 1990s of changing the regulatory structure...but various interested parties objected.)

As a result, state Insurance Departments combine responsibility for industry regulation and consumer advocacy. It's a tough mix; and most Insurance Commissioners tend to focus on one part or the other.

If consumer advocates don't like a commissioner, they will complain that the fox—beholden to big-money insurance companies—is guarding the henhouse. If the insurance industry doesn't like a commissioner, it's spokespeople will complain that an opportunistic politician is destroying the marketplace.

And the response is usually one way or the other because not all insurance commissioners are alike.

Florida's commissioner puts on a baseball cap and goes undercover to bust crooked agents; but California's takes a more buttoned-down approach to fraud—focusing on crooked claimants.

A Quick Review of the Mechanics

Insurance is a necessary part of a stable economy—but insurance consumers are usually at a disadvantage in understanding their policies, negotiating and defending their own interests. The resulting disputes arise at the very time that policyholders need coverage most—after the loss. So, the law generally recognizes that insurance claims disputes are unique in the disparate power of the opposing parties. This still doesn't make claims litigation easy. It's far better to avoid legal action entirely.

Throughout the course of this book, we will consider the specific steps you need to take to avoid particular kinds of claims hassles. But, some precautions apply to insurance generally.

- Shop on the basis of claims-paying reputation as well as price. Don't give a company your money—no matter how cheap its rates—if it has a reputation for consistently denying claims. (Your state Department of Insurance may or may not publish insurance companies' complaint histories. If it doesn't, you can check a company's financial condition with ratings agencies like A.M. Best, Standard & Poor's or Weiss.)

- Make an inventory of your personal possessions and a file of related receipts and warranties. A videotaped record is a useful extra effort here. Update the information whenever you buy or sell anything of significant value.

- If you suffer any loss that even *might* be insured, tell your insurance company immediately. An agent counts as the insurance company in this context—but problems sometimes crop up between the agent and the company. So, notifying both (at least initially) isn't a bad idea. If theft is involved, notify the police or other authorities. And keep a log of all communications.

- If there's property damage, do what's necessary to prevent further damage, and keep track of your receipts for repairs.

- No matter how upset or angry you may be about the loss you've suffered, keep in mind that an insurance claim is a business transaction. Try to treat it as such.

If you run into trouble getting a claim paid, consider hiring an attorney to help make your point. (We'll consider the details of *that* process at the end of this book.) But, if you follow the guidelines suggested in this book and have picked a decent company, your claim will probably be paid with minimal hassle.

Part One:

Cars, Trucks and Things You Drive

Chapter 1

What Happens When Someone Hits You

Stirred by the emotions that come after an accident, some people unleash anger and frustration at the adjusters and clerks who are part of the claims process. They shouldn't.

It's important to remember that making an insurance claim *is* a process. Making a claim on your auto policy is like any other aspect of a contract transaction. The best companies will be supportive and understanding of what you've experienced.

But what you really want is to get your claim paid.

In this chapter, we'll consider how you can make a claim in the most effective way when you're not the at-fault driver. Throughout, a fairly consistent pattern emerges. In states that have passed insurance reforms aimed at limiting premiums, systematic problems related to claims often follow.

It seems to be a market-driven response: If you pay less for insurance, you're likely to have more trouble making a claim.

When you do have to make a claim, don't be afraid to count on your agent—if you have one. Agents who are eager to keep your business can become your best advocates.

On the other hand, if they're not helpful or are difficult, don't hesitate to go to your insurance company's consumer complaint department. The fact that agents sometimes—and it's usually just *sometimes*—get in the way of making a claim is a big reason that a growing number of people deal directly with insurance companies.

> Although state laws vary on requiring consumers to make claims within a certain time period, most companies prefer that claims be filed within 15 days. If someone's been hurt in an accident, there's been serious damage or some law has been broken, call the police first. You can call your insurance company later.

Of course, insurance companies want to be notified as quickly as possible. The sooner you file a claim, the sooner you'll get a settlement.

The biggest reason you will probably have to call your insurance company quickly is to start coverage for towing or a replacement rental car—if you've chosen those optional coverages.

> Most states require that insurance companies either process a claim, or at least tell you why it hasn't been processed, within 60 to 90 days.

Some people will want to pay for damages out of pocket, even if they have no deductible. The presence of an at-fault accident in someone's claims history (especially if it's not the first) can raise premiums dramatically enough that it's worth avoiding the claim altogether.

> This kind of informal settlement is usually legal...it's just not usually a good idea. The damages that follow from an auto accident can involve more than just a bent fender—and they can take several weeks or months to manifest themselves.

If the damage is minor, a private settlement can't do much harm. But, if the damage in question is in any way major (your car isn't driveable or someone has been injured), you will want the official oversight that the insurance company offers—even if this means suffering some bureaucracy.

Calculating a Settlement

In most cases, there is no dollar amount stated as a maximum limit of auto insurance coverage. The maximum limit is usually the actual cash value (ACV) of the vehicle minus any deductible.

When determining the ACV for an entire vehicle—or the damaged portion of one—an insurance company considers the amount of depreciation as a vehicle ages. Insurance adjusters also use tables that show current market values for different makes, models and years of vehicles.

Insurance companies may either repair or replace a damaged vehicle, and they also have the option of simply paying the ACV of the stolen or damaged property. According to the standard policy provisions, the insurance company is only obligated to pay the lesser of these amounts.

In practice, the insurance company is likely to decide that the ACV is the lesser of the repair or replacement cost. When repair costs exceed the cost of replacing the entire vehicle, it will usually be considered a total loss and the settlement will be based on the depreciated market value of the car. This same principal applies to total loss situations and partial loss situations.

Disputes Over Valuation

The method your insurance company uses to value cars that have been totaled—at least totaled in the eyes of the insurance company, is not paying more for repairs than the car would sell for on the market.

Another common debate is over a car's "diminished value" following an accident that owners can never fully recover from insurance companies. When the owner of a totaled auto disagrees with an insurance company over its value, the parties face a difficult situation. What to an appraiser may be a hunk of chrome and fiberglass could hav sentimental value to the owner.

Years of loving care, regular oil changes and waxes won't eke out nearly as much at resale as the owner put in. Even if a car is repaired perfectly, when the owner later sells it, savvy buyers such as auto dealers won't pay as much.

If you disagree with the value placed on your vehicles you will often find that you've got three basic options:

- keep in close, even irritating, contact with the insurance company;

- complain to state insurance officials; or

- file a lawsuit.

(When you have a dispute with your own insurance company, you have more tools. Many policies require mandatory arbitration.)

But consumers without a working car and no cash or time to challenge an insurance company's valuation are at a definite disadvantage in negotiations.

Disputes over valuation don't get much coverage in the media—but they are a major problem for people making claims.

Larry Culbertson, a compliance officer with Oregon's state insurance department, said that disputes about car valuations made up nearly 300 of the 2,400 auto insurance complaints he handled each year during the late 1990s.

"It's a very difficult one to work with," said Culbertson. "There just really aren't any two cars the same."

One side-effect of a valuation dispute: Paying off a car loan on a wrecked vehicle can pose a problem when the car is a newer problem.

> The replacement amount suggested by the insurance company doesn't always take into account the cost for paying off the car loan. Insurance companies call that condition being "upside-down" on a loan because you owe more than the car is worth. If you are financing a car and figure to be upside-down for part of the term, make sure your car insurance is equal to the loan amount. (The finance company will usually—though not always—insist that you carry this level of insurance.)

Frequently, financial institutions that loaned money for the purchase are open to compromise if the consumer obtains a replacement loan through the company.

Cost Containment

A number of states have started using HMO-like cost containment mechanisms to manage auto insurance costs. This kind of system allows you to save money on annual premiums. But, when it comes time to make a claim, you have to let your insurance company choose the repair shop it uses.

The system aims at reducing fraud, since customers, agents and repair shops would find it harder to inflate prices. But, from a claims perspective, several key questions remain:

- What would prevent an insurance company from contracting with cut-rate repair shops that do sloppy work? Presumably, the company would save money, but faulty repairs can be dangerous to you.

- Would the change drive small repair shops out of business? Small repair shops are concerned that insurance companies will divert policyholders to bigger firms in return for discounts.

These systems don't just apply to car repairs. Some states have tried to include medical payments in cost containment schemes. Most notably, in 1995, New Jersey Insurance Commissioner Drew Karpinski suggested a plan under which drivers could cut their automobile insurance bills by $50 a year if they join a managed health care network (used only for personal injuries caused by accidents—not other medical care) chosen by their insurance company.

Supporters argued the reform would eliminate cozy situations in which doctors or chiropractors exaggerate injuries to support legal claims. New Jersey regulators estimated that 20 percent of all personal injury protection (PIP) costs were due to fraud. They argued that closer scrutiny of medical bills through managed care would help stop that abuse.

> **Lawyers and doctors argued that drivers would suffer from poorer medical care so insurance companies could reap higher profits.**

Karpinski said the changes were designed to give drivers more freedom in keeping costs down. The option would be voluntary. He said he proposed the coverage option because New Jersey consumers said they wanted more alternatives for reducing their bills, which were among the highest in the nation.

Robert Wallach, president of the New York-based Robert Plan—which specializes in providing auto insurance to urban drivers on the East Coast, has been a vocal advocate of the managed care option. The Robert Plan was the first insurance company to support Karpinski's plan. "Without managed care, the losses make New Jersey an unsustainable market for anyone who does not have a very select market," he said.

In Colorado, which has had an optional managed care program since 1991, the savings have averaged between $15 and $30 per policy annually. Nearly 60 percent of all drivers there opt for the alternative.

Average costs for personal injury protection rose 120 percent in Colorado between 1985 and 1990—before the optional plan—versus 76 percent nationwide. By contrast, from 1990 through 1993, those costs dropped 4 percent in Colorado compared to a 15.5 percent increase nationwide.

> **While some states are moving toward cost containment, others have moved in the opposite direction—stressing what they call "consumer choice." In Chapter 3, we will consider how these plans impact claims.**

In Massachusetts, a little-noticed regulation called the Weld rule—issued in early 1994—required that insurance companies give policyholders who file claims a long list of repair shops for auto repairs, rather than a short list of shops that have agreed to do repair work at predetermined prices.

The state's attorney general, several auto insurance companies and a number of consumer groups joined together to denounce the rule. They claimed it would push up insurance premiums by $30 to $40 a year for Massachusetts

drivers, who already paid among the nation's highest premiums.

The Weld rule countered a sweeping auto insurance reform package, which had been passed into law in 1988. While the Weld rule allowed insurance companies to highlight preferred shops, people making claims can choose repair shops where they might not receive full coverage for repair work.

> **A caveat:** Insurance reform often has as much to do with politics as it does with getting claims paid. Be wary of any auto insurance reform that calls itself "pro-consumer"—or people who call other reforms "anti-consumer." Your interest is in making sure you have coverage that works when you need it. If a reform plan leaves you open to repairs that cost more than your settlement, you probably shouldn't support it.

Stacking Claims

Stacking insurance against a single claim allows drivers who insure more than one vehicle with the same insurance company to combine specific kinds of coverage—most often the uninsured/underinsured motorist coverage—from all insured vehicles.

> **For example:** If you have $50,000 of uninsured/underinsured motorist coverage on each of two cars, you could stack them and apply $100,000 of coverage toward one accident.

In December 1994, the New Jersey Supreme Court ruled that an anti-stacking provision in the state's auto insurance system didn't prevent a man who suffered catastrophic injuries in a motorcycle accident from recovering personal injury protection (PIP) benefits from two insurance companies.

The 7-0 ruling resolved the case of Brian Lihou, who was seriously hurt in 1987 when the motorcycle he was operating collided with a car. Because he was riding a motorcycle, his medical bills were not covered under the basic PIP benefits coverage of his auto insurance policy with the state-run Joint Underwriting Association.

The policy, however, contained an extended medical expense benefits provision, which furnished up to $10,000 coverage for injuries in motorcycle accidents. So the JUA paid Lihou the $10,000.

Lihou, who was living with his mother at the time, also sought coverage under her auto insurance with Aetna Casualty, on which he was listed as a

driver. Aetna refused to pay, arguing the anti-stacking provision prohibited Lihou from being paid by two insurance companies. Lihou sued.

A trial court agreed with Aetna, as did the appeals court. But the state supreme court ordered Aetna to pay. In a nine-page, unsigned opinion, the justices concluded:

> Supporting our determination are sound public-policy considerations, perhaps best illustrated by the circumstances of this case. [Lihou]'s medical expenses exceed $35,000.
>
> Requiring Aetna to pay its $10,000 limit—the maximum that the insurance company can provide under the [insurance] commissioner's regulation—will result in no windfall to [Lihou], no double recovery of any medical expense, and indeed [Lihou] will be left with a balance of over $15,000 in uncompensated expenses.

So, the right to stack claims—which usually costs about $10 a year—is worth buying. However, don't expect a huge windfall in an anti-stacking dispute. The main issue in stacking is that a claimant should not be able to make money on a claim.

Enforcing Releases

Sometimes, when you make an auto insurance claim, the company will agree to pay quickly if you sign a release freeing it from any further liability connected to your claim. Be extremely careful about signing any releases an insurance company offers.

The 1993 Arizona appeals court case *Bobby Sid Taylor v. State Farm Mutual Automobile Insurance Co.* shows how complicated a hastily-signed release can make an insurance claim.

The case began with an automobile accident that occurred in 1977. The accident involved three vehicles—one occupied by Anne Ring and passenger James Rivers, the second by Douglas Wistrom, and the third by Taylor.

Ring, Rivers and Taylor all were injured. Ring, her husband and Rivers filed actions against Taylor and Wistrom. Taylor's insurance company, State Farm, retained attorney Leroy W. Hofmann to defend Taylor.

Taylor also retained attorney Norman Bruce Randall, who filed a counterclaim against Ring for Taylor's damages. Taylor, therefore, was represented by both Randall and Hofmann in the matter.

The Rings and Rivers settled with Wistrom before trial, so Taylor was the only party left facing the Ring/Rivers claims. At trial, the Rings and Rivers obtained combined verdicts against Taylor for approximately $2.5 million in excess of his insurance policy limits. The court of appeals affirmed the judgments.

The Rings eventually settled with State Farm. Taylor, however, sued State Farm for bad faith seeking damages for the excess Rivers judgment, claiming, among other things, that State Farm improperly failed to settle the Rivers matter within policy limits.

State Farm asked for a summary judgment, claiming that Taylor relinquished his bad faith claim when, in 1981, he signed a release drafted by attorney Randall in exchange for State Farm's payment of $15,000 in uninsured motorist benefits.

The release Taylor signed read, in part:

> WHEREAS, having been fully apprised of all settlement offers made by the plaintiffs in the consolidated cases referred to above, during the discovery process, prior to trial, during the trial, and subsequently, BOBBY SID TAYLOR maintained and does now maintain that the operation of his motor vehicle on April 9, 1977 did not contribute to the injuries sustained by the plaintiffs, and at no time has he insisted, demanded, or even encouraged his insurance company to settle the plaintiffs' claims within his policy limits, and
>
> WHEREAS, one of the drivers of an automobile involved in the collision on April 9, 1977, to wit: DOUGLAS ALAN WISTROM, was uninsured on the date of said collision, and BOBBY SID TAYLOR having a bona fide belief that the negligence of DOUGLAS ALAN WISTROM contributed to his bodily injuries sustained in that collision, and
>
> WHEREAS, BOBBY SID TAYLOR has demanded compensation from STATE FARM under the uninsured motorist coverage afforded to him, and
>
> WHEREAS, BOBBY SID TAYLOR desires to settle the uninsured motorist claim, and to relieve STATE FARM of any and all other contractual claims, interests, or causes of action he has or may have against STATE FARM, and
>
> WHEREAS, STATE FARM has agreed that uninsured motor-

ist coverage is available to BOBBY SID TAYLOR and appropriate under the facts surrounding the collision on April 9, 1977, and STATE FARM having been fully apprised in the premises,

THEREFORE, in consideration of the mutual covenants contained herein, STATE FARM agrees to pay the sum of $15,000 to BOBBY SID TAYLOR in full satisfaction of all contractual rights, claims, and causes of action he has or may have against STATE FARM under the policy of insurance referred to herein, in connection with the collision on April 9, 1977, and all subsequent matters, and BOBBY SID TAYLOR hereby accepts that sum pursuant to the recitals contained herein.

Taylor also asked for a summary judgment, seeking a ruling that the release did not prohibit his bad faith claim.

The judge denied both requests, finding that the release was ambiguous and that therefore contradictory evidence was admissible at trial to aid in interpreting the release.

A second judge, who presided at the trial, also denied State Farm's motion for directed verdict based on the release. Having been instructed on the interpretation of the release, the jury returned a verdict in favor of Taylor for compensatory damages of $2.1 million. The court also awarded Taylor $300,000 in attorney fees.

The court of appeals reversed, holding that the release agreement was not ambiguous and therefore the judge erred by admitting evidence to vary its terms. Based on the agreement's "four corners," the court held that "it clearly release[d] all policy contract rights, claims, and causes of action that Taylor has or may have against State Farm."

According to the court, because the release should have been strictly enforced, there was no basis for Taylor's bad faith claim. Taylor appealed.

The state supreme court wrote:

> ...Taylor released "all contractual rights, claims, and causes of action he has or may have against State Farm...in connection with the collision [and] subsequent matters."

> ..It is reasonable to believe that if the parties had agreed to release the bad faith claim, they would not have drawn the release so narrowly—confining it to "contractual" and "subsequent" matters, with no mention of tort claims or bad faith.

> Surely, State Farm knew what language would effectively re-

lease it from Taylor's potential bad faith claim. It can be inferred that sophisticated parties in the business of settling insurance claims, faced with the task of releasing a claim as large as Taylor's, would have used more specific or at least broader language if that was their agreement.

...For these reasons, we hold that extrinsic evidence produces support for Taylor's contention that the release language was not intended to release his bad faith claim.

The trial jury had resolved the release issue in Taylor's favor. The high court left that resolution undisturbed.

Delaying Payment

Insurance companies used to settle claims more quickly than they do today. The theory was that if they settled quickly, they could do so for a smaller amount—they'd just make sure the policyholder signed a release denying any further claims related to the accident in question. But, as policies have become more complicated and releases harder to enforce, many insurance companies have changed their tactics.

> **Now, some insurance companies make the tactical decision to delay payments as long as they can without inviting lawsuits.**

You don't have to accept the delays, though. There are several basic principles that you should use in collecting from insurance companies:

- Analyze every part of an accident or other loss for how it might be covered by your policy—liability, collision, medical payments, uninsured motorist. (Rules differ by state and specific policy, but you can usually wait as long as two weeks to report an accident to your insurance company—but not police.)

- Consider all of the claims you might make following an accident or loss. If you have health, homeowners or renters insurance, can you make claims under these coverages?

- Never accept a first offer—or even a first denial—by an insurance company as the final, unequivocal word. You know insurance companies will delay or deny claims if they can. If they do, ask for an explanation for their delay or denial. In

response, you should gather facts and reread your policies yourself. If you can't decipher everything in the policy, talk to your agent or—if necessary—a lawyer.

Even if denial isn't an insurance company's ultimate goal, by playing the denial game, it can achieve something almost as advantageous—a lengthy delay in paying the claim. The longer an insurance company can hold on to its money, the better off it is.

> **But the law, and more importantly the courts, don't give insurance companies free rein to delay fair settlements as they please.**

In June 1995, an Alameda County, California, jury handed down a $3.9 million punitive damage award for a man who sued his insurance company for not adequately compensating him after a car crash killed his only son.

The Superior Court jury found that the insurance company, Texas-based United Services Automobile Association (USAA), acted in bad faith when it offered David Clayton compensation of $10,000. He was entitled to $175,000, said his lawyer, Richard Seltzer of Oakland.

The 1990 accident had occurred in the Oakland hills, when an oncoming vehicle crashed into a car driven by a friend of Clayton's 15-year-old son, Zachary. The son was crushed by the impact. Though neither driver's insurance company disputed the liability, the two policies had a combined coverage limit of only $125,000.

The Claytons' USAA policy included $300,000 in uninsured/underinsured motorist coverage. When the company offered David Clayton $10,000, he wrote to the company's president to complain. A response came back saying he would have to pursue arbitration if he was not satisfied. Reluctantly, he did.

Three days before the scheduled day of the arbitration, USAA offered Clayton $175,000. Clayton later sued.

The company's about-face 15 months after the accident was a key factor in the case. "The jury found that they didn't have any significant new information three days before arbitration," said Seltzer. "I asked the jury to send a message to this company and others that they can't do business this way. If they're going to accept money for premiums...they can't turn their backs on people when they have tragedies."

Although USAA is expected to appeal the award, the verdict—totaling $4.3 million including other damages—sent a signal to other insurance firms

about the costs involved of delaying payments excessively.

Three months earlier, the largest auto-insurance insurance company in Northern California had settled a massive lawsuit that charged the company with refusing to pay the medical bills of 78 accident victims.

The lawsuit had begun as 78 separate complaints, which were consolidated in 1991. Each policyholder had been insured by the California State Automobile Association in the late 1980s, and each told a similar story of being in a car wreck, getting treatment and having his or her benefits delayed—or denied—after an examination by a company doctor.

According to lawyers who worked on the case, CSAA decided in 1987 to stop paying for treatments by chiropractors and other doctors of soft-tissue injuries, the bruises and strains that often result from car accidents. But company officials denied making any such decision, contending that they were merely taking more time to investigate sudden increases in the number and expense of questionable claims.

But a criminal investigation had bolstered the policyholders' claims. In 1991, the San Francisco district attorney's office and the state Department of Insurance had opened investigations into allegations that CSAA was paying claims late, in part or not at all.

The investigations ended a year later when the company agreed to pay about $260,000 in what it called "assessments."

CSAA spokesman Barry Shiller said the cost of policyholders' medical claims had jumped 42 percent from 1985 to 1987, and that soft-tissue claims were the single biggest cause. "The [policyholders] did not think that it was reasonable to ask them to look at a health care bill and verify that they were at the doctor's office as many times as was listed," Shiller said.

He also stressed that the settlement was not an admission of guilt and was "far less than we would have spent to try it (the case) before a jury."

> CSAA settled the case after two days of a trial that lawyers had expected to last almost a year. The amount of the settlement was confidential, but sources said it totaled more than $4 million.

Bad Faith

Lawsuits or regulatory complaints relating to delays or denials usually allege bad faith on the part of the insurance company. This is one of the heaviest clubs you can wield to strike back at an insurance company.

One way in which an insurance company can act in bad faith is by not investigating a claim with an eye toward providing coverage. "The investigation should be geared toward paying the claim, not denial," said William Shernoff of Shernoff, Bidart & Darras, a California-based risk management consulting group. "Nine out of 10 times, however, that investigation is designed to turn something up that justifies denying the claim. Their eye should be toward protecting their policyholder, but it's not."

In January 1995, State Farm—the largest provider of auto insurance in Arizona—was ordered to pay $910,000 to a family after a jury found that the company acted in bad faith on an accident claim.

Three children in the Ahring family were injured in a head-on collision in 1989. The ownership of the truck in which they were riding was in dispute, and State Farm was accused of failing to disclose a memo that would have cleared up ownership. According to John Osborne, a lawyer for the Ahrings, the pickup was a loaner from a garage to the children's grandfather, Milburn Sherwood. Osborne described Sherwood as senile and said that after the wreck, the garage owner insisted that the grandfather had bought the truck.

The point was important, because the other driver, who was at fault, did not have insurance. Because it was initially thought that the grandfather owned the truck, the family collected under his uninsured motorist insurance, provided by State Farm.

But the family would have been much better off collecting under the garage's policies, which provided higher coverage. The garage's uninsured motorist coverage was through Truck Insurance Exchange.

The family sued State Farm after a memo was discovered at a State Farm agent's office clearly indicating that the garage owned the truck. The family's lawyers alleged that State Farm was motivated to hide the memo because of confusion over whether it might be liable (among other things, it had issued an umbrella liability policy to the garage).

Steve Smith, a lawyer representing State Farm, said the verdict would be appealed. Smith said the memo was never hidden and proved nothing. He said the jury was swayed by the injuries suffered by the Ahring children.

Regulatory Reform Issues

In 1993, California Insurance Commissioner John Garamendi put in place a number of regulations to simplify the claims process.

The California regulations were loosely patterned after model standards adopted in 1991 by the National Association of Insurance Commissioners.

Insurance industry analysts predicted their use in California may influence other states' treatment of similar standards.

> **Increasingly, though, auto insurance companies look at all the lawsuits as reason to pay claims quickly.**

Among the 1993 regulations:

- Within 15 days of any notice of claim, an insurance company must acknowledge receiving the notice. The company must start its investigation within 15 days of receiving the notice.

- Within 40 days of receiving a notice of claim, an insurance company must affirm or deny the claim and affirm or deny liability.

- If 40 days isn't sufficient time, the company must write to the claimant and specify why more time is needed, and what further information it needs.

- A denial of a policyholder's claim, in whole or in part, must be accompanied by a letter that spells out the policy provisions and factors on which the company is relying. All written denials must include a notice that the company's decision can be reviewed by the Insurance Department, and must provide the department's address and phone number.

- Insurance companies must disclose to their policyholders all benefits, coverage, time limits or other relevant provisions of any policy they have issued that may apply to a claim.

- "Any other communication" that "reasonably suggests that a response is expected," and that regards a claim not in litigation, must be responded to within 15 days of receipt.

> **Garamendi also started an annual survey he called the "Good, Bad and Ugly"—which measured consumer complaints against insurance companies. Other states have started similar surveys.**

Garamendi said that the annual survey, coupled with stringent regulatory efforts, would help insurance companies improve their customer service as well as significantly drive down the number of justified complaints filed with the department in 1993.

> A justified complaint is one that involves a violation of the Insurance Code or other insurance laws, or one in which the consumer was unable to get an insurance company to respond to his or her concerns of questions. Typical complaints involve delay of payment on claims, disputes on amounts owed to policyholders by their insurance companies and misrepresentation of coverage purchased.

But as important as consumer complaints and violations of the Insurance Code are to state regulators, what they are pursuing most agressively is stepping up efforts to stop fraud.

In 1996, the owner of a New Jersey auto body shop pleaded guilty to bribing insurance officials to inflate damage claims—a scam that earned him about $75,000 over three years.

James T. Mazzaro, the owner of Mazzaro and Son Auto Body Shop Inc., pleaded guilty in Superior Court to theft by deception and commercial bribery. He admitted he conspired with two appraisers for the New Jersey Manufacturers Insurance Co., who filed inflated or false repair bills; Mazzaro pocketed the extra cash.

The scam was detected after a customer told a company representative that Mazzaro was making unnecessary repairs.

"What we uncovered was a very imaginative array of ways to exaggerate these bills," said company spokesman Patrick Breslin.

In one instance, Mazzaro and the appraisers reported that an air bag that had never been deployed or damaged needed to be replaced at a cost of about $1,000. In another case, he further damaged a car to inflate the repairs.

Breslin said the company does not know how much it lost due to the scam, but that losses were in the hundreds of thousands of dollars, including money taken by others involved.

In all, the insurance company documented more than 100 instances of inflated or false damage claims between 1992 and 1995.

In August 1994, company officials turned over the results of their investigation to the state Division of Criminal Justice. In addition to his criminal plea, Mazzaro paid New Jersey Manufacturers $270,000 in damages earlier this year. He also agreed to pay a $175,000 consent judgment to the state Department of Insurance's fraud unit.

Common Coverarge Disputes

As important as pricing and claims are to the insurance process, what really counts in insurance is coverage. When you make a claim on your auto

policy, will it pay? The most common cause of coverage disputes is vague or subjective language in the insurance policy.

For example, in the section of the standard policy that deals with the duties you have after an accident, you're told that you have to inform the insurance company promptly.

The use of subjective words like "promptly" lead to problems of interpretation in some cases. In the duties section, its use is intended to provide the flexibility necessary for you in reporting some cases.

> **For example, you might be hospitalized and be in serious condition for several days or weeks after an accident. Family members might be unaware of the insurance policy requirements. Such inability to make a report immediately after an accident would be taken into consideration by the insurance company in reviewing your claim. In most cases, It's not likely that coverage would be denied because of this kind of delay.**

Insurance companies try to shy away from subjective or interpretive language, though. As we've seen elsewhere, ambiguous language creates a presumption of coverage. As one court ruled:

> To find coverage does not rewrite the contract; it merely broadly interprets ambiguous terms against the insurance company so as to effectuate the policy behind the law to provide comprehensive insurance coverage to innocent parties injured by uninsured vehicles.

Location

There is sometimes disagreement between insurance companies and policyholders as to exactly where a vehicle is located. One factor that might enter into the determination could be whether the policyholder has a permanent residence, such as a house or apartment—if not, the person might be living out of the vehicle. The standard policy doesn't cover vehicles being used as residences.

> **The percentage of time spent "living out of" the auto could also be a factor—a two-week vacation in a camper would probably not be considered "use of a vehicle as a residence."**

If the auto is parked at one site and never moved, it would more likely be considered to be used as a premises. However, in any of these cases, coverage would always apply while the auto is being used for transportation purposes.

One big factor in a location disagreement between insurance companies and policyholders is what kind of neighborhood the policyholder lives in.

If you live in a big city, you will probably pay more for auto insurance. If you live or park your car in certain zipcodes or areas that are high in crime, your coverage may be even more expensive still.

Contents

Contents of a vehicle or personal effects are not covered under a standard auto policy. This may seem unfair, because all drivers carry belongings around in their cars. But, in order to make the risk projections for auto insurance feasible, insurance companies can't calculate such a variable factor.

When you buy insurance on a car, the premiums that the insurance company charges for physical damage coverage ("collision" and "other than collision") are based on the maximum amount that the insurance company might have to pay if the vehicle were a total loss.

> **For example: The insurance company might charge $200 for one year's coverage on an $8,000 car. The most the company could expect to pay to repair or replace the car would be $8,000. But it has no control over the value of any items you might carry in the vehicle on any given day. If you were transporting a $100,000 painting in an $8,000 car and the car and painting were destroyed in a collision, the insurance company would be unfairly penalized if it had to pay out $108,000 when it had collected premium for only $8,000 of value.**

Personal property items (such as clothing, cameras, sporting equipment, tools and all the things you carry around in your car) should be insured under a different type of policy. Most people have this coverage under a homeowners insurance policy, but coverage is also available under Personal Property Floaters and other specialized property insurance policy forms.

Fraud

Finally, one of the coverage issues that insurance companies pursue most aggressively is suspected fraud. If a company even thinks that a claim might be bogus, it will delay—and perhaps deny—any coverage.

"Every American household is burdened with more than $200 annually in additional insurance premiums to make up for this type of fraud," said FBI Director Louis Freeh in a 1995 press release. "Staged automobile accidents are a major contributor to the more than $20 billion a year property and casualty insurance fraud problem—out of an estimated $70 billion to $80 billion a year in health care fraud—and illustrate the subversion of the American health care system by unscrupulous medical providers and their partners in crime."

So, insurance companies have good reason to suspect fraud. According to the FBI, typical cases involve one of several scenarios:

- Caused accidents in which an innocent victim can be made an unwitting participant in an actual accident, such as a sideswiping (law enforcement people call this scam "swoop and squat").

- Staged accidents in which vehicles with prior damage are brought together and made to appear to have been involved in an accident.

- Paper accidents in which no accident occurred but false accident reports were filed to support insurance claims.

- So-called "phantom vehicle" claims, in which motorists claim to suffer a loss from a hit-and-run driver who does not exist.

- Personal-injury mills, in which lawyers and physicians—some working alone, some working together—submit claims for patients' nonexistent or exaggerated injuries.

- Cars abandoned by owners hoping to cash in on the theft coverage in their insurance polices.

> **Historically, based on a financial decision to avoid expensive trials, insurance companies have agreed to settle suspect medical and auto damage claims. But that's changing. These scams—especially the "swoop and squat" claims—have become a national problem.**

Solo drivers—more often women—and tourists are the favorite targets of swoop and squat teams. As a result, rental car companies and large insurance companies have been hit with millions of dollars in false claims.

Law enforcement agencies have also clamped down on the more organized insurance fraud rings.

The National Insurance Crime Bureau estimates that fraud costs insurance companies at least $20 billion a year and forces the average household to

pay an additional $200 a year in premiums. And average auto rates are on a pace to come down for the first time in at least 21 years, thanks in part to a decline in fraudulent claims.

Experts say a large portion of the fraud is associated with car insurance.

In December 1998, State Farm announced it had filed two lawsuits in Texas to recover more than $4.6 million in claim payments from firms and individuals who allegedly bilked the insurance company by staging car accidents in the Dallas and Houston areas over the last few years.

The Illinois-based insurance company could recover more than $13.8 million, however, including legal expenses and punitive damages, because the suits were filed under the Racketeer Influenced and Corrupt Organizations law, which allows recovery of three times actual damages.

State Farm Insurance, the largest home and auto insurance company in the country, has more than tripled its anti-fraud force to 1,300 employees during the late 1990s.

A State Farm spokesman said the company files suits to deter fraud and to "recover this money, with which we can lower the honest policyholder's premium."

The lawsuits came two months after Allstate Corp., the country's second-largest home and auto insurance company, filed a $1.95 million suit against the former owners and operators of 13 medical clinics in Chicago, saying they charged the Northbrook, Illinois-based insurance company for services that were unreasonable, unnecessary or not provided.

"The purpose of this whole effort is to make sure doctors and chiropractors and others know that it's not a victimless crime. They're raising your premiums and my premiums by doing this," said Edward Moran, who heads Allstate's special investigative unit. Moran's group of 630 employees was organized in 1998 to pursue insurance fraud more aggressively.

> **Allstate had filed several suits in the previous 12 months, including the largest lawsuit ever against a ring in Los Angeles that it claimed staged auto accidents. It sought $107 million in that suit.**

Allstate also was awarded $10 million in another recent California suit, and has sued for fraud in New Jersey and Philadelphia.

In October 1998, the First Trenton Indemnity Co. sued New Jersey resident Sylvain Evra, claiming he had intentionally crashed his 1978 Cadillac into drivers pulling out of parking spots in both Montclair and Paterson.

The suit sought to relieve the insurance company of paying $21,000 in

from Evra and one of his passengers.

The suit referred to a Montclair police report in which a woman says Evra first flashed his lights to indicate he'd let her pull out from her parking spot—and when she did, he "purposely ran into the side of her vehicle."

Despite the accusation by that driver—who was not injured—Evra and his passenger submitted insurance claims in connection with the 1996 crash. Furthermore, First Trenton claimed Evra intentionally had smashed the Cadillac into another car in nearby Paterson four months later. He was cited for careless driving in connection with that crash, according to First Trenton.

In the late 1990s, insurance companies alleged that thousands of people in New Jersey had been engaged in purposefully crashing cars—with the city of Passaic cited by authorities as the center of the scams. In its case, First Trenton's suspicions were raised by the accident report, according to the suit.

One national expert said claimants think they have little to lose in filing a questionable claim. "You may not get the claim paid, but the chances of getting criminally prosecuted are pretty rare in a situation like that," said Dennis Jay of the national Coalition Against Insurance Fraud. "If you have some idea there's no way there's going to be criminal prosecution, why not?"

For the previous four years, the state Department of Law and Safety had filed criminal insurance fraud charges against an average of only 57 people per year. In the late 1990s, the industry started getting more serious.

Appraisers crawled under cars and used tape measures to check exactly how much the shock absorbers behind bumpers had been jammed after minor accidents.

Crash experts used the tape-measure data to estimate the likelihood that the driver could have suffered a neck, spine or back injury. If someone had a two-mile-an-hour crash but reported serious back problems, the company might refuse to pay the claim.

One company also used three "crash-busters," vans that drive to the houses of customers as soon as possible after an accident to appraise the damage and try to settle the claim quickly.

Lawsuits typically arise after claims are paid and an insurance company has gathered evidence that the claims were fraudulent.

If the insurance company suspects fraud, it will demand full compliance with the policy. Policyholders have significant duties in first party claims. These duties are found in the "Conditions—Duties After Loss" section of the policy and go well beyond a general requirement to cooperate.

The policy probably requires the insured person to supply proofs of loss within a particular time period, to supply medical and wage information, to submit

to an examination under oath, and to refrain from filing a lawsuit before fulfilling the policy requirements.

Exclusions

Auto insurance policies also include some specific exclusions that limit or deny coverage.

> **Exclusions cause the majority of claims disputes.**

Some exclusions exist simply to remove coverage for above-average risk factors which are not anticipated in average rates and premiums, and that the coverage is often available for an additional charge. This is the case with audio, visual and data equipment and the tapes, records and other media used with such equipment. The basic policy form excludes coverage because these are items of value which have an above-average exposure to theft losses (they are easily removed and are often targets for thieves).

On the other hand, some people want specific drivers excluded from coverage. These special exclusions have become increasingly common in recent years. The 1994 Michigan case *Lynn McMillan v. Auto Club Insurance Association* considered the issue of a named driver exclusion to an auto policy.

McMillan owned a 1989 Dodge Ram van and was insured under a no-fault automobile insurance policy issued by the Auto Club. At the time in question, McMillan lived with Mervin Carl Timmerman, who had a poor driving record and had previously been involved in an accident with one of McMillan's cars.

In exchange for a lower premium, McMillan obtained a policy from the Auto Club with a named-driver exclusion that explicitly excluded Timmerman as a driver of the insured vehicle. The named-driver exclusion provided that various non-mandatory coverages, including comprehensive and collision, would be void and of no effect if the vehicle were operated by Timmerman.

While this insurance policy was in effect, McMillan drove himself to the hospital, where he was admitted and treated for a cardiac problem. McMillan asked his brother to return the van to McMillan's home. He instructed his brother that Timmerman was not to be allowed to drive the van or to have access to the van's keys.

Nevertheless, Timmerman found the keys in a drawer at the house, took the van and was involved in an accident with a tree, causing approximately $12,000 worth of damage to the van.

McMillan filed a claim with the Auto Club, which denied the claim on the basis that the vehicle was being operated by the named excluded driver at the time of the accident.

McMillan maintained, and the Auto Club did not dispute, that Timmerman had taken the vehicle without permission at the time of the accident and had been instructed on prior occasions that he was not to drive the vehicle.

McMillan sued, arguing that he was entitled to coverage under the policy because the vehicle had been stolen. The Auto Club maintained that whether the vehicle had been stolen or not was irrelevant because—in either case—it was being operated by a named excluded driver and, therefore, no coverage existed under either the comprehensive or collision coverages of the policy.

The insurance policy issued to McMillan contained the following provision under the heading "Authorization for Excluded Driver":

> WARNING—When a named excluded person operates a vehicle all liability coverage is void—no one is insured. Owners of the vehicle and others legally responsible for the acts of the named excluded person remain fully personally liable.

The trial court sided with McMillan, ruling that coverage was available because the vehicle had been stolen. The Auto Club appealed.

"While we agree with the Auto Club that it is irrelevant whether McMillan's claim [is] one seeking recovery of a loss for theft or one for collision, because both are excluded under the named excluded driver provision, we do not share the Auto Club's conclusion that the issue of theft is irrelevant to the decision whether the provision excluding a named driver applies," the appeals court ruled.

The insurance policy provided for coverage in the event of both theft and collision. It also contained an excluded-driver provision that nullified various coverages—including theft and collision—if the vehicle were operated by a named excluded driver.

"That provision, however, is silent on the issue of what effect, if any, theft by a named excluded driver may have on those coverages," the appeals court wrote. "We conclude that this silence allows for two possible interpretations of the contract: either that the provision excluding a named driver applies in all circumstances where the vehicle is being driven by a named excluded driver or that it applies only where the named excluded driver is operating a vehicle with the insured's permission."

The court ruled that reasonable expectation would have a lot to do with which interpretation it would choose. It would favor McMillan's version—

that the exclusion only applied if permission were given—particularly in light of the fact that exclusionary clauses are usually construed strictly against the insurance company.

> **Reasonable expectation is an important issue in coverage disputes.**

"In reading the provisions of the policy, we believe that a reasonable insured [person] would expect that if the named excluded driver were allowed to operate the vehicle then the various coverages would be void," the *McMillan* court wrote. "However, we also believe that a reasonable insured would also expect that if the vehicle were stolen, even if stolen by a named excluded driver, then there would be coverage under the policy."

In other words, the policy put McMillan on notice that he wasn't to allow Timmerman to drive the van. But it didn't say he was without coverage if Timmerman took the van without permission.

The court ruled that "assuming that insurers may exclude from coverage claims arising from theft by named excluded drivers, the excluded-driver provision must incorporate specifically language that notifies the insured that the exclusion applies even in the event of theft by the named excluded driver."

The excluded-driver provision in McMillan's policy did not exclude specifically coverage where there was a theft by the named excluded driver. Therefore, McMillan was entitled to coverage if the vehicle were stolen by the named excluded driver.

Underinsured Motorist as a Weak Excuse

Uninsured and underinsured motorist coverage (UIM)—the insurance you buy to cover you if the person who hits you doesn't have insurance—is a common dodge that insurance companies will use to avoid paying claims.

The primary purpose of uninsured motorist insurance "is to assure financial compensation to the innocent victims of motor vehicle accidents who are unable to recover from financially irresponsible uninsured motorists."

In order to qualify for UIM benefits under any UIM policy "insuring" the injured person, that person must demonstrate that the limits of the policy "held" by him or her are greater than the aggregate liability limits insuring the allegedly underinsured at-fault driver.

When an automobile accident occurs in the course of employment, a policy "held" by a regular employee of a business enterprise includes the policy

of the enterprise that covers the employee in the course of employment.

UIM coverage is optional first party coverage insuring the policy holder, and others, against the possibility of injury or property damage caused by the negligent operation of a motor vehicle whose liability insurance coverage is insufficient to pay for all losses suffered. In most states, the coverage must be offered by insurance companies as a mandatory option; however, most states prohibit the stacking of UIM benefits on either an intra-policy (i.e., where an "insured" in a single policy that covers many cars may recover under UM coverage of each car) or inter-policy (i.e., recovery from more than one policy for injuries sustained in a single accident) basis.

The June 1997 New Jersey Supreme Court decision *Diana French v. New Jersey School Board Association Insurance, et al.*, considered one such example.

In April 1991, Diana French was driving a school bus for her employer, Hudson County Area Vocational Technical School. A taxi cab struck the school bus in the rear and French sustained serious injuries. Since the accident, French has undergone multiple surgeries and has been unable to return to work.

French brought a legal action against the taxi company, which ultimately settled for $25,000, the liability limits of its policy insuring the taxi. French then sought benefits under the UIM coverage contained in the insurance policy issued to Hudson by the New Jersey School Board Insurance Group. That policy provided UIM coverage in the amount of one million dollars.

French also had personal automobile insurance through Allstate Insurance Company with UIM coverage in the amount of $25,000.

The trial court held that any UIM recovery by French was limited to the $25,000 available under her personal Allstate policy; and that because no UIM coverage was created when that policy was compared with the at-fault driver's liability limit, summary judgment in Allstate's behalf was appropriate. French appealed.

The state Supreme Court started out with a public policy comment:

> As this case illustrates, we did not expect or intend that the amount of liability held under a personal insurance policy would be the sole criterion or litmus test for determining UIM coverage issues.

Portions of the statute and the standard uninsured/underinsured motorist endorsement approved by the Commissioner of Insurance "plainly envision[ed]" one being able to secure benefits under more than one UIM endorsement. In that regard, New Jersey law stated:

Uninsured and underinsured motorist coverage provided for in this section shall not be increased by stacking the limits of coverage of multiple motor vehicles covered under the same policy of insurance nor shall these coverages be increased by stacking the limits of coverage of multiple policies available to the insured.

Obviously, that provision assumes that the individual is insured under multiple UIM policies, as there would be no reason to prohibit policy stacking if one could have access to benefits under only the UIM policy one purchased, as described above. Moreover, the standard UM/UIM endorsement approved for use in personal New Jersey automobile insurance policies defines "insured," for the purposes of UIM protection, as follows:

1. you or any "family member";

2. any other person "occupying your covered auto";

3. any person for damages that person is entitled to recover because of bodily injury to which this coverage applies sustained by a person described in 1 or 2 above.

Plainly, therefore, both the statute and the standard UIM endorsement contemplate situations in which one could conceivably receive benefits under more than one UIM policy.

Some insurance companies assume that an employer's UIM policy covers an employee for work-related injuries, although there might be a dispute about whether the employer's policy or the personal policy would be primary.

It would be inconsistent with the plain language of the UIM endorsement of the policy and with the reasonable expectations of both the employer and employee to deny the benefits of UIM coverage to an employee injured while operating the employer's vehicle during the course of employment.

No public policy or statute prevents an insurance company from providing greater coverage to an insured person than is provided under the personal insurance of that insured person.

For example, a parent should not be prevented from providing UIM coverage for a resident-child greater than the child might have on a personal auto so long as the risk is understood and accepted by the insurance company. After all, the parent is likely to bear the burden of any unreimbursed expenses.

The New Jersey Auto Insurance Buyers Guide describes Uninsured/ Underinsured Motorist Coverage in the following manner:

Despite New Jersey law, which requires auto insurance, many

cars are not covered by insurance. Some motorists break the law. Many others are residents of other states which do not require auto insurance by law.

Because these motorists can cause accidents, you are required to buy uninsured motorist coverage. This coverage does not benefit the uninsured driver. It will provide benefits to you, your passengers or relatives living with you if a motorist without insurance is legally liable for injuries to these persons or for damage to your car or its contents.

There are other motorists who have auto insurance coverage but with very low limits. When you buy uninsured motorist coverage above the minimum limits required by law, you are also provided coverage to protect you from those motorists who are underinsured. If you are in an accident caused by such a motorist, underinsured motorist coverage will pay damages up to the difference between your underinsured motorist coverage limit and the other driver's liability coverage limit.

When the intent of parties to the insurance contract to extend coverage to others is uncertain, the matter of personal choice may become the dominant theme. In a series of cases, the Appellate Division read New Jersey law as standing for the principle that if a person is injured while fortuitously using or occupying a vehicle covered by a policy under which the person is not a named insured, that person's UIM recourse is "defined by [the injured person's] own policy and not by the policy covering the fortuitously occupied vehicle or, indeed, any other policy."

In this case, the plain language of the policy and the undoubted common intent of the parties to the UIM contract is that the policy covers the bus driver as an employee of the school district. The language of the policy is unambiguous in this regard. The UIM endorsement covers anyone "occupying a covered auto."

By whom is a policy of the fictitious being of a corporation "held" if not by corporate employees? Diana French, the bus driver who was injured in the accident with the taxi cab, thus "held" UIM coverage greater than the at-fault driver's liability coverage.

In this case, involving a full-time employee of an enterprise, the probable fair expectations of an insurance company and policyholder, absent specification to the contrary, are that the policy provides UIM coverage for employees of the business entity, in this case the bus driver herself.

We expect that there will not be many cases that will not be covered by clear policy language. Still, other complexities remain. For example, once the threshold test for a UIM claim has been met, the statute contemplates that the insured is free to pursue UIM benefits under other policies under which he or she may be insured—whether under his or her personal policy, as the occupant of an employer's vehicle, the permissive occupant of a motor vehicle owned by any other insured person, or as the resident in the household of a relative possessing his or her own UIM insurance. Each of those UIM policies is opened up to the insured once the threshold test is met.

Simply stated, UIM coverage provides to an insured person added protection against the risk of being injured by a negligent driver having an inadequate limit of liability insurance to cover the extent of the insured's injuries.

The court concluded: "The judgment of the Appellate Division is reversed and the matter is remanded for arbitration of French's UIM claim."

A motor vehicle is underinsured when the sum of the limits of liability under all bodily injury and property damage liability bonds and insurance policies available to a person against whom recovery is sought for bodily injury or property damage is, at the time of the accident, less than the applicable limits for underinsured motorist coverage afforded under the motor vehicle insurance policy held by the person seeking that recovery.

A motor vehicle shall not be considered an underinsured motor vehicle under this section unless the limits of all bodily injury liability insurance or bonds applicable at the time of the accident have been exhausted by payment of settlements or judgments. The limits of underinsured motorist coverage available to an injured person shall be reduced by the amount he has recovered under all bodily injury liability insurance or bonds.

Obviously, the statute expresses no mandate regarding the persons that are to be insured under the standard UIM endorsement. Nevertheless, in establishing the key threshold analysis to determine the existence of a potential UIM claim in the first instance (again, comparing the UIM limits with the tortfeasor's liability limits), the statute directs that the potential UIM claimant is to use the UIM policy "held" by that person.

The March 1998 Maryland Appeals Court decision, *Jimmy Young v. Allstate Insurance Co.*, dealt with some basic issues of who can make a claim under a

The March 1998 Maryland Appeals Court decision, *Jimmy Young v. Allstate Insurance Co.*, dealt with some basic issues of who can make a claim under a standard auto policy. It also involved an insurance company working hard to delay a claim.

On July 18, 1995, Jimmy Young, an employee for the District of Columbia public school system, was operating a large step van provided by the District of Columbia for regular use in servicing the District's public schools. At lunch time, Young parked the vehicle near a McDonald's restaurant, turned off the ignition, exited the truck, and went to the rear of the vehicle to check the padlock on the back doors.

While standing to the rear of the bumper of the parked truck, Young noticed a car coming from the opposite direction. The vehicle, driven by Antonio Milano made a sudden U-turn, coming close to Young's truck as it veered around. As the vehicle turned, it made a squealing noise which caught Young's attention, causing him to turn around and look to his right. After virtually completing the U-turn, Milano backed the vehicle he was driving into Young's right knee.

Despite the impact, Young was not pushed into anything and he did not fall. He did, however, grab his knee and sit down on the rear bumper of the parked truck. Milano stopped his vehicle, rolled down his window, apologized to Young, and then fled the scene.

Young brought action against Allstate Insurance Company to recover uninsured motorist (UM) benefits for injury sustained while standing behind a vehicle furnished by his employer for his regular use.

In December 1996, Allstate filed a Motion for Summary Judgment claiming that Young was not covered under the policy's uninsured motorist provisions because he was using a truck provided by his employer for his "regular use" when the accident occurred.

The Allstate policy excluded vehicles not owned by Young that were provided for his "regular use."

On appeal, Young argued that the lower court erred when it granted Allstate's Motion for Summary Judgment based on a finding that he was "in, on, getting into, or getting out of" a vehicle provided for his "regular use," as opposed to finding that he was a pedestrian at the time of the accident.

Allstate disagreed, claiming that the policy excludes vehicles not owned by Young that are provided for his "regular use" from the definition of "insured auto" as used in the policy's uninsured motorist endorsement. Consequently, said Allstate, Young is excluded from claiming uninsured motorist protection while "in, on, getting into, or getting out of" the step van that his

employer had provided for his "regular use."

The appeals court reversed the decision, claiming that the lower court misconstrued the insurance contract and uninsured motorist law.

The uninsured motorist endorsement of the Allstate policy provides, in part, under the section entitled "Part 5 Uninsured Motorist Insurance Coverage SS":

> We will pay damages for bodily injury, sickness, disease or death, or property damage which an insured person is legally entitled to recover from the owner or operator of an uninsured auto. Injury must be caused by accident and arise out of the ownership, maintenance or use of an uninsured auto.
>
> Under the policy, insured persons include:
>
> 1. you and any resident relative;
>
> 2. any person while in, on, getting into or out of an insured auto with your permission;
>
> 3. any other person who is legally entitled to recover because of bodily injury to you, a resident relative, or an occupant of your insured auto with your permission.
>
> An insured auto under the policy is a motor vehicle:
>
> 1. described on the declarations page (This includes the motor vehicle you replace it with.);
>
> 2. not owned by you or a resident relative, if being operated by you with the owner's permission. The motor vehicle can't be furnished for the regular use of you or any resident relative.

Obviously, the policy placed Young within the first class of insured persons. But the policy excluded vehicles such as the truck Young was driving from the definition of "insured auto."

However, according to the appeals court, the plain language of the contract indicates that Young, the named insured, is eligible for UM coverage for physical injury whether he is in an insured vehicle or not. To reiterate, the policy provides:

> We will pay damages for bodily injury, sickness, disease, or death...which an insured person is legally entitled to recover from the owner or operator of an uninsured auto. Injury must be caused by accident and arise out of the ownership, maintenance or use of an uninsured auto.

As indicated in the policy, said the court, the first category of "insured persons" is defined in a separate sentence as "[appellant] and any resident relative." It contains no limiting language. The restrictive language of "while in, on, getting into or out of an insured auto" is included with the second defined class of "insured persons" which clearly increases the coverage allowed in the first class but does not restrict it in any way. The court wrote:

> If Allstate had wanted to limit the policy's UM coverage on Young, it could have easily written the limitation into the first clause which provides the coverage as it did in the other clause(s). For example, the first class of insured persons hypothetically could have been defined as [y]ou and any resident relative while not in, on, getting into or out of a motor vehicle furnished for the regular use of you. To be clear, we are not saying here that such an exclusion would be valid. Rather, we give the example to show that an exclusion should be clearly implicated by the policy, lest the drafter fall prey to self-created ambiguities. The restriction regarding the furnishing of a vehicle for regular use applies to whether a vehicle is insured, not whether a person is insured. The policy clearly indicates that appellant, as named insured, is an "insured person."

The court also ruled that Young did not fall under a valid policy exclusion as alleged by Allstate.

Allstate sought to exclude coverage for Young, the named insured, because he was "in, on, getting into or out of a vehicle not owned by him, but instead, furnished to him by a third party for his regular use."

However, Young was not "in, on, getting into or out of" the truck provided for his "regular use," said the appeals court. He had exited the vehicle, closed the door behind him, and walked to the rear of the vehicle to ensure that the padlock on the rear doors was secure. Young's attention was focused on going to a nearby McDonald's for lunch.

> Upon hearing the squealing of a car making a sudden U-turn, Young turned away from the truck. His attention was then focused on the wayward U-turning vehicle driven by Milano. After completing the U-turn, Milano backed into his knee. [Young] was no longer "getting out" of the truck—he had nearly, if not completely, concluded checking the padlock when his attention was drawn by the...U-turning car, causing him to change his orientation by turning around and looking to the right.

Consequently, the court found no merit in Allstate's claims.

The Court of Appeals reversed the circuit court's decision, claiming that Young was an "insured" entitled to UM benefits, regardless of whether the vehicle was an insured automobile and he was in, on, getting into or out of it.

Tips for Getting Your Claim Paid

After all things are considered, there are some simple steps that any policyholder can follow to maximize his or her chances of making an auto claim successfully. Simply stated, they include:

- Never accept a claim settlement that you believe is too low. If two repair shops say your damaged car needs to be fixed at a cost of $2,000, but the insurance company's adjuster offers you just $500, it's time to start negotiating.

- Ask the repair shop for line-item estimates that explain what needs to be done and why, and send these to all parties: your agent, the insurance company's director of consumer affairs, the manager of the claims department and anyone else involved.

- If the insurance company still denies your claim or insists you take it to court for your money, don't be intimidated. Ask for the language in your policy or in state law that allows it to deny your claim. Save all paperwork and log all phone conversations with company representatives.

- If what your insurance company says doesn't agree with your reading of your policy, ask your state regulator for help. (A list of consumer affairs contacts at each state's insurance commissioner's office is included in the appendix at the end of this book.) While state insurance commissioners usually have no legal authority to force an insurance company to pay an individual claim, the commissioner can fine a company or take other punitive actions if an insurance company makes a practice of unfairly underpaying or denying claims.

Chapter 2

What Happens When
You Hit Someone

Even the best, most cautious driver may at some time be the at-fault driver in an automobile accident. In even a simple accident, the insurance issues can get dizzyingly complicated.

One issue that comes up often, in the wake of an accident: How will the insurance company divide a liability limit between two people making claims against a single at-fault driver from a single accident?

> **To be more specific: If your liability limit is $100,000 per accident and there are two other cars involved in an accident you caused, how will each of those drivers' claims be settled?**

The insurance company will give each claimant a share of the limit of liability proportionate to his or her claim in relation to the total of all claims submitted.

To answer the specific question: If one driver claims $60,000 in liability damages and the other claims $90,000, the insurance company will give each a proportional part of the $100,000 limit—$40,000 and $60,000, respectively. They'll have to sue you directly for the rest of their claims.

But a more common conflict affecting liability limits: set-off provisions that limit one kind of coverage when another has been claimed.

The 1990 Nevada Supreme Court decision *Karen Ellison v. California State Automobile Association* considered the insurance company's medical payments set-off—which is supposed to prevent a double payment of medical expenses when claims are made under an auto policy.

Karen Ellison had an automobile insurance policy from the California State Automobile Association (CSAA). The policy provided both medical payments coverage and uninsured motorist coverage which included a medical payments provision within it. Separate premiums were assessed for each of the two coverages.

The uninsured motorist coverage provided a set-off provision coordinating the two coverages which stated:

> If an insured person has valid and collectible automobile medical payments insurance available to him, the damages which he shall be entitled to recover from the owner or operator of an uninsured motor vehicle shall be reduced for purposes of uninsured motorist coverage by the amounts paid or due to be paid under such automobile medical payments insurance.

A similar clause was included in the medical payments provision of the policy. It provided:

> Any amount paid or payable for medical expenses under the Liability or Uninsured Motorist coverages of this policy shall be deducted from the amount payable under this part.

Ellison was injured in an accident with an uninsured motorist and incurred medical expenses. CSAA paid the medical expenses under the medical payments portion of the policy. The uninsured motorist claim subsequently went to arbitration and the arbitrator awarded Ellison $10,617.96. This award included $7,000 for pain and suffering and $3,617.96 for medical expenses. CSAA paid the pain and suffering award but, asserting the medical payments set-off provision in the policy, refused to pay the amount awarded for the medical expenses. It claimed that under the set-off provision Ellison was entitled to only one payment of medical expenses which CSAA had already paid.

Ellison sued the CSAA to recover the remainder of the arbitrator's award. The District Court in Clark County, Nevada, granted CSAA's motion for summary judgment. Ellison appealed.

The issue in the appeal was whether a medical payments set-off or crediting provision contained in an automobile insurance policy was enforceable. If so, it would prevent an insured person from recovering twice for payments under separate provisions of the policy which independently provided medical payments recovery for personal injuries.

The state's high court concluded:

> We [support] the decision of the district court [in favor of the insurance company].... Recovery by [Ellison] in excess of 100

percent of damages is a windfall which will not be countenanced by the court absent clear agreement providing such coverage.... The parties' contract unambiguously provides for only one payment of medical expenses if there is overlapping coverage and such expenses result from an accident with an uninsured motorist.

Eight years earlier, the same court had defined its position on set-offs. In the 1982 Nevada supreme court decision *Sullivan v. Dairyland Insurance Co.*, an insured driver's passenger sustained physical injuries that were far in excess of the driver's liability coverage. The passenger sought to collect both the liability and the medical payments coverage from the insurance company.

Dairyland relied on a set-off clause that allowed it to deduct medical expenses from the uninsured motorist insurance payment. The state supreme court determined that the passenger could recover under both coverages despite the set-off clause because "...the set-off clause only operates to prevent double recovery for the same elements of damage...."

The court concluded that although the set-off limitation was in keeping with the reasonable expectations of the policyholder, it was inapplicable when the damages exceeded the coverage limits.

What a Deductible Means

One big factor in determining how your auto insurance will pay a claim is any deductible that applies. The intent of deductibles in comprehensive coverage is to encourage drivers to assume responsibility for the smaller, more affordable losses that can occur to a car. (They don't usually apply to liability or medical payment claims.) This eliminates small claims and paperwork for the insurance company and helps keep premiums down.

If the damage to your car is smaller than your deductible or even close to your deductible amount (between $500 and $1,000 in most cases—though the amount varies), it might make the most sense not to make a claim at all. You can shop around, pay cash for the repair and never tell your insurance company. This prevents the company from noting that you had the accident.

> **In situations where you're the at-fault driver and have a deductible for liability claims, you can offer to pay for the repairs to the other person's car yourself.**

Delay Tactics Insurance Companies Use

Insurance companies can use an ongoing investigation to justify a delay in paying any claims. This used to be a tactic used mostly by fly-by-night companies—but, in the late 1990s, even quality carriers are looking hard at claims for anything that might give them extra time to pay a claim.

> **These delays can't go on forever, though. Most states' unfair claim practices laws require the insurance company to complete its investigation within 30 days of notice. Typically, the insurance company can then notify the policyholder or other claimant that more time is needed and investigate further.**

Ignoring or resisting this requirement can create defenses for the insurance company. In a recent case, the insured person refused to submit to an examination under oath, claiming the request was unreasonable because he had already submitted to two recorded statements. The insurance company argued that the policy required submission as a matter of law and the policyholder's refusal justified dismissal. The court agreed and upheld dismissal.

Sometimes the issue isn't so clear. For example, the policy usually requires the insured person to supply records and documents for inspection. Without an express condition, does the insured person have to sign a blanket authorization for financial records? Does the general cooperation clause (often found outside the "Duties After Loss" section) compel the person to do whatever the insurance company wants?

In the personal injury protection (PIP), no-fault medical, or underinsured motorist context, the requirement to provide medical access and information can create issues. Can the required medical authorization be limited to the subject of the injury? If the PIP form allows the insurance company to require a medical examination, can the insurance company obtain a psychiatric one?

The policyholder can reject unreasonable demands; but, if the court later supports the insurance company's request, the policyholder can lose coverage. Even if the policy does not clearly support the insurance company's request, case law interpreting the policy may support it. Refusal to comply, no matter how unreasonable the request may seem, can endanger the claim.

If the insurance company adds a policy-violation defense to a fraud defense, the consumer has problems. Judges and juries often suspect fraud in high-profile claims disputes but then conclude that the insurance company has failed to prove it. A policy violation gives the court an excuse to find for the insurance company.

If the claim isn't paid within four or five months, the situation changes dramatically. The insurance company refuses to accept or deny the claim. Delay begins to grind on the policyholders, draining personal and financial resources, exhausting their emotions and compromising the evidence.

Personal relationships suffer, as policyholders and other claimants blame each other for the insurance company's intransigence. Filing suit for coverage and bad faith is often the only way to ensure that the claim will be resolved.

In these cases, interrogatories (written questions) and depositions (oral questions) can require the insurance company to identify the basis for its denial and to state each fact on which the denial is based. These formal question-and-answer sessions provide many experts with state of the art information on how insurance companies handle various kinds of claims.

Complete claim files are often assembled—for the first time—for the formal questioning. Many companies have multiple files at different levels of supervision for the same claim. There may even be separate investigation files. Insurance companies often resist discovery of claim files, so lawyers for policyholders find themselves going to the judge for help.

And they usually help. The mental impressions, conclusions, and opinions of an insurance company's adjusters and employees are discoverable. For example, the Arizona Supreme Court reasoned:

> The claim file contains a "blow-by-blow" diary of the insurance company's investigation and decision-making process.... No matter how the test is defined, bad faith is a question of reasonableness under the circumstances.... The portions of the claims file which explained how the company processed and considered [the plaintiff's] claim and why it rejected the claim are certainly relevant to these issues. Further, bad-faith actions against an insurance company, like actions by client against attorney, patient against doctor, can only be proved by showing exactly how the company processed the claim, how thoroughly it was considered and why the company took the action it did.

The insurance company may produce what purports to be the claim file but no list of withheld documents. In this case, claimant attorneys need to get out their pens—asking for a so-called "privilege log," listing each document withheld and that electronic communications be printed and produced.

The December 1997 Ohio Appeals Court decision *Magan R. Plessinger, et al., v. Rex A. Cox, et al.*, considered a fractured family, a fractured skull and an insurance company trying to hide behind an exclusion.

Magan Plessinger was the daughter of Michelle Plessinger and Rex Cox. Michelle and Rex divorced, and Michelle received custody of Magan. In 1989, Cox moved the court for visitation with Magan, which he was granted. The trial court gave Rex visitation with Magan on alternating Thursdays from six o'clock to eight o'clock and Sundays from one o'clock to three o'clock.

In March 1992, Magan—who was four years old—visited her father, pursuant to the court ordered visitation agreement. During the visit, Cox negligently placed Magan on his Yamaha minibike motorcycle and allowed her to drive it. Magan lost control of the vehicle, crossed an adjacent highway and collided with a tree. She fractured her skull so severely that bone fragments were lodged in her brain. Magan also suffered other significant physical and emotional problems as a result of the accident.

Cox owned several insurance policies, including an automobile insurance policy with State Auto Insurance and a homeowner's policy issued by Central Insurance.

In March 1996, a civil action was filed against Rex and several insurance companies, in the names of Magan and Michelle. Magan and Michelle sought coverage for Magan's injuries under the uninsured/underinsured provision of the State Auto policy, and, in the alternative, as individuals injured by the named insured—Cox—under the policy's liability coverage. State Auto denied the request for coverage because:

> 1) they did not qualify as "insureds" under the policy,
>
> 2) the minibike motorcycle was not covered by its uninsured motorist provision, and
>
> 3) there was no uninsured "motorist" involved in the accident. (State auto also denied Rex liability coverage for the accident.)

Magan and Michelle likewise sought coverage under Central's liability provision of its homeowner's policy. Central denied coverage on the grounds that its policy excluded coverage for:

> 1) injuries arising out of the ownership, maintenance, or use of motor vehicles or other motorized land conveyances;
>
> 2) injuries arising out of the entrustment by an insured person of a motor vehicle or other land conveyance; and
>
> 3) injuries suffered by an insured person.

In July 1996, Magan and Michelle moved the trial court for judgment on the pleadings and, in the alternative, for partial summary judgment on the issue of coverage under State Auto's policy. In November, State Auto filed a

motion in opposition and a cross-motion for summary judgment. On the same day, Central moved the trial court for summary judgment on the issue of whether it had a duty to defend or indemnify Cox.

Magan and Michelle opposed Central's request for summary judgment and a made a cross-motion for *their own* summary judgment. The trial court denied State Auto's motion and granted Magan and Michelle's.

State Auto and Central appealed the trial court's decision.

Cox's policy provided that "relatives" of Rex who "reside" with him qualify as insured people under the policy. Under Ohio law, a relative "resides" with an insured person when the relative lives with that person for "some duration" and with "some regularity." Pursuant to a court ordered custody and visitation decree, Cox takes custody of Magan on alternating Thursdays from six o'clock to eight o'clock and on alternating Sundays from twelve o'clock to three o'clock. State Auto argued that this amount of time is not sufficient to constitute "some duration" and with "some regularity."

The court agreed. Excluding individuals from the definition of "an insured" does not violate the uninsured/underinsured motorist statute because, as a threshold matter, its mandates do not apply unless the individual seeking coverage under an insurance policy's uninsured/underinsured provision qualifies as an insured person.

Because the statute only applies when one satisfies a policy's definition of an "insured," it is only then that an insurance company is prevented from circumventing the uninsured/underinsured statute's mandates by using exclusions that eliminate coverage for those who would otherwise be entitled to such coverage, said the court.

To qualify as an insured person under State Auto's policy, Magan needed to be a "relative" of Cox who was "residing" with him. It was beyond question that Magan, as Cox's daughter, was a "relative." So, the only issue was whether Magan was "residing" with Cox.

The court concluded:

> We find that the better rule in cases involving minor children of divorced parents, who both have custody or visitation rights, is that the minor is deemed to have dual residencies for insurance purposes at least in cases where the minor is in the custody, care, supervision, and control of the insured parent at the time of the accident pursuant to the court's custody and/or visitation decree. Because Magan was within her father's custody, supervision, control, and care pursuant to a court decree at the time of the accident, we find her to be a "resident" of her father's

household for the purposes of State Auto's insurance policy.

Having determined that Magan qualifies as a "resident" of Rex's household, we determine that she satisfies the policy's definition of an "insured." Because we find that Magan satisfies the policy's definition of an "insured," we are unable to conclude that the trial court erred in determining that she is covered under State Auto's policy. Accordingly, we reject State Auto's first argument.

State Auto also argued that Michelle was not an insured person under the terms of Cox's policy. Cox's policy covered Rex, the named insured, and "relatives" of Rex who "reside" with him. State Auto argued that Michelle was not an insured person under his policy because: as his former spouse, she did not qualify as a "relative;" and she was not "residing" with him at the time of the accident. However, Michelle's attorney contended that she did not need to be a "relative" of Cox or to "reside" with him because her claims are derivative of Magan's claims, who was an insured person under the policy.

Although Michelle's attorney was correct in the argument that an individual may recover UM coverage for derivative claims, said the court, to be entitled to such coverage the individual asserting the derivative claims must be an "insured" under the policy.

"Under these facts we cannot find, even in the broadest interpretation of the term, that Michelle "resided" with Cox. Thus, we must accept State Auto's argument and hold that the trial court's decision that Michelle is entitled to UM coverage under Cox's policy with State Auto was erroneous," said the court.

State Auto didn't give up. Next it argued that, even assuming that Magan was an insured person under Cox's policy, her claims were barred by the "off-road vehicle" exclusion set forth in the policy. The exclusion provides that the term "uninsured motor vehicle" does not include any vehicle or equipment "[d]esigned mainly for use off public roads while not on public roads." However, the court was unpersuaded by State Auto's arguments.

Lastly, State Auto argued that even assuming that Magan is an "insured" and that the "off-road vehicle" exclusion is inapplicable, she is still not entitled to UM coverage under the policy because she was not injured by an uninsured "motorist."

However, State Auto failed in this argument, too. Ohio's UM/UIM statute does not require that the uninsured or underinsured individual was actually operating the vehicle at the time of the accident. Instead, the statute only

requires that the policyholder who is seeking UM/UIM coverage suffered injuries "arising out of the ownership, maintenance, or use of a[n uninsured or underinsured] motor vehicle." Therefore, State Auto's policy does not require that the uninsured or underinsured individual actually operated the vehicle at the time of the accident. Rather, it mirrors the uninsured/underinsured statute, and provides that it will pay compensatory damages to an INSURED who has suffered injuries "arising out of the ownership, maintenance or use of the 'uninsured motor vehicle.'"

Although Cox was not operating the vehicle, said the court, the chain of events leading to the accident stemmed directly from his "use" of the motorcycle. The motorcycle was in Cox's "use" by his act of entrusting the motorcycle to Magan. Cox placed Magan on the motorcycle, started it, and sent her off driving it. In addition, the motorcycle was in Cox's "use" because he was using the motorcycle to entertain Magan.

The assignment of error was overruled as to Magan and sustained as to Michelle.

Central offered three arguments in support of its claim that the trial court erred in granting summary judgment in favor of Magan and Michelle and in denying its own motion for summary judgment.

First, the company claimed that it was entitled to summary judgment on Magan's claims because its exclusions for bodily injury arising out of an insured person's entrustment of a "motorized land conveyance" and for injuries arising out of the ownership, maintenance or use of a vehicle owned by the insured person apply to obviate coverage.

Second, Central argued that it was entitled to summary judgment because Magan's claims are barred by the exclusion for injuries suffered by an "insured."

And, finally, Central argued that, assuming that those exclusions are valid and enforceable, they should also apply to bar coverage for Michelle's loss of consortium claim.

The court held that it was unnecessary to consider Central's first argument because Magan and Michelle were excluded from coverage under Central's second and third arguments. In Central's second argument, it asserts that the trial court erred in granting Magan and Michelle's motion for summary judgment and denying Central's motion because Cox's homeowner's policy with Central excluded coverage for bodily injuries suffered by an insured person under its policy. The policy defined the term "insured" as the named insured and "relatives" of named insured who "reside" in the named insured's household.

For the exclusion to be implicated, the individual requesting coverage must be an "insured" under the policy, in other words, the named insured or a "relative" of the named insured who "resides" with the named insured. Magan is a "relative" of Cox and she "resided" with him at the time of the accident.

Thus, the court concluded that Magan was an "insured" under Central's homeowner's policy, and, consequently, that her injuries are excluded from coverage under that policy. "Because we have determined that the policy does not cover Magan's injuries, we must find that Michelle's damages, which stem from Magan's uncovered injuries, are likewise not covered by the policy. On these bases, we determine that the trial court erred in finding that Magan and Michelle are covered under Central's policy," said the court.

Pro-active Tactics

In the late 1990s, Allstate Insurance Co. created a system to decrease auto claim costs by contacting and negotiating directly with people who have been injured in auto collisions by Allstate policyholders. Allstate, in implementing this nationwide practice, seeks out those who have not retained counsel and promises to assist them with the claims process.

The result is that claims representatives seem to be improperly influencing consumers to accept less than full recovery for their injuries and improperly persuading them to surrender their right to counsel.

The company calls this strategy the Allstate Customer Service Campaign. The plan works like this:

A representative calls the injured party to obtain the facts of the collision and establish rapport. The representative is instructed to "show genuine empathy" and "act as [an] advocate in [the] claims settlement process" to make the person feel he or she is not dealing with an adversary. During this initial contact, the representative asks injured parties whether they have retained counsel.

Second, the representative sends a letter to those who have no attorney to "reaffirm" the representative's phone conversation. The letter says Allstate thinks of the injured party as someone who is "entitled to quality customer service." It asks for medical bills, proof of wage loss, and an authorization form to get all the consumer's medical and employment information.

Included with this letter is the customer service pledge, which tells the injured person that he or she is considered a customer just like the policyholder. The pledge reminds the person he or she is free to discuss payment of the claim when ready, and Allstate promises to fully explain the claims pro-

cess and conduct a quick and fair investigation.

The third part of the plan is a brochure, "Do I Need an Attorney?" It is selectively mailed to injured claimants who are considering whether to retain counsel. It lists five leading questions with unattributed or potentially misleading answers that offer supposedly compelling economic arguments against attorney representation.

The University of Massachusetts at Amherst studied the influence of Allstate's campaign on claimants. Nearly one-third of those surveyed firmly believed the company was concerned about them and would deliver on its customer service pledge. Sixty-seven percent found the pledge persuasive and said they would follow its advice.

The study also found that older people were more likely to be skeptical about the pledge than young adults. Most people who were surveyed thought the document was both factual and informative and said they would consider not hiring an attorney.

Allstate has even changed the incentive structure for its claims representatives to reflect the focus on increasing the number of unrepresented claims. Employees are rewarded based on the percentage of unrepresented claims they process.

> **The customer service pledge hides the conflict of interest between a policyholder's insurance company and the person injured by the policyholder. The pledge disguises the adversarial process by calling the injured claimant a "customer," who is entitled to quality service.**

Why would Allstate engage in such a campaign? The answer is quantified in Allstate's claims-handling training manual. According to the manual, people who file claims with the assistance of counsel settle for two to three times more than those who are unrepresented.

In addition to the pledge, the company's "Do I Need an Attorney?" brochure contains potentially misleading information. For example, it claimed attorneys commonly received fees ranging between 25 and 40 percent of a total settlement, plus expenses. This is a misstatement at best as laws governing attorney fees vary from state to state and cannot be construed generally.

The brochure also advises when an individual's statute of limitations begins to run. This information can only be determined on the basis of the jurisdiction where the collision occurred or the state of residence for the injured, and, even then, tolling provisions are often the subject of intense court battles.

Allstate provides no sources for information in the brochure and no details about state laws that would affect an injured party's lawsuit. The brochure is a business document giving legal advice, yet it is ambiguous.

The claims representatives' telephone scripts are the first indicators of Allstate's intention to stand as proxy for a claimant's counsel, in effect representing both sides in an adversarial situation. Representatives are to discuss the statute of limitations, to notify the claimant of his or her ability to file a court action at any time, and to explain the "early settlement option" whenever the claimant is ready.

Consequently, unauthorized-practice-of-law committees of several state bar associations have launched actions against the company, resulting in demands that it stop its telephone and letter campaign in their state or at least alter its letters to accurately portray the true nature of Allstate's relationship with injured people.

Of the five states where actions against Allstate have been resolved—New Jersey, New York, North Carolina, Virginia and West Virginia—four determined that Allstate's letters constituted the unauthorized practice of law.

For example, the West Virginia State Bar Committee on Unlawful Practice found that because the Allstate document was "specifically and solely directed and targeted to individuals who have been injured by an Allstate insured....the document is not commercial speech...but instead takes the form of a specifically drafted business document."

Connecticut has passed a bill preventing Allstate from distributing its brochures. Agents who send out these communications face a $7,500 fine or forfeiture of their insurance licenses.

Negligent Entrustment

The 1994 Louisiana case *Carolyn Sue Panzico (for Jennifer Powell) v. Dianne Price, et al.* considered some complicated family connections and another often-disputed issue—negligent entrustment. This issue relates particularly to the insurance issues raised when you lend someone your car.

In January 1989, a car driven by Danny Knight struck Jennifer Powell, who was standing in an A&P parking lot in Monroe, Louisiana. Powell was seriously injured.

The car belonged to Dianne Price, the named insured on the State Farm policy that covered the vehicle. Price had given her stepson, Shane, who was a minor, permission to use her car one evening for a date. When his date was canceled, Shane picked up Danny Knight and the two boys went for a ride.

They eventually parked the car and stood visiting with friends. Shane gave Danny permission to borrow the car to drive to a nearby A&P, where he hit Powell.

Danny was sixteen-years-old at the time of the accident. Police investigation of the accident revealed that he did not have a driver's license. Shane, however, was not aware that Danny was without a license. He had seen Danny driving in the past and assumed that, because he was old enough to obtain a license, he had one.

Jennifer Powell's mother, Carolyn Panzico, sued on behalf of her daughter for damages—mostly relating to back injuries—arising from the accident.

Danny Knight, his father and State Farm Fire and Casualty Insurance Company were formally dismissed as defendants following a private settlement. The remaining defendants were Dianne Price, her son Shane and State Farm Mutual Automobile Insurance Company.

At trial, Powell's attorneys asserted two theories of liability: First, that the omnibus clause of the Price's insurance policy extended to cover Danny's driving of the vehicle; and, second, that Shane had negligently entrusted Danny with the car.

Dianne Price and Shane both testified that he had very limited access to Dianne's vehicle. The keys were unavailable to him. He had to seek special permission and state his purpose each time he wanted to borrow the car. If permission was granted, Shane was reminded not to drink and drive or to allow anyone else to drive the car. Price was unaware that Shane previously let his friends drive the car.

The court concluded that Danny was not covered under the omnibus clause of Dianne Price's insurance policy because it was not reasonably foreseeable to Price that Shane would lend her car to a third driver. It also found the claim of negligent entrustment lacked merit because the evidence was not sufficient to establish that Shane negligently entrusted Danny with Price's car. Furthermore, the court found that if there had been any negligence, it was strictly in Danny's operation of the vehicle, not in Shane's lending the car to him.

Powell's attorneys appealed, arguing that once initial permission has been granted, auto liability coverage extends to anyone who drives the car except a thief.

The court found, as a fact, that Price could not have reasonably foreseen that Shane's date would be canceled, that he would go out with Danny and that he would allow Danny to drive the car. The appeals court agreed with the trial court ruling.

Powell's attorneys also argued that Shane was negligent in lending a

vehicle to Danny, who was not a licensed driver. The appeals court also rejected this argument firmly:

> [Louisiana law] establishes that persons are responsible for the
> damage caused by the things within their custody. To be responsible for negligently entrusting that which is in our custody to one who is incompetent to use it requires the knowledge that the person is incompetent.

The trial court found that the evidence was insufficient to find that Shane knew that Danny was not a licensed driver or that Danny was an inexperienced or bad driver. In fact, Shane had witnessed Danny driving in the past, which indicates that Danny was experienced behind the wheel.

The court found a reasonable foreseeability test compelling. In explaining this test, it cited an earlier state supreme court decision:

> Implying permission, as in other contractual implications, is
> nothing less than a judicial extension of the terms of an obligation by reading into the language a meaning which is not clearly expressed. It is, in effect, a rewriting of the contract between the parties.... It is an authority to be most carefully exercised calling for a proper restraint by courts.

In the late 1980s, a number of state court decisions had proceeded to imply exactly this permission. Several held that even when there has been express prohibition against third drivers, it may be reasonably foreseeable that the initial permittee would allow another to use the car. The context in which the prohibition is made is a necessary ingredient in determining reasonable foreseeability.

The Louisiana supreme court had itself rewritten some insurance policies in this way. In the decision *Norton v. Lewis*, it chose to use the word "permission" in the broadest sense possible, citing cases involving both initial and second permittee cases. It held that:

> Once the permission, whether express or implied, to use a motor
> vehicle is established it is given a wide and liberal meaning in
> determining coverage. So long as the initial use of the vehicle
> is with the consent, express or implied, of the insured, any
> subsequent changes in the character or scope of the use do not
> require additional specific consent of the insured; coverage will
> be precluded only where the deviation from the use consented
> to amounts to theft or other conduct displaying utter disregard
> for the return or safekeeping of the vehicle.

Though the Louisiana courts contradicted this theory in the Price decision, many courts might stand by it. So, be careful to whom you lend your car.

Overlap and Subrogation

When an accident occurs, an injured person may be entitled to recover under more than one policy. When an accident is covered by more than one insurance policy, often one policy is considered primary coverage, meaning that that policy would pay first up to its policy limit. Then, if the claim was greater than the primary policy's limit, the second policy involved would pay the excess amount of the claim, up to its limit of liability. The second policy is then said to be excess coverage.

The 1992 Nebraska appeals court decision *Hartford Fire Insurance Co. v. George and Lucille Davey* considered the issue of subrogation.

In August 1987, George and Lucille Davey were injured in an automobile accident near Gretna, Nebraska. They made a claim against the responsible party, Jerome Simon.

In September 1988, the Daveys settled with National American Insurance Company of Nebraska, Simon's insurance company. At the same time, the Daveys executed a release of all claims against Simon and National American resulting from the accident. All of the medical bills incurred by the Daveys were paid by National American.

The Daveys had an automobile liability policy with Hartford Fire Insurance Co.. Jo Coffey, senior claims representative for Hartford, who had been advised of the accident and potential claim of the Daveys, closed the company's file on the case in 1987.

"[National American] took the information from me on our insureds [and was] going to assume the medical payments and also property damage. We closed our file," Coffey said. "Since they were going to assume full liability there was nothing more for us to do."

No payment of any kind was made by Hartford to the Daveys at that time. The Daveys' policy with Hartford included a medical payments provision. This included the following language:

> We will pay reasonable expenses incurred for necessary medical and funeral services because of bodily injury:
>
> caused by accident; and

sustained by an insured.

We will pay only those expenses incurred within 3 years from the date of the accident.

The same policy also contained the following subrogation language:

If we make a payment under this policy and the person to or for whom payment was made has a right to recover damages from another we shall be subrogated to that right. That person shall do:

whatever is necessary to enable us to exercise our rights; and

nothing after loss to prejudice them.

If we make a payment under this policy and the person to or for whom payment is made recovers damages from another, that person shall:

hold in trust for us the proceeds of the recovery; and

reimburse us to the extent of our payment.

Not satisfied with their recovery of more than $130,000 from National American, the Daveys made a claim with Hartford in September 1988, under the medical payment provision, for $5,286. Hartford paid this claim.

After issuing the checks, Coffey sent a letter to National American dated October 21, 1988, notifying National American of Hartford's subrogation lien for payments made to the Daveys.

Several weeks later, Coffey received a letter from National American, indicating that National American had settled the claim with the Daveys and that the Daveys had executed a release of all claims. Coffey called the attorney representing the Daveys and asked them to return the payments Hartford had made. When the demand was refused, Hartford sued the Daveys for breach of contract.

The trial court ruled against Hartford and held that Daveys did not have to reimburse the $5,286 in medical payments. It concluded that the extra payment from Hartford was made voluntarily, not because of a mistake of fact.

The trial court went even further in explaining its position:

Courts do not exist to redress every improvidence, and...the general rule, applicable here, is that all payments made under a contract are presumed to be voluntary, and the party seeking to recover payment has the burden to prove that it was involuntary. A mistake of fact (which...must be distinguished from

a mistake of law) may sometimes justify restitution. [Hartford] does not allege fraud or mistake, but claims mistake in its brief.

[The Daveys] were not expected to divulge the progress or state of any such settlement efforts....

[Hartford] knew the identities of the third party tortfeasor and his liability insurance company and knew that the facts of the accident rendered the liability insurance company liable to defendants and that payment by settlement was probable.

Hartford appealed, insisting it still had rights to demand repayment from the Daveys. When Hartford eventually paid the Daveys $5,286, the Daveys had already settled with and released Simon and National American. They no longer had any rights against Simon or his insurance company.

When Hartford paid the Daveys, Hartford was subrogated to the rights the Daveys had against Simon and his insurance company as of the date payment was made by Hartford—which were none.

Hartford knew, according to the testimony of its own claims manager, that National American was assuming liability for medical payments and property damages. The trial court had made a specific finding of fact that Hartford knew that payment by Simon's insurance company was probable and that a settlement and release would accompany such payment. The appeals court ruled that Hartford ignored these facts and chose to make payment to the Daveys.

"We realize that this decision may require greater effort by Hartford in investigating similar claims prior to payment," the court concluded. "However, the court cannot extend aid to one who has made a voluntary payment for which it was not legally liable."

The Inevitable Impact of Technology

Most insurance companies evaluate estimate quality after the appraisal has been completed and often the audits occur after payment has been issued. Estimate audits are usually quality checked by desk reviewers who read and analyze each claim by hand. As a result, insurance companies may spend time on files with no aberrations and fail to review others with obvious problems.

In May 1998, CCC Information Services announced the availability of Quality Advisor, which it called "the claims industry's first-ever software product that automates the auto physical damage claims review process."

Exactly what does that mean?

Quality Advisor allows claims adjusters, reinspectors and desk reviewers to decrease settlement cycle time, lower loss costs, and enhance the quality of collision damage estimates by identifying irregularities and errors in a claim before payment is made.

According to CCC, significant expense savings are obtained by the improved productivity among staff that audit claim files. For example, a top five insurance company that served as a beta test for Quality Advisor reported a reduction in severity and expense per claim of $55.

"Most often, errors in an auto damage claim—like accidental use of an incorrect labor rate—are not caught until after payment has already been sent to the consumer or collision repairer," commented Karoline Obora, product manager at CCC. "With Quality Advisor, this problem is eliminated because the software verifies the accuracy of an estimate much earlier in the claims cycle. Quality Advisor helps reduce costs because it identifies any miscalculations or inaccuracies long before the claim is paid, and in many cases, before work on the vehicle has even been started."

Obora continued, "Manually reviewing 100 percent of estimates is often viewed as cost prohibitive. Quality Advisor eliminates an outdated manual process, electronically scanning each estimate to identify errors and inconsistencies and enabling the claims reviewer to take corrective action before it is too late."

These programs consolidate estimates and supplemental information into one file to check rates, identify inconsistencies and verify that all the parameters included in each file are consistent with the guidelines set by an insurance company. In addition to tracking and reporting on estimate quality for staff appraisers and direct repair shops, the programs also measure and report on the productivity of staff performing the reviews.

Companies like CCC suggest that the states update their regulations pertaining to things like valuations of totaled cars.

Under these proposals, state laws would be updated to recognize and regulate computerized databases (which are being used anyway by the largest auto insurance companies)—and to provide added consumer benefits.

Under a proposal that CCC made in Oregon, if consumers couldn't find comparable replacement vehicles for the amount paid by the auto insurance company within a month, they could require that the auto insurance company either find the equivalent or fork over more cash.

CCC surveys actual cars for sale in specific geographic regions and monitors prices and availability. The company offers a free search service to con-

sumers looking for particular models, so the find-it or pay-up contingency in its proposed regulation wouldn't be a problem.

"I refer to it as the 'put up or shut up' position," said Art Chartrand, an attorney representing CCC. "You have to price it in the real world."

The CCC method would pertain to all totaled autos, new or old. But it would probably have the greatest effect on the valuation of older vehicles, and on those the owners think have retained more of their value over time than insurance companies do. It would give consumers a little more power in negotiating settlements.

While there are dozens of new products like this one that come to the insurance market every year, this example illustrates more clearly than most why the claims adjusting process is changing so radically.

Bad Faith

Cries of "bad faith" usually fill the air around any major insurance claim dispute. The charge is so common that it deserves special note. The Colorado Supreme Court decision *Farmers Group, Inc. v. R. Bruce Trimble* shows how complicated bad faith claims can be.

In 1977, Mid-Century Insurance—a subsidiary of Farmers Group, Inc.— issued a homeowner's liability insurance policy to Bruce Trimble and his wife. Another Farmers unit issued an automobile liability insurance policy to Trimble.

The Farmers automobile liability policy contained a bodily injury liability limit of $50,000 per person. It also authorized Farmers to make such investigations and settlements of claims as it deemed expedient.

In November 1978, Trimble's 19-year-old son, Douglas, drove Trimble's automobile onto the front yard of neighbor Robert Jensen.

Douglas had had arguments with Jensen, "so [he] and a friend were going to do a wheelie through his front lawn with the car," says an attorney who was involved in the case. "Well, Jensen wakes up and hides behind the bushes when Trimble's son came back for the second pass at the yard. He jumps up from the bushes [to confront Trimble's son] and ends up getting dragged down the street. He was pretty seriously injured."

Trimble reported the incident to a Farmers agent, and the company immediately began an investigation. Three weeks later, a Farmers agent forwarded a letter to Douglas stating that the automobile policy's "intentional act exclusion" might operate to deny him coverage.

In early 1979, Jensen offered to settle the case for $50,000—the policy

limit of the automobile policy. Farmers rejected the offer, because it still had questions about coverage (and because there was a possibility that Jensen's homeowner's policy might assert a personal injury protection benefits lien for medical payments made to Jensen). Farmers never informed Trimble or his son of Jensen's settlement offer.

In March 1979, Jensen filed a civil action against Trimble, his son and the son's friend, asserting claims for $200,000 compensatory and $200,000 exemplary damages. Jensen claimed Trimble had made the family automobile available to his son, who was a minor, knowing of his son's poor driving record, problems with alcohol and other behavioral problems.

In April 1979, Farmers selected an attorney to defend Trimble and his son against Jensen's claims. A letter from Farmers also told the Trimbles that the attorney retained by Farmers "will represent your personal interests without cost to you."

In November 1979, Jensen's attorney informed the Trimbles' attorney and a Farmers agent that a recent legal decision had established coverage for Jensen's negligent entrustment claim under Bruce Trimble's homeowners policy. This letter was forwarded to a Farmers agent but not to Trimble.

In October 1980, Farmers and its subsidiary filed a lawsuit against Trimble. They sought a declaration that Trimble's homeowners policy provided no coverage for the claims made by Jensen. Trimble retained a separate attorney, answered the complaint and asserted several counterclaims against Farmers.

In April 1981, Jensen's claims against Trimble were settled. Jensen received $50,000 under the Farmers auto policy and $12,000 under the homeowners policy. In connection with that settlement, Farmers also reimbursed Trimble for certain legal costs he had incurred.

Farmers' complaint against Trimble was dismissed as moot. Trimble's counterclaims against Farmers were not.

Trimble's claim alleged a breach of the implied covenant of fair dealing by failing to represent Trimble's interests properly and promptly. Farmers made the defense that evidence of intent, such as intentional misconduct, actual dishonesty, fraud or concealment was a prerequisite to recovery on a claim of bad-faith in an insurance contract. This claim bounced the case up to the Colorado Supreme Court.

The high court rejected Farmers argument. "The duty of the insurance company to act in good faith when dealing with its policyholder is characterized in many jurisdictions as a duty implied by law as a covenant of the insur-

ance contract," it ruled.

It concluded that the basis for an insurance company's duty of good faith and fair dealing is grounded on "the special nature of the insurance contract and the relationship which exists between the insurance company and the insured."

It went even further:

Particularly when handling claims of third persons that are brought against the policyholder, an insurance company stands in a position similar to that of a fiduciary.

By virtue of the insurance contract, the insurance company retains the absolute right to control the defense of actions brought against the policyholder, and the policyholder is therefore precluded from interfering with the investigation and negotiation for settlement.

Given the quasi-fiduciary nature of the insurance relationship, we are persuaded that the standard of conduct of an insurance company in relation to its policyholder in a third party context must be characterized by general principles of negligence.

The question of whether an insurance company has breached its duties of good faith and fair dealing with its policyholder is one of reasonableness under the circumstances. The relevant inquiry is whether the facts show the absence of any reasonable basis for denying the claim.

"This is a very liberal standard against the insurance companies. It is probably the most liberal, compared to other states who require either malice or the absence of any reasonable basis," says Thomas Roberts, the attorney who represented Trimble in the final stages of the lawsuit. "We could have a bad faith claim based only on delay, and all the worry, grief and turmoil caused. This was the first important result of this case, because insurance companies think that as long as they ultimately pay up, it doesn't matter how long they drag it out."

Going After a Bad Insurance Agent

Bad faith charges are not only used by people going up against insurance companies in court. Insurance agents, underwriters and even adjusters can face the familiar charge, too. A 1983 lawsuit addresses how this can happen.

Howard Esser sold insurance to Joseph Lazzara.

Esser had handled the Lazzara's personal and business insurance needs for 20 years. Esser had agency agreements with several insurance companies,

including Aetna and Reliance. These contracts authorized Esser to bind insurance coverage—that means make a temporary contract—and entitled him to receive commissions on the business placed with these companies.

In 1973 Esser recommended that Lazzara increase his automobile liability coverage limits from $500,000 to $1 million. Lazzara agreed and had Esser obtain the additional coverage. Esser was to renew coverage unless otherwise instructed. Lazzara did not give any instructions to Esser as to how the coverage was to be structured, or with whom it was to be placed. In order to provide coverage for $1 million, Esser wrote primary coverage of $300,000 with Reliance and excess coverage of $1 million with Aetna. Both policies were renewed several times.

In July 1977, Reliance issued the Lazzara policy with split liability limits of $100,000 per person and $300,000 per occurrence. The split-limit policy created a $150,000 gap because it would cover only $100,000 per person, and the Aetna policy required limits of $250,000. Esser renewed the split-limit policy several times.

On August 13, 1979, Lazzara's daughter, Diana, was involved in an automobile accident that killed Anthony Bond. A lawsuit was filed by the estate of Anthony Bond and Donna Bond, his widow, against Joseph Lazzara, Diana Lazzara and Reliance. The trial court issued a judgment for $510,000. Reliance paid only $100,000 of the judgment due to the split-limit policy. Aetna paid the excess amount.

In January 1983, Lazzara filed suit against Esser for the unpaid $150,000.

In the trial court and subsequent appeals, Esser's primary argument was that he was an agent of the insurance company, not a broker for Lazzara. The district court held, as a matter of law, that Esser acted as an insurance broker for the purposes of acquiring and maintaining auto insurance for Lazzara, rather than as an agent for the insurance company. Thus he "had a duty to act in good faith and with reasonable care, skill and diligence in compliance with Lazzara's instructions."

The trial court order Esser—the insurance broker—to pay the $150,000.

The Illinois courts have defined an insurance broker as:

One who acts as middleman between the policyholder and the insurance company, and solicits insurance business from the public under no employment from any special company, but, having secured an order, places the insurance with the company selected by the policyholder, or, in the absence of any selection by him, with the company selected by such broker.... An insurance agent, on the other hand, has a fixed and permanent relationship to an

insurance company that the agent represents and has certain duties and allegiances to that company.

The Illinois appellate courts have applied four criteria in determining whether a person is an agent or a broker:

- who called the intermediary into action;

- who controls its actions;

- who pays it; and

- whose interests it represents.

The appeals court ruled that Esser had served Lazzara for many years. Lazzara had called Esser into action by requesting that Esser obtain additional limits. Furthermore, Lazzara did not ask for a specific insurance company, but relied on Esser's judgment. A significant argument raised by Esser was that, once he procured the insurance, he ceased being Lazzara's agent. The court held that, since his instructions were to maintain the agreed-upon coverage, his authority extended beyond the mere procurement of the policy.

The court ruled that an agency/company agreement does not establish a fixed and permanent relationship. Esser was not required to place a specific amount of written premium with a company, was not paid a salary, had no allegiance to any insurance company and was permitted to enter agency agreements with other companies.

The appeals court concluded: "This lengthy, complex and expensive case could have been avoided by Esser by simply notifying the policyholder of the gap and by securing the limits needed to maintain the minimum primary limits of $250,000."

It upheld the ruling for Lazzara.

Rental Car Issues

A great vacation can instantly turn sour if you have to return a rental car that you've banged up. Although the topic is covered in scores of magazines (travel and business) and many books, most people are not sure how insurance claims work when they're driving rental cars.

> Standard personal automobile policies typically cover all vehicles operated by the policyholder, including rental cars. But a growing number of standard policies are beginning to limit that coverage—for the designed, if not expressed, purpose of limiting coverage for rental cars.

To be completely sure, you should contact your insurance agent and read your contract. If you are not covered, adding rental car coverage to your policy will probably be cheaper than buying the additional coverage every time you rent, especially if you rent cars frequently.

In addition, you may automatically have coverage if you rent the car with a credit card. If you plan to rely on your credit card's coverage, check with the credit card company to determine what it covers. In many cases, this credit card coverage is excess over any standard coverage—but, if you don't have the standard coverage, the excess may not apply.

Even if you're covered under your own auto insurance policy, you may want to opt for the additional rental car coverage simply as a matter of convenience. That way, if the rental policy becomes the primary insurance company, any damage to the rental car you have will be covered by the rental insurance. This way you may avoid having to submit the claim to your own insurance, and therefore avoid a raise in your rates.

If you are renting a car outside the United States, it is almost always a good idea to pay for the extra coverage (minimal coverage is usually required), because your insurance usually does not cover you in foreign countries.

Another Claim Problem: Counterfeit Parts

In October 1998, the Supreme Court cleared the way for a massive lawsuit against State Farm Mutual Automobile Insurance Co. involving restrictions it imposes to hold down the cost of car repairs.

The justices declined to review a state-court ruling that granted class-action status to the case.

The plaintiffs say State Farm violated policyholder agreements and deceived customers by requiring the use of parts made by companies other than the original manufacturer when settling accident claims. The case, which is scheduled for trial next spring, involves as many as five million policyholders and seeks more than $2 billion in damages.

Although the justices' action came without comment and set no precedent, business groups worry that the case will encourage aggressive use of class-action litigation. Indeed, the company said in its brief that the case "hangs like a Damoclean sword over State Farm, threatening to force it into an unwarranted settlement."

Lawyers for the plaintiffs say the claims are sufficiently similar to warrant consolidation.

In March 1999, USAA Casualty Insurance Company was hit with a lawsuit that claimed the insurance company encouraged auto repair shops to use "imitation" parts in repairs—and then hid the practice from policyholders.

The suit, filed in Washington's King County Superior Court, sought class action status for USAA policyholders nationwide whose vehicles had been repaired using the allegedly sub-standard parts.

USAA policyholder agreements state that repairs will be made using parts that restore vehicles to pre-crash physical condition and cash value.

According to the lawsuit, repair parts that don't come from an original equipment manufacturer (OEM) can threaten a vehicle's structural integrity, resale value, and manufacturer's warranty, and cannot return the car to its pre-accident value.

Plaintiffs' attorney Steve Berman said it is a breach of contract and a violation of Washington's Consumer Protection Act when an insurance company mandates the use of imitation parts without informing the policyholder.

"We trust our insurance companies to provide safe repairs and return our cars to pre-crash value, but USAA is misleading its policyholders and threatening their safety," said Berman. "Repair shops call these parts `Taiwan trash` for good reason—they have substandard fit, impact resistance, and mechanical operation. This is an issue when it comes to things like crash protection."

The lawsuit against USAA also claimed that the company committed breach of contract and violation of good faith and fair dealing by forcing repair facilities to use imitation parts without disclosing that estimates were based on use of the cheaper imitation parts.

The USAA suit followed on the heels of similar class actions against major insurance companies—including GEICO Insurance, a subsidiary of Berkshire Hathaway; Allstate Insurance Company; and Nationwide Insurance. All of the lawsuits claimed breach of contract with policyholders and, if certified by the courts, would represent policyholders across the country.

Conclusion

On-the-spot adjustments are only one way that companies in California are trying to distinguish themselves in the increasingly competitive world of auto insurance. Insurance companies are cutting premiums, adding services and comparing their rates directly to rivals' as they vie to win new customers.

The average paid claim nationally for bodily injury, for example, dropped 7 percent between 1993 and 1996, to $10,610, according to the Insurance

Information Institute, a trade group.

Insurance companies also cite legal decisions that limit their potential payouts as a force behind the dropping rates. One example: Proposition 213, which California voters approved in 1996, prohibits drunk drivers, uninsured motorists and fleeing felons from suing for pain and suffering damages.

"We've had occasions where the adjuster arrived on the accident scene before it even cleared and wrote a check," said David Pratt, Progressive's Southern California general manager.

Even less aggressive marketers have turned to rate cutting and service improvements to defend their market share.

The Automobile Club of Southern California cut its rates by 25 percent over the last five years, transforming it from one of the state's more expensive insurance companies to one of the less expensive, Chief Executive Tom McKernan said.

The Auto Club also beefed up its claims service, opening a 24-hour telephone service center and forging alliances with auto repair shops, glass manufacturers and rental car companies to increase convenience and lower costs, McKernan said.

Chapter 3

No-Fault Coverage Claims

During the 1970s and 1980s, no-fault auto insurance plans gained popularity around the United States. Simply said, the plans reversed the idea of liability auto insurance. Rather than being responsible for damage caused to other people or property in an auto accident, insured drivers were responsible for taking care of their own needs—regardless of who had caused the damage.

No-fault auto insurance was viewed, among other things, as a form of universal health care: people injured in auto accidents would receive unlimited medical care and wage loss, regardless of fault. Compensation for non-economic damages—"pain and suffering"—would be limited, in minor accidents only, to reduce the associated legal and investigation expenses (the so-called "transaction costs").

However, in the late 1980s and 1990s, most of the states that had experimented with no-fault auto insurance backed away from the systems. The public was concerned about the cost of auto insurance, rather than the desirability of providing universal health care. Consumer advocates claimed that no-fault systems were more expensive that traditional ones; therefore, they didn't make much sense to the people paying premiums.

The insurance industry defended no-fault, arguing that it was a means of lowering auto insurance premiums. The industry re-packaged and modified no-fault programs several times to suggest such savings.

The question of whether no-fault raised or lowered the cost of auto insurance remained a major part of the debate over auto insurance reform. One thing that wasn't debated: No-fault systems create all kinds of claims problems. They turn policyholders into claimants, too—and pit them against their insurance companies.

The Case for No-Fault

During the 1990s, the California-based Rand Corporation issued a series of widely distributed reports on no-fault auto insurance. Press releases accompanying the reports invariably suggested that no-fault proposals, including proposed federal no-fault legislation, would dramatically lower insurance costs in many states. The Rand reports were cited by no-fault supporters to bolster their argument that no-fault could lower premiums dramatically.

But the reports did contain some problematic data. The "savings" described by Rand took the form of lower costs to insurance companies, not lower premiums for policyholders—a point omitted from the attendant publicity generated by the insurance industry.

Critics complained that, by depriving consumers of the leverage of adequate legal remedies, no-fault proposals inevitably placed consumers at a disadvantage relative to insurance companies. The elimination of compensation for pain and suffering removed the incentive for ethical lawyers to accept auto accident cases, since their fees would then have to be paid out of the recovery of actual medical expenses and lost wages.

> **Limitations on claims and compensation might reduce payouts enough that insurance companies could reduce rates and still maintain their desired level of profitability. An example: The federal no-fault legislation not only eliminates the requirement that insurance companies pay for non-economic losses, but makes other potential sources of compensation—workers compensation and taxpayer-subsidized programs such as Medicare—the primary source for payment of claims.**

In 1995, for example, insurance companies paid out a national average of 65 cents for every $1 in auto insurance liability premiums they received.

Other no-fault proposals would reduce benefits to as little as $15,000 in medical coverage. Such policies might cost insurance companies less—but would offer little or nothing of value to most consumers when it came time to make a claim. And the public senses this. Skepticisms about no-fault claims payment is a major reason why no-fault proposals are disfavored by the public—even considering the promised price reductions.

No-Fault Reform Efforts

Most insurance experts insist that pure no-fault remains a mirage. But some reformers keep pushing. In 1997, Senator Mitch McConnell's Auto

Choice Reform Act was winding its way through Congress. The reform would give drivers in the U.S. a choice of two insurance plans.

You could choose "personal-protection insurance," which would be very close to pure no-fault. McConnell estimated that it would save the average policyholder $243 a year in premiums.

Or you could choose "tort-maintenance coverage," which would allow policyholders to sue each other endlessly, without restriction. Premiums would be priced accordingly. Think of this one as "pay to play."

Who would play the insurance lottery if the ticket cost them a few hundred extra bucks a year? Maybe no one, and that realization has sent the Association of Trial Lawyers of America into its war room. In a 35-page fax, Ralph Nader condemned no-fault, saying it "forces good drivers to pay for bad drivers."

They're hitting at the basic idea of no-fault—you collect from your own insurance company. And they're pretending that, under no-fault, bad drivers pay the same premiums as good drivers. Which is nonsense.

In April 1998, Governor Frank O'Bannon announced the creation of a consumer protection division within the Indiana Department of Insurance to offer more protection to policyholders against unfair and deceptive insurance company practices.

That action was in response to a record 5,278 complaints against companies filed with the department in 1997, bringing the total to 21,000 since 1993.

Critics said—and even the state's insurance commissioner acknowledged—that the department was limited by a lack of staff and money to follow through on problem areas such as unfair denial of claims, delayed payment of claims and illegal exclusions.

Insurance Commissioner Sally McCarty said the new division would result in a more thorough investigation process.

Before the changes, the department's consumer consultants could do little more than gather complaints, solicit responses from companies and report back to people making the complaints.

What No-fault Really Means for Auto Claims

No-Fault insurance usually means problems for people trying to make claims. Insurance companies tend to operate on a "cost-plus" basis: accident costs are passed through to consumers, along with a considerable markup for overhead and profit. Thus, the more accidents and claims, or the higher the

medical and car repair costs, the greater the justification for higher rates which, in turn, yield more revenue for investment and ultimately higher profits.

The insurance industry reform approach recognizes the subjective nature of the underwriting process, as revealed by the inherent inability of insurance underwriters to correctly estimate the degree of risk posed by any one policyholder. Lastly, it acknowledges that an imperfect insurance marketplace often frustrates social policy goals—such as ensuring that all motorists have the opportunity to purchase compulsory insurance at a fair price. The insurance industry reform approach views the insurance function as being so directly related to the economy and society that insurance companies carry a quasi-public responsibility, which requires public oversight and regulation.

The April 1997 Colorado state appeals court decision *Ronald Klein v. State Farm Mutual Automobile Insurance* considered a typical claim dispute involving no-fault auto insurance. On December 17, 1989, Ronald Klein was injured in an automobile accident. Shortly thereafter, Klein sought treatment for his injuries.

Klein had insurance under a policy issued by State Farm Mutual Automobile Insurance Company that provided personal injury protection/no-fault insurance coverage. Klein's health care providers submitted statements to State Farm for payment. State Farm paid over $21,000 under the medical portion of the policy and $8,000 for lost wages, but denied certain other bills.

Klein brought suit against State Farm, alleging violations of the Colorado Auto Accident Reparations Act (the so-called "No Fault Act"). Klein alleged breach of contract by failure to pay insurance policy proceeds, bad faith breach of an insurance contract, and the willful and wanton failure to make prompt payment of benefits. Klein's main allegation was that State Farm had violated the No Fault Act by not paying or denying the claims within the thirty-day requirement.

The jury returned a verdict for State Farm. Klein appealed.

On appeal, Klein contended that, because the No Fault Act mandated binding arbitration, the trial court lacked jurisdiction to hear claims arising under that statute. The appeals court disagreed.

In 1989, the No Fault Act was amended to provide in pertinent part that any "action for breach of contract brought pursuant to subsection (1) of this section shall proceed to binding arbitration," pursuant to the Uniform Arbitration Act. However, the section of the Act Klein referred to was amended in 1991 to state:

> If a dispute arises under subsection (1) of this section, the insured ... and the insurer may agree to resolve the dispute through

binding arbitration.... If there is no agreement concerning binding arbitration, the insured ... may bring an action in contract in the appropriate court to resolve the dispute.

Despite the 1991 amendment, the court's consideration was limited to the 1989 version of the statute because Klein's accident occurred in 1989. However, "[E]ven under the version of the No Fault Act requiring arbitration, the court does have jurisdiction if the right to arbitration is not invoked," said the appeals court.

Courts have held that a party may waive its right to arbitration by taking actions that are inconsistent with an arbitration provision, such as failure to submit claims to arbitration. The appeals court held that Klein's actions were inconsistent with the right to arbitrate and constituted a waiver of the mandatory arbitration requirement.

Klein asserted that, State Farm clearly failed to pay, deny, or request further proof as to his claims within thirty days of the receipt of reasonable proof of expenses, therefore, the jury's verdict was unsupported by the record.

According to Klein, under the No Fault Law, insurance companies are required either to pay or deny claims within thirty days of receipt of proof of the fact and amount of the expenses incurred.

In Klein's opinion, a health care provider's bill with an accompanying explanation established reasonable proof. The appeals court rejected this reading of the statute.

The statute provides that benefits are overdue if not paid within thirty days after the insurance company receives reasonable proof of the fact and amount of expenses incurred. Consequently, payment necessarily requires the receipt of "reasonable proof" as to expenses. If reasonable proof of the fact and amount of expenses incurred during that period is in question, an ancillary question is whether the thirty-day period has begun to run.

Klein contended that nothing in the statute required him to submit proof that the expenses were reasonable and necessary in order to commence the thirty-day period. Rather, he need only have submitted reasonable proof of the fact and amount of expenses.

The appeals court wrote:

> In our view, the submission of bills in a particular case, based on the information available to the insurer, may be sufficient proof that treatment was reasonable and necessary. But, in other circumstances, it may not. The statute does not require that the insurer decide whether to pay for any service within thirty days simply because proof of treatment and the amount of expenses

has been submitted. By the plain terms of the statute, the proof submitted must be reasonable. Further, the proof submitted must demonstrate that the expenses incurred were reasonable and necessary and accident-related. Accordingly, the thirty-day payment period does not begin until the insurer receives reasonable proof that the expenses were reasonable and necessary and were incurred for bodily injury arising out of the use or operation of a motor vehicle.

According to Klein, he submitted proof of expenses for chiropractic care, use of a therapeutic machine called a Med X machine, and prolotherapy, and State Farm did not pay those bills within thirty days. According to his evidence, the prolotherapist bills were submitted beginning in January 1992 and State Farm made no decision until July 1992.

In addition, State Farm presented evidence that the chiropractor had provided treatment from 1990 until the summer of 1992 and that the chiropractor had been paid over $16,000. According to a claims adjuster for State Farm, Klein had an independent medical examination (IME) in June 1990.

Klein had undergone a second IME in November 1990 and the examining doctor felt that he was at maximum medical improvement and that the Med X treatment was not reasonable and necessary. However, State Farm paid for chiropractic care through January 1991.

Evidence was also suggested that Klein was referred to another doctor and underwent further Med X treatment until April 1991. State Farm's independent medical examiner issued a third report in April 1991 indicating that the use of the Med X rehabilitation was not a service of medical necessity.

Klein was also referred to a third doctor for prolotherapy treatments from January 1992 to early 1993. As a result, State Farm sent Klein's attorney a letter in February 1992 informing him that it had requested an IME from a second doctor to be conducted in March 1992 regarding the prolotherapy. In April 1992, State Farm sent another letter to Klein informing him that the independent medical examiner was going to review the prolotherapy bills. The IME physician opined in a May 1992 report that the treatment was not reasonable and necessary and also reported that the use of a Med X machine by the second doctor was not reasonable and necessary. In July 1992, State Farm also decided that the prolotherapy was not reasonable and necessary, but paid for the initial visit. About seven months later, State Farm sent another check for a prolotherapy treatment.

The jury was asked to determine whether "the defendant breach[ed] the contract by failure to pay or delay in payment for any of the Klein's reason-

able, necessary and accident-related health care bills and expenses in accordance with provisions of the Colorado Auto Accident Reparations Act." The jury's answer was "no".

Klein also asserted that the trial court had abused its discretion by improperly qualifying two experts. The appeals court disagreed.

State Farm offered an expert witness in the areas of osteopathy and occupational therapy. However, during the expert's testimony, plaintiff's counsel objected because the witness was not a chiropractor and because he was not certified on Med X machines. The trial court overruled the objection.

Klein contended that the trial court erred by allowing this expert testimony without a more complete foundation showing his qualifications. The appeals court disagreed.

> **Klein further argued that the trial court had erred in qualifying an attorney as an expert in insurance claims handling, insurance industry standards of care, and no-fault coverage since he had no expertise in adjusting claims and exhibited a lack of knowledge of the industry. The appeals court disagreed, and asserted that there was an adequate foundation to demonstrate the witness' familiarity with and knowledge of insurance industry standards.**

Klein also contended that the trial court improperly admitted hearsay evidence of a report and addenda in State Farm's no-fault file of a physician who was not available to testify.

The court rejected this contention.

Klein also argued that the trial court erred in refusing to instruct the jury that treatment prescribed by a licensed and competent health care provider is reasonable and necessary. Specifically that the term "reasonable and necessary" in the No Fault Act should be defined so as not to confuse the jury. The appeals court disagreed.

The trial court rejected the following tendered jury instruction:

> Treatment undertaken by the insured, when such treatment is justifiably prescribed by competent health care providers, it [sic] must be covered under the Colorado Auto Reparations Act, even if other practitioners suggest other treatment or no treatment at all is appropriate.

> Even if Klein's instruction was supported by the statute, a comparison of the court's instructions and the tendered instruction showed that the jury was instructed on all of the elements and necessary points of law regarding the language of the No Fault

Act. The court instructed the jury, inter alia, that in order for Klein to recover from the State Farm for breach of contract, it must find, by a preponderance of the evidence, that the treatment not paid for by was reasonable and necessary as a result of the accident—a question for the jury to determine.

Klein was not entitled to instruction that treatment prescribed by licensed and competent health care provider is reasonable and necessary.

For All These Reasons, It's a Dying Trend

Confronted with the demise of no-fault systems throughout the nation, various academicians, consultants and institutions associated with the insurance industry are now promoting a no-fault proposal which they call "consumer choice." Like other so-called "pure" no-fault proposals, the "choice" system would completely prohibit claims for non-economic damages.

Motorists who choose to be covered by the traditional Personal Responsibility System are still prohibited from suing a negligent motorist who has chosen to be covered under the no-fault option. To obtain pain and suffering coverage, the motorist operating under the tort system must purchase it as a first-party coverage from her own insurance company. Thus, a potentially negligent driver's choice to operate fault-free overrides another driver's choice to operate in a Personal Responsibility System in which negligent drivers may be held accountable. Drivers who choose no-fault impose their choice on drivers who do not.

Various lawyers' groups have been able to prevent pure no-fault from being tried anywhere. The states that claim to have no-fault have, in fact, a semi no-fault that allows lawsuits when injuries rise above a threshold.

The threshold in some states simply specifies a dollar value of medical bills. Call that an incentive. "Keep taking X-rays till you jump the threshold or you glow in the dark," one lawyer told me. Hawaii is a fascinating example of how this incentive works. That state raised its dollar threshold substantially in successive years. Guess what happened. A large share of the state's medical claimants inflated their costs at the same pace, keeping them eligible for lawsuits.

A better threshold, as used in Michigan and New York, spells out specific injuries—loss of a limb, for example—that open the door to suits. But these so-called verbal thresholds also usually include something about "percent permanent disability." A little shopping around will find a chiropractor

who'll say you're partly disabled.

No-fault states have the highest average automobile insurance premiums. Of the ten states where auto insurance was most expensive in 1989, eight were no-fault states. Since then, three of those states—Pennsylvania, New Jersey and Connecticut—have repealed their mandatory no-fault systems. (However, no-fault remains optional in Pennsylvania and New Jersey). In 1995, six of the top ten most expensive states (including D.C.) had no-fault systems. Note that in 1995, New York—the model state for the "verbal threshold" no-fault proposals promoted by the insurance industry earlier in this decade was the fifth most expensive state in the nation (up from sixth place in 1994).

Premiums in mandatory no-fault states rose nearly 25 percent greater than in non-no-fault states. The average auto insurance premium in states with mandatory no-fault systems grew an average of 45.6 percent between 1989-95, a growth rate nearly 25 percent greater than in Personal Responsibility System states. The latter saw an average 36.8 percent increase over the same period. California, which implemented insurance industry reform during this period, is included for purposes of comparison.

Why No-fault Cuts Claims Payments

The NAIC data demonstrate that no-fault systems—including mandatory no-fault laws—are more expensive than personal responsibility systems based on tort liability. No-fault's restrictions on tort-based compensation for non-economic damages do not offset the higher costs of no-fault. There are several reasons for this experience:

- Under no-fault, both the innocent victim and the motorist who caused the accident are compensated with medical, wage loss and other benefits—regardless of who is at fault. Paying the claims of both parties is inherently more expensive than under the Personal Responsibility System, in which the liability policy of the at-fault driver covers the innocent driver only. This conclusion is affirmed by many insurance industry experts, including advocates of no-fault, who acknowledge that no-fault was not conceived as a cost-saving measure but rather as a more efficient method of providing unlimited accident benefits and avoiding lengthy legal disputes over issues of fault.

The nation's largest auto insurance company, State Farm, has stated:

The adoption of no-fault reparation systems may or may not

lead to a reduction in the cost of auto insurance. The advantage of no-fault lies in a redistribution of insurance benefits based on need rather than fault, not its potential cost saving.

Other relevant points:

- Under no-fault, insurance companies are required to provide benefits to policyholders on a first-party basis. Thus, no-fault claimants do not face the kinds of corroborative pleading, evidentiary and procedural hurdles that exist under the Personal Responsibility System. As a result, no-fault offers policyholders greater opportunity to maximize their claims. For example, the availability of medical care up to the limits of the no-fault policy encourages greater utilization of health care services. The more generous the no-fault benefits, the greater the incentive to take advantage of them. For the same reason, no-fault creates a fertile environment for inflated or fraudulent claims. For example, individuals who are not covered by other forms of health insurance, or who are hurt at work but seek greater benefits than their workers' compensation coverage provides, may file claims under the no-fault system for injuries or illnesses not caused by the operation of a motor vehicle.

- No-fault does not reduce litigation costs. Litigation over property damage—for which the vast majority of car accident claims are filed—continues under no-fault, because no-fault systems typically retain the liability system for property claims. Litigation over whether a particular plaintiff has met the threshold after which lawsuits can be brought is common in no-fault states. Finally, there is anecdotal evidence that suits by motorists against their own insurance company for failure to pay no-fault benefits have skyrocketed.

- Liability insurance and other coverages remain necessary for many motorists in no-fault jurisdictions. Depending upon the generosity of the available no-fault benefits, motorists must still purchase additional first party coverage to protect themselves against serious accidents caused by uninsured, underinsured or unregistered motorists. What's more, some motorists must also purchase additional liability coverage in

the event they cause an accident that results in damages to another motorist in excess of the no-fault benefits available to that driver. Absent such insurance, the at-fault motorist risks a potentially devastating civil judgment against his or her home or other assets. Finally, under no-fault systems, motorists must still purchase property damage liability protection, since no-fault typically covers only bodily injury.

- There is significant evidence that the threat of liability acts as a deterrent to dangerous driving. The absence of fault leads to higher accident rates and correspondingly higher losses that must eventually be recouped through rate increases.

Reforming the Reforms

A study conducted by the Joint Economic Committee shows litigation expenses cost about 28 cents in every auto premium dollar.

Notably, the auto choice concept has generated significant nonpartisan support. A parallel bill, co-sponsored by ranking Democrat Senator Daniel Patrick Moynihan of New York, has been introduced in the Senate.

And a host of academic and business groups, ranging from the Joint Economic Committee to Americans for Tax Reform, have lined up in support.

To be sure, auto choice also has its share of critics. The powerful Association of Trial Lawyers of America (ATLA) is actively fighting the legislation, for example.

"We oppose no-fault because it denies people their legal rights without letting them know that they are giving them up," an ATLA official said.

What auto choice would do is create a new type of car insurance policy—called personal protection insurance—that could become available in every state. Insurance is regulated by states, not the federal government.

This bill would not change that, so state regulators would ultimately decide whether or not this policy would be offered in their states.

The policy would differ from those offered at the same time in that it would eliminate coverage for liability—the coverage that kicks in when somebody sues you. Instead, your car insurance coverage would cover any damage sustained by you in an accident—regardless of whether that damage was inflicted on the car, on your body or on one of your passengers. Classic no-fault insurance.

The other guy's policy would cover the damage to his car, self and passengers. Bickering over who caused the collision would become obsolete except in cases where economic damages exceed the individual's policy limits.

In such cases, you would be able to sue, based on fault, to recover any so-called economic losses that were not covered already. And, if an insurance company took more than 30 days to pay an undisputed claim, the policyholder could sue to force payment and get both attorney fees and interest, computed at a 24 percent per annum rate, until the claim was paid, the auto choice bill says.

What's an economic loss? Anything that comes with a quantifiable price tag—car repairs, medical bills and lost wages, for example.

What would not be covered under this basic policy is compensation for so-called pain-and-suffering damages. These hard-to-quantify damages, which are imposed in litigation to punish wrongdoers and compensate accident victims for the emotional toll of an accident, often amount to three times the cost of economic damages.

If you wanted to retain your right to sue for noneconomic losses under the auto choice system, you would have to buy a separate tort maintenance coverage policy. And, even then, you wouldn't necessarily be able to sue the person who caused the accident. You would be suing your own insurance company, under your TMC policy, to get compensated for pain and suffering.

> **By making the people who sue solely responsible for the cost of litigation, auto choice advocates maintain the cost of personal protection insurance—basic car insurance—would drop dramatically.**

However, trial lawyers counter that several states already have some form of no-fault insurance and, by and large, these states have higher—not lower—auto insurance premiums.

In reality, all these systems allow accident victims to sue if their damages—whether defined by economic losses or the severity of injury—exceed a certain threshold.

Insurance companies maintain that this encourages consumers to inflate their medical costs in order to slip over the hurdle and gain their ability to sue for noneconomic losses.

"It's true that no state has adopted a true no-fault system," the ATLA said. "But that's the only experience we have to judge no-fault."

"While auto insurance premiums are out of control because of the tort system, a no-fault system would provide much needed balance and billions of

dollars in savings for consumers," said Virginia Republican congressman James Moran during a February 1999 debate.

Moran, an original co-sponsor of auto choice in the House, noted that auto insurance premiums over the past 10 years have risen at twice the rate of inflation. The problem, he said, is litigation: "It's not that the insurance industry is making more money or people are being paid more compensation. The reason is the role of the legal system."

Indeed, he said, most payouts in the auto insurance system go to lawyers rather than accident victims.

On top of that, he said, the system is terribly skewed. Victims of serious accidents, he said, receive only 9 percent on average of their economic damages. By contrast, he said, those involved in "nuisance" accidents get significantly more than their economic damages because of the incentives on insurance companies to settle.

Backing Away from No-Fault

The insurance companies that wrote 70 percent of Pennsylvania's auto coverage cut their average medical claim payment by 12 percent between 1989 and 1991. The average claim paid fell to $1,729 from $1,964, Pennsylvania Insurance Department figures showed. During the same time period, the consumer price index for medical care—a measure of inflation—rose by 9 percent a year.

These trends illustrated the problems with no-fault coverage: Lower medical payments and higher premiums. Through the 1990s, no-fault states looked at various reform-of-the-reform plans tried to turn the trends around.

The Louisiana state legislature considered various plans, finally supporting one in 1998 that focused on what supporters called "cost-containment." The plan would:

- help control auto insurance rates;

- not seriously affect the availability of medical care for auto insurance patients; and

- result in health-care providers shifting costs to other payers.

In other words, doctors and other providers would charge other patients or their insurance companies more to make up the difference. Supporters of the proposal say it would help eliminate fraud and faked injuries. (Louisiana trailed only California in the percentage of injury claims from accidents in which property damage claims were filed.)

In Louisiana, nearly half the accidents involving a property damage claim also generated an injury claim. In California, more than 60 percent did; the national average was 29.3 percent.

Jeff Albright, executive vice president of the Independent Insurance Agents of Louisiana, said exaggerated medical claims play an important role in pushing up auto rates.

People run up medical costs to bolster their claims for pain and suffering damages, Albright said. It's the minor accidents and small claims that lie at the root of Louisiana's high rates.

The simple fact remains that auto injury claims generate lawsuits, whatever the system. And that means dealing with attorneys from insurance companies and victims; depositions; court appearances; medical reports to both sides; delays in payment; and lots of wasted time.

During the summer of 1997, congressman Dick Armey introduced a bill that would alter the auto insurance landscape drastically by creating the first nationally available no-fault car insurance policy. But the bill got shoved aside while Congress pushed to complete the tax law before summer recess.

Armey, who had sponsored only two other bills in his legislative tenure, tried to get his bill—a variation on auto choice—passed before congress adjourned. "This is very high on my legislative agenda," Armey said. "It's always difficult to predict how long something will take. But my goal is to get (auto choice) passed before this session ends."

With the cost of the average auto policy running $750, auto choice advocates estimated that the policy could save the average driver $243 a year.

Some studies have indicated that as much as one-third of a low-income family's after-tax wages goes to paying auto insurance. And the savings could be greater—averaging more than $300 annually—in high-rate states such as California, Connecticut, New York and New Jersey. Texans should expect an average rate cut of $269. Two-car families could enjoy double the savings.

Former Georgia Commissioner of insurance Tim Ryles told the U.S. Congress: "[N]o matter what proponents tell you about insurance fraud, no-fault will not do anything to control it. On the contrary, no-fault is to insurance fraud what octane level is to gasoline: the more no-fault you have, the greater the fraud."

Part Two:

Houses, Apartments and Places You Live

Chapter 4

The Mechanics of Homeowners Coverage Disputes

You may believe that your insurance company is on your side...or there for you...or like a rock or a good neighbor, as its motto proclaims.

This lasts until a winter storm knocks the fascia off of the front of your house and you have to file a claim under your homeowners policy...and the company cancels your policy because you didn't tell them you *had* any fascia.

Insurance companies have fairly broad discretion in paying claims. This discretion puts a lot of pressure on the companies to behave ethically and consistently. Assuming—for the sake of argument—that most behave ethically, the bigger problem remains the consistency part. This lack of consistency creates the kind of claims problems that turn into lawsuits.

One typical case from the early 1990s illustrates this point.

A San Francisco woman who had a homeowner's policy with Fireman's Fund Insurance Co. reported that burglars stole $60,000 worth of personal property. The claim seemed suspicious to the Fireman's adjuster, who referred it to the company's special investigations department.

Just before the claim, the woman had been notified that her policy was about to expire for non-payment of premium. She showed up at her insurance agent's office—in person—on the eve of the expiration date to pay.

Two weeks later, the agent received a report that the woman's home had been burglarized the day before she paid the premium. The woman claimed that her losses included thousands of dollars worth of clothing.

Fireman's investigators knew that burglars almost never steal clothing—they concentrate on cash, jewelry, electronic equipment and other portable or easily resalable goods.

A Fireman's investigator interviewed the woman and created a file on the claim. However, in the absence of clear proof of fraud—and with a valid policy in effect—it seemed that the insurance company would have to make good on the loss.

The chief investigator recommended waiting a few weeks, so his staff could look into the claim more carefully. This kind of delay was allowed under the terms of the Fireman's Fund policy.

An insurance company has the right and the option to investigate and settle any lawsuit and claim. It also accepts an obligation to defend any lawsuit or claim—but if it pays the limit of its liability to settle a suit or claim it is no longer obligated to provide any further defense.

More than a month later, the case still was not settled. The insurance company's investigators had discovered a few complications. Among these: the woman herself hadn't reported the burglary—a relative had. But there was a logical explanation. The woman had trouble writing English and needed the relative's help. "It looks like we're gonna pay [for the stolen clothes]," the chief inspector said.

What You Have to Do When a Loss Occurs

If something happens that causes an insurable loss, the duties required of you as the policy owner are quite explicit. The policy states that you must:

- provide the insurance company with immediate written notice of loss;

- notify the police in case of loss by theft and a credit card or fund transfer card company in case of loss under Credit Card or Fund Transfer Card coverage;

- protect the property from further damage. If repairs to the property are required, you must:

 1) make reasonable and necessary repairs to protect the property; and

 2) keep an accurate record of repair expenses;

- separate damaged and undamaged personal property and put it in the best possible order;

- furnish a complete and detailed inventory showing destroyed, damaged, and undamaged property, quantities, costs, ACV, and the amount of loss claimed;

- forward any legal papers received, such as a summons, to the company immediately, because there is usually a time limit for responding to such documents;

- within 60 days submit a signed proof of loss stating the time and origin of loss, the interest of all parties in the property, the presence of other insurance, the values of each item, and other information which the policy requires.

Also, the insurance company may request that you produce appropriate records, exhibit what remains of damaged property, and submit to examinations under oath. You must comply with these requests "as often as may be reasonably required."

Your insurance company will either send you a proof of loss form to complete or arrange for an adjuster to visit your home. In either case, you should document your loss as thoroughly as possible. If you prepared an inventory before the loss, this task will be easier.

A proof of loss report should set forth, to the best of your knowledge:

- the time and cause of loss;

- specifications of damaged buildings and detailed repair estimates;

- an inventory of damaged personal property;

- other insurance which may cover the loss;

- the interest of you and all other parties (mortgage companies, lien holders, etc.) in the property involved;

Losses are adjusted with and paid to you—unless the policy indicates payment should be made to someone else, such as a mortgage holder.

- changes in the title or occupancy of the property during the term of the policy;

- receipts for additional living expenses incurred and records that support the fair rental value loss; and

- evidence or affidavit that supports a claim under the Credit Card, Fund Transfer Card, Forgery and Counterfeit Money coverage, stating the amount and cause of loss.

An adjuster may want to see all damaged items, so avoid throwing out anything after a loss has occurred.

Whether your insurance company sends and adjuster or a proof of loss form, it's a good idea to make a list of everything that's been stolen or damaged as soon as possible. This list should include a description of each item, the date of purchase, and what it would cost to replace (if you have replacement-cost coverage).

Some advance work can help you fulfill these duties. Any relevant receipts, bills, photographs, or serial numbers from high-ticket appliances and electronic equipment will help establish the value of your losses.

> Don't wait for a major loss to do this. You should keep a list that includes this information in a safe place at all times.

According to the loss payable clause of the standard policy, if you provide the proof of loss and other information—and the amount of loss has been agreed upon—the insurance company will pay for the loss within 60 days (specific state laws may modify this time limit).

You must assist the insurance company in making settlements, making claims against other parties who might be responsible for the loss, be available for court trials, hearings, or suits, and give evidence as required.

A Case Study of Duties After a Loss

The issue of when repairs are made—and how this affects whether they're covered—is the center of many claim disputes. The September 1990 Louisiana appeals court decision *Dwight and Phyllis Sayes v. Safeco Insurance* offers a good example of this kind of claim issue.

It also wraps a discussion of essential terms like "actual cash value" and "replacement value" into the dispute.

The Sayeses bought a homeowner's insurance policy from Safeco in February 1988. On March 7, 1988, the Sayes home was severely damaged by fire. On May 3, the Sayeses furnished a proof of loss to Safeco in the amount of $37,888.61—the estimated cost of repairing the damage.

Safeco paid the Sayeses $21,875.53, the depreciated or "actual cash value" of the damaged property. It stated that, under the terms of the policy, the balance of the loss was not payable to the Sayeses until the property had actually been repaired.

On July 14, 1988, the Sayes filed suit against Safeco to collect the $16,000 difference between the actual cash value and replacement value.

As is usual in these cases, the Sayeses also sought penalties and attorney's fees. Safeco filed a motion for declaratory judgment, asking the court to rule that no further payments were due under its homeowners policy until the damages to the Sayes house had actually been repaired. The trial court granted Safeco's motion, requiring only that Safeco pay the Sayeses a "fair rental value" for comparable housing for a period not to exceed six months after payment of the actual cash value.

The Sayeses appealed, arguing that:

1) Safeco's policy, if it does not require payment until after repair, violates [a Louisiana law in force at the time],

2) the trial court erred in finding that the policy did not require payment for the estimated cost of repairs before the repairs were actually made, and

3) the trial court erred in not finding them entitled to penalties and attorney's fees.

The appeals court started it review by going back to the policy in question. Under the "General Conditions" section of the policy, the language read:

5. Loss Settlement. Covered property losses are settled as follows:

...c. Buildings under Coverage A or B at replacement cost without deduction for depreciation subject to the following:

....When the cost to repair or replace the damage is more than $2500, we will pay the difference between actual cash value and replacement cost only after damaged or destroyed property has actually been repaired or replaced.

However, the policy also contained an "Option A—Home Replacement Guarantee," which read:

For additional premium, Item 5c under General Conditions shall not apply to Coverage A—Dwelling. In its place, the following shall apply:

We will settle covered losses to the dwelling under Coverage A without regard to the limit of liability shown in the Declarations.

You agree to:

1. insure the dwelling to 100% of its replacement cost as determined by us.

2. accept any yearly adjustments by us of Coverage A reflecting changes in the cost of construction for the area.

3. notify us of any addition or other remodeling which increases the replacement cost of the dwelling $5,000 or more:

a. within 90 days of the start of construction; or

b. before the end of the current policy period;

whichever is greater, and pay any resulting additional premium; and

4. repair or replace the damaged dwelling.

If you fail to comply with any of the above provisions, item 5.c. under General Conditions shall apply to Coverage A-Dwelling.

According to the Sayeses, under "Option A", they were not required to repair the damages before receiving payment but were only required to agree to make such repairs. However, Safeco, while not disputing the amount owed, held that such repair cost is not due under the policy until after the Sayes' home is actually repaired.

According to Safeco's interpretation of the policy, because the Sayeses had not yet repaired the damages as they agreed to do under "Option A", payment was not due until after the actual repairs were made. However, the court noted that Safeco's reasoning was circular and, under its interpretation of the policy, "Option A" would require the repairs be made before payment was due for a covered loss. The court held that the policy was ambiguous

Under Louisiana law, as in most states, any ambiguities in a contract are to be construed against the drafter of a contract.

"Option A" applied if the Sayeses "...agree to...repair or replace the damaged dwelling," said the court. But "Option A" does not say that it will only apply, if they actually make repairs to the damaged dwelling, before payment of repair costs will be due. If this is what Safeco intended, it could have used the same unambiguous language it used in Section 5(c)(2) of the General Conditions of the policy.

The Sayeses "agreed to...repair or replace the damaged dwelling" as required by "Option A" of the policy and submitted a proof of loss for the estimated cost of such repairs.

The appeals court agreed with Safeco's statement in its brief that "[t]he obligation of payment by the insurer is reciprocal to the obligation of repair

by the insured" under the terms of the policy. The Sayeses did have an obligation to repair. However, because the policy was silent and ambiguous as to whether—under "Option A"—when the policyholders agreed to make the repairs the repairs actually had to be made prior to payment, the policy had to be interpreted against its drafter, Safeco.

"The trial court was manifestly in error and clearly wrong in holding otherwise," said the appeals court.

On the Sayes' claim for penalties and attorney's fees, however, the court ruled that Safeco had paid the actual cash value and did not claim that it would not pay the replacement value, but only that it would not pay until after the repair was made. "Though we do not agree with Safeco's position, Safeco's argument is reasonable and was made in good faith. Safeco's actions were not arbitrary or capricious; therefore, plaintiffs are not entitled to penalties and attorney's fees," said the court.

The judgment of the trial court was reversed, and Safeco was ordered to pay the Sayeses $16,013.08, for the repairs, plus interest.

Property Valuation

Property losses under the basic homeowners or dwelling form are generally settled on an actual cash value basis. All forms support the principle of indemnity, which—in this context—means recovery may not exceed the smallest of four amounts:

- the ACV of the property at the time of loss,

- the policy limit for the coverage,

- the amount necessary to repair or replace the property,

- the amount reflecting the insured person's interest in the property at the time of the loss.

When a loss is adjusted on an actual cash value basis, a deduction is made by the insurance company for the depreciation of the property. The term depreciation refers to the gradual reduction in the value of property as a result of time and use.

> **Example: The original roof on a home is 10 years old when it is destroyed. The roof has an expected life of 20 years and has provided the owner with 10 years of service prior to the loss. If the loss is adjusted on an actual cash value basis, the company may pay the insured person just half of the cost to replace the roof.**

The broad and special forms provide replacement cost coverage for structures, but only if the amount of insurance on the damaged house is 80 percent or more of the full replacement cost of the house at the time of loss. And final recovery may not exceed the amount actually spent to repair or replace the property or the policy limit for the damaged house.

Replacement cost means to replace new up to the limits of the policy, less any deductible, with no reduction in the amount due to depreciation.

Example: Following a fire in the kitchen of your home, the cost to restore the roof above the kitchen to its original condition is $700. If the insurance company assumes the entire amount of the repair cost (in this case $700), then you have had the loss adjusted on a replacement cost basis.

If you fail to carry coverage of at least 80 percent of the full replacement cost of the house at the time of loss, the insurance company will pay the larger of the following amounts (subject to the policy limit):

- the ACV of the part of the house damaged, or

- a proportion of the cost to repair or replace the damaged property equal to the amount the insurance coverage bears to 80 percent of the house's replacement cost.

This is why it is important to maintain an adequate level of insurance-to-value. Even when replacement cost coverage applies, final recovery may not exceed the amount actually spent to repair or replace the property, or the policy limit for the damaged structure.

If you and your insurance company don't agree about the value of a loss, your method of appeal is outlined by the standard policy. The insurance company states:

> If you and we fail to agree on the amount of loss, either may demand an appraisal of the loss. In this event, each party will choose a competent appraiser within 20 days after receiving a written request from the other. The two appraisers will choose an umpire. If they cannot agree upon an umpire within 15 days, you or we may request that the choice be made by a judge of a court of record in the state where the [house] is located. The appraisers will separately set the amount of loss. If the appraisers submit a written report of an agreement to us, the amount agreed upon will be the amount of loss. If they fail to agree, they will submit their differences to the umpire. A decision agreed to by any two will set the amount of loss.

From time to time, policy owners bring suits against their insurance companies when they are dissatisfied over claim adjustments. Before this can be done, you must comply with the policy provisions concerning the reporting of the loss, cooperating with the company in settling the loss, etc.—and any suit must be brought within one year after the loss.

If a covered property loss makes a part of the residence premises rented to others, or held for rental by the insured person, uninhabitable, the standard policies cover the loss of fair rental value minus any expenses that do not continue.

Payments will be made for the shortest time required to repair or replace the damaged property or, in the case of displacement of the insured person's household, until he or she settles in a new residence. The initial property damage obligates the insurance company and payments are not limited by policy expiration. If a civil authority prohibits use of the residence premises because a peril insured against has damaged neighboring premises, this coverage is limited to a maximum period of two weeks.

Other Dwelling and Property Claims Issues

In most instances, insurance companies settle claims by making payments to the policyholder. However, they have the option of repairing or replacing property. This will occur when replacement can be made at a cost to the company which is less than that which you could negotiate.

> **Payments known as up-front payments—which include temporary living costs and other incidental costs paid in advance—are voluntary to the insurance company. A company can require you to incur the expenses first and be reimbursed later.**

Example: A fire occurs at your home and the damage is so extensive that the house can't be lived in until repairs are made. You rent rooms in a motel and take all your meals in restaurants. Services you provided for yourself, such as laundry, must now be provided by others at a greater cost. Additional living expense will pay the additional cost of living over and above your normal costs for housing, food, laundry, or other expenses.

The pair and set clause in the standard policy recognizes that the loss of one item from a pair or set may reduce the value of a pair or set by an amount greater than the physical proportion of the lost item to the set. It usually comes into play when items of jewelry, fine arts or antiques are involved.

An abandonment clause prohibits you from abandoning property to the insurance company in order to claim a total loss. Although the company may choose to acquire damaged property which can be sold for salvage and may choose to pay a total loss, you cannot insist that the insurance company take possession of any property.

Example: You have a loss due to a fire in your garage. Most of the contents are damaged, but some are not. You can't tell the insurance company, "There was $4,000 worth of stuff in the garage. Pay me $4,000 and the contents of the garage are yours." The company will usually not accept this kind of a proposition because it has to make arrangements for hauling, repair, and sale of the salvageable property and it does not care to do this.

If property that has been stolen and paid for by the insurance company is recovered later on, you can elect to take the property and pay back the insurance company the amount it originally paid for the loss. An alternative is to keep the money and let the company keep the property.

Despite the specified amount of insurance, a policy owner's insurable interest may limit the amount paid on a claim. Other parties may have an insurable interest in your property as an owner, mortgage holder, vendor, lien holder, stockholder, joint owner, bailee, or lease holder.

Once an insurance company has paid you for the loss you sustained, it acquires your rights in the claim. This transfer is called subrogation.

Example: Your neighbor loses control of his car and crashes into your garage. Your insurance company, after paying you, now has the right to sue your neighbor to collect from him the amount it paid to you. Once you receive payment, you "subrogate," or pass on, your rights in the claim to the insurance company.

Legal Tactics

Insurance lawsuits often take on a David v. Goliath tone. This is because people cling stubbornly to a number of preconceived—and generally negative—notions about insurance companies. Among these notions:

- The only goal of an insurance company is to make money, often at the expense of individual policyholders.

- Insurance policies are designed to give insurance companies maximum opportunity to deny claims.

- The claims process allows delay in payment, so that companies can retain their money as long as possible.

• Insurance company employees are often less than candid.

Lawyers with a lot of experience suing insurance companies follow these notions automatically. They will usually claim that the company's conduct has been devastating—causing financial ruin, physical and emotional problems, or damage to the family structure—or so one-sided that it deserves some big-ticket legal remedy.

And lawyers who sue insurance companies a lot are used to long, drawn-out disputes. Because the companies have the financial resources to fight, they will usually do so until they think there is a strong certainty of losing. This can mean procedural motions, delays and appeals of rulings or verdicts.

"But, once they see that there's a likely loss scenario, it's amazing how quickly they fold up shop and try to settle," says one California-based insurance lawyer. "It's one of the hardest things to learn about this work. You're not sure there's ever going to be any closure to the suit and then—bang. Suddenly, there's an offer on your desk."

Why the sudden change? A long period of denial bolsters the perception that insurance company claims employees are trained to keep the company's money for as long as possible to maximize profits.

But it's not easy getting there.

The legal proceedings, when they do move forward, can get surprisingly personal. An insurance company may ask a lot of questions about your background and emotional history. A court may allow this questioning if you've claimed any sort of emotional distress.

Other common delaying tactics:

• The insurance company will usually ask a judge to separate breach of contract issues from improper claims handling issues. Proceeding with these issues in two separate phases often works to the insurance company's advantage. It lessens the overall impact of a company's foot-dragging; and, if the company wins on the issue of coverage, the claims handling issues become moot.

• The company will sometimes claim that privilege issues complicate the case. If these arguments are successful, the court may allow the company to keep its claim files secret.

• The company may make it difficult for you to locate employees with information about key issues in the case.

- The company may assert as an affirmative defense that it acted reasonably and in good faith in taking the advice of counsel.

- The company's lawyers may use what legal experts call a "full-court press"—objecting to every question in depositions, forcing motions to get any company information, and raising objections to written discovery on virtually every request.

> **Generally, larger insurance companies are more likely to use these hardball tactics. However, an aggressive lawyer should be able to turn any of these delay tactics against the insurance company. The tactics usually reinforce the worst impressions about insurance companies.**

Expert witnesses have become fixtures in insurance lawsuits. These experts can be both useful tools and damaging obstacles. Attorneys, judges, and independent qualified claims personnel are often consulted as experts in insurance litigation. They can testify about:

1) the reasonableness of settlement offers,

2) the standard or customary practice of insurance companies and their employees and agents, or

3) the ultimate issue of whether the insurance company acted in bad faith or in violation of implied or statutory obligations.

Usually these experts are retained solely for the purpose of giving opinions on issues in the case, as opposed to insurance company employees, who, because of their involvement in a claim file, can testify on the facts.

Insurance company employees can also be considered experts because of their special "knowledge, skill, experience, training, or education," which may entitle them to testify in the form of an opinion. These employees may be asked to give their opinions about whether the company met the obligations imposed by the covenant of good faith and fair dealing, as well as with specific statutory obligations. The issues for expert testimony may include:

- whether the insurance company has given as much thought to the interests of its policyholders as to its own interests;

- whether the insurance company conducted a thorough investigation of the facts;

- whether the insurance company objectively evaluated the claim;

- whether the insurance company made reasonable attempts to resolve or settle the claim;

- whether the insurance company processed and handled the claim consistently with acceptable claims practices; and

- whether the insurance company followed its own internal procedures, and, if so, whether these procedures constitute a "fair" and "good faith" process for handling the claim.

The expert on claims issues may impact any punitive damages in a case. A court is not likely to permit such an expert to testify about the insurance company's "state of mind" in handling the claim—so the expert can't speculate about whether the claims handling was "fraudulent," "malicious," or "vexatious." However, an expert's testimony on claims issues may influence the jury's view of the case and ultimately affect the punitive damages issue.

Extrinsic Evidence

A summer 1998 Texas Supreme Court ruling reveals a potentially troubling development for insurance companies with regard to the consideration of extrinsic evidence in coverage disputes, according to at least one policyholder attorney.

The case—*Balandran v. SAFECO Insurance Co. of America*—involved a coverage dispute over a claim for property damage caused by leaking plumbing. The Seattle-based insurance company denied the claim, citing an exclusion in a homeowners insurance policy for property damage caused by ruptured plumbing.

Originally, the Balandrans filed suit against SAFECO in Texas District Court, but the case was transferred to federal court.

After the trial court found in favor of the insurance company, the Balandrans appealed. The Court of Appeals sought certification of the controlling issues in the case with the Texas supreme court in view of a previous appeals court decision in a similar case, which drew a sharp reaction from Texas regulators. The high court's ruling turned on a dispute over the language of a homeowners' insurance policy exclusion, which created an exception reinstating coverage.

While SAFECO interpreted the exclusion to clearly exclude coverage, the Balandrans argued that the exception provided coverage.

To determine whether the dispute suggested an ambiguity, the high court considered the circumstances surrounding the filing and regulatory approval of the policy form, and found that "the circumstances surrounding the drafting of this policy... support the Balandrans' theory" in support of coverage.

In a dissenting opinion written by Justice Priscilla Owen and signed by Justice Hecht, the dissenting justices asserted that the high court "resorts to inadmissible extrinsic evidence to find support for its construction of the policy... .When the policy is not ambiguous on its face, extrinsic evidence may not be used to create an ambiguity."

Justice Owen asserted that, addressing this same issue in another similar case, *Sharp v. State Farm Fire & Casualty Insurance Co.*, the Court of Appeals "correctly concluded that 'the Sharps may not point to the revision process to create an ambiguity'... Ironically, the federal courts have correctly applied Texas law, while this court has not."

For his part, however, Chief Justice Thomas R. Phillips, writing for the majority, noted in a footnote that "Contrary to the dissenting justices' contention, we are not considering this evidence for the purposes of creating an ambiguity. Because the Balandrans' interpretation of the contract language is reasonable, an ambiguity exists on the face of the policy. We merely highlight this evidence because it further supports the result we reach."

John MacDonald, an attorney in the Philadelphia office of Anderson Kill & Olick, said that the high court's opinion citing its consideration of extrinsic evidence from the regulatory record and the insurance industry's internal drafting history was a victory for policyholders.

MacDonald said it represented an important change from a previous high court decision involving the interpretation of the absolute pollution exclusion in *National Union Fire Insurance Co. v. CBI Industries.* (In that ruling, the high court had stated that extrinsic evidence couldn't be considered to prove an ambiguity in a policy.) He said that when such evidence was allowed in coverage disputes, the policyholder nearly always prevails.

John Harrison, a San Antonio attorney who represented the Balandrans, said although the high courts opinion was a victory for his clients it hardly represented new law in Texas. "It's a little bit of whittling away of the doors to extrinsic evidence. It's not going to establish longstanding precedent," Harrison explained.

He said the high court ruled that the policy in question was ambiguous on its face, and only cited the extrinsic evidence in support of its finding.

Brian Blakeley; a San Antonio attorney who represented SAFECO, said the court decided the case on issues of plain insurance law, which requires ambiguities in contract language be decided in favor of coverage.

According to Blakeley, the decision was good for policyholders, because it "broadens the scope of homeowners policies dramatically. [If] damage to a foundation is caused by water leakage, then it's covered."

Although Blakeley declined to put a figure on the cost of the decision to insurance companies, he said it would be "significant." According to Harrison, the Balandrans' attorney, the impact would be in the billions of dollars.

In the Balandran case, although the claim was for only about $66,500, because of penalties, interest and legal fees, SAFECO owed almost $400,000.

Delay Tactic: Allegations of Fraud

A summary judgment motion is a legal tactic that's particularly useful when an insurance company denies a claim, alleging fraud.

Your insurance company may make this allegation when it doesn't know precisely where or how a fire started. Absent clear evidence of accidental origin, the your insurance company assumes you burned the property. These assumptions will seldom survive summary judgment, particularly where motive is unclear.

In one case, insured homeowners sued on their claim after a house fire, and the insurance company counterclaimed for fraud, alleging owner arson.

The insured people moved for summary judgment, supported by the husband's affidavit that stated, "I did not have anything to do with causing the fire, nor did I pay anyone or request anyone to set the fire." The trial court granted judgment for the policyholders, and the insurance company appealed.

The appellate court said the affidavit shifted the burden of proof to the insurance company to present substantial evidence on the arson issue. To establish a prima facie case of arson, the insurance company must prove:

1) the fire was intentionally set;

2) the insured person had a motive to burn the home; and

3) the insured person either set the fire. or had it set, which may be proved by circumstantial evidence implicating the insured person.

In this case, the insurance company failed to meet its burden, and summary judgment for the policyholder was proper.

Sometimes the insurance company is half right. An insured person burned the house or otherwise violated the policy. Another insured person, such as a spouse or business partner, may be completely innocent. Innocent co-insureds may bear the loss if coverage is unavailable.

The divorcing spouse who burns the family home can impoverish the innocent spouse if fraud by any insured person forfeits coverage for all. Developments in the law help those who have been victimized twice—first by the insured wrongdoer and then by the insurance company who refuses to cover the innocent co-insured.

A growing body of case law recognizes that co-insureds have rights independent of each other and that a policy violation by one insured person may not void the policy as to the other. As one court summarized:

> The minority view—previously the majority view—denies an innocent spouse recovery either because the underlying property ownership is an indivisible tenancy by the entirety, or because the wrongdoing of one spouse is imputed to the other under a theory of oneness of the married couple. The present majority view... allows an innocent or divorced spouse to recover even though the co-insured spouse is at fault. The majority view courts reason that policy language excluding coverage must be explicit or that what is in question is the spouse's interest in the insurance policy, not the interest in the real property, or that the fault of the wrongdoing spouse cannot be imputed to the innocent spouse.

Many modern cases favor innocent co-insureds. Courts have protected them by saying that their rights and obligations under the policy are severable. This argument is based on the language of the New York Standard Fire Policy, which provides:

> Concealment, fraud. This entire policy shall be void if, whether before or after a loss, the insured has wilfully concealed or misrepresented any material fact or circumstance concerning this insurance or the subject thereof, or the interest of the insured therein, or in case of any fraud or false swearing by the insured relating thereto.

Courts have reasoned that policies speak of fraud or misrepresentation by "the insured." Thus, the antifraud provision must mean "the insured who violated the policy has no coverage." If the rights and obligations under the policy are severable rather than joint, a co-insured who does not participate in the policy violation is protected.

Insurance companies have countered with new policy language that voids coverage on fraud by "any insured." Many courts held carriers could thus eliminate claims of innocent co-insureds.

Those opinions, however, overlooked that most states require carriers to use the New York Standard Fire Policy language or other, equally liberal, language. Thus, even if the policy says that fraud by "any insured" voids coverage, the court will look to the language of the Standard Policy and hold coverage is voided only as to "the insured" who committed the fraud. Most modern courts presented with the Standard Policy argument have protected the innocent co-insured.

An Allegation of Illegal Claims Denial

What did State Farm do after its former claims specialist Amy Girod Zuniga exposed internal policies for denying earthquake coverage? The company obtained a gag order against her and, according to State Farm attorney Julie Robac, removed her declarations from the courthouse so that "any Joe Schmoe in the public can't just go in there and get a copy...."

The insurance company immediately brought a SLAPP (Strategic Lawsuit Against Public Participation) suit against Zuniga while another action—one in which Roderick and Krista Taylor sued State Farm for failure to provide earthquake coverage—was pending.

Although the *Taylor* trial court held that Zuniga's declarations should be made public, it agreed, based on attorney-client privilege, to temporarily seal the declarations during State Farm's appeal.

California's Second District Court of Appeal ruled that Zuniga's declarations were public because substantial evidence established a finding of a prima facie case of the crime/fraud exception to the attorney-client privilege.

In June 1997, the Los Angeles Superior Court granted Zuniga's motion to dismiss State Farm's SLAPP suit against her. On July 9, 1997, the California Supreme Court denied State Farm's petition for review. Zuniga's declarations are now open to the public.

> **Zuniga testified that her supervisors at State Farm instructed her "to lie, destroy documents, and manufacture evidence" in order to win a summary judgment in a class action suit handled by Steven "Bernie" Bernheim. Additionally, she said State Farm failed as required by law to notify policyholders who did not have earthquake coverage. Instead, she claims that agents forged policyholders' names, indicating they waived earthquake coverage.**

Zuniga alleged that her supervisor repeatedly advised her and others to refer to the signing of policyholders' names as "unauthorized signatures,"

never as forgeries, when discussing this subject. A State Farm senior executive also allegedly ordered employees not to admit that these unauthorized signatures were made unless ordered to do so by a court.

Zuniga also stated she was told by a State Farm superior that American Home Co., which provides errors and omissions coverage for State Farm's agents, would not provide coverage to State Farm against forgery cases because State Farm knew of this conduct and had effectively sanctioned it.

Conclusion

When a thief breaks into your house and makes off with your stereo, television, personal computer and microwave oven, it's fairly simple to come to an agreement with your insurance company over the amount of your claim.

But what happens when the thief also carries off that signed Picasso print you bought 20 years ago for a few hundred dollars that is now worth a few thousand, or the sterling silver service for 12 your grandmother left you?

> **Many insurance policies that routinely cover high-cost electronic equipment will pay you little or nothing if the stolen item is an heirloom without previously established value. The problem is compounded if the missing item is something you can't document having owned.**

To eliminate the chance of being caught without coverage for those expensive items that can't easily be replaced, insurance agents advise customers to attach special riders and stipulations to their homeowners insurance covering items such as antique furniture, artworks, coins, jewelry, Oriental rugs, silver and stamps. These possessions sometimes require their own separate policies, depending upon their value. The policies may include general coverage for an entire collection (say, $10,000 worth of insurance) or a list of each object and its appraised value.

The good news is that while getting these items appraised may be cumbersome, and does cost extra, the premium for the added coverage isn't that much, unless your Picasso is worth millions. Coverage for a list of antiques and silver worth $50,000 probably won't add much more than $100 to your annual premium.

These "fine arts riders," as they are called, protect owners of pieces that are likely to increase in value. Ordinary homeowner policies assume that whatever one owns will never be worth more than the amount one paid for it and, in general, insurance depreciates the values of objects.

With a fine arts rider, an appraisal is usually suggested for individual pieces or an entire collection in order to determine the amount of insurance needed, and premiums are calculated accordingly.

It is also possible to "schedule" objects, so that insurance coverage and premiums go up a certain percentage periodically.

Salomon Brothers, the New York City-based investment firm, charts the relative values of various investments, such as stocks and bonds, and commodities, among them gold, silver, art, Chinese jade and precious gems. Art, jade and gems have continually topped these annual lists, increasing an average of 15 percent a year. That may aid one in finding an appropriate level for scheduling insurance coverage increases, although collectors are free to choose whatever percentage they prefer.

The values of objects must be within reason, however. One cannot simply purchase a number of pieces of Depression glass and, based on a hunch that they will soon dramatically rise in value, insure them at 10 times the amount one paid. "The insurance company would probably get a little suspicious at that," said Jim Mellors, an insurance adjuster for the Chubb Group. "They would be likely to ask themselves, 'Why would someone want to insure something at 10 times its value? Is he expecting a fire or theft?'"

> **It is up to you to have objects evaluated by a reputable appraiser who is considered an expert in the particular collectibles area. Your insurance company will be likely to accept the appraised value, basing premiums on this, but companies want to see that the appraiser has the right credentials.**

However, since appraisers charge between $50 and $150 per hour for their work, most homeowners want to keep their number down. Charles Rosoff, a partner at New York City-based Appraisal Services Associates, noted that "it is very important to tell an appraiser at the outset why you are getting something appraised, because an accredited appraiser may only do an appraisal for one purpose. If you are looking to sell the item, one needs to look at the data for selling in order to determine the fair market value. If you are looking to insure the item, one looks at the replacement cost. There is also something called the marketable cash value, if you had to sell the item right away instead of waiting for the fair market value. You get different values for all of these."

The system does have an occasional problem. During the late 1990s, the Chubb Group, one of the country's largest art insurance companies, paid an art collector approximately $1 million after his home was broken into and his

art collection stolen. The works were eventually recovered and reappraised by Chubb, which found they were actually worth closer to $200,000. Chubb soon thereafter filed a suit against the collector for fraud.

However, with pieces of recognized value, a rider on an insurance policy can save a homeowner from receiving a settlement for theft or damage that is far below the object's actual value. Most regular insurance policies have deductibles, some of which are rather high.

If a thief walks off with a fur coat or a fine art print, a $1,000 deductible may wipe out the possibility of a claim (although, one could argue, the lower premiums one paid because of the high deductible somewhat make up for the loss). Most fine arts riders have no deductibles, so everything is protected.

One effective way to reduce the premiums for both regular and fine art policies is to install some sort of burglary prevention or alarm system. Some insurance companies require homeowners to have a system that will automatically notify the police or security company in the event of a break-in. One of the benefits can be a reduction of around 6 percent in the premium on your homeowner policy and some negotiable discount on a rider.

> If you are a collector, photograph the objects you are insuring and place these photographs in a fireproof safe or safe deposit box along with the bill of sale and a sheet listing the objects' value, the name of the creator (if relevant), and the works' dimensions and medium. This may be used as evidence if the objects are stolen or damaged.

Fine arts riders are specific, spelling out such things as what is to happen if a stolen object for which a claim has been paid is recovered. Most homeowners would like to reserve the right of first refusal. They may not want the object back if it has been damaged or if they are happier with the money. Other costs—such as shipping the object if it turns up overseas, or legal fees if the question of ownership is to be decided in court—may dissuade the owner from taking it back as well. Still, it's nice to be asked.

Most insurance companies that offer homeowner policies will provide a fine arts rider or collectibles floater. (The latter is designed more for esoteric collections, such as political campaign buttons, than art, antiques and jewelry). If one company doesn't offer this type of coverage, find one that will.

Chapter 5

How Natural Disasters and Catastrophes Stir Up Trouble

You don't have to be a tornado-chasing meteorologist to know that natural disasters and catastrophes have become a growing part of modern life. Opinions differ on the cause of this growth—some say the number of disasters has actually increased, others say the popular media has simply become more aware of them. Whatever the reason, disasters can cause some big problems for people trying to make insurance claims in the wake of the damage.

To be sure, insurance companies try to come through for policyholders in the critical—and high-profile—days after a natural disaster. These situations can be a center stage for good companies to separate themselves from other players in the market. But they pose special problems for consumers.

For example, settlements may come a little too quickly after a hurricane, tornado or earthquake. In some cases, homeowners with losses will sign away their rights to make claims later in exchange for a check immediately. They will feel like they've been made whole...and begin rebuilding. Weeks or months later, they'll learn that they suffered more or different damage than they'd originally thought. But, by that point, it's too late. The insurance company has a document waiving rights.

In an even more common scenario, uninformed consumers may think they have coverage for damage that's excluded from their policies. They make a claim—and they find out they have no protection for a specific kind of loss. This happens most often with flood or earthquake losses, which are both excluded from standard homeowners policies.

In addition, state insurance commissioners urge consumers to be wary of fast-buck repair artists and insurance companies reluctant to pay up.

Scenes of disaster are "inundated with folks looking to make a fast buck...following the storms and preying on people in the midst of emotional and physical trauma," Alabama insurance commissioner Richard Cater said.

The same people who go around selling black water as driveway sealer show up after storms with a ladder and some cheap plywood on their pickup trucks, Cater warned.

Insurance claims in the United States have totaled more than $1 billion in the first three months of 1998. "Which is a great deal ...but it's manageable," Glenn Pomeroy, president of the National Association of Insurance Commissioners, said.

Much of the damage was blamed on the Pacific Ocean warming called El Niño, which does affect weather around the globe and can intensify the storms that normally plague America.

But, with any rash of damage comes an increase in cases in which insurance companies deny claims. Pomeroy said: "Don't take `no' for an answer."

> **If your claims are denied, recheck your policy. Then, if you still feel you were unfairly refused payment, you should appeal to the company claims manager and to the state insurance commissioner if necessary.**

Pomeroy described a Colorado case in which a woman had changed insurance companies and suffered severe damage from a hailstorm. The new company insisted it was old damage; the old company insisted the damage had occurred after the change.

The state insurance commissioner had to intervene, he said, getting the companies to split the payment.

And in California, he said, state officials arrested a man who was telling people he could get them a free solar heating system. He would provide a wrecked system so they could claim a storm had blown it off the roof. When the claim was paid, he would sell them a new solar system.

Hurricanes and Floods

Gary Sanderson felt luckier than most when it came time to repair his Delaware home. Back-to-back northeasters left Sanderson's beachfront house—normally 1,200 feet back from the Delaware shore—under three feet of water with furniture floating from room to room.

"I already have the check to cover the structural damage, and I'm waiting on the check to cover the contents," said Sanderson. "I've paid flood in-

surance premiums for 18 years, but this is the first time I've ever had to file a claim."

Sanderson was one of four million Americans who had flood insurance through the 30-year-old National Flood Insurance Program (NFIP).

The problem, said Jo Ann Howard—head of the NFIP—was that most homeowners don't know their regular insurance policies don't cover "this most prevalent of natural disasters from which no state is immune. Federal disaster relief only goes so far... and so do individual grants, which pay a maximum of $13,400 and average only $2,500 a family. That doesn't go far to rebuilding a home or a business."

The 1994 federal court decision *Daniel Holtz v. Omaha Property and Casualty Insurance Co.* considered some of the finer mechanical points of how government-mandated insurance works in the wake of a watery, catastrophic loss.

Holtz owned a house in Miami and was the named insured under an Omaha flood policy on that house. In August 1992, the house was damaged by flooding that resulted from Hurricane Andrew. At the time of the damage, the policy was in full force and effect. Holtz filed a claim for losses caused by the flooding.

Omaha refused payment on the claim, citing an exclusion in the policy for flood damages occurring "below the lowest elevated floor of the [house]." The house was described in the policy as an "elevated, single-family residence consisting of three or more floors with a garage and enclosed area at the ground floor." However, like most houses in south Florida, it had no basement. But there was a twist here. Holtz had converted part of his ground-floor entryway into an enclosed living space. For the purposes of the policy, this was a basement.

And, like most flood policies on houses in south Florida, the Omaha contract was based on some fairly detailed and, at times, confusing language.

Its declaration page described the base elevation of the residence at 15.0 feet—which represented the elevation of the first elevated floor. The ground floor of the property, including the garage and an enclosed area, contained Holtz's "hot water heater, air conditioning equipment, clothes washer and dryer, and certain other equipment." These ground-floor items were described in Holtz's application—but the policy excluded coverage for the following:

> Enclosures, contents, machinery, building components, equipment and fixtures located at an elevation lower than the lowest elevated floor (except for the required utility connections and the footing, foundation, posts, pilings, piers or other founda-

tion walls and anchorage system as required for the support of the...building), including...finished basement walls, floors, ceiling and other improvements...and contents, machines, building equipment and fixtures in such basement areas.

Making things even more complicated, there was an exception to this exclusion. The Omaha policy did provide coverage:

in basement areas and in areas below the lowest elevated floor of an elevated...building for sump pumps, well-water tanks, well-water tank pumps, oil tanks and the oil in them, cisterns and the water in them, pumps and/or tanks used in conjunction with solar energy systems, furnaces, hot water heaters, clothes washers and dryers, food freezers and the food in them, air conditioners, heat pumps and electrical junction and circuit breaker boxes; and coverage is also provided in basement areas and in areas below the lowest elevated floor...for stairways and staircases attached to the building which are not separated from the building by elevated walkways and for elevators and relevant equipment....

The insurance company—which only offered the flood insurance because Florida law and FEMA guidelines said it had to—based its denial on the exclusion. Holtz—who bought the policy because Omaha had a reputation for not jerking people around—based his claim on the exception to the exclusion. A heavy dispute was brewing.

Omaha insisted that Holtz's losses weren't covered because the area of damage was an "enclosure...at an elevation lower than the lowest elevated floor" which was above ground and, therefore, not covered by the "basement" provision in the policy.

Holtz insisted that Omaha's policy was ambiguous at best and could not be read to exclude coverage for the ground level of the insured property including the garage and the enclosed area.

Holtz and Omaha were both so confident of their positions that they each asked the court to make a summary judgment. One side was going to be sorely disappointed. The court concentrated on the exception-to-the-exclusion language. It ruled that the company couldn't claim the exclusion because:

upon close scrutiny of [the exclusion] in its entirety, [the court] finds a significant ambiguity in this provision and some doubt as to whether it should exclude the ground floor. On the one hand, the provision excludes from coverage enclosures "lower

than the lowest elevated floor" which can be read to define a first floor enclosure below the lowest elevated floor which is not a basement as defined in the policy. On the other hand, the use...of the phrase "basement areas and in areas below the lowest elevated floor" in two separate places...can be interpreted as intent to provide the same coverage for areas below the lowest elevated floor whether such areas are basements or first floor "enclosures."

Finding an ambiguity, the court had to construe the policy strictly against the insurance company and in favor of Holtz. It concluded:

...the purpose of this policy was to afford flood protection for the insured property. Adopting an interpretation against coverage, based on a distinction between basements and first floor enclosures, would frustrate the obvious purpose of that policy.

So the court issued the summary judgment for Holtz—and ordered Omaha to make him whole for the his damages in the flood.

Earthquake

In June 1998, State Farm Insurance Co. paid $100 million to some 117 policyholders to settle a lawsuit alleging that the company had unfairly cut its earthquake coverage before the 1994 Northridge earthquake. The settlement—hammered out before a retired state Supreme Court justice working as a mediator and filed under a seal of confidentiality—marked the largest known single payout by an insurance company involved in post-earthquake claims.

Lawyers for the homeowners said the case could also expose State Farm to claims by thousands of other policyholders whose insurance was covertly pared years before the Northridge quake.

In an infamous memo, State Farm executives considered sending policyholders a written clarification of their earthquake coverage. But the executives decided against the idea, saying that it would "appear inconsistent with our marketing philosophy since we don't want to sell the coverage."

The company did restructure the policies available to customers, however. It replaced two insurance plans with a less costly "combined limit policy" and eliminated the notion of "guaranteed replacement," the idea that it would pay to replace homes destroyed by an earthquake even if the cost exceeded a homeowner's coverage limit.

"There were a lot more people that were victims of State Farm's marketing ploy," said George Kehrer, founder of the nonprofit homeowners group that advised most of the plaintiffs. Nonetheless, Kehrer said he felt "a great sense of relief and satisfaction that a wrong had been made right."

Northridge resident Irene Allegro and 116 other homeowners alleged that State Farm secretly restructured their policies in 1985 to limit the amount of money they could recover if their homes were damaged in an earthquake. The homeowners said State Farm concealed the true nature of the changes by sending notices that described the coverage as "new" or "different," without disclosing that it also amounted to less.

State Farm had been under pressure to settle the case since May 1997, when a Superior Court judge found that the company had "failed to give specific notice in 'clear and understandable language,'" "as required under state law. The company appealed that ruling, but settled before the appellate court could decide the case.

Lawyers for Allegro and the other homeowners said that about 25,000 other policyholders were similarly misled and could sue the company based on the Superior Court's ruling. State Farm officials declined to discuss the potential for future litigation, but noted that the company admitted no wrongdoing in the settlement. "Ultimately, settlement, although a bitter pill, is the best way to go," said company spokesman Bill Sirola. "There are business considerations that must be weighed."

Lawyers for the plaintiffs and other advocates, however, said the case could pave the way for numerous lawsuits by other property owners, who purchased insurance before 1985. "The fact that State Farm paid a $100-million settlement to more than 100 people indicates that there was massive fraud and wrongdoing and that there are many other policyholders entitled to money as well," said Harvey Rosenfield, founder of the Santa Monica-based Proposition 103 Enforcement Project. But even if other homeowners file new lawsuits, experts said, they would have to navigate particularly murky territory in insurance law, and prove that they had not missed a one-year statute of limitations that insurance companies believe has been established by California court decisions. While insurance companies like State Farm make it their business to assess risk, the unpredictability of earthquakes has been a source of anxiety in the industry for more than a decade.

Before 1984, insurance companies tried to limit their potential liability in disaster-prone states like California by capping sales of certain policies. Under a state law that became effective that year, however, insurance compa-

nies were required to offer earthquake coverage to people who had homeowners' insurance.

Jerry Yandell didn't know about the change in his coverage until it was too late. He had insured eight rental properties and his Chatsworth townhouse before 1985, and hoped to retire on the rental income before the Northridge quake shook his dream to the ground.

State Farm eventually offered a settlement equal to his coverage limit, $641,000, although the damage to all his properties was estimated at more than $1 million. "We went to our agent and I said: 'I know the damage is more than [our policy limit], but I have guaranteed replacement,' " Yandell said. "The agent looked at me and told me: 'No, you don't.' I could have just fallen off my chair."

Stung by a federal criminal investigation of its conduct in the aftermath of the Northridge earthquake, Allstate Insurance Co. fired back by suing a California firm it accuses of defrauding the big company.

The firm, Building Permit Consultants, convinced "large numbers of homeowners" in the Los Angeles area to file false claims with Allstate related to the devastating 1994 temblor, according to a civil fraud complaint lodged in a California federal court.

The Southern California company allegedly orchestrated a scheme that cost Allstate and other unnamed insurance companies millions of dollars.

Separately, a prominent Chicago attorney lodged a class action against Allstate accusing the company of systematically short-changing policyholders who obtained arbitration awards.

Neither lawsuit had any direct bearing on the federal investigation of Allstate that came to light in early 1998.

> **FBI agents seized thousands of documents at Allstate offices, acting on claims made by a former employee and others that the company had reduced its pay outs to quake victims by secretly changing engineering reports.**

Allstate executives denied any wrongdoing. In fact, the executives said at the time that the giant insurance company had been a victim of quake-related fraud. They vowed to file civil litigation backing up their claim, and the Building Permit Consultants case is the first of at least two, an Allstate spokesman said.

According to the suit, Allstate claimed that Building Permit Consultants "cold-called" and sent direct-mail solicitations to homeowners in Northridge

after the quake. The homeowners were told they could obtain insurance proceeds for quake damage, even if no actual damage had occurred, according to the lawsuit.

Homeowners who went along with the scheme were asked to sign a contract agreeing to share as much as half of the insurance proceeds with Building Permit Consultants, the lawsuit alleged.

"The terms of these contracts created an incentive to fraudulently inflate the nature and extent of earthquake damages as well as the method and cost of repairs," the lawsuit said.

When Allstate would deny benefits, Building Permit Consultants would use biased appraisers to back up their bogus claims, or refer homeowners to attorneys who would file litigation adopting the inflated cost estimates, the lawsuit said.

Allstate named three principals of the firm as defendants in the case, including a former government employee who was convicted in a bribery incident that occurred prior to the earthquake.

According to published reports, John Kaldawi was found to have solicited a $10,000 payoff in 1993 to expedite building-permit approval while working for the Los Angeles Building and Safety Department. He was fined and sentenced to four years probation.

Allstate is seeking damages of more than $1 million in its lawsuit. Meanwhile, in the lawsuit brought against Allstate, Illinois resident and Allstate policyholder June Hogan accuses the company of refusing to pay part of an arbitration award after she was injured in a car accident.

The company improperly reduced the size of her award by $5,000, sending her $55,000 instead of the $60,000 she was owed, according to the lawsuit, filed on her behalf by former Illinois Appellate Judge Dom J. Rizzi. Allstate had engaged in "a uniform practice" of reducing arbitration payouts without just cause, the suit alleged.

Not as Much Coverage as Most People Think

If you're insured by any of the various state-run or state-supported homeowners insurance programs and a natural disaster strikes, there's a chance you may not be able to get your claim paid promptly.

Therein lay the source of Floridian Harry Webb's headache after Hurricane Georges rocked the state's northern Gulf Coast in September 1998. Laws allowing insurance companies to charge customers higher deductibles for hurricane damage left Webb on the hook for what was arguably no different

than any other North Florida rainstorm.

One gust may have sent a branch on Webb's 100-year-old oak tree crashing down, punching a hole through the roof of his enclosed patio. Webb didn't know for certain. He had been away from home for several days.

At first, agents from his insurance company, State Farm, told Webb that his deductible would be $500 for a $1,900 repair to the roof.

But shortly thereafter, the agents called Webb back. Because the storm in Jacksonville could be linked to the front that included Hurricane Georges, Webb would have to pay State Farm's special hurricane deductible.

For Webb, this came to 5 percent of the value of his home—or about $5,300. That left him digging into his own pocket to fix his roof.

A State Farm spokesman, Tom Hagerty, declined to discuss Webb's claim, citing a company policy on discussing individual claims. But Hagerty did confirm that the company had adopted a "broad view" of what constituted hurricane damage. "Even though there may be some confusion as to whether a hurricane hit on a particular date (the higher hurricane deductible) is in effect from when a hurricane watch or warning is issued in any part of Florida until 72 hours after the hurricane watch expired," Hagerty said. The damage also needs to be caused by the hurricane storm system.

Allstate Insurance Co. has a similar policy, said Leslie Chapman Henderson, a company spokeswoman.

And you shouldn't count blindly on the Feds to bail you out. The Federal Emergency Management Agency, or FEMA, will offer emergency food and shelter to those who need it.

> **FEMA offers low-interest loans and some outright grants. FEMA officials suggest that if you think you're going to need financial help, get the loan process moving quickly—don't wait to see how much insurance protection you'll get before filing an application. Get bids from several licensed contractors on repairs and present them to your adjuster. You should be free to pick the contractor of your choice, with the adjuster's consent. Some companies provide lists of recommended contractors.**

Harry Webb wasn't an isolated case. In the wake of Hurricane Georges, officials with several insurance companies were seeking refuge behind the law's special deductible. A band of storms associated with Georges dumped more than an inch of rain on the Gulf Coast, according to the National Weather Service. And that's good enough for most insurance companies, regardless of whether the storms packed anywhere near the punch of a standard hurricane's 74 m.p.h. winds.

"Losses related to that meteorological event (Georges) are subjected to the hurricane deductible," said Rade Musulin, an actuary with the Florida Farm Bureau Insurance Co.

Although Florida dodged the worst of Georges—meteorologically—it felt the financial impact. The state had already passed more laws about how insurance claims are handled after a natural disaster than any other state.

In a homeowners insurance market still reeling from Andrew's $16 billion in insured losses during 1996, a higher deductible specifically tied to hurricanes offered a means of lowering the liability of insurance companies in the event of a big storm.

For homes worth less than $100,000, a company could impose up to a 2 percent deductible for hurricane damage. For homes valued at more than $100,000, a company could maintain a 5 percent deductible.

Where the law has proven troublesome is in the exact definition of what constitutes "hurricane damage."

"When cases like this have come up in the past, we will try to resolve any dispute between the homeowner and his insurance company," said Dan McLauglin, a spokesman for the Florida Insurance Department. "The view we take is the reasonable person test. ... Is there any obvious logical connection between the hurricane and the damage?"

The Insurance Department was also planning to propose legislation to resolve some of the ambiguities about what counts as hurricane damage.

Insurance companies appeared likely to resist such a change, however. "I think it is premature to pass a new law," Musulin said. In the vast majority of cases, a hurricane strikes or it doesn't.

That's a tautological statement that should give any policyholder pause.

Catastrophe Models

In February 1998, an independent actuarial analysis commissioned by the Florida House Committee on Financial Services concluded that the hurricane catastrophe models used by insurance companies are "far better than any current alternative" to estimate homeowner losses.

The models were developed by Applied Insurance Research (AIR) of Boston and approved by the Florida Commission on Hurricane Loss Projection Methodology, an independent body set up by the Legislature.

Florida Insurance Commissioner Bill Nelson nevertheless refused to approve insurance company rates based upon the models, saying they are unrealistically high.

The report by Robert Biondi, an actuary with Milliman & Robertson, said the models are generally accepted within the actuarial profession and judge superior to older methods.

It also said that although some homeowners will pay higher rates, the increases won't approach the 1,500 percent predicted by Nelson and some homeowners will pay lower rates.

The study also compared actual residential losses paid by selected insurance companies in 13 hurricanes going back to 1983 and concluded that actual losses were $963.6 million, 4 percent higher than the $926.4 million that would have been predicted by the AIR model.

The study said the AIR model is used by 65 insurance companies that collect about 40 percent of total U.S. property insurance premiums and by 80 reinsurers that underwrite about 90 percent of the U.S. catastrophe reinsurance market. (Reinsurance is the insurance that insurance companies buy—to protect themselves from big swings in policy claims.)

Meanwhile, a panel of three arbitrators had been hearing a dispute over whether the Florida Windstorm Underwriting Association, the state's pool covering more than 300,000 homeowners, should receive a 62 percent rate increase over three years.

Commissioner Nelson rejected that request. Existing law provided for an arbitration panel to hear appeals of such decisions (although Nelson was in the process of asking the state legislature to remove that provision of the law).

The panel already had granted State Farm a 25 percent rate increase after Nelson turned it down.

In other action, after the batch of tornadoes had hit the state, Nelson ordered that insurance companies providing coverage to tornado victims not charge more than the standard, minimum deductible on any damage claim, typically $250 or $500. He said many insurance companies in Florida otherwise might charge higher deductibles, ranging from 2 to 10 percent of a home's insured value, on damage claims stemming from windstorms.

"We do not want insurers misinterpreting or bending any rules on homeowners insurance, especially at a time like this," Nelson said.

Preparing for Disaster

In January 1998, after the severe ice and snow storms in Canada and the Northeastern United States, companies could only tally the cost of property damage little by little, updating as claims roll in and keeping a watchful eye on the implications of the storms for the future.

In the United States, claims in New York, Vermont, New Hampshire and Maine were projected to be in the vicinity of $200 million, according to early estimates from Property Claim Services.

But thousands of people remain without power and many weren't able to return to their homes, said Gary Kerney, assistant vice president of the New Jersey-based division of American Insurance Services Group. "We'll be taking a second look and releasing a report in about 60 days," he said.

In Canada, the Insurance Bureau of Canada tallied about 250,000 claims that amount to about $365 million in insured losses, said Stan Griffin, vice president at IBC. North of the border, as in the United States, damage included many small individual claims such as damage to cars from falling tree branches.

"We won't likely see the larger and more complex losses from businesses and farms for several days or even weeks," said Ray Medza, general manager for IBC in Quebec.

On farms, livestock and poultry have been destroyed by freezing temperatures and business interruption has been extensive, the IBC said.

"This is very major event from the insurance standpoint and one of the largest catastrophes that we have had in this country for many years," said Yves Brouillette, president of Canada's ING Group, which had seen almost $20 million in claims.

"We had been thinking about earthquake as the major potential disaster in Canada—especially on the West coast," Brouillette said. It wasn't expected that an ice storm could involve damage of such magnitude, and it's hard to project what the ultimate cost will be, he said.

The largest part of ING's claims involved major losses from homeowners, Brouillette said.

Claims from business interruption are more difficult to evaluate and aren't covered in all cases. It depends on individual policy coverage and the circumstances, said PCS's Kerney.

"It's not a carte blanche for power losses," he said. There are distinctions between interruption from overall loss of power as opposed to damage caused by downed power lines on a particular property.

Brouillette agreed. Business interrupted as result of damage from the storm itself was small, he said. Insurance companies had added a lot of frills to policies in the previous ten years and, in many instances, they didn't realize how costly the provisions might be.

So, they were resisting claims more fiercely than usual.

Helpful Tips

The National Association of Insurance Commissioners offered the following checklist of claims practices:

- Contact your insurance company immediately. Take notes on any conversations that include the names and titles of all persons spoken to, when the conversations took place and what subjects were covered. Save the notes in case of a dispute.

- Make temporary repairs so any damage doesn't worsen, but don't make permanent fixes until the insurance adjuster visits to see the extent of the damage.

- If you think your insurance company improperly denied your claim, review your insurance policy, which should be kept in a bank safety deposit box or other safe place away from your home or business. If you're convinced you were wrongly denied, "don't take no for an answer," Pomeroy says: appeal to your insurance agent, the company's claims manager, your state insurance commission and, finally, a lawyer.

- Plan for adequate insurance coverage. That means coverage for renters, too, in addition to flood insurance and regular homeowners and business coverage.

- Know that if you hire a "public adjuster" to work on your insurance claims, he or she can claim 10 to 15 percent of any payout.

- Beware of scam artist contractors who will charge five times or more the normal amount and won't bring your home or business up to building code requirements.

What should you do after a natural disaster strikes? Follow the normal "duties after a loss"—but do so even more conscientiously than you might otherwise.

Contact your insurance company. If you need to file a claim, you should immediately contact your insurance company either directly or through an agent. You might want to check your monthly premium bills, in many cases, insurance companies set up special toll-free or local telephone numbers to handle information and questions regarding claims.

If you need to, make any temporary repairs necessary to prevent further damage from occurring. Put tarpaulins over openings, unplug drains, move undamaged possessions to a safe place. But don't throw away damaged items

and don't start any permanent repairs or call repair people without first getting instructions from the adjuster.

> **An important note: You should never attempt to make permanent repairs on your home until an adjuster has inspected it. Making permanent repairs before the adjuster has seen the damage could result in denial of your claim.**

If the damage to your home has made it uninhabitable and you need to move somewhere else temporarily, be sure to let your insurance company know where you will be, or at least how to get hold of you.

Always keep records. It's important to takes notes of all conversations-the name of the person you talked to, what was said, etc. If possible, take pictures of the damage.

Insurance companies usually send adjusters to the worst-hit homes first. So, if your home has only minor damage, be patient.

Conclusion

If you and your insurance company can't settle on how much it will cost to repair your home, contact the company's claims department manager. If you still can't agree, you and the insurance company can present the claim to a state-run mediation program.

Remember: Litigation should be a last resort in settling a claim. Cases can cost thousands of dollars in legal fees and take years to resolve.

> **If your claim is rejected and you think it is valid, work your way up the line. Talk to supervisors or the claims manager. If this approach doesn't work, contact your insurance company's claims executive—the name is usually on the first page of the policy—at its headquarters.**

If you are still unsatisfied, you may want to contact the state insurance department or consult a lawyer. Of course, the later may not be practical unless a large sum of money is involved. However, some lawyers will at least look over your claim for a nominal charge and might even advise you on whether you have a valid case. If this is the route you choose, be sure you ask about the fees, and if the insurance company has offered a settlement, ask the lawyer whether you'd be better off suing the company.

Chapter 6

Avoiding Common Homeowners Claims Problems

Many factors and influences can cause problems when you make a claim with your homeowners insurance company. It's a good idea to anticipate these problems as fully a possible—and avoid them.

Most disputes between companies and policyholders center on coverage issues—whether or not a particular loss is insured by a policy. The main mechanism insurance companies use to protect themselves against the negative financial impact of big claims is to deny coverage on some fundamental issue. This usually means an issue not related to the specifics of the claim.

Understanding the concepts behind these problems is an essential tool to finding the right insurance solution for you. This chapter will explore the common problems involved with coverage and provide you with the knowledge to avoid these problems.

Fundamental Coverage Issues

One fundamental coverage issue is insurable interest. Insurance interest has to do with who has the right to make a claim on the proceeds of a policy.

Following the 1994 Northridge earthquake, California mortgage lenders, insurance companies and homeowners were locked in a battle over earthquake insurance claims.

Many of insurance companies, instead of paying claims directly to homeowners, made out checks with mortgage lenders as co-payees. The lenders, in turn, were reluctant to sign over earthquake insurance claims until the homeowners could prove that rebuilding had begun.

However, most homeowners couldn't begin to rebuild until they collected money from the insurance company. This created a gridlock that kept rebuilding from proceeding.

The California Department of Insurance warned insurance companies that forcing homeowners to get lenders to sign claims was illegal. But the insurance companies argued that mortgage lenders with an insurable interest in an insured dwelling had to be treated as co-payees.

Consumer advocate groups argued that the complication was an intentional tactic used by insurance companies to delay paying earthquake insurance claims.

As might be expected, the insurance companies denied any intentionality. Some individual companies expedited payments. But processing earthquake claims took longer in the wake of the earthquake than many policy owners expected.

Neglect

If a covered loss causes damage in such a way as to expose an insured dwelling to further damage, you have an obligation to make reasonable repairs or to take other steps to protect the dwelling or any property.

> **Example: If a windstorm blows away a portion of your roof, the policy would pay for—and actually require—temporary repairs to the roof to avoid further damage to the interior of the structure. If you don't make the reasonable repairs, the policy won't cover the further damage.**

Likewise, the standard policy allows you to move property from a your home threatened by a covered peril to a place of safety for a period of 30 days. The removed property is covered during the move and at the other location for loss from any cause—which expands coverage considerably.

However, if you don't take the opportunity to remove personal property, your insurance company might interpret this as failure to reasonably protect your property from damage.

Disputes related to issues of failure to protect a dwelling or property usually occur in combination with disputes related to specifics of a claim. You might not expect this kind of thing to be what determines your dispute—but you might be surprised when you go to trial. Courts put a lot of weight on failure to prevent further damage.

If your insurance company is looking for a reason not to pay a claim, it may try to expand a dispute over prevention into a dispute over neglect—which is explicitly excluded from coverage.

Charges of neglect often turn back to the phrase "reasonable means of prevention". Some insurance companies interpret it to mean that you should do the same things to protect the property that you would if there were no insurance on the property. But not all courts agree with this definition.

> Another important factor to many insurance companies is how the expiration of a policy affects coverage. In fact, the easiest way for an insurance company to deny a claim is to show that the policy wasn't in effect when the loss occurred.

Of course, the issues involved in this tactic are not always clear. If a loss occurs just before the expiration date of your policy and continues for two months afterward, the loss would be fully covered. However, a dispute could arise over when—exactly—the loss first occurred.

Example: You make a claim that, because of an insured flaw in the construction of your house, a series of accidents began during a policy's coverage period and has continued afterward. If your insurance company can show that the loss didn't begin and continue—but is, in fact, several losses occurring independently—it can limit its liability to claims that relate to accidents that occurred during the policy period.

Cancellation and Nonrenewal Issues

Other issues that affect the term of a policy—and, therefore, any claims made—are cancellation and nonrenewal. The standard homeowners policy describes at length how and when a policy can be canceled:

> You may cancel this policy at any time by returning it to us or by letting us know in writing of the date cancellation is to take effect.
>
> We may cancel this policy only for the reasons stated below....
>
> When you have not paid the premium, we may cancel at any time by letting you know at least 10 days before the date cancellation takes effect.
>
> When this policy has been in effect for less than 60 days and is not a renewal with us, we may cancel for any reason by letting

you know at least 10 days before the date cancellation takes effect.

When this policy has been in effect for 60 days or more, or at any time if it is a renewal with us, we may cancel:

If there has been a material misrepresentation of fact which if known to us would have caused us not to issue the policy; or

If the risk has changed substantially since the policy was issued.

...When this policy is written for a period of more than one year, we may cancel for any reason at anniversary by letting you know at least 30 days before the date cancellation takes effect.

So, your insurance company is only allowed to cancel a policy for a few reasons in order to prevent it from canceling just because you have made claims.

The most common cancellation dispute occurs when a policy owner claims that the insurance company has canceled the policy under false pretense. That is, the company points to one of the allowed reasons but is actually canceling because it doesn't want to pay a legitimate claim. This is a difficult charge to prove.

The same issues are raised by nonrenewal, which is a slightly less abrupt version of cancellation. When your insurance company elects not to renew your policy, it simply waits until some period (usually 30 days) before the expiration date and informs you—in writing—that it doesn't want to continue the coverage.

In the 1995 New Jersey appeals court decision *Anna and Vincent Montalto v. Merrimack Mutual Fire Insurance*, the court considered how a company can lawfully cancel an insurance policy.

Vincent Montalto was the named insured on a homeowners insurance policy issued by Merrimack, effective October 1989. On February 14, 1990, Merrimack informed Montalto by certified mail that the homeowner's policy would be canceled by the end of March.

In mid-March, Elena DiGiacomo slipped and fell on the steps leading to a New Jersey duplex—half of which was owned by the Montaltos. She sued the Montaltos and their neighbors for injuries resulting from her fall.

Montalto passed along a copy of DiGiacomo's lawsuit to Merrimack. The insurance company immediately denied coverage, pointing to the February 1990 notice of cancellation as the date at which its coverage stopped.

Montalto sued Merrimack, asking the New Jersey court for a declaratory judgment forcing the insurance company to cover DiGiacomo's claims. He argued that the notice of cancellation failed to comply with state insurance regulations requiring a warning period before termination of a policy.

He also argued that Merrimack had breached its contract with him, because the cancellation even conflicted with specific contractual provisions of the insurance policy itself.

Merrimack answered, arguing that its notice of cancellation fully complied with state regulations...and terms laid out in the policy.

The court hearing these initial arguments ruled that Merrimack's notice of cancellation failed to comply with state regs. It ruled for Montalto and ordered Merrimack to cover the DiGiacomo claims. (It didn't say anything about the breach-of-contract issue raised by Montalto.)

Merrimack appealed the decision.

In September 1985, New Jersey had adopted emergency regulations effectively prohibiting insurance companies from canceling certain kinds of policies mid-term. According to state regulators, the emergency action was necessary because:

> The Department of Insurance is receiving numerous complaints from both agents and insureds concerning mid-term cancellations, block cancellations and nonrenewals of entire lines of insurance, the failure to provide timely notice of such terminations and mid-term increases in premiums with respect to property and casualty/liability insurance coverages.

However, the state limited the emergency regs to commercial lines of insurance. It didn't apply to personal lines—coverages like homeowners and standard auto or life.

Noting this distinction, the appeals court ruled:

> We conclude that cancellation of a homeowner's insurance policy is governed by [other statutes, which state,] "Notice of cancellation and nonrenewal of fire and casualty coverage," which states in part: "All fire and casualty policies of insurance, except accident and health policies, shall provide for the issuing company to give...thirty days' written notice to the insured of the cancellation of any policy."

Since the record was clear that Montalto had received thirty days' notice of the cancellation of the policy, Merrimack had complied with the statutory and regulatory requirements for cancellation.

This left Montalto's argument that Merrimack had breached the terms of its insurance contract. Although the lower court had not ruled on this matter, the appellate court considered the relevant policy language:

> Cancellation.We may cancel this policy only for the reasons stated below by letting you know in writing of the date cancellation takes effect. This cancellation notice may be delivered to you, or mailed to you at your mailing address shown in the Declarations. ...When this policy has been in effect for 60 days or more, or at any time if it is a renewal with us, we may cancel: (a) if there has been a material misrepresentation of fact which if known to us would have caused us not to issue the policy: or (b) if the risk has changed substantially since the policy was issued. This can be done by letting you know at least 30 days before the date cancellation takes effect.

Montalto's policy had been in effect for more than sixty days. The notice of cancellation indicated that the reason for cancellation was "increase in hazard." However, Montalto argued that there had been no such increase.

The appeals court couldn't resolve this dispute. So, it reversed the statute ruling in favor of Montalto and sent the case back to trial "to determine whether Merrimack had an objective, reasonable ground for its conclusion that there was an increase in hazard."

If you receive a nonrenewal notice, you should get another policy lined up as soon as possible and be very careful about documenting any losses that occur during the remaining policy period. If you make a claim, you may have some problems getting it paid fully.

Beyond the handful of fundamental issues, most coverage disputes focus on three kinds of issues—all related to the specific details of a given claim. The three kinds of issue are related to: dwellings and structures, personal property and policy exclusions.

Dwelling and Structure Issues

With respect to the dwelling and other structures, the standard homeowners policy says that it covers any direct loss.

Unfortunately, this definition can prove problematic. For instance, it doesn't apply to certain losses that you might think of as being direct. The following are some exceptions:

- structural collapse is only covered to the extent of the certain provisions;

- losses resulting from freezing while a dwelling is unoccupied are covered only if an attempt has been made to maintain heat in the structure or if the water supply has been shut off and plumbing, heating, air conditioning and interior sprinkler systems have been drained;

Example: You live in Maine, but during the height of winter each year you spend several months in Florida. If the plumbing system bursts due to freezing and leakage causes damage to your house, there will be no coverage. However, if you drain the plumbing and shut off the water supply—or you provide heat in the building—there will be coverage.

- certain outdoor structures—such as pools, decks, gazebos, etc.—are not covered for damage by freezing, thawing, pressure, or weight of water or ice. However, losses to certain types of property usually located outside the building are covered if caused by collapse;

Example: A fence collapses, damaging the cesspool which is located beneath it. Coverage would apply to the fence and the cesspool.

- heft of materials or supplies used or for use in construction of a dwelling is not covered (this includes such items as lumber and other building materials; pipe, and fixtures whether installed or not); and

- there is no coverage for vandalism if the dwelling has been vacant for a period of over 30 days.

Vacant means that there is no one occupying the dwelling and the dwelling is not furnished. A dwelling that is furnished but not occupied temporarily, such as when the owner is on vacation, is not considered vacant.

All of these issues can result in legal disputes between you and your insurance company. The best way to avoid the disputes is to be forewarned. Other than that, you'll need to prove that the exception happened concurrently with a covered direct loss.

The November 1992 Michigan appeals court decision *Tina Cortez v. Fire Insurance Exchange* deals with a nearly textbook case of a replacement cost dispute.

Tina Cortez' home was destroyed by fire. At the time of the fire, Cortez maintained a homeowner's policy with Fire Insurance Exchange. The policy provided benefits of up to $36,000 for loss or damage to her home. Cortez filed a proof of loss, asserting the actual cash value of the dwelling was in excess of $35,000.

Fire Insurance Exchange denied the claim, citing Cortez' failure to submit valid proofs of loss. Shortly thereafter, Fire Insurance Exchange issued a $16,000 check to Cortez' mortgagee. This sum represented Fire Insurance Exchange's assessment of the cash value of the dwelling. Cortez did not contest this valuation.

However, Cortez brought an action under her homeowners policy when Fire Insurance Exchange refused to pay additional funds up to the policy limit of $36,000. Fire Insurance Exchange denied liability for further replacement benefits under the contract absent proof showing Cortez had repaired or rebuilt the dwelling. Cortez claimed inability to repair or rebuild. The trial court held that Cortez' performance under the contract was impossible because, absent cooperation by the insurance company in providing benefits under the contract, Cortez could not afford to either rebuild or repair the dwelling.

So, the trial court awarded her $20,000, the additional property damage coverage provided under the contract. Fire Insurance Exchange appealed.

According to Fire Insurance Exchange, the trial court erred in awarding Cortez $20,000 because the contract of insurance explicitly provides for the additional replacement-cost she had actually repaired or rebuilt the dwelling. The contract reads in pertinent part:

When the cost to repair or replace is more than $1,000 or more than 5 percent of the limit of insurance in this policy on the building, whichever is less, we shall pay no more than the actual cash value of the damage until repair or replacement is completed.

Fire Insurance Exchange claimed that contract provisions limiting an insurance company's liability to pay replacement cost only in the event the damaged property is actually repaired or rebuilt are expressly authorized by statute. The appeals court agreed:

However, [Michigan insurance code] addresses replacement-cost insurance provisions that require the insurer to provide replacement with "new materials of like size, kind and quality." The contract of insurance at issue in this case provides for replacement cost for "equivalent construction."

So, Fire Insurance Exchange was required to rebuild or replace the lost or damaged property "to a condition and appearance similar to that which existed at the time of loss based on the use of conventional materials and construction methods."

The Michigan insurance code provided, in part:

An insurer may issue a fire policy, insuring property, by which the insurer agrees to reimburse and indemnify the insured for the difference between the actual cash value of the lost or damaged insured property at the time of the loss or damage, and the amount actually necessary to repair, rebuild, or replace the lost or damaged insured property to a condition and appearance similar to that which existed at the time of the loss or damage based on the use of conventional materials and construction methods which are currently available without extraordinary expense. The insurer's liability shall not exceed the amount of liability covered by the contract of insurance.

The Michigan Code contained a subsection limiting an insurance company's ability to withhold replacement-cost benefits until repairs have been made where the amount of the loss or damage to the insured property exceeds the amount of liability covered by the contract.

The appeals court concluded:

There is no dispute in this case that the replacement cost of Cortez' damaged property exceeds the $36,000 contract liability. Therefore, pursuant to s 2827(3), Fire Insurance Exchange was not authorized to withhold her replacement-cost benefits on the bases that she had not actually repaired or replaced the property.

The Court of Appeals held that the policy was subject to the statute that covers replacement cost policies that require an insurance company to rebuild or replace the damaged property to a condition and appearance similar to that which existed at the time of loss and, therefore, under that statute, the insurance company was required to pay insured's benefits even though insured had not yet actually repaired or replaced the property.

Other Structure Issues

Most local building codes contain provisions relating to the demolition and rebuilding of a damaged building. These can require an older house to be repaired up to code—that is, to modern building standards. A standard homeowners policy will only cover the addition cost of building up to code if you pay an additional premium.

> **Example: If your vintage 1920s villa is partially damaged in a covered loss, local laws may require an upgrading of the electrical or plumbing systems. This may mean the use of costlier building materials or methods. The increased costs for the repairs aren't usually covered by a basic policy.**

The best way to avoid this problem: If you have an older home, buy addition coverage.

Finally, a number of conditions can cause damage to a dwelling but are not covered since they are caused by ordinary or excepted conditions. A few of these conditions are:

- wear and tear, marring, and deterioration come under depreciation due to age and are not covered;

- inherent vice is the ability of something to destroy or damage itself without the intervention of outside help;

> **Example: Milk will sour in a sealed container and under refrigeration due to bacteria contained in the milk. Rusting of metal is not inherent vice since it is the product of a ferrous metal being exposed to air.**

- rust, mold, dry rot, and wet rot are the result of property being exposed to harmful conditions over a period of time and can result from lack of, or improper, maintenance and therefore are not the property subject of coverage;

- industrial smoke, agricultural smudging or smog can certainly damage property over a period of time but, if coverage were provided for these maintenance losses, many homeowners would never have to pay for having their homes painted;

- settling, cracking or bulging of pavement, foundation, walls, floors or ceilings are also considered maintenance losses;

- damage caused by birds, vermin, insects, rodents, or domestic animals is not covered.

(An important element of the vermin and insect exclusion is damage caused by termites. This isn't covered. That's one reason why it's important to control pests in any house you own.)

Personal Property Issues

Specific types of personal property—and not always the types you would expect—may cause lots of coverage disputes between you and your insurance company. The following are a few illustrative examples of these kinds of property and the disputes they cause.

Trees, plants, and shrubs are covered under a standard policy only against a few named perils—and only if they are on the residence premises. There is a per loss limit and a per item limit. The per loss limit is 5 percent of the amount of coverage on the dwelling and the per item limit is $500 per tree, plant, or shrub.

You may spend more on plants than you initially figure—and try to make a big claim after a loss. If you do, you may need to consider an endorsement that increases this coverage.

A homeowners policy provides up to $500 coverage for lost or stolen credit cards—even though federal law limits the liability of the card holder to $50 per card. The policy also covers the unauthorized use of the cards.

However, coverage does not apply to the use of the card by a resident of your household, a person who has been entrusted with the card, or the use of the card by any person if you have not complied with the terms and conditions of the card—such as exceeding the credit limit of the card.

Similar coverage is provided for bank cards used with automatic teller machines that are taken from the home. Check forgery or forgery of any negotiable instrument is covered under this provision. This can be an important issue if thieves steal blank checks from your house.

If you have credit card theft or check forgery problems involving members of your household, you can't make claims on your homeowners policy. Some people try this—but they aren't usually successful. If you suspect problems with family members, limit access to your financial instruments and have systems in place for canceling cards and checks if necessary.

Other provisions in a homeowners policy exclude property losses arising out of business pursuits. As a growing number of people work out of their homes, this is an argument insurance companies are more likely to make. The 1995 New York state appeals court decision *Winona Boggs v. Commercial Mutual Insurance Company et al.* dealt with one insurance company's attempt to interpret a residential property as a business use.

In January 1992, Winona Boggs's barn—located behind her residence in trendy/rural Saratoga County—was damaged by a windstorm. Boggs filed a claim for the loss under her homeowner's insurance policy with Commercial Mutual.

Commercial Mutual denied coverage under a portion of the policy which excluded coverage for "structures designed or used for business."

The policy defined a "business" as "a trade, profession, or other occupation... all whether full or part time." The policy did not define "designed" or "used."

Boggs sued, arguing breach of contract against both Commercial Mutual and the Cote Agency, Inc.—which had sold her the policy. She also claimed negligence on the part of Cote, based on its failure to provide her with adequate insurance coverage.

Following the initial rounds of discovery, the Cote Agency asked the court to dismiss the charges against it on the basis that Commercial Mutual had improperly denied coverage.

Commercial Mutual argued that the term "designed" referred solely to the original purpose for which a structure was constructed. Boggs had admitted in trial testimony that the barn had been built in 1948 for the specific purpose of storing lumber, which was to be sold to a paper company. Therefore, Commercial Mutual concluded, it didn't have to cover the barn—no matter how Boggs had used it.

The trial court agreed with this argument, concluding that the barn had been "designed or used for business" within the meaning of the policy. It ruled that the exclusion was clear, and that the insurance company was free of liability. The insurance agency, on the other hand, was liable for the damages to Boggs's barn.

Cote appealed, arguing that the insurance company was at fault because its policy language about business use could reasonably be interpreted in more than one way.

The appeals agreed with Cote:

> We conclude that the clause "designed or used for business" is
> ambiguous.... Where there is ambiguity, it is the insurer's bur-

den to prove that the construction it advances is not only reasonable, but also that it is the only fair construction of the language. It must also be kept in mind as to how the clause will be interpreted by the "average [person] on the street." ...No such clarity of meaning is evident from the exclusion clause at issue. It cannot be said that proposed insureds, in reading the language, would not think themselves covered against the loss that did, in fact, occur.

In other words, an average person reading the policy could reasonably interpret the words "designed or used for business" as referring to the structure's design or use during the insurance policy's effective period.

In the Boggs case, the commercial use of the barn had ended by 1957. The policy was not issued until 1991. Therefore:

It would have been reasonable for plaintiff to have assumed that because the barn was no longer used for a commercial purpose and since it had not been designed for such use during the policy's effective period, that the exclusion did not apply. We also note that the policy's failure to define the terms "design" or "use" gives rise to an ambiguity that must be construed in the insured's favor.

Because there was a reasonable interpretation of the exclusionary clause different than the one advanced by Commercial Mutual, it had failed to sustain its burden of proof. The trial court should not have issued a judgment in the company's favor. And, finally, the appeals court made the suggestion insurance companies hate to hear:

If Commercial Mutual intended to exclude coverage for structures designed for a business purpose at the time they were built, it should have done so in clear and unambiguous language.

The appeals court sent the whole case back to the lower court, with instructions to modify its ruling. Commercial Mutual quickly settled with Boggs.

Memberships

Common coverage problems also arise from membership in homeowners or community associations.

Loss assessments against individual members of property owners associations are not usually made unless the insurance covering the collectively

owned property (e.g., the clubhouse, other outbuildings) does not cover the loss involved or is not in sufficient amount to entirely cover the loss.

When this occurs, assessments can be made if the bylaws of the organization allow them. If this is the case, the policy will pay up to $1,000 per loss.

A caveat: Loss assessments against members for liability claims made against the association are covered separately under the liability sections of the homeowners policy.

A standard homeowners policy will cover your property that is kept in a separate apartment on the residence premises that is rented out on a regular basis. However, property in a rented apartment off the premises is excluded.

General Exclusions and Other Issues

The general exclusions to a standard homeowners or dwelling policy limit coverage for the perils of ordinances or laws, earthquake, flood, power interruption, neglect, war and—in a reference to the days of the Cold War—nuclear hazards.

These exclusions cause many disputes between policy owners and insurance companies—especially when the company interprets a claim as based on an excluded peril and the policy owner sees it as something else.

A complicated note: An excluded loss which is caused by a covered peril is covered.

Example: You're away from home for a week of skiing, but you maintain the radiant heating in your home while you're away. Squirrels eat the insulation around the electrical wiring, which causes a short circuit cutting off the electricity. As a result, the plumbing system freezes and bursts in several places, causing severe water damage. While the damage by rodents would not be covered, the resulting damage by water would be covered—because you had complied with the requirement to maintain heat in the building while it was unoccupied. The water damage was an ensuing loss.

There is no coverage for damage to the contents of a dwelling or other structure by rain, hail, sleet, sand, or dust unless the dwelling first is damaged by wind or hail allowing rain or dust to enter the building and damage the contents. A simple leaking roof due to wear and tear is not covered.

Likewise, coverage on personal property within a structure is provided with the condition that the roof or a wall of the structure is damaged first by a falling object.

Example: If a utility pole falls on your house, smashes through the roof and destroys your brass bed, the bed is covered.

Severe storms can cause the accumulation of the various forms of frozen water on a roof and the weight will eventually become so great that the roof will collapse. If this causes damage to the contents, those contents would be covered.

The disputes that arise from these sequential loss scenarios usually center on the insurance company not believing that the loss occurred sequentially, as described. Primary evidence of the loss—such as videotapes or photographs—can substantiate this kind of claim. An affidavit from a neighbor who saw what happened—or any other witness—will also help.

There is no coverage at another residence owned, rented to, or occupied by you unless you are temporarily residing there. So, coverage doesn't apply to your summer house unless you're staying there.

If you are tempted to bend the truth in claiming you were living in a second home when a loss occurred. You may want to rethink your motives. Like other misleading statements, this kind of thing can cause more trouble than the coverage it allows. In most cases, it makes more sense to buy a basic dwelling policy for your second home.

Coverage is provided for a student away from home if the student has occupied the premises at any time 45 days prior to the loss. Anecdotally, many people seem to claim they meet this requirement—that the student who's suffered a loss has been home recently—even when they don't. Anecdotally, they seem to get away with claiming this.

There is no theft coverage for boats, their equipment or furnishings, or outboard motors while away from the premises.

There is coverage for other personal property, such as clothing, if stolen from a boat.

Trailers and campers are, likewise, not covered for theft while away from the residence premises.

The disputes that usually follow from these claims turn on the issue of where your boat or trailer was when a loss occurred. Location can be difficult to establish—which usually works to your advantage. Unless the insurance company can prove the property wasn't on premises, it will probably have to pay the claim.

Claims related to the accidental discharge or overflow of water or steam from appliances can cause some problems.

These claims are covered under a standard policy—with the following exceptions:

- the drain of a washing machine malfunctions causing an overflow of water—the damage done by the overflow to personal property is covered but there is no coverage for repairing the washing machine;

- several rooms of a dwelling are closed off during the winter to conserve heat and the lack of heat in these rooms causes a pipe to freeze and rupture—there is no coverage for the ensuing water damage;

- a pipe on the side of your neighbor's house bursts and water flows into your basement recreation room, damaging the contents—there is no coverage.

Some adjusters—especially in the Northeast and Midwest—pride themselves on ferreting out abuses of water damage in houses. You are most likely to have a problem with this kind of claim only if you end up drawing one of these adjusters.

Several other causes of water damage are also not covered by the standard policy. These include:

- natural accumulations of water on the ground, overflow of natural bodies of water, or waves;

- backing up of sewers or drains in the result of an overload of the sewage or drainage system, or the blockage of such systems; and

- water which percolates or seeps underground and usually involves damage to property below ground level or structures on the ground such as sidewalks and driveways or concrete slabs.

If a direct loss by fire, explosion, or theft occurs because of water damage losses, coverage is provided. So, if a backed-up sewer causes an electrical relay station in your neighborhood to explode and your house catches fire as a result...you're covered.

The standard homeowners policy excludes coverage for damage caused by earth movement—which includes earthquakes, land shock waves and tremors. It also excludes coverage for volcanic eruption.

Volcanic eruption is not defined in the policy as clearly as earth movement is. However, the two perils share many characteristics.

In the Mount St. Helens eruption, several things happened: The explosion created airborne shock waves and land shock waves; there were various tremors; and huge amounts of dust were blown into the air which settled over vast areas causing damage and creating clean-up situations.

Earth movement can occur in a number of ways, such as an earthquake, mine subsidence, sinkholes, or the collapse of a palisade. This peril is excluded except for resulting direct loss by fire, explosion, theft, or breakage of glass. And this exclusion holds up in most disputes.

The purpose of the war exclusion is to remove from the policy even the most tenuous possibility of coverage for any loss due to warlike activity or its consequences.

However, the related exclusion of terrorist action—which has begun to appear in most policies in recent years—may cause a growing number of disputes in the future.

Unfortunately, if terrorist attacks become more common in the United States, companies will probably expand their exclusionary language for this risk. As a policy owner concerned about this risk, your only choice will be to pay more for additional coverage.

> **A final note: If losses resulting from the general exclusions occur with perils that are covered under the policy—either together at the same time or in a prior or later sequence—there will be no coverage.**

If an earthquake causes pipes to burst and cause water damage to the furniture in your living room, you're not going to have an easy time making a claim. Although water damage is ordinarily a covered peril, because it occurs in connection with earthquake (a general exclusion), it is not covered.

Fires That Don't Burn the House to the Ground

Whatever the damage, filing an insurance claim can be stressful. Not to mention your vulnerability in the adrenaline-infused chaos that follows a loss resulting from something like a house fire. And the amount of help that an insurance company provides to its customers varies widely.

"For most people, it's an unusual event, so they're intimidated and nervous," said J. Robert Hunter, director of insurance for the Consumer Federation of America. "But don't assume that you'll have a hard time with a claim," Hunter said. "Some companies are really concerned about helping their policyholders. Some others say, `It's your problem.'"

> **Don't be surprised if you are approached by a number of people, clipboards in hand, wanting you to sign up for their services—to board up the windows, to clean up after the fire, or to replace the kitchen cabinets or anything else destroyed by the fire or the firefighters—that may not be needed or covered under your policy.**

Call your insurance company before you sign anything and, even then, be careful what you sign. A policyholder whose house was badly damaged by the Loma Prieta earthquake was presented a check for more than $300,000 by her insurance company. She noticed fine print to the effect that endorsing the check would be accepting her claim was paid in full. She didn't sign, and the insurance company ended up paying nearly double the amount to repair her three-flat home.

Don't let your insurance company's contractor, returning with an estimate for replacing the kitchen the way it had been that's been authorized by the company, tell you that the sooner you sign the sooner you'd be back making pancakes and waffles in your kitchen.

Why? Despite your insurance company's warranty for the work of the contractor it sent out, you can choose your own contractor and make changes to your house that you've thought about for a while. As long as your changes are within the limits of your insurance company's appraisal, the company will pay the bills.

Don't sign any a waiver of "the three-day right to cancel." (Most state laws mandate that a consumer who signs a contract on his own property has three days—or some similar period—in which to change his or her mind.)

Here are some steps that you can take to minimize problems.

- Are there things you can do to prepare in advance for a claim? One way to expedite the claim process is to have a detailed inventory of your belongings, ranging from appliances and furniture to clothing and jewelry. It helps to have photos or a videotape of what each room looked like before anything was damaged. It's also a good idea to set aside the number of your homeowners policy and the phone numbers of your agent and insurance company.

- When should you make your claim? Don't wait. Even if the damage appears modest, your claim will give an insurance company some idea of how many policyholders are likely to file claims.

- How quickly will a claims adjuster come to your house? Under normal conditions, insurance companies try to have adjusters inspect damage the same day they are notified. Depending on the severity of a storm and the extent of damage, it can take days rather than hours. That's partly because insurance companies try to tackle the more serious claims, such as the loss of a roof, first.

- How much repair work should you do immediately after a storm? Just enough to protect your home and belongings.

- What information should you have when reporting a claim? It helps to have the policy number, but the most important information is the extent of the damage. "Often, we have people call and say, `I have a little leak in the corner of my living room,' " said Mary Beth Cramer, a spokeswoman for State Farm. "They haven't gone up to see what kind of damage there might be in the attic," which could be considerable.

- What if you discover additional damage after you've settled a claim? Contact your agent or insurance company. "A claim can always be revisited," said State Farm's Cramer. "It's a pretty simple thing to write another check."

- What if you have a dispute with the claims adjuster over the amount of damage you've suffered? Talk to your agent and then to the company. Most insurance companies have systems for resolving disputes. It helps to keep brief notes at every stage of the claims process. When there's a dispute, "about half of the claims can be settled if they see you are serious and not asking for an unreasonable amount," said Robert Hunter of the Consumer Federation of America. If you don't get sufficient help, write to the insurance company's management and then to state insurance regulators.

Insurers and agents caution against having a contractor make permanent repairs before you talk with an adjuster. "Our concern is that you will do permanent repairs that aren't covered by the policy and you thought were

covered," said Cramer of State Farm. Insurers and agents also warn of unscrupulous contractors who frequently descend on areas that have widespread damage from hurricanes, tornadoes and other calamities. Too often, these contractors demand large down payments and then do shoddy or incomplete work, said Michael Erwin, a spokesman for the Insurance Information Institute.

Planning pays off. You can't stop a tornado or a winter storm, but you can start now to lay the groundwork for a smooth claims process if disaster does strike. The most important thing you can to do is keep a detailed, up-to-date home inventory stored in a safe place away from home. You can create one by listing the contents of your home on paper. It's even better to accompany the list with photos of the home and each room, or a video. Be sure to include the contents of closets and drawers.

There are two reasons for the inventory:

- If your home is destroyed, it will help you make sure you don't forget items when submitting a claim.

- It will help document your loss to the insurance company. You can tell your company you had a collection of hundreds of jazz and classical CDs. But they may dispute that. Your case is stronger if you can show them a photo of the collection.

For some special items, a photo may not be enough. For example, it's hard to tell from a picture whether a piece of furniture is an antique or a reproduction. So if you own antiques or expensive works of art, you should keep a record of the purchase and an appraisal attached to your inventory, says Robert Hunter, director of insurance for the Consumer Federation of America. Especially valuable pieces may also require a special rider on your insurance policy. Talk to your agent if you have questions about that.

Know what's insured, and what isn't. You also should make sure your home and contents are insured for replacement value.

And you should familiarize yourself with what your policy covers and what it excludes. For example, most homeowners insurance policies will cover water damage caused by a burst pipe. But they will not cover damage caused by water that seeps into your basement from the ground.

So if you live in a low-lying area near a river or stream, you should consider separate flood insurance. You can buy flood insurance as long as your community participates in the National Flood Insurance Program.

But some natural disasters, such as recent landslides in California—in which the land under a house shifts—are not covered by flood insurance or by most homeowners insurance.

When a catastrophe occurs, your first reaction may be to start cleaning up debris and putting what's left of your home in order. But that's a mistake. "Don't disturb anything until after the insurance adjuster sees the damage," says Jeanne Salvatore of the Insurance Information Institute, an industry-funded educational service.

There are two exceptions. You should take any steps necessary to protect yourself and your family. And your policy obligates you to take temporary steps to prevent any additional damage to your home.

For example, if a window blows out, you should try to board it up or cover it with plastic so rain or snow doesn't continue to leak into your home. If you don't, the insurance company can refuse to pay for any damage that stems from your failure to act.

But before making temporary repairs, you should take photos of the damage. Remember that you are building a case, and that is part of your evidence.

Keep a diary. One of the most important tools is a diary. As soon as you contact your agent to report a claim, you should begin to keep a detailed written record. It should include the names of everyone you talk to about your claim, the dates and summaries of the conversation.

If you call contractors for estimates, take notes. When the insurance company sends an adjuster, write down his name, phone number and anything he tells you.

If you spend money on repairs, keep copies of receipts so you can get reimbursed. If your home is so damaged that you can't safely stay in it, your insurance company usually will pay for some temporary living expenses.

The August 1996 Alabama state appeals court decision *National Security Fire and Casualty Company v. Tommy and Terri Coshatt* considered a dispute of a fairly egregious denial.

In 1993, Tommy Coshatt and his wife Terri bought a homeowner's insurance policy from National Security Fire and Casualty Company. On March 23, 1993, a snowstorm damaged the Coshatts' home; and they sought payment under their policy. The Coshatts contacted their National Security agent, Jack Barber, within two days of the storm and Barber advised them to make any necessary repairs.

The damage was repaired on March 18 and 19, 1993.

In May 1993, National Security hired independent adjustor James Keat to adjust the claim. Keat inspected the repairs, and recommended payment of the Coshatts' claim. However, the Coshatts' claim was denied on June 22,

1993, because the company claimed they did not allow National Security to investigate the cause and extent of the loss.

The Coshatts sued National Security, claiming breach of contract and bad faith refusal to pay. At trial, the court granted the Coshatts' motion for a directed verdict on the breach of contract claim and submitted the case to the jury for determination of the amount of contract damages and a verdict on the bad faith claim. The jury returned a verdict for the Coshatts , awarding them $1,600 as damages for the breach of contract and $30,000 as punitive damages on the bad faith claim.

National Security appealed, claiming that the trial court's decision on the breach of contract claim was wrong because:

1) a question of fact existed as to whether the Coshatts permitted National Security to view the damage before making repairs, and

2) a question of fact existed as to whether the Coshatts presented National Security with false statements about the repairs.

According to National Security, the Coshatts did not give proper notice to allow the company to inspect the property before the damage was repaired. However, evidence established that the Coshatts had notified Barber of the damage at least four days before the repairs began.

And, according to Alabama statute, notice to a company's agent is notice to the company.

National Security presented no rebuttal to agent Barber's testimony that he was notified in a timely manner and that he had authorized the repairs. In addition, National Security had no evidence that the Coshatts ever impeded its efforts to examine the property. In fact, both Barber and Keat, the independent adjuster, were permitted complete access to the property.

National Security also argued that it had properly denied coverage because the Coshatts submitted a false claim. Their repair bill was based on an estimate that included costs for touch-up painting that had not been completed at the time of submission.

The court didn't buy this argument. It ruled:

> ...the fraud forfeiture language in the policy would allow National Security to deny coverage only in the event it shows that the Coshatts "intentionally misrepresented" a "material fact" in their claim. At most, the evidence [of] the "false claim" was an inaccurate repair bill. However, testimony by the repairman revealed that all such work was eventually performed.
>
> ...there is no substantial evidence that the Coshatts intentionally misrepresented their claim.

National Security also argued that the trial court had erred in submitting the Coshatts' bad faith claim to the jury because the Coshatts were not entitled to a directed verdict on their breach of contract claim.

According to the court, this argument had no merit because a number of facts supported the inference that National Security knew it had no legitimate basis for denying the Coshatts' claim.

The court wrote:

> National Security knew, through Barber, of the claim within two days of the damage, and National Security authorized repairs before it undertook any inspection. When an independent adjusting firm inspected the property and repairs, it recommended that National Security pay the claim. National Security "lost" its telephone records concerning Barber's and the Coshatts' communications with its home office; it also "lost" the recording of the conversation between the adjuster and Mrs. Coshatt. National Security never raised any discrepancies in the claim with the Coshatts, the repairman, Barber, or the adjuster before it denied coverage. After the Coshatts asserted their bad faith claim, National Security came up with the "false claim" argument as a basis for its denial of coverage.

This was all pretty sleazy. And, the court ruled, the trial court properly submitted the Coshatts' bad faith claim to the jury.

The Coshatts had also appealed the court's decision, hoping to increase their damage award. They argued that the trial court committed reversible error by refusing to admit their evidence of similar denials of coverage as "pattern and practice" evidence of bad faith on National Security's part.

According to the court, the Coshatts made no specific offer of proof to establish exactly what they sought to admit. And, the appeals court noted, case law involving pattern and practice evidence shows that there is no abuse of discretion by a trial court in refusing to admit evidence in a case.

In all regards, the judgment of the trial court was affirmed.

One of the appeals court judges did write a dissent, though. And—as is often the case—the dissent raises some useful points to consider on how the denial of an insurance claim might work.

The dissent offers insurance companies the kind of legalisms they can use in justifying a denial:

> The record indicates factual disputes regarding whether National Security received notification of the claim before the damage was repaired and whether anyone from National Se-

curity authorized the repairs. Additionally, there are factual disputes as to whether the Coshatts breached their obligations under the policy to allow National Security to inspect the damage before it was repaired.

Conclusion

The possibilities are endless for problems that occur in a homeowners policy or claim. Hopefully, we've given you enough information to avoid not only the problems we mentioned, but also to distinguish and avoid other common grounds for dispute.

Knowing how to approach a claim and an insurance company's reaction is key to avoiding misperceptions and confusion that arise in a dispute.

A smart way to avoid these problems is to read the policies closely when determining what homeowners insurance to purchase.

Chapter 7

Homeowners Liability and Related Claims

One of the most important reasons that people buy homeowners insurance is for the liability coverage that it provides. This coverage applies to situations in which people—not in your household—lose something or are injured while on your property.

But it also applies to just about any non-business liability that can crop up in the course of your life: your dog bites a neighbor, you are accused in a civil lawsuit of assaulting a pushy in-law, your six-year-old son is sued—again, in civil court—for sexually harassing one of his classmates.

When it comes to risks like these, "your" claim isn't really at stake. But you will surely have an interest in your insurance company paying as required (often, this includes legal defense costs).

So, liability claims are important.

Third-Party Medical Payments

Medical payments paid by your insurance company to third parties injured while on your premises are voluntary and are not to be construed as admitting liability should the injured party bring suit at a later date.

The insurance company can't be joined in a lawsuit against you by an injured third party, since the company is not involved in the occurrence which results in a suit. Furthermore, the company has no obligation to make any payment under liability until a final judgment has been rendered or the company has agreed to settlement of the claim.

> If you become bankrupt or insolvent, the company remains obliged to provide coverage and to respond to the terms and conditions of the policy.

Your homeowners policy may include the following language: "With respect to the personal liability coverage, this policy is excess over any other valid and collectible insurance."

The practical application of this clause varies, depending on the other insurance. Duplication of coverage often ends up with both insurance companies contributing to payment of a loss.

The other insurance clause doesn't apply to so-called true excess liability insurance—like standard umbrella liability policies. Umbrella policies remain a secondary form of insurance to a homeowners policy.

Things You Can Do to Strengthen Claims

Common practices that help support claims:

- keep careful records,

- verify the adjuster's estimate, and

- don't settle for an unfair settlement.

The amount of temporary living expense you can expect usually depends on what you've lost. Policies cover the cost of renting a comparable home or apartment. If you can figure out what the rental value of your home was, that's usually the amount you can get reimbursed for renting another place.

Temporary living allowances will also pay for extraordinary expenses caused by your displacement. These include boarding a pet in a kennel, renting furniture and eating at restaurants while you're living in a hotel or motel.

Insurance companies won't pay ordinary living expenses such as groceries, regular evenings out or ordinary utility bills.

Some insurance companies limit temporary living expense payments either by a dollar amount or a time period. Others limit by both time and dollar amount. Still others have no limitations.

If you are not getting enough payment to cover your temporary living expenses you can request more. But it helps if you're prepared to give reasons.

For instance, you know it's going to cost $3,000 to pay a deposit and the first month's rent on a comparable home. And you can reasonably expect to

spend at least $1,000 replacing enough clothing, shoes and personal items to get by for a few months.

> If you're in a crunch for rebuilding money, you may disregard any replacement cost loss settlement provisions and make a claim under the policy for loss or damage to buildings on an actual cash value basis (the ACV will usually be a lower amount). You can then make a claim within 180 days after loss for any additional losses according to the replacement cost provisions.

Consider one example: Your house is severely damaged in a covered accident. You plan to rebuild, but you're going to use a different floor plan. You can collect the actual cash value amount after the loss. Once you've decided exactly what the rebuilding will involve, you can collect additional amounts on the basis of replacement cost so long as a claim is made within 180 days of the date of loss.

Liability Coverage Disputes

A man accused of beating his wife should not expect his homeowners' insurance to cover him if she sues for damages.

That was the ruling that a state appeals court handed down in March 1997 in a quirky test case establishing precedent in a developing area of the law called "marital torts."

The ruling arises from the divorce of Joann and Peter Coppola, a Morris County couple married for 25 years.

As part of their divorce settlement, Peter Coppola agreed to pay $20,000 to his ex-wife to settle claims that he abused her physically and psychologically.

Under New Jersey law, when people file for divorce, they also may seek money damages as compensation for abuse they allegedly endured. Such claims are called "marital torts," an area of the law that allows one spouse to sue another for injuries sustained during a marriage. It was that kind of claim that Joann Coppola raised against her former husband, with whom she lived in the Lake Hiawatha section of Parsippany for most of the marriage.

Rather than challenge the charges in court, Peter Coppola paid the money and then sought to recoup the $20,000 from his homeowners' insurance company, Merrimack Mutual Fire Insurance Co. He sought the money from the insurance on a second home in Caldwell.

> **Essentially, the husband asserted that he never intended to harm his wife and that any injuries he caused were accidental. Often, homeowners' insurance policies cover accidental or negligent injuries caused by the homeowner.**

Rejecting his claims, the court said that when it comes to spousal abuse, "any form is so inherently injurious that it can never be an accident."

In a decision written by Judge John E. Keefe, the court said, "Given the fact that our Supreme Court has recognized the seriousness of spousal abuse, and has even considered the problem of domestic violence to be a 'national epidemic,' allowing spouse abusers insurance coverage for their intentional abuse, whether it be physical or emotional, would contravene the public policy clearly enunciated by our Supreme Court, and the intent of the Legislature in its enactment of the Prevention of Domestic Abuse Act."

Appellate Division Judges Michael King and Erminie Conley joined Keefe in the unanimous ruling.

Reacting to the decision, New Jersey lawyer Karl Fenske, who represents the former husband, emphatically denied that Peter Coppola abused his wife and called the ruling "a bad decision." He said he would talk to his client about asking the state Supreme Court to review the decision. There is no automatic right of appeal because the ruling was unanimous.

"This is not your classic wife-beater case," Fenske said, maintaining that the disagreements between the two were not violent.

The appeals court decision quotes Peter Coppola as admitting that arguments between the two "boiled over into pushing and shoving, hair-pulling, scratching and the like."

The court decision said the wife alleged 29 instances of physical and emotional abuse against her and their children. She also alleged that on Dec. 30, 1989, things escalated to the point where she contacted a battered women's service, which called the police.

In January 1990, a family court judge entered a mutual in-house restraint order, forbidding harassing and violent activities between the two. In March 1990, there were two more incidents, which included what the court called "menacing behavior with a knife" and the kicking of Joann Coppola's bedroom door.

Peter Coppola said he did not intend to cause his wife to develop post-traumatic stress syndrome or battered women's syndrome, which she alleged she suffered.

Robert Colquhoun, the lawyer for the insurance company, did not return telephone calls yesterday. The ex-wife, a dental hygienist, did not participate in this stage of the case, because the dispute is between Peter Coppola, who works in the shipping business, and his insurance company.

Richard Pliskin, a spokesman for the judiciary, said he did not have any data on the number of spousal abuse cases filed each year but that the concept was first recognized in New Jersey in 1978.

Last year the law was expanded when the state Supreme Court, in *Brennan v. Orban*, ruled that victims of spousal battery could seek jury trials. Since then, a great deal of interest has developed in how this area of law will develop and whether allowing jury trials will change divorce law or curb spousal abuse.

Intentional Acts

Insurance groups are poised to support new rules aimed at protecting innocent victims of deliberate acts.

Safeco Insurance Co.'s 1997 settlement with a policyholder over a domestic abuse claim is a signal that a long-running battle between property/casualty insurance companies and state regulators may be coming to an end.

A week after the Seattle-based company and Kittis Bolduc of Kent, Wash., announced they'd reached an out-of-court settlement, a subcommittee of the National Association of Insurance Commissioners passed a model law that prohibits unfair discrimination against domestic abuse victims in property/casualty underwriting.

The Market Conduct and Consumer Affairs Subcommittee passed the model on a voice vote at the winter national meeting, sending it to the NAIC Executive Committee for action in March at the spring meeting in Salt Lake City. The vote occurred right in Seattle, where the NAIC was holding its winter annual meeting and where Washington Insurance Commissioner Deborah Senn has been hammering insurance companies for years over the domestic abuse issue.

Senn headed the working group that pushed the model law for over a year. Senn, an elected commissioner who runs a media-conscious, pro-consumer department, was involved in getting Safeco and Bolduc to reach an agreement.

Industry representatives appear resigned to the fact that the NAIC will approve some version of the model. The NAIC already has similar model

laws on its books that prohibit discrimination of abuse victims involving health, life, and disability insurance. Model laws may be adopted in full, in part, or not at all by state legislatures.

Property/casualty companies and trade groups haven't given up entirely on the issue. As with all legislation, the devil is in the details, and industry lobbyists are seeking to narrow the language in the act. Lenore Marema, vice president of the Alliance of American Insurers, argues that the model "defines victims of abuse so broadly that it could cover mental cruelty or even rudeness." This sort of vague language, she says, "will lead to confusion and litigation, rather than to protection for actual victims."

> **The property/casualty model act requires an insurance company to pay claims to an innocent abuse victim for intentional property damage caused by a third party even though the victim was a co-insured on the homeowner policy. In doing so, the act overturns the industry's long-standing practice—backed by the courts—of not paying claims to any policyholder for any intentionally destructive act.**

Pamela Young, assistant general counsel of the American Insurance Association, said in a letter to the NAIC that "many claims may be paid, not because the co-insured is innocent, but because the insurance company cannot prove otherwise."

In Bolduc's case, she claimed abuse by her ex-husband who intentionally burned down their home during their divorce dispute Safeco refused to pay her claim and a state court agreed with the company, based on the exclusion in the policy that denied payment to co-insureds for any intentional act. But Safeco's denial garnered intense negative media coverage for the company. Senn criticized Safeco, saying that Bolduc was being victimized twice, first by her husband and then by Safeco.

Terry Fromson, managing attorney for the Women's Law Project, based in Philadelphia, says new laws are needed, not only to compensate innocent victims, but also to end an insurance industry underwriting practice that "undermines the public policy of ending domestic violence and abuse."

A different conflict involving the clash of social problems and insurance industry practices came up earlier last year. How it was resolved has similarities to the domestic abuse issue.

The recent battle was between major property/casualty companies and national housing groups over alleged insurance redlining.

In those cases, Allstate Insurance Group and State Farm Group agreed to change their underwriting criteria as part of negotiated settlements with consumer organizations that had filed federal complaints. Allstate hired one of the groups, the National Fair Housing Alliance, to serve as a consultant.

When leading companies change fundamental business practices, as Allstate and State Farm agreed to do, the rest of the industry eventually would go along. For purely competitive reasons, if nothing else, companies can't afford to be perceived as anti-customer.

Similarly, in agreeing to pay Bolduc's claim, even though it had won in court, Safeco said it was changing its underwriting criteria and would even support passage of a bill in the Washington Legislature to protect innocent abuse victims who were not complicit in intentional acts.

Basil Badley, Washington counsel for the American Insurance Association, said his organization was looking to accomplish the same social goal, but without focusing solely on domestic abuse victims.

"We'd like to see legislation that would protect any person who is an innocent insured, an abuse victim or otherwise, when there is evidence of an intentional act or fraud," said Badley. "We think that has a pretty good shot at being passed."

Innocent Spouse Doctrine

In December 1987, Washington-based Safeco Insurance agreed to settle a coverage dispute involving a claim filed by a homeowner whose ex-husband allegedly abused her and intentionally set fire to her home.

The confidential settlement ends a long legal fight in which Safeco had sought to deny the claim of Kittis Bolduc, of Kent, Wash., because of exclusions written into her policy for losses caused by co-insureds and intentional acts. Although divorced at the fume, Ms. Bolduc's ex-husband technically still was a co-insured.

Patricia Hillis, a Safeco representative, said the dispute had to be settled outside the contract because a court had upheld its denial of the claim based on the co-insured and intentional acts exclusions.

Hillis explained that Safeco pressed the dispute in the courts in order to clarify whether the policies offered coverage in cases involving domestic violence, but was uncomfortable with the result.

She said Safeco currently is trying to find language to protect innocent co-insureds in cases involving domestic violence, and itself, from fraud.

During the announcement of the settlement in the Office of Insurance Commissioner Deborah Senn, Bolduc said "I am relieved that my children and I can finally get back to living our version of the American dream....With this settlement, Safeco has given us the means to get our life back on track," she added.

For her part, Commissioner Senn commended Safeco for stepping up to the plate and settling the case. "Safeco has been a leader on women's issues. It is appropriate that Safeco has now agreed to honor its policy with Kittis and help her get her family back on their feet," she said.

Senn also announced that Safeco has informed her office that it has committed to working on passage of state legislation to prohibit discrimination against victims of domestic abuse.

> **Until that point, Safeco had opposed the state legislation that among other things would ban the co-insured and intentional acts loss exclusions language in cases of domestic abuse.**

"It is clear that the public exposure of Kittis' case has moved this issue forward," Senn said. "After four years of trying to pass this bill, we are encouraged that victims, advocates, legislators and officials, and, now, insurance companies, will be standing together to make insurance discrimination illegal in our state," she said.

That legislation, which had languished through three sessions of the state legislature, appeared to be gaining momentum, according to Jim Stevenson, a representative for Senn.

He said although insurance companies have been uniformly against the bill, which would ban all forms of unfair discrimination against victims of domestic abuse by insurance companies in all lines, lawmakers previously opposed to the bill have started lining up in support of it.

Both Bolduc and Senn were joined during the announcement of the settlement by Senator Patty Murray, who introduced a federal anti-discrimination bill—the Victims of Abuse Insurance Protection Act of 1997.

"My office has been contacted by a number of women who report similar treatment by their insurance companies," said Murray. "I was informed by an insurance agent who visited my D.C. office that she had been instructed to deny policies to any women whose medical records revealed a history of abuse. This pattern of discrimination is the insurance industry's dirty little secret," she added.

In addition to the pending Washington and federal legislative efforts, Senn has led the National Association of Insurance Commissioners effort to draft a model

law to deal with the problem of unfair discrimination against victims of domestic abuse by insurance companies.

The model, which could be adopted by state legislatures, would bar insurance companies from the following practices in cases involving domestic abuse: refilling to Issue, renew or re-issue insurance policies: canceling or otherwise terminating coverage; restricting or excluding coverage; or adding a premium differential to a property or casualty insurance policy on the basis of the abuse status of the applicant or insured person.

It also would bar companies from using the co-insured and intentional acts exclusions to deny claims in cases involving alleged domestic abuse.

Chapter 8

Condos, Rentals and Other Specialty Claims

In some cases, your insurance needs may not be as broad as the coverages that the standard homeowners insurance package offers. You may not need liability or personal property insurance—especially if you are insuring a second home or certain kinds of investment real estate. In these situations, you may prefer to buy the more limited but less expensive dwelling insurance.

For example, a common alternative to traditional home ownership—and therefore traditional homeowners insurance needs—is condominium ownership. Young people making their first real estate investment sometimes start with a condominium; on the other hand, many people choose to buy condos as second homes.

The insurance issues that follow from owning a condominium are distinct enough that the insurance industry has created separate policies for this market.

Still, when it comes time to make claim, this specialty coverage has to pay. Because it is less common, payment is sometimes an issue.

In this section, we will look at the insurance policies and coverages that apply to the various other kinds of residences and compare the claims issues that each presents.

Condominiums and Claims

Condominiums are attractive as first investments or second homes because they usually require less day-to-day maintenance than single-family homes.

When you purchase a condo, you buy an apartment and join a condominium association. The association usually maintains the facility—managing the sales of condo units and the upkeep of the building and attached grounds.

When condominiums first became popular in the late 1960s and early 1970s, insurance companies wrote policies for condo associations with wide-ranging coverage because the number of claims were few and far between. Today, things have changed. Lawsuits between condo associations and individual unit owners are more prevalent, forcing insurance companies to define coverage more narrowly to reduce their exposure.

Most condos carry fire and casualty coverage for the association's real property and liability coverage on the common areas of the condominium—as well as for their boards of directors, officers and employees. But if you own—or are thinking of buying—a condominium, your primary interest should be in insuring yourself and your unit. Because condo associations make decisions by committee, they often underinsure liability and other risks, leaving you with little to no coverage when it comes time to file a claim.

D&O liability is an important issue for condo associations. In the event that someone—particularly any of the unit owners—sues the association for failing to perform its duties properly, D&O coverage will cover the losses. However, some condo associations focus on this liability so much that they underinsure other risks, leaving you hanging if a loss occurs.

> **In a condo association, there is individual responsibility or ownership for some parts of the building within the unit (such as fixtures or cabinets). The ownership and insurance responsibilities are defined in the association's Master Deed or Bylaws.**

The HO-6 insurance policy form, which covers co-op and condominium owners, provides coverage for liability and personal property. While insurance purchased by the co-op or condominium association covers much of the actual dwelling, if you want coverage for improvements to your condo, you must write them into a separate policy.

Example: If you add a porch, you'll need an endorsement (an addition to your policy that expands its coverage).

The HO-6 form works best as a layer of insurance above what your condo association has. It automatically provides only a few thousand dollars of building coverage. Otherwise, the HO-6 form is very similar to the HO-4 form, which insures personal property against loss by broad form perils.

The HO-6 form takes into account the facts that:

- condominium owners own only a portion of the building in which their units are located;

- as a member of the association of unit owners, each individual unit owner has shared ownership in the building structure; and

- disputes over shared liability can result in large legal judgments against individual owners.

Often, buyers and owners of other common-interest communities, such as townhouses and cluster homes, have to depend on incorporation articles, by-laws and regulations set by their residents' association. This can leave room for a lot of problems.

For instance, if a fire started by your neighbor damaged your adjoining condo, your neighbor's insurance company might refuse to pay for the damage, claiming that your insurance should pay. The result could be that you and your neighbor, both insurance companies and a couple of attorneys would square off in court.

In most cases, to avoid these problems, condo owners buy insurance to cover the contents of their unit and condominium associations buy coverage on the real property. Still, problems remain. One common problem is that condo policies often don't include broad water damage coverage—for problems like sewer and drain back-up. High-rise buildings also have problems with wind-driven rain—though most associations aren't covered for that.

You buy a thirtieth-floor condo for its excellent views of the resort area where you plan to live a few months each year. You come back to the condo six months later, to find your furniture soaked and the walls covered with mildew. A series of storms, which didn't do much series damage on the ground, caused driving rain to seep through the picture windows in the units several hundred feet up. Unless your condo association has specific coverage for this rain, you may not be insured.

Claims made by underinsured condo owners are a big issue between condo associations and their insurance companies. If problems occur and the association finds it doesn't have adequate coverage for the damage, you could wind up in court with the board of the association for neglecting its fiduciary duty to protect members.

> **In several states, condo associations are required to provide comprehensive or blanket coverage for all members—but many states don't. Condo owners living in buildings that don't have blanket coverage against liability and property damage usually have to provide their own coverage.**

The 1994 California appeals court case *Marina Green Homeowners Association v. State Farm Fire and Casualty Co.* set several precedents relating to condo insurance.

Marina Green was an association formed to manage an 18-unit condominium in San Francisco. In 1986, the association entered into a contract with State Farm for residential property insurance covering the condominium structure. State Farm did not offer Marina Green earthquake coverage at that time.

In January 1988, Marina Green asked State Farm's agent to renew the property insurance and to get a quote for adding earthquake insurance to the policy. The agent told Marina Green that State Farm would not provide earthquake coverage for the condominium.

In October 1989, the condo was severely damaged by an earthquake. The association filed a claim with State Farm for the damage. When its claim was denied, Marina Green asked that the insurance policy be reformed to provide earthquake coverage.

> **Reformation is a process by which an insurance policy is rewritten to add an omitted coverage retroactively. It's an unusual measure, most often happening by court order after a lawsuit.**

State Farm refused, quoting California state law which held that an insurance company had no obligation to offer earthquake coverage "to a condominium association for a building of over four dwelling units."

Marina Green sued State Farm, alleging breach of duty to provide earthquake insurance. The trial court granted summary judgment in favor of State Farm. Marina Green appealed.

On review, the appeals court agreed with the lower court that State Farm did not have a legal duty to offer earthquake insurance. The appeals court went on to write that:

The issue in this case is whether an insurance company owes any duty to a homeowners association, or the members thereof, to provide earthquake insurance covering a condominium structure, as opposed to the airspace comprising each individual condominium unit within that structure.

Each condominium owner in the Marina Green project was the sole owner of a unit and a common owner of the structure. Therefore, the appeals court concluded:

> In specifying that insurance be offered to cover condominium
> units, [the state law] on its face refers to interests in the spaces
> inside the condominium's structure. The further specification

that insurance be offered to cover individually owned units is consistent with the differentiation between that interest which can be owned separately, i.e., units, and that interest which only can be owned jointly, i.e., the structure.

It follows that...the term "policy of residential property insurance" is defined as including a policy covering the interest of an individual in the space of each unit, and presumably in the contents and fixtures, etc. within that space, but not the interest of the joint owners in the structure.

So, Marina Green's assets as a condominium association did not count as a residence—and State Farm did not have to make the earthquake coverage available.

Dwelling Policies

Alternative residential insurance needs include more than just the complex issues raised by condominium associations. In fact, the most common variation on homeowners coverage that most people buy is the group of coverages that insurance companies refer to as dwelling insurance.

This insurance applies to the dwelling structure that is listed in the declarations of your insurance policy—and to all of its attached structures on your property.

> **The main distinction between dwelling and homeowners insurance is that dwelling is more limited. It does not include liability coverage and—sometimes—does not include coverage for personal property.**

A complete dwelling package will usually consist of the following coverage elements:

- a declarations page that identifies specific data, terms and conditions (must be included),

- a dwelling property coverage form (must be included),

- an optional theft coverage endorsement,

- an optional personal liability supplement (personal liability coverage and medical payments to others), and

- various other supplements or endorsements (similar to coverage options under the homeowners program).

> A dwelling policy which includes theft and personal liability coverages is very similar to a standard homeowners policy. Many of the coverages and the basic limits of insurance are identical. However, the appeal of the dwelling package is that it provides the flexibility to include only property coverage.

Dwelling policy forms filed by the Insurance Services Office (ISO) are in use in nearly every state. Standard forms are generally issued and endorsements are used to adjust the coverage where required by law.

Who is an Insured?

Just as in a homeowners policy, an important part of the claims process involved in a dwelling policy is distinguishing who is—and is not—covered under the policy. Generally, because the dwelling package doesn't include liability coverage, its coverage extends to fewer people.

> Insurance on the dwelling and any other structures is provided for the named insured, and for the named insured's spouse if a resident of the same household.

If personal property is insured, you and all members of your family residing at the described location are covered for property which they own or use. However, the personal property of guests and servants may be covered at your request.

If you die, coverage continues for your legal representatives. Until a legal representative is appointed, a temporary custodian of the estate would also be covered.

Three Dwelling Forms

Three dwelling property forms are available to most people in most cases. The different forms provide different degrees of coverage, and the names given to the forms reflect a progressive expansion of both the perils and losses covered. The three forms are:

- the basic form—which insures against the perils of fire, lightning, and (limited forms of) internal explosion (a package of optional coverages can be added for an addition premium);

- the broad form—which insures all of the standard and optional perils available on the basic form and expands several of those; and

- the special form—which insures against any risks which are not excluded.

> **Many insurance companies offer the same three-level variation in their homeowners policies. The basic form—which may not be the first policy the insurance company offers—will usually cost 20 to 30 percent less than the others.**

Dwelling forms include other conditions which are common to property insurance coverages. All three dwelling forms have provisions regarding abandonment, appraisal, assignment, concealment or fraud, legal action, insurance company's option to repair or replace, insured's duties in the event of loss, waivers, mortgagee and subrogation clauses which are similar to those found on other personal and commercial property insurance forms.

If you buy the basic form, you can—and probably should—purchase the extended coverage (EC) and vandalism or malicious mischief (VMM) supplements. The EC package covers damage caused by:

- windstorm or hail (interior damage covered only if wind or hail first makes an opening),

- explosion (a slightly broader term than internal explosion)

- riot or civil commotion,

- aircraft, including self-propelled missiles and spacecraft,

- vehicles (not including vehicle damage to fences, driveways and walks or damage caused by any vehicle owned or operated by the named insured or any household member),

- smoke, meaning sudden and accidental damage from smoke (but not smoke from fireplaces or from agricultural smudging or industrial operations), and

- volcanic eruption other than loss caused by earthquake, land shock waves or tremors.

VMM may be purchased only if EC is purchased. When VMM is covered, it does not cover:

- glass parts of a building other than glass building blocks,

- losses by theft (but building damage caused by a burglar is covered),

- damage by vandals after the building has been vacant for 30 consecutive days or more.

The broad form expands coverage for explosions, vehicle damage and vandalism or malicious mischief. It also adds coverage for the following perils not covered by the basic form:

- damage to covered property caused by burglars, but not theft of property (the basic form only covers building damage by burglars);

- damage caused by falling objects (damage to a building's interior or its contents is covered only if the falling object first damages the roof or an exterior wall);

- damage to a building or its contents caused by weight of ice, snow, or sleet;

- accidental discharge or overflow of water or steam from a plumbing, heating, air conditioning system or fire protective sprinkler system, or from a household appliance (but not damage caused by freezing or continuous seepage);

- sudden and accidental tearing apart, cracking, burning, or bulging of a steam or hot water heating system, an air conditioning or automatic fire protective sprinkler system, or an appliance for heating water;

- freezing of a plumbing, heating, air conditioning or automatic fire protective sprinkler system, or of a household appliance;

- electrical current (but not damage to a tube, transistor, or similar electrical component).

The burglar and discharge or overflow perils are suspended whenever the dwelling has been vacant for more than 30 consecutive days.

The freezing peril is suspended whenever the dwelling is vacant, unoccupied, or being constructed, unless reasonable care was taken to maintain heat in the building, or to shut off the water supply and drain systems and appliances.

The special form provides the most complete coverage. Coverage for the dwelling and other structures are provided against any risks which are not

excluded. Personal property is insured against all the broad form perils. If any excluded loss is followed by a loss which is not excluded, the additional loss is covered by the special form.

If you experience a loss that involves water damage from a fire protective sprinkler system, the policy will cover the loss caused by water and the cost of tearing out and replacing any part of a building necessary to repair the sprinkler system. But it will not cover any damage to the system itself.

Minimum amounts of insurance are usually required for the broad and special forms. This is because people sometimes choose very small amounts of coverage for dwelling insurance. (Since the policies only cover the value of buildings—which usually aren't primary residences—minimizing dwelling coverage can make sense.)

Property and Losses Covered

There are insuring agreements and exclusions for the types of property and losses that you can't file a claim for under a dwelling policy.

A total of five insuring agreements are found on dwelling forms. Three describe property covered, and two describe specific types of covered losses. The available coverages are:

- Coverage A—Dwelling

- Coverage B—Other structures

- Coverage C—Personal property

- Coverage D—Loss of fair rental value

- Coverage E—Additional living expense (not included on the basic form)

Dwelling coverage applies to the dwelling described in the declarations—and to all attached structures and service-related building equipment at the described location. This coverage also insures materials and supplies on or adjacent to the described location for use in the construction, alteration, or repair of the dwelling or other structures.

Other structures on the described location which are separated from the dwelling by a clear space, or connected only by a fence, utility line, or similar connection, may be insured under Coverage B.

Coverage C applies to personal property which is at the described location, usual to dwelling occupancy and owned or used by you or members of your family. If personal property is moved to a newly acquired principal resi-

dence, this coverage will automatically apply at the new location for 30 days—but not beyond the policy expiration date.

Coverage D pays the fair rental value of that part of the described location rented to others or held for rental at the time of damage. Fair rental value is the rental value less expenses which do not continue (such as heat and electricity) while the property is unfit for use.

Coverage E pays additional living expenses incurred by the insured while the property is unfit for use.

Additional living expenses means any necessary increase in living expenses (such as rent for alternative housing) incurred so that the household can maintain its normal standard of living.

If a civil authority prohibits use of the insured property because a peril insured against has damaged a neighboring location, dwelling forms limit payments under Coverages D and E to a maximum period of two weeks.

All three of the dwelling forms include other coverages, which are extensions of the major coverages. The basic form includes eight other coverages. The broad and special forms make some modifications to these coverages and include three additional coverages. The extensions of coverage are:

- the cost of removing personal property from a location,

- damage to other structures at the location,

- debris removal expense,

- tenant's improvements, alterations, and additions,

- worldwide personal property coverage,

- rental value and additional living expense,

- reasonable cost for repairs,

- fire department service charges,

- lawns, trees, shrubs, and plants (broad and special forms only),

- collapse of a building (broad and special forms only),

- breakage of glass or safety glazing material (broad and special forms only).

All three dwelling forms *exclude* coverage for the following items:

- accounts, bank notes, bills, bullion, coins, currency, deeds, evidences of debt, gold other than goldware, letters of credit, manu-

scripts, medals, money, notes other than banknotes, passports, personal records, platinum, securities, silver other than silverware, tickets and stamps,

- aircraft and parts, other than model or hobby aircraft,

- animals, birds, or fish,

- boats other than rowboats or canoes,

- credit cards and fund transfer cards,

- data, including data stored in books of account, drawings or other paper records, electronic data processing tapes, wires, records or other software media,

- intentional loss arising out of any act committed by or at the direction of the insured, or any person or organization named as an additional insured, with intent to cause loss,

- land, including the land on which the dwelling or other structures are located,

- losses caused by neglect of the insured person to use all means to save and preserve property,

- losses caused by ordinance or law,

- losses caused by perils having catastrophic potential (the policies contain common exclusions for losses caused by flood waters, earth movement, nuclear hazards and acts of war),

- losses caused by power failure,

- motor vehicles, other than motorized equipment which is not subject to vehicle registration and which is used to service the described location, or is designed to assist the handicapped,

- motor vehicle equipment and accessories, and any device for the transmitting, recording, receiving or reproduction of sound or pictures which is operated by power from the electrical system of a vehicle, including tapes, wires, discs, or other media for use with such device, while in or upon the vehicle,

- structures rented or held for rental (except as a private garage) to any person who is not a tenant of the dwelling,

- structures used in whole or in part for commercial, manufacturing, or farming purposes,

- under coverages for fair rental value and additional living expense, any loss or expense due to cancellation of a lease or agreement.

Miscellaneous Dwelling Endorsements

Although dwellings under construction are eligible for dwelling policy coverage, an endorsement must be attached to modify some of the policy provisions, particularly provisions concerning the amount of insurance and the premium.

The amount of insurance shown for a dwelling under construction is a provisional amount, usually based on the expected completed value. The amount of coverage actually in effect on any given date is a percentage of the provisional amount, based on the proportion that the actual value at the time bears to the completed value.

Normally, a dwelling policy would cover the actual cash value or replacement cost of damaged property. It would not cover any additional expenses resulting from the enforcement of building codes that require the use of improved materials or safety systems that were not required when the original structure was built.

For an additional premium, an endorsement may be attached to a dwelling policy to cover the additional loss that may result from any ordinance or law regarding the construction, repair or demolition of property.

Under the earth movement exclusion, there is no coverage for earthquake or other forms of earth movement, including earth sinking.

For an additional premium, coverage for sinkhole collapse may be attached to the policy.

> **Loss by sinkhole collapse means actual physical damage caused by sudden settlement or collapse of the earth supporting insured property resulting from underground voids created by the action of water on limestone or similar rock formations.**

An endorsement may be attached to cover various building items owned by condominium unit owners. A limit of insurance must be shown for this coverage and an additional premium will be charged.

Covered unit owner building items may include property which you are responsible for insuring under any agreements with other property owners.

For an additional premium, an endorsement may be attached to provide you with coverage for losses caused by water which backs up through sewers or drains or which overflows from a sump pump, even when caused by mechanical breakdown of the pump. Normally these losses would be excluded.

A variety of other endorsements may be used to provide special coverages and to modify policy provisions in ways that meet your needs.

Renters' Claims

Even if you're just renting your first apartment out of school, you may have things you need to protect—computers, TVs and VCRs, stereo equipment, sports equipment and so on. These things can be worth thousands—or tens of thousands—of dollars if a loss should occur.

So, it's surprising that less than half of all renters in the United States bother to protect their personal belongings and furnishings with insurance. People under 40 are particularly remiss.

Tenant advocacy groups and others—like Illinois-based Condominium Insurance Specialists of America—estimate that as few as one in four renters in their twenties and thirties buy insurance. The number remains low—even though renters insurance is relatively cheap.

The HO-4 insurance policy form—called the renters policy in the insurance industry—is available from most property and casualty insurance companies. Some confusion comes from the fact that the coverage is called different things by different companies—the contents broad form, broad theft coverage or tenants insurance—but, whatever it's called, the coverage is inexpensive enough to be worth a look from just about any renter.

The May 1997 United States Court of Appeals decision *Raymond A. Huberts v. The Travelers Indemnity Company* offers a colorful example of a renter's unusual personal property dispute.

Raymond Huberts began composing a manuscript of biographical work entitled *The Lisa Rohn Case—Revisited* sometime after he was forcibly returned to the United States from El Salvador in April 1992 to face indictment on two counts of passport fraud.

Huberts and Rohn had been partners in a massive credit card scam in the mid-1980s, for which each was eventually imprisoned. The pair had become romantically involved, and two daughters were born of the union. Shortly following Rohn's release from federal confinement in 1991, Rohn murdered

her fiance, Roger Paulson, who had contacted the authorities upon discovering that Rohn was again involved in criminal activity.

The story received considerable notoriety, becoming fodder for supermarket tabloids and a made-for-TV movie.

Huberts completed his manuscript in August 1994, and mailed the manuscript to Janus Publishing Co. in London, England, to be appraised.

During the same period of time, Huberts obtained renter's insurance from Fireman's Fund that provided loss coverage for another manuscript that he had previously completed and submitted for appraisal. Awaiting the appraisal of the Rohn manuscript, Huberts obtained two more renter's policies for his cottage. One was issued by Travelers through AAA Insurance Agency of Orlando, Florida; the other was issued by the United States Automobile Association (USAA).

Shortly thereafter, Janus informed Huberts that it had appraised the Rohn manuscript at $185,000.

Huberts then wrote to AAA and USAA, seeking to extend the existing policies to cover the Rohn manuscript. Before writing to USAA, Huberts applied to State Farm for another Renter's policy, specifically requesting coverage for the Rohn manuscript. All three insurance companies informed Huberts that they could not provide the coverage that he sought.

Huberts finally insured the manuscript through First Virginia Insurance Services Agency, which, like AAA, is an agent for Travelers. Huberts stored the manuscript in a small safe in the cottage, along with the floppy computer disks upon which the word processing file was stored.

Travelers issued the policy on December 23, 1994, after Steve Atwell of First Virginia had taken Huberts's application over the telephone. Question No. 10 on the application inquired of the prospective insured whether any insurance had been "declined, cancelled or nonrenewed." According to Atwell, Huberts answered that question.

On May 5, 1995, after an overnight trip to Washington, D.C., Huberts returned to the cottage to discover that it had been ransacked. The telephone line had been cut, the rear door had been pried open, the computer console had been smashed for the burglar alarm, and the door to the safe stood wide open with nothing left inside.

Huberts contacted his alarm service provider, which, in turn, reported the incident to the county sheriff's office.

Huberts told investigators that he had written the combination to the safe in an address book that he had kept in a drawer of his computer desk. The address book had been taken, but the computer and other items of pecuniary

value had not been disturbed. A private detective whom Huberts asked to inspect the crime scene prepared a report, in which he opined that the intruders may have stolen the manuscripts in the hope of destroying information that could clear Rohn of Paulson's murder.

Huberts notified his insurance companies of the incident a couple of days later. Firemen's Fund paid the full $150,000 appraisal value of the first manuscript. Travelers, however, refused to pay Huberts's claim for the Rohn manuscript.

On July 20, 1995, Huberts filed suit against Travelers to enforce the terms of the insurance contract providing coverage for property loss. Travelers counterclaimed for rescission, asserting misrepresentation and fraud.

Upon discovery, Travelers requested that the court ask Huberts to produce his computer's hard drive so that another copy of the manuscript might be extracted from it. However, Huberts claimed that he had not saved the file to the hard drive and that, even if he had, the hard drive and motherboard had been replaced after the computer sustained a bolt of lightning during an electrical storm in July 1995.

Each side moved for summary judgment, submitting memoranda and other materials in support of their motions. The district court denied Huberts's motion and granted Travelers' cross-motion, ruling that "[o]n his application for insurance, [Huberts] had answered in the negative when asked whether he had ever had "any insurance declined, cancelled, or non-renewed."

According to the district court, Huberts's failed earlier attempts to procure coverage for the Rohn manuscript would have been material to the risk assumed by Travelers, i.e., either to its decision to issue the policy in the first instance or to its determination of the premium to be charged.

Huberts appealed.

The appeals court noted that Travelers' entitlement to rescission depended not only on the materiality of Question No. 10 to its decision but also on the threshold issue of misrepresentation—whether the question was asked of Huberts and, if so, whether Huberts answered falsely.

At his deposition, Huberts had flatly denied that he had ever been asked Question No. 10. Nevertheless, the trial court had "found" that:

1) the question had been asked,

2) Huberts answered it "No," and

3) Huberts's answer was knowingly false.

The appeals didn't take the position. It noted that Huberts insisted that "Travelers made no effort to explain the meaning or intent of the question...."

On another occasion, as part of a formal stipulation of facts, Huberts had agreed that "Travelers never explained to [him] what 'any insurance declined' meant[.]"

According to the appeals court, the district court's reliance was misplaced. It had been clearly stated:

"Huberts denies Atwell asked if any insurance had been declined, canceled or nonrenewed. However, for the sake of this Motion, Huberts assumes the truth of Atwell's representations."

In light of this unequivocal caveat, said the appeals court, it is plain that the subsequent contentions purported to amount to a concession were instead merely an acknowledgment of the potential materiality of the issue in dispute.

The appeals court held that the district court resolved a genuinely disputed, material fact in favor of the movant—something it may not do.

Still, on appeal, Travelers argued contended that Huberts's claim was fraudulent as a matter of law.

"Though the circumstances surrounding the ransacking appeared suspicious to all but the terminally naive—particularly in view of Huberts's background," the court held that the question of his claim's veracity should have been left to the jury.

The district court's judgment was vacated—and the case was sent back for trial.

The Mechanics of Renter's Insurance

Under a Renter's policy, your personal property is insured against loss by the broad form perils under and HO-4 policy.

Homeowners form HO-4 may be issued to any of the following:

- a tenant non-owner of a dwelling or apartment,

- a tenant non-owner of a mobilehome,

- an owner-occupant of a condominium unit,

- an owner-occupant of a dwelling or apartment when not eligible for coverage under one of the combined building and contents homeowner forms.

The policy is purchased most often by renters of apartments, dwellings or condominiums who do not require the complete range of coverages—liability coverage, dwelling structure coverage, etc.—provided by the other standard homeowners forms.

A renter doesn't usually need to insure the building in which he or she lives. And renters who don't want to pay for liability protection can opt for a policy that covers only personal property.

The Importance of Coverage

Landlords will sometimes require that tenants carry some form of renter's insurance. (This usually applies to luxury apartments or, conversely, rent-controlled units.) In states with large urban centers, insurance regulators have outlawed these requirements in the name of consumer protection.

Unfortunately, these prohibitions send the message to many people that renter's insurance is a rip-off. That's unfortunate because renters policies can be a bargain.

Example: In the mid-1990s, USAA—the Texas-based insurance company that specializes in covering military and former service personnel and their families—offered a tenant protection plan that cost $169 a year in New York City and insured $20,000 worth of belongings, with a $100 deductible. The policy also provided replacement cost coverage—and $100,000 of personal liability coverage.

Renter's insurance can be written in a comprehensive form for all risks that aren't explicitly excluded or for named perils only. Named perils coverage averages about 20 percent less expensive.

Even insurance written on a named perils basis should cover fire, theft or water damage. These are primary hazards renters face.

Although it doesn't cover the building itself, an HO-4 policy does provide a limited amount of coverage for building additions and alterations. (This coverage is also known as leasehold improvement insurance.) In short, this means that if you spend money to improve the apartment or house you're renting—and haven't been reimbursed by your landlord—the renters insurance will cover the investments you've made in the place.

How much coverage you need depends, of course, on the value of your belongings. Once you've calculated the value of the things you own, you simply have to ask yourself how much of this you could stand to lose.

If you don't own more than a few hundred dollars of any specific kind of personal property, you probably don't need renters insurance. But, if you care enough about a hobby, activity or other experience to invest thousands of dollars in related equipment, you probably do want to insure those things.

Theft Claims

One reason that renter's insurance is so attractive is that it covers personal property against theft.

By comparison, basic dwelling policies do not provide any theft coverage for personal property. A broad theft coverage endorsement has to be added to a dwelling policy—at additional premium—to provide such coverage.

For many insurance companies, the broad theft coverage endorsement— sold in a slightly different version as stand-alone insurance—*is* renter's insurance.

Theft coverage provides insurance against loss by the following two perils:

- theft, including attempted theft, and

- vandalism and malicious mischief as a result of theft or attempted theft.

A caveat: The vandalism coverage won't apply if your residence has been vacant for more than 30 consecutive days immediately before the loss. In most cases, though, this limit won't be an issue for renters.

Broad theft policies (or endorsements) contain three definitions that affect the coverage:

- business means any trade, profession or occupation,

- insured person means the named insured and residents of the named insured's household who are either relatives of the named insured or under the age of 21 and in the care of any insured person,

- residence employee means an employee of any insured who performs duties related to maintenance or use of the described location, including household or domestic services, or similar duties elsewhere which are not related to the business of any insured person.

Property used for business purposes isn't considered personal property and, therefore, isn't covered.

Only property that belongs to an insured person is covered—so, if the $2,000 camera you're keeping for a friend gets stolen from your trendy downtown loft, you may have some explaining to do.

Finally, property of residence employees is covered only if you ask the

insurance company to add language saying so. This may raise your premium—though many companies will add the coverage for no additional cost.

A limit of liability must be shown for on-premises coverage. This limit is the most the insurance company will pay for any one covered loss at the described location. On-premises coverage applies while the property is:

- at the part of the described location occupied by an insured person,

- in other parts of the described location not occupied exclusively by an insured person, if the property is owned or used by an insured person or covered residence employee,

- placed for safekeeping in any bank, trust or safe deposit company, public warehouse, or occupied dwelling not owned, rented to or occupied by an insured person.

This type of insurance policy limits coverage either with one general dollar limit or a range of dollar limits applicable to different types of personal property.

In the first case, a policy would insure all your property—regardless of type—to a limit of $20,000.

In the second, a policy would insure computer equipment up to $5,000, stereo equipment to $2,000, sports equipment to $1,500, etc.

Although limits of liability are shown for the maximum amount of insurance for any one loss, special sub-limits of liability usually apply to specific categories of insured property. Each limit is the most the insurance company will pay for each loss for all property in that category.

An example of the special limits of liability might be:
- $200 for money, bank notes, bullion, gold and silver other than goldware and silverware, platinum, coins and medals,

- $1,000 for securities, accounts, deeds, evidences of debt, letters of credit, notes other than bank notes, manuscripts, passports, tickets and stamps,

- $1,000 for watercraft including their trailers, furnishings, equipment and outboard motors,

- $1,000 for trailers not used with watercraft,

- $1,000 for jewelry, watches, furs, precious and semiprecious stones,

- $2,000 for firearms,

- $2,500 for silverware, silver plated ware, goldware, gold plated ware, and pewterware, including flatware, hollowware, tea sets, trays, and trophies.

Limits similar to these are found on homeowners policies. The intent of the policies is to provide basic coverage for special items of value which may be subject to theft losses. However, some people collect particular items and may have disproportionate exposures not contemplated in average insurance rates. Most policies will not allow the full limit of liability to be applied to a specific kind of property.

> **If you have greater exposures, higher limits may be available for an additional premium charge, or a separate personal property floater may be purchased.**

In some cases, off-premises theft coverage is available. This coverage applies while the property is away from the described location, as long as it is:

- owned or used by an insured person, or

- owned by a residence employee while in a dwelling occupied by an insured, or while engaged in the employ of an insured.

Example: If you ride your $2,000 mountain bike from the houseboat you're renting to the mountains north of Seattle—and someone steals it while you're waiting to pay for a cafe latté—the insurance company will get you a new bike.

A number of conditions apply to off-premises coverage:

- you can only buy it if you've bought on-premises coverage,

- a separate limit of liability must be shown for off-premises coverage (this limit—usually lower than on-premises limits—is the most the insurance company will pay for any one loss),

- off-premises coverage does not apply to property that you move to a newly acquired principal residence.

That last point is a considerable issue in renter's insurance.

> **One of the ways in which insurance companies shield themselves from the volatility that sometimes accompanies the renter's lifestyle is by limiting the transferability of a renter's policy from one location to another.**

If you move during the policy term to a new principal residence, the limit of liability for on-premises coverage will apply at each residence and in transit between them for a period of 30 days after you begin to move the property. When the moving is completed, on-premises coverage applies at the new described location only.

The March 1997 Idaho court of appeals decision *Sandra Perry v. Farm Bureau Mutual Insurance Company of Idaho* highlights several unfortunately common problems that occur in renters' claims.

In December 1994, Sandra Perry began sharing a home with her boyfriend Roy Smith. She bought a renter's policy to cover the house and her personal property in it.

After going out of town for a week in May 1995, she returned to discover that numerous items and personal property had been removed from the home. She later learned that Smith was responsible for taking the property, which Perry valued at $20,000.

Perry filed a claim of loss with her insurance company, Farm Bureau, seeking to recover the value of the property taken from her home.

Farm Bureau denied the claim pursuant to a provision in Perry's policy which provided coverage for: "10. Theft, including attempted theft and loss of property from a known location when it is likely that the property has been stolen.... The term 'theft' shall not include ... wrongful conversion or embezzlement....."

Perry sued Farm Bureau to pursue her right to recover under the policy.

Farm Bureau asked the court for summary judgment on the specific exclusion for loss by wrongful conversion and embezzlement. Asserting that the plain meaning of "wrongful conversion" and "embezzlement" presupposes the converting of lawful possession into unlawful possession, Farm Bureau claimed that no genuine issue of material fact existed with regard to Smith's conversion of Perry's property, Therefore, Farm Bureau claimed that it was entitled to judgment as a matter of law.

In support of its motion, Farm Bureau referred to Perry's deposition, in which she stated that she and Smith had co-signed the lease on the home and that Smith was authorized to use her personal property.

The trial court ruled for the insurance company. It agreed that Smith's conduct constituted wrongful conversion or embezzlement, thus excluding coverage under the policy. The court rejected Perry's argument that the exclusionary clause was ambiguous. It ruled that the wording of the policy would show a person of average intelligence that "wrongful conversion and embezzlement" means something which can be distinguished from "theft."

Perry appealed.

On appeal, Farm Bureau restated its position that the exclusion for "wrongful conversion and embezzlement" excludes from coverage losses caused when a person in lawful possession of the insured's property converts that property to the person's own use.

But, this time, the court didn't agree. The court of appeals concluded that Smith's relationship with Perry was not that of a fiduciary, whose duty it was to act primarily for the benefit of Perry vis à vis her property.

The appeals court wrote:

> Neither does the evidence suggest that Perry had entrusted her property to Smith. In the absence of such a special relationship, and having discovered no case law supporting the district court's conclusion that Smith's appropriation of Perry's property was embezzlement, we hold that the district court's conclusion was erroneous.

Smith's appropriation his girlfriend's property could not be characterized as anything other than theft, the court concluded. The district court had erred in applying the terms "wrongful conversion and embezzlement" to exclude coverage under the policy.

Farm Bureau would have to pay Perry's claim.

Property Not Covered

Broad theft coverage does not apply to the following types of property:

- aircraft and parts, other than model or hobby aircraft,

- animals, birds, or fish,

- business property of an insured person or residence employee on or away from the described location,

- credit cards and fund transfer cards,

- motor vehicles, other than motorized equipment which is not subject to motor vehicle registration and which is used to service the described location, or is designed to assist the handicapped,

- motor vehicle equipment and accessories, and any device for the transmitting, recording, receiving or reproduction of sound

or pictures which is operated by power from the electrical system of a motorized vehicle, including tapes, wires, discs, or other media for use with such device, while in or upon the vehicle,

- property held as a sample or for sale or delivery after sale,

- property of tenants, roomers and boarders not related to an insured person,

- property separately described and specifically insured by any other insurance,

- property while at any other location owned, rented to or occupied by any insured person, except while an insured person is temporarily residing there,

- property while in the custody of any laundry, cleaner, tailor, presser or dyer except for loss by burglary or robbery,

- property while in the mail.

You may recognize some of these exclusions from standard homeowners and dwelling policies. A number of these recur through all the various forms of household insurance.

The broad theft form adds two conditions that can influence whether or not property (which would otherwise be covered) is covered:

- in addition to standard duties after loss, theft coverage requires the insured person to notify the police when a theft loss occurs,

- the other insurance condition that applies to standard homeowners and dwelling forms is changed slightly—if a theft loss is covered by other insurance, the insurance company is only obligated to pay the proportion of the loss that the limit of liability under the theft endorsement bears to the total amount of insurance covering the loss.

Part Three:

Possessions, Property and Things You Own

Chapter 9

Making Claims for Damage to Things

You don't have to be Bill Gates to own thousands of dollars worth of computers, stereos, TVs, telephones and sports equipment. And this doesn't even include things like musical equipment, tools, animation cells or other collectibles.

What's the best way to protect this stuff? Should you buy insurance? If so, what kind of insurance should you buy?

The insurance industry has a saying: The best insurance is the kind that pays when you make a claim. This is said in ironic half-jest; but it's funny (at least to insurance agents) precisely because it will probably always be a tough thing to maintain.

This is why, to some people, insurance companies seem to change the rules constantly in order to protect themselves from making payments.

Miscellaneous personal property—the things that someone owns—has always been difficult to insure against loss. It's either tough to value accurately or to prove existed at all. So, when it comes to insuring personal property, it is important to do the detail work of making inventories and checking specific points of coverage.

If they think about the question at all, most people figure the things they own are covered by their homeowners insurance. But people should think about the question more than they do.

Even if you don't own a home, chances are you own other things. You may own a car, a boat, a set of nice golf clubs or a new computer. You probably have a bicycle, a stereo or other nice stuff. All of these items, no matter what they cost, are of some importance to you. They have insurable value.

Although the insurance industry of today is dominated by life, home and auto insurance, it's useful to remember that modern insurance got its start protecting people against the loss of things. Three hundred years ago, the informal exchange that became Lloyd's of London began pooling money among English merchants to insure against merchandise being lost at sea.

At various times for various reasons, the things you own might be destroyed—by fire, automobile accident, earthquake, theft...and the list goes on, endlessly. And this doesn't even begin to address the ever-troubling issue of liability.

We live in a litigious world. No matter who you are, the wrong mix of circumstances can find you liable—and your nice stuff at risk—if you are found negligent for losses suffered by another person.

For instance: Your neighbor, Mr. Lockhart, strolls over to the house you're renting to return the weed whacker he borrowed last week. Muffy, your normally well-behaved Rottweiler, mistakes Mr. Lockhart for a criminal and bites him on the leg and...er...lower back.

Chances are, Mr. Lockhart won't be so chummy with you anymore. And, having seen all the high-end gardening gear in your garage, he may also decide to sue for the pain and suffering he's had to live through since Muffy's vicious assault.

Liability risk doesn't have to have four legs and German breeding. You're late for work, so you rush out and forget to turn off your iron. A few hours later, your landlord calls to say that fire department investigators have concluded your iron was responsible not only for the fire in your apartment but also the damage to three other units.

The landlord will be upset—but probably not as much as the couple upstairs whose $20,000 collection of vintage jazz recordings was destroyed because your shirt looked wrinkled. If they didn't have insurance on those Charlie Parker LPs, they'll be looking to you for compensation.

> **Disastrous losses can strike just about anyone at any time. Naturally, these types of risks can be insured against...if you know how to get the right coverage.**

Not only can you purchase insurance to cover your possessions for damage from fire, smoke, vandalism, theft, and freezing, you can also purchase liability coverage which will protect you, your family and even your pet, against claims and suits in the event that you or your property are responsible for damage to others.

Insurance isn't a simple matter. The insurance industry is set up so insurance companies will profit even when they have to pay claims...but claims eat into these profits. So, even the best insurance companies work hard to avoid paying claims.

Of course, not all insurance companies are looking to bilk you out of the premiums you pay, but it doesn't hurt to know all the facts before you make an important financial decision such as purchasing insurance.

What's Worth Insuring?

Before determining the type of coverage that you should buy, you need to determine what possessions are of insurable value to you if a loss occurs. This, in turn, leads to an obvious question: What is a loss?

In insurance terms, a loss is any reduction in the quality, quantity or value of something.

Under various insurance policies, loss refers to death, bodily injury, disease, property damage, the physical disappearance of property, lost income, incurred expenses, a reduction in the quality of life (i.e., pain, suffering or handicap) or an obligation to pay for any such loss.

There are some guidelines you can follow to figure out how much insurance you need to cover the loss of your possessions.

One simple way to calculate your insurance needs is to make a list of everything you own that has some insurable value to you—such as furniture (including carpets, drapes, etc.), art or other decorations, appliances, clothes and other possessions. To organize this inventory, you simply divide the list into relevant rooms in the house or apartment.

For each household item, list most recent comparable value or insured value from other coverages for market value. Debts and restrictions include mortgages, liens and other encumbrances on real estate property. They also include margin loans on capital investments and liquidation costs or penalties on accessible pension funds.

Insured values work best if they include relevant receipts or bills. You should also keep other support documents—including photographs or serial numbers from appliances and electronic equipment—with the inventory.

The total value of all these things—even if you couldn't raise it by selling everything tomorrow—is what you need to protect. Once you have an inventory, your insurance agent can help you determine the value of your

possessions. The value of possessions will give you an idea of how much property coverage you need.

If you're not using an insurance agent, the insurance company you're using—or thinking of using—should be able to provide you with historical price ranges for the various kinds of personal property you want to protect.

Property losses under the basic homeowners or dwelling form are generally settled on an actual cash value basis. All forms support the principle of indemnity, which—in this context—means recovery may not exceed the smallest of four amounts:

- the ACV of the property at the time of loss,

- the policy limit for the coverage,

- the amount necessary to repair or replace the property,

- the amount reflecting the insured's interest in the property at the time of the loss.

When a loss is adjusted on an actual cash value basis, a deduction is made by the insurance company for the depreciation of the property. The term depreciation refers to the gradual reduction in the value of property as a result of time and use.

> If you are looking to insure your possessions under a homeowners policy, make sure that you insure the contents for the maximum amount. If you don't, when you file a claim you may find that your insurance company insures personal property for only 50 percent of your home's insurance.

For example, you would only get $100,000 towards your personal property if your home was insured for $200,000. However, if you find out ahead of time, you may want to purchase more insurance or a floater scheduling valuables separately.

If you have personal property that is not scheduled on your homeowners policy, it should be insured with the more expensive, replacement cost coverage so that if a loss occurs, you can replace it rather than receiving only the actual cash value (ACV) you paid for it. (ACV coverage ill take depreciation into consideration giving you only a percentage of what the item's cost was when you purchased it based on the years you have owned it.

The final recovery may not exceed the amount actually spent to repair or replace the property or the policy limit for the damages.

If after meeting with an adjuster, you and your insurance company fail to agree on the value of your loss, your method of appeal is outlined by the standard homeowners policy. The policy states:

> If you and we fail to agree on the amount of loss, either may demand an appraisal. In this event, each party will choose a competent appraiser within 20 days after receiving a request from the other. The two appraisers will choose an umpire.... The appraisers will separately set the amount of loss. If the appraisers submit a written report of an agreement to us, the amount agreed upon will be the amount of the loss. If they fail to agree, they will submit their differences to the umpire. A decision agreed to by any two will set the amount of the loss.

Some other points to remember about claims for personal property:

- When there is a loss to a pair or a set, the insurance company has the right to restore or replace any part of the pair or set in order to restore its value, or to pay the difference between the ACV of the property before and after the loss.

- Supporting evidence is required for losses insured by the credit card, fund transfer, forgery and counterfeit money coverage and, in the case of a credit card or fund transfer loss, the insured must notify the appropriate card company.

- Coverage for personal property usually kept at an insured's residence other than the residence premises is limited to the larger of $1,000 or 10 percent of the standard personal property limit. But if personal property is moved to a newly acquired principal residence, this limitation does not apply during the first 30 days after the property is moved.

Making the Claim

The effort you put into purchasing the right kind of insurance coverage comes into play when you have to make a claim on your policy.

As a policyholder, instead of sitting back and waiting for a disaster to happen, you should familiarize yourself with the steps that go into the claims-making process to avoid costly and time consuming mistakes.

According to the Insurance Information Institute, more than $75 billion are paid out each year to policyholders with claims resulting from losses suffered during fires, hurricanes, tornadoes, robberies, auto accidents, dog bites,

falls and a host of other traumatic accidents. It's important to remember that filing a claim is a process, and knowing you rights through this process can be pivotal to getting your claim paid.

Your insurance company at any time and for any reason has the right to investigate any claim that you make. But if you present your circumstances effectively, your insurance company may allow your claim, which can save you a crucial amount in expenses. This chapter will focus on the most effective way to make a claim and get it paid in the event of loss to your personal possessions.

The process of making a claim and getting it paid is the adjustment process. To make this process work for you, it is first important to know what your duties are when a loss occurs.

Your Duties at the Time of a Loss

If you experience an insurable loss, there are several duties required of you as a policy owner before your coverage can kick in. If you don't follow these rules, you may wind up paying for the loss out of your own pocket, as did this couple in a 1989 case of misrepresentation in Missouri.

In January of 1981, Barbara and David Meeker purchased a homeowners policy from Shelter insurance to cover the Meekers' home and its contents.

In July of 1983, the Meeker home and all of its contents were destroyed by fire.

The Meekers filed a claim which Shelter denied, contending that the policy was void because the Meekers had made false representations regarding prior fire losses, when they applied for coverage. Shelter said it would not have issued the policy if it had known about these prior losses.

After the fire in question, which the evidence indicates was of incendiary origin, the Meekers were contacted by Robert Barnett, an adjuster for Shelter, who took recorded statements from them regarding the fire.

Mrs. Meeker then admitted to five prior structure fire losses, as well as various vehicle losses due to fires. The first structure fire occurred when their home in Dewitt, Iowa, burned and their personal property was destroyed. Two ceramic shop fires followed as well as, two mobile home fires in Missouri.

Following receipt of the investigatory materials, an attorney for Shelter, wrote to the Meekers advising them that Shelter was denying their claim.

In response, the Meekers sought damages for: dwelling coverage; personal property coverage; additional living expense coverage; removal of de-

bris coverage; unlawful conspiracy; negligent conduct; other structures coverage; and coverage for loss of trees, shrubs, plants and lawns.

Prior to trial, the court dismissed a number of the Meekers complaints.

During trial, the Meekers denied that they had misrepresented the number of their prior fires. Barbara Meeker testified that when asked her about prior fire losses, she told the agent they had had "several," including the house in Iowa, the two ceramic shop fires, and the two mobile home fires in Missouri.

After evidence was heard at the jury trial, the court ruled that a legitimate inference could be drawn when coupling the agent's testimony regarding the Meekers' statements to him regarding prior fire losses with his testimony that he would not have issued the binder had he known of the prior fire losses.

The court entered judgment in favor of Shelter for $36,071.96 plus $13,149.22 interest for dwelling coverage, $37,130.19 plus $19,722.68 interest for property coverage, and $1,500 for additional living expenses.

In response, the Meekers alleged that the court overlooked, misinterpreted, or misstated material matters of law and fact in arriving at its opinion.

The court ruled the allegations and arguments, meritless and the motion for rehearing, or in the alternative to transfer to the Supreme Court, was denied.

Your insurance company may also request that you submit appropriate records, exhibit the remains of the damaged property, or submit to examinations under oath.

> **If you don't comply with your duties after a loss occurs, your insurance company will not be obligated to pay your loss.**

Contacting your insurance company and the police after you have suffered a loss is a relatively important part of the claims process and fairly simple. But in addition to complying with your duties after a loss—you want to do them in a way that will assure you the maximum timely settlement. And knowing how your insurance company looks at a claim will help you with this process.

In order to get recovery for losses covered by your policy, promptly notify your insurance company should a loss occur.

In most cases, you have 20 days to provide notice of a claim to your insurance company or agent. If for some reason you can't make this time frame after an accidental injury, you must send notice of a claim as soon as

reasonably possible. Don't throw anything out after a loss has occurred, an adjuster may want to see all the damaged items before approving your claim.

> **If a loss covered under your policy causes damage in such a way as to expose your property to any further damage, you have an obligation to make reasonable repairs or to take other steps to protect the property.**

For example: If a windstorm blows away a portion of your roof, the policy would pay for—and actually require— temporary repairs to the roof to avoid further damage to the interior of the structure. If you don't make the reasonable repairs, the policy won't cover any further damage.

A standard policy allows you to move your property from a premises threatened by a covered peril to a safe place for a period of 30 days. Coverage would apply to the property for moving and while at the other location for loss from any cause—which expands your coverage considerably.

However, if you don't take these precautions, your insurance company may interpret that as a failure to reasonably protect your property from damage.

If your insurance company is looking for a way to get out of paying a claim, it may try to expand a dispute over prevention into a dispute over policy owner neglect—a specifically excluded coverage.

Disputes between you and your company generally center around coverage issues—specifically, whether or not a loss is covered under your policy. Because companies protect themselves from the negative financial impact of paying out large claims, they often deny coverage by pointing at some fundamental issue—often something not related to the specifics of the claim. This is why it is so important to know your duties as a policy holder after a loss occurs.

Limit of Liability

When a covered loss occurs, your insurance company has a limit of liability, or legal responsibility to honor their contractual agreement to pay damages to you or to a third party on your behalf.

> **The limit of liability is simply the amount of coverage, the maximum amount of insurance or upper limit that the insurance company is legally obligated to pay if a covered loss occurs.**

If a covered loss occurs for less than the limit of liability, your insurance company will pay the amount of the loss (minus any deductible that may apply). If the amount of the covered loss is more than the limit of liability, your insurance company will pay the limit of its coverage and you will be responsible for paying the additional costs.

Proof of Loss

It is important to document your loss as thoroughly as possible. After contacting your insurance company, they will usually send you a proof of loss form to complete.

In some cases, they may send an adjuster out to your house to go over the form with you. By having an inventory ahead of time, filling out this form will be a lot easier.

A proof of loss form generally tends to have uniformity with different insurance companies. If you're aren't sure what should go into this report, here are a few guidelines on what should be included:

- the time and cause of the loss;

- specifications of damage and detailed repair estimates;

- any damaged personal property;

- any other insurance which may apply;

- the interest of you and all other parties in the property involved (such as mortgage companies, lien holders, etc.);

- changes in the title or occupancy of the property during the term policy;

- if possible, receipts for any property that has been damaged;

- evidence or affidavit that supports a claim under the Credit Card, Fund Transfer Card, Forgery and Counterfeit Money coverage, stating the amount and cause of loss.

Losses will be adjusted and paid to you—unless the policy indicates that payment should be made to someone else, such as a mortgage holder.

It's a good idea to make a list of everything that's been stolen or damaged as soon as possible. Include a description of each item, the date of purchase, and what it would cost to replace today (If you have replacement-cost coverage). Any receipts, bills, photographs, or serial numbers from high-ticket purchases can also be helpful in establishing the value of your losses.

You don't have to wait for a major loss to occur to do this. You should keep a list that includes this information in a safe place at all times.

Abandonment

An abandonment clause prohibits you from abandoning your property to your insurance company in order to claim a total loss.

Although the company may choose to acquire the damaged property which can be sold for salvage and may choose to pay a total loss, you cannot insist that your insurance company take possession of any property.

For example: You have a loss due to a fire in the storage shed in your backyard. Most of its contents are damaged, but there are some that are not. You can not tell your insurance company , "I had $6,000 worth of stuff in the shed. Pay me $6,000 and the stuff is yours." Your insurance company will usually not accept this kind of a proposition because it has to make arrangements for hauling, repair, and sale of the salvageable property and it usually does not care to do this.

> **If you collect on a loss due to a theft and the property is recovered two months later, you have the option to take the property and pay your insurance company the original amount paid for the loss. Or you can keep the money and let the company keep the property.**

If property that has been stolen and paid for by the insurance company is recovered later on, you can elect to take the property and pay back the insurance company the amount it originally paid for the loss. An alternative is to keep the money and let the company keep the property.

Despite the specified amount of insurance, your insurable interest may limit the amount paid on a claim. Other parties may have an insurable interest in your property as an owner, mortgage holder, vendor, lien holder, stockholder, joint owner, bailee, or lease holder.

Once an insurance company has paid you for the loss you sustained, it acquires your rights in the claim. This transfer is called subrogation.

Example: Your neighbor loses control of his car and crashes into your garage. Your insurance company, after paying you, now has the right to sue your neighbor to collect from him the amount it paid to you. Once you receive payment, you "subrogate," or pass on, your rights in the claim to the insurance company.

If you become bankrupt or insolvent, the company remains obliged to provide coverage and to respond to the terms and conditions of the policy.

Your homeowners policy may include the following language: "With respect to the personal liability coverage, this policy is excess over any other valid and collectible insurance."

The practical application of this clause varies, depending on the other insurance. Duplication of coverage often ends up with both insurance companies contributing to payment of a loss.

The other insurance clause doesn't apply to so-called true excess liability insurance—like standard umbrella liability policies. Umbrella policies remain a secondary form of insurance to a homeowners policy.

Once your insurance company has paid you for the loss, it has the rights in the claim. This transfer is called subrogation.

For example: Your neighbor loses control of his car and crashes into your garage and its contents. Your insurance company, after paying you, now has the right to sue your neighbor to collect from him the amount it paid top you.

Once you receive payment, you "subrogate," or pass on, your rights in the claim to the insurance company.

If your insurance company fails to provide you with claims forms within 15 days after receiving your notice, you may comply with the policy's proof of loss requirements by writing to your insurance company and detailing the occurrence, and the character and extent of the loss.

Millions of insureds often slip up on their insurance coverage— later to find out that the new $2,000 computer that they brought home isn't covered when stolen three weeks later.

Don't wait till you get home from the store to purchase coverage. Chances are, you'll know ahead of time that you are going to make a purchase of that size. Insure it first—then bring it home.

Most people know that they need to insure their possessions, but they often get careless when it comes down to purchasing coverage. At times, they often leave out items or don't purchase the right amount of coverage. One way too help avoid this is to videotaping everything you own.

Appraisers are now suggesting that you simply walk through your residence with a video camera and tape everything. Film the paintings on your walls, your jewelry box, and even your closet. Most people remember to insure their jewelry and their mink coat but forget to appraise their wardrobe, which could be as much as $50,000.

If you have a videotape, photos or the actual appraisal written down—be sure to make a hard copy of it and keep it of the insured premises.

People often go through all the trouble of paying for an appraisal, taking photos, or videotaping only to leave this evidence on the insured premises.

This won't help if your house burns down and takes the appraisal with it.

If your list is on a computer program, or you have receipts, appraisals, photos or tapes, be sure that they are kept safely off the premises. A good suggestion is to keep these items in a safety-deposit box or inside a vault off the insured premises.

Loss Payable Clause

The loss payable clause of a standard policy, states that if you provide the proof of loss and other information—and the amount of loss has been agreed upon—your insurance company will pay for the loss within 60 days (laws may vary with this time limit in each state).

> **Your duty as a policyholder is to assist the insurance company in making settlements, making claims against other parties who might be responsible for the loss, be available for court trials, hearings, or suits, and give evidence as required.**

If you don't provide proof of loss information, or in some way alter the information, you may find yourself shelling money out of your own pocket for repairs or even replacements.

However, there is a time limit on certain defenses. This limits the period in which your company may try to deny coverage by questioning the truthfulness of your statements on an insurance application. Depending on the state in which you live, this law will vary from either a two- or three-year period.

After your policy has been in effect for the specified number of years, your insurance company can no longer contest coverage on the basis of your omissions or misrepresentations unless your insurance company can prove that they were made with the intent to defraud. This provision is also called the incontestable provision.

If you have provided the necessary proof of loss forms and the actual amount of the loss has been agreed upon by both you and your company, the company will have 60 days to pay out your claim. Even if you are angry because your property has been stolen, you can't change the black and white of the policy.

In the 1992 Illinois appeals court decision *John Mazur v. Dena Hunt, Crum and Forster and United States Fire Insurance Co.*, a policyholder's impatience worsened his loss.

Thieves broke into John Mazur's home and stole several pieces of jewelry. U.S. Fire paid him for some of the jewelry taken—items for which he had signed a proof of loss report.

However, U.S. Fire refused to pay for the loss of two additional pieces which were not included on the proof of loss form. Mazur sued U.S. Fire and its agents for not covering those two pieces, which he claimed were worth $41,000.

He alleged breach by U.S. Fire and Crum and Forster of the "newly acquired property" provisions of his insurance policy. Under these provisions, U.S. Fire was required to pay the lesser of "25 percent of the amount of insurance for that class of property" or $10,000.

For these alleged violations, Mazur sought compensatory damages of $10,000, costs, pre-judgment interest and attorneys fees.

He also alleged that the jewelry at issue was fully covered under the policy. On this count, he charged U.S. Fire with breaching the policy and sought compensatory damages for the full value of the jewelry, $41,000, plus costs, pre-judgment interest and attorney fees.

Finally, he charged Crum and Forster insurance agent Dena Hunt with fraud. He claimed she used the proof of loss report to bar his claim for the two pieces of jewelry that were omitted.

According to his complaint, Mazur signed the loss report because Hunt said it would not bar his subsequent claim for the two recently-acquired pieces.

He said she said by signing right away, he could get some of the money and not lose his right to claim the two additional items of jewelry at a later time. For this alleged misrepresentation, Mazur wanted compensatory damages of $41,000 and punitive damages of $2 million.

U.S. Fire and Crum and Forster answered that the proof of loss form had been "executed by the plaintiff in full satisfaction and indemnity for all claims and demands upon the insurance company issuing the Insurance Policy in question."

They argued that the final fraud charge should be rejected because Illinois insurance law provided administrative remedies for coverage disputes.

The trial court sided with the insurance company and agent. It rejected Mazur's lawsuit. He appealed.

The appellate court didn't buy his argument any more than the lower court did. It ruled held that Mazurs' claim for fraud against the company and

agent based on alleged negligent misrepresentations was preempted by the Insurance Code.

"Although labeled as a fraud count, the issue in [this case] is the amount of loss payable under the policy, with allegations that defendant's failure to pay is unreasonable or vexatious, a claim which is preempted" by the insurance code, the court wrote. "Apart from not being paid for the two pieces of jewelry, [Mazur] has not alleged that he suffered any additional harm from defendants' conduct."

Also, it is important to maintain an adequate level of insurance-to-value. Even when replacement cost coverage applies, the final amount may not exceed the amount that you actually spent to replace the property, or the policy limit for the damaged property.

If you don't agree with your insurance company about the value of a loss, your method of appeal is outlined by the standard policy. The insurance company states:

> If you and we fail to agree on the amount of loss, either may demand an appraisal of the loss. In this event, each party will choose a competent appraiser within 20 days after receiving a written request from the other. The two appraisers will choose an umpire. If they cannot agree upon an umpire within 15 days, you or we may request that the choice be made by a judge of a court of record in the state where the [house] is located. The appraisers will separately set the amount of loss. If the appraisers submit a written report of an agreement to us, the amount agreed upon will be the amount of loss. If they fail to agree, they will submit their differences to the umpire. A decision agreed to by any two will set the amount of loss.

> From time to time, policy owners bring suits against their insurance companies when they are dissatisfied over claim adjustments. Before this can be done, you must comply with the policy provisions concerning the reporting of the loss, cooperating with the company in settling the loss, etc.—and any suit must be brought within one year after the loss.

Be sure to update your insurance coverage. Many people forget to update their coverage beyond the automatic inflation of most policies.

Whenever language in an insurance policy is ambiguous, any dispute over coverage is ruled in favor of the policy owner. The insurance company has its opportunity to set terms in the drafting of the policy.

Finding Coverage

Before you buy insurance for your personal possessions, you should assess coverage you already have.

One place to find coverage for your possessions is under a typical homeowners or dwelling policy. A homeowners policy combines property and liability coverage; a dwelling policy covers only property. In either case, the property coverage is designed primarily for real property.

These kinds of insurance often don't provide full coverage for personal possessions; they usually limit coverage to a couple of thousand dollars. And these limits aren't usually enough to replace fine things.

Most policyholders have to purchase additional coverage to insure possessions for their full worth.

Some policies also provide a limited coverage for works of art, antiques, musical instruments, cameras, sports equipment, and oriental rugs. If you own something that doesn't seem to fit any of the above, you may want to look somewhere other than your homeowners policy for coverage.

However, homeowners and dwelling coverages aren't the only...or even the best...way to insure possessions. And suburban homeowners aren't the only people who need the protection.

Even if you're just renting your first apartment out of school, you may have things that you need to insure—computers, TVs, VCRs, stereo equipment, sports equipment, etc. These things can be worth thousands—or tens of thousands—of dollars.

The renters policy is purchased most often by renters of apartments or condominiums who do not require the complete range of coverage provided by the other standard homeowners forms.

If you're lucky, you may also find some coverage under your auto insurance policy. However, these possessions must be part of your car—not just items that were stolen from your car. Cellular phones, tapes, CDs, suitcases, purses, golf clubs and any other items you carry around in your car, are not covered under your auto policy unless they are "of" your car.

A caveat: Under an auto policy, coverage is not provided for damage to any property of others that is in your possession. If you borrow a friend's Ming vase for a tea party, accidentally leave it in the driveway and then back over it with your Dodge pick-up, there will be no coverage.

An auto policy also doesn't cover things like radar detectors. Because the purpose of the detectors is to help you avoid obeying the speed limit (and

because such equipment has been outlawed in some states), insurance companies won't provide coverage for the devices...under auto policies.

Lastly, some people protect their possessions by purchasing warranties or customized insurance policies from manufacturers or retail sellers.

As we will see later in this book, these coverages are usually trouble for two reasons: First, they're often full of exception, exclusions and loopholes; second, they're almost always more expensive per dollar of coverage than blanket insurance purchased for all of your possessions.

Additional Coverage

If you're starting off with a homeowners or renters insurance policy, you will probably need to look into buying separate, additional coverage for possessions of high or particular value. In the insurance industry, these additions to a standard policies are called floaters.

> **A floater is an endorsement tailored to a specific item; the coverage floats with the property wherever it goes.**

Floaters can be used to insure a number of particularly valuable possessions, such as jewelry, furs, cameras, computer equipment, musical instruments, silverware, stamps, coins, antiques, paintings, etc. They can be written either as separate policies or as endorsements—additions to a standard policy that expand its coverage.

> **Whether written for a business or an individual, an umbrella policy serves two major functions: it provides high limits of coverage to protect against catastrophic losses, and it usually provides broader coverage than underlying policies.**

Umbrella policies will provide insurance on an excess basis, above underlying insurance or self-insured retention—a layer of losses absorbed by the insured.

The coverage that we have discussed so far has applied mainly to property at a fixed location—your home, your apartment, your car. But you may own property that you either move around or need to transport somewhere— such as an expensive fur coat, camera equipment or a musical instrument. A typical insurance policy won't cover this type of property, or will, at very low limits.

Insurance coverage designed to cover certain kinds of personal property which is not at a fixed location falls into a group of policies known as marine or inland marine insurance.

While these complicated types of insurance are usually purchased by businesses, some individuals who own a lot of nice things...or a few nice things worth a lot of money...end up using them.

> You can also purchase specialty or customized insurance coverage to insure your valuable possessions. These types if insurance can be purchased on a stand-alone basis or as endorsements to more traditional policies. They include famous odd-ball coverages, like the policies written on tenor Luciano Pavoratti's voice or TV star Mary Hart's legs.

Common Flashpoints of Possessions Coverage

As we've mentioned already, people tend to err in thinking that their basic insurance will protect their unusual assets. Considering this point from another perspective may help illustrate its importance.

Here are just a few kinds of property losses which are not covered by standard insurance and therefore, may require you to purchase a customized or specialty policy:

- articles separately described and specifically covered by other insurance;

- animals, birds or fish;

- property of roomers, boarders and other tenants who are not related to an insured person;

- accounts, drawings, paper records, electronic data processing tapes, wires, records, discs, or other software media containing business data (blank records or media are covered);

- losses caused by the common power failure and ordinance law exclusions;

- losses caused by the neglect of an insured person to use all reasonable means to save and preserve the property;

- any intentional loss arising out of an act committed by, or at the direction of an insured person; and

- losses caused by or resulting from, contributed to, or aggravated by earth movement.

To make sure that you have adequate coverage, pay close attention to the wording of your policy. This applies particularly to the exclusions sections of most standard forms.

Here are a few examples, taken from actual policies, which may leave holes in your coverage:

...personal property and structures that are not buildings (e.g., a TV antenna tower) are valued at actual cash value (replacement cost less depreciation) or the necessary cost of repair.

...awnings, carpeting, etc., might be considered as building items but are to be valued at actual cash value and not replacement cost, which is the usual settlement basis for buildings.

> **Standard types of insurance do not always cover full replacement value of personal possessions. So, be wary of promises or assurances that agents give you about policies that cover full replacement value. This term is used freely—but it only applies in a relatively few policies.**

The terms "replacement value" or "full replacement value" usually refer to the structures (house, garage, etc.) covered in a homeowners or dwelling policy. They don't usually apply to the personal property inside the structure.

Other Dwelling and Property Claims Issues

In most cases, insurance companies generally settle claims by making payments to you, the policy owner. However, your insurance company also has the option of repairing or replacing the damaged property. This will occur when replacement can be made at a cost to the company which is less than that which the insured could negotiate.

> **The pair and set clause recognizes that the loss of one item from a pair or set may reduce the value of a pair or set by an amount greater than the physical proportion of the lost item to the set. It usually comes into play when items of jewelry, fine arts or antiques are involved.**

Example: A pair of antique candelabra is valued at $3,000. One of the sticks is stolen in a burglary. The value of the one remaining is established at

$1,200—so the value lost is $1,800. This would be the amount of the loss. If the missing candelabra could be replaced for $1,700, then the company has the option of making the replacement.

Strengthening Claims

Be sure to read your policy. This is very important. If you know what kind of coverage you have, you are more than likely to receive all that you are entitled to. The following is a list of common practices that help to support claims:

- Keep careful records. Make copies of everything. It's also a good idea to take notes at any meetings and conversations you have with your agent, insurance company or claims adjuster.

- Verify the adjuster's estimate. Don't accept an estimate without getting a written bid from another contractor.

- Don't settle for an unfair settlement. If you can't reach an agreement with your adjuster, contact your agent or the company's claims manager.

If you're still dissatisfied, some state insurance departments offer mediation services. In addition, most policies allow for an independent appraisal or arbitration process to resolve disputes over money. That decision is usually binding.

Keep track of when your premium is due and the expiration date of your policy. If you're late paying a renewal you may find yourself in a lot of trouble.

The easiest way for an insurance company to deny a claim is to show that the policy was not in effect when the loss occurred.

Of course, the issues aren't always so clear. If a loss occurs just before the expiration date of the policy and continues for two months afterward, the loss would be fully covered.

However, a dispute could arise over when—exactly—the loss first occurred.

Example: You make a claim that, because of an insured flaw in the construction of your house, a series of accidents began during a policy's coverage period and has continued afterward. The company may have to pay for damage which happened after the policy term.

If the insurance company can show that the loss didn't begin and continue—but is, in fact, several losses occurring independently—it can limit its liability to things that happened during the policy period.

Special Coverages

Other specialty coverages that apply to personal property:

- Mysterious disappearance/theft is a coverage essential for portable computer equipment in case of a claim, usually supported by a police report, of theft or disappearance. For example, such a claim may follow accidentally leaving a portable computer in a taxi and being unable to retrieve it.

- Valuable papers and records/cost of research coverage. Unless specified otherwise in a policy, coverage for magnetic media is limited to the value of replacement of the physical media, not the inherent value of the magnetic content. In your computer policy you may want to include coverage for research and replacement cost of information lost on the media for which duplicates do not exist.

- Utility interruption is the coverage for electrical surges and usually includes lightning that accesses equipment through electrical lines. Policies limit coverage for surges due to a power fluctuation within a specified distance from the premises. Lightning is still covered with no distance limitation. Before such a claim is paid, the company checks with a national registry of lightning strikes and/or with the electric company.

- The typical computer policy specifically excludes "data processing equipment installed in motor vehicles licensed for highway use." With the expanded use of wireless terminal technologies used in delivery trucks and other motor vehicles, such coverage may be appropriate.

- Policies do typically cover property "in transit or off-premises at a temporary location." The coverage is sometimes subject to interpretation with portables and company-owned desktop computers permanently located in an employee's home office. These items may be "permanently temporary," so "floater coverage" may be advisable.

- Programming errors exclusion coverage. Most policies exclude programming errors. Thus, you should consider asking programming vendors for a certificate of insurance to confirm that they have an error and omissions policy (malpractice insurance).

Misrepresentation

If any party to an insurance contract misstates a matter of fact, a misrepresentation has occurred. This can be grounds for nullification of the policy—or damages in excess of the policy limits.

> **An applicant who has been canceled by previous companies for excessive claims and does not show this on the application is making a material misrepresentation, since the company would probably not issue a policy if this information was known. As in the case above, the contract can be voided by the company and any claim denied.**

If you have an insurable loss, it is helpful to know the duties required of you as a policy owner. Generally, your policy states that you are required to:

- provide the insurance company with immediate written notice of a loss;

- notify law enforcement in case of loss by theft and a credit card fund transfer card company in case of loss to credit card or fund transfer card;

- protect your property from any further damage or make necessary repairs to protect the property;

- submit a complete and detailed inventory of all damaged and undamaged property, quantities, costs, ACV, and the amount of loss claimed;

- forward any legal papers received, such as a summons, to the company immediately;

- within 60 days of the loss, submit a signed proof of loss stating the time and origin of loss, interest of all parties involved, other insurance, value of each item, and any other information which the policy requires.

The June 1992 decision *Shelia Sturgeon Russell v. Farmers & Merchants Insurance* dealt with a complex personal property claim. The insurance company went to great lengths to deny the claim—but the court eventually ruled that its denial was bogus.

On January 31 1987, after an evening out with friends, Shelia Sturgeon Russell returned home at approximately 1:30 a.m. She discovered that the home and a shed on the premises had been burglarized. A large quantity of personal property had been taken or destroyed.

At the time of the loss, Sturgeon Russell had a homeowners policy with Farmers & Merchants Insurance Company, which included coverage for loss of personal property due to theft and vandalism. The named insureds on the policy were the Sturgeon Russell and her former husband Phillip Sturgeon.

In the midst of marital discord, Sturgeon had moved out ten weeks earlier, leaving Russell and their three children in possession of the home and its contents.

Lt. Dan Armour investigated the burglary and theft for the Sikeston police. He provided information, including copies of statements from persons he interviewed, to the defendant's investigator. Armour suspected the plaintiff was involved in the perpetration of the burglary and theft, and he expressed his suspicions to the defendant's investigator. From the exhibits on file and Armour's testimony, it appears his investigation was confined to January and February 1987. At trial Armour said the crime remained unsolved and no arrests were ever made.

On February 13, Patrick Hillman, an employee of General Adjustment Bureau (GAB), an independent adjusting firm hired by the defendant to investigate the plaintiff's claim, provided the plaintiff with inventory forms on which to list missing and damaged items. Because the plaintiff was unsure of what items were missing from the shed and their value, she asked her son to enlist the aid of her estranged husband in identifying and valuing those items.

Russell later said:

> And then when it come to the shed, as I said before, I couldn't
> get along with my ex-husband, so my son called him on the
> phone, and Phillip told him, because Phillip had come in and
> took his stuff that he wanted, and what was left was supposed
> to have been mine. That was our agreement, so he told Phillip
> what he had left out there, and then Phillip told me and also he
> listed it. He gave me the prices and everything of what he could
> remember that it cost.

One problem with this statement—her son and his father were both named Phillip, so the statement remains obscure. As a part of his investigation, on February 19, 1987, Hillman submitted to the defendant his first report, in which Hillman stated:

> As advised we have six pages of inventory completed by Shelia
> Sturgeon and we will be meeting with Phillip Sturgeon to verify
> that the items were actually in the home at the time of the al-
> leged burglary....As soon as that is completed we will be for-
> warding a blank proof of loss to Shelia Sturgeon.

The six-page inventory completed by the plaintiff contains 96 separate entries of items of personal property. One of the six inventory pages, which has the hand-written designation "Paul-Lisa" at the top, contains nine entries, including a three-wheel vehicle valued at $2827.46. The three-wheeler was recovered February 17. The total value of all items on the six-page inventory, excluding the recovered three-wheeler, is $17,157.10.

After Russell completed the inventory, Hillman met with Sturgeon who reviewed the six-page list. Sturgeon questioned the age of numerous listed items, he identified a ring that he said was lost prior to the burglary, and he noted several items (a comforter, a camera, and five household appliances) that he had "never seen" at the house.

Sturgeon said that the last time prior to the burglary he was in the house was "right before Christmas" and that, following the November 1986 separation, when he was in the house he "went through the kitchen and sat in the living room"; he did not go to other parts of the house.

On March 23, 1987, Hillman submitted his second report to the insurance company accompanied by four enclosures—including Russell's proof of loss form.

The proof of loss form, dated March 5, 1987, names "Phillip & Shelia Sturgeon" as the "insured." The form bore the signatures of Russell and her ex-husband and an acknowledgment by a notary public. On the proof of loss form, they claimed a total loss of $17,157.78, an amount sixty-eight cents more than the total value of items on the plaintiff's inventory, excluding the three-wheeler. The proof of loss form included this statement: "The property insured belonged at the time of the loss, to Shelia Sturgeon and no other person or persons had any interest therein except Paul Russell...."

Farmers & Merchants, through its claims attorney Richard Carroll, denied the claim in a detailed six-page letter addressed to Russell and Sturgeon and dated August 14, 1987. A return of premium was tendered with the letter.

In the letter, the insurance company set out five reasons for its action. Chief among these: Russell and Sturgeon had engaged in material concealment, specifically, that they had "lied not only on your application for homeowners insurance coverage with this company, but you have continued to perpetrate a fraud on this company by lying on your proof of loss and inventory forms."

Specifically, the letter read:

Our investigation has revealed several material misrepresentations made by you with respect to prior losses. For example, on question 18 on page 1 of the application, you left blank the

space asking for "Applicant's loss record past three years (on this or any other property)?" Likewise, question 2 on page 2 of the application asks "How many fire losses has applicant or any member of applicant's household had?" You answered "None." Question 3 on page 2 of the application asks for "Applicant's loss record on other than fire losses for the past three years on this or any other property?" The answer space there is left blank. In truth and in fact, you had made three prior claims within the three year period covered by the application.... In short, you deliberately lied to procure insurance coverage.... Based upon these material misrepresentations, we have elected to declare this policy void from its inception.

Russell had applied for the insurance policy sometime in June 1986. Because she and Sturgeon previously had sustained a $64,840 fire loss and an $18,986 tornado loss at the premises, their existing coverage with another company had been canceled. In shopping for new coverage, Russell called the Ziegenhorn insurance agency of Sikeston:

I talked to a girl over the phone. She asked me a few questions and the price of the insurance was pretty low, so we went ahead...with Ziegenhorn.

Q. What did you do after you decided that that's who you were going to purchase the insurance from?

A. She asked me a few questions on the phone and told me that I could come by later and bring a check in for the insurance, so that's what me and my husband did....

Q. And did you sign an application?

A. Yes, but it was blank.

Q. Was there anything on the application?

A. No.

Q. Was the document that you signed, did it have any typing on it?

A. No, sir.

Q. Did you in any way lie on your application?

A. No, sir.

Q. You answered every question that was asked you; is that correct?

A. Yes, sir.

She denied the two hand-written responses "None" on the original application were in her writing. She admitted that answers on the application concerning prior losses were false; she admitted she and Sturgeon had previously suffered the fire and tornado losses.

Her testimony that she had signed the application in blank was uncontradicted.

Adjustor Hillman identified Exhibit G as his sixth report to the defendant concerning his investigation. The report, dated March 31, 1987, states in part, "We contacted Beth Pigg a former employee of the Ziegenhorn Agency who had met with your insured, Shelia Sturgeon and had her to sign the application. This secretary has left the Ziegenhorn Agency and she refused to give me a statement in regards to the facts of the application."

In its denial letter, Farmers & Merchants also asserted that Russell and Sturgeon's "practice of deceit continued on your inventory forms and proof of loss." The insurance company pointed that the proof of loss form "states that you had never before suffered a burglary, theft or robbery when, in fact, you claimed to have suffered a burglary in January of 1985, where you claimed the loss of a Tappen microwave oven." The company also stated it had learned "from several reliable sources, including Mr. Phillip Sturgeon himself" that many of the items on the inventory "were not in the residence at the time of the alleged burglary...."

The letter stated the following additional reasons for denying the claim.

- Russell and Sturgeon had not complied with the terms of the policy by their failure "to provide us with bills, receipts and/or other documentation evidencing ownership."

- They had refused "to sign the tendered authorization forms for release of medical, tax, and bank records" which would have allowed Farmers & Merchants "to check for any possible financial motivation that you may have had for 'arranging' this burglary.

- "Given the fact that you were admittedly behind on many bills and that Mrs. Sturgeon has not been gainfully employed since at least 1981, there is a valid concern on our part that you ei-

ther removed items to make it appear as though a burglary had occurred or caused someone else to remove them."

- "Our policy expressly excludes from coverage 'loss caused by theft; a. Committed by an insured;' and 'Intentional loss, meaning any loss arising out of any act committed: (1) by or at the direction of an insured...'"

- "As a result of these exclusions, your loss would not be covered by the policy, since our investigation has revealed that the alleged burglary was no burglary at all, but an attempt by Shelia Sturgeon, Paul Russell and others to defraud this company."

- "Not only do we have witnesses who will testify that Mrs. Sturgeon lied on the inventory sheets and asked her husband to do the same, but we also have neighbors who will testify that they saw Paul Russell loading things into his pickup and hauling them off the day of the alleged burglary."

The denial letter concluded, "We further invite you to execute the previously submitted authorizations and to make full compliance with all reasonable requests that we make of you. If you choose to do so, we will again reconsider the matter...."

The authorization forms referred to in the denial letter included one that would have permitted the Internal Revenue Service to release federal income tax returns, one that would have allowed release of "any and all" medical information, and one that would have authorized the release of:

> any and all information that anyone might have ... concerning my/our past and present condition of well/ill being, my/our past and present employment or earnings record(s), my/our prior and present insurance records of all types and kinds, my/our health records and any and all types of records that relate in any way to my/our mental or physical condition, or my/our prior records of insurance claims or earnings, Workmen's Compensation documents of all types and kinds, any type of government records of any type or kind, whether the same be from any federal agency, state agency or local government agency, any and all bank or other financial records (at any institution whatsoever of any type), or any combination of the same.

Russell sued Farmers & Merchants Insurance Company for refusal to

pay for an alleged personal property loss that was insured under a homeowners policy issued to her and her former husband.

At trial, Sturgeon testified that prior to filing the March 5, 1987, proof of loss, Russell asked him to claim some things that were not his, specifically a three-wheel motorcycle, tools, shotguns, and a sapphire and diamond ring. He said Russell "offered to catch up on my van payments and to pay me for my loss if I would claim these items as mine." Sturgeon said Russell also offered him "a quick divorce." Sturgeon admitted that the prior losses omitted from the proof of loss statement were his as well as Russell's.

Instead, he filed his own claim to Farmers & Merchants.

By a check dated April 4, 1988, the company paid Sturgeon $4,281 to settle his separate claim. In exchange for the payment, Sturgeon signed a "Release of All Claims and Agreement" in which he agreed to "cooperate with the [insurance company] in any action brought by his former wife, Shelia J. Sturgeon," and stated that all the assertions in the company's August 14, 1987, denial letter were true.

Russell testified that she was unaware, until "a few months" prior to the May 22, 1991, trial, that Farmers & Merchants had paid Sturgeon on his separate claim. Farmers & Merchants' attorney Carroll testified at trial that "based upon the completed investigation up to that point, August 14, when I wrote this letter, this information is false. The application is false."

Carroll made it clear that the August 14, 1987, denial letter was directed to both Russell and Sturgeon, that it was intended to deny all claims under the policy arising from the alleged burglary and theft, and that the allegation of misrepresentations on the application applied to both Russell and Sturgeon.

Nevertheless, Carroll acknowledged that "later" he decided "to believe [Sturgeon] and not [Russell]." In April 1987, Farmers & Merchants had obtained a sworn statement from Sturgeon, a statement that does not appear in the record. Based on that statement and "in talking with him," Carroll determined that Sturgeon was telling the truth.

Carroll paid Sturgeon even though he "did not require a bunch of receipts" from him. He said he did not require the documentation from Sturgeon because he did not believe Sturgeon was involved in any misrepresentations on the application or the claim. Regarding Russell's claim, Carroll admitted that the defendant's attorney had requested receipts for only 39 of the items on her list, that Russell provided "some" receipts to the defendant's attorney in January 1988.

The jury reached a verdict in Russell's favor. The court then entered judgment in the amount of $17,157.78 for theft loss; $1,550 for interest;

$2,020.20 penalty for vexatious refusal to pay; and $7,500 for attorney fees. Farmers & Merchants appealed.

The Court of Appeals held that:

- there was substantial evidence from which the jury could conclude that the false answers about prior losses on the application were result of agent mistake rather than Russell's bad faith;

- evidence was sufficient to support a jury finding that Farmers & Merchants's refusal to pay Russell's claim—after paying Sturgeon's claim—was willful and without reasonable cause, thus warranting statutory penalty for "vexatious refusal to pay"; but

- evidence did not support the award of attorney's fees.

Conclusion

If you have chosen your insurance effectively, making a claim will be pretty straightforward. Of course, the circumstances leading up to a claim (burglary, fire or other disasters) can make even the calmest mind nervous and edgy.

This chapter has focused on the effective measures to take with regard to a claim—from reporting an accident to choosing the right claim adjuster.

This book has attempted to give you a basic understanding of the insurance that covers your valuable possessions. This is complicated coverage...much more so than homeowners or car insurance.

Your valuables may be as simple as a nice stamp collection or as complex as tens of thousands of dollars in somewhat business-related electronic equipment.

Part Four:

Your Life...and Everything That Means for Your Affairs

Chapter 10

Life Insurance as a Death Benefit

Life insurance plays an important role in the financial planning of most people. More than 80 percent of American households have purchased some form of individual life insurance policy.

In the purest sense, life insurance is a contract that pays a death benefit to someone when an insured person dies. The primary purpose of life insurance is to protect against the risk of premature death—dying too soon.

Premature death exposes a family or a business to certain financial risks such as burial expenses, paying off debts, loss of family income and business profits.

You also may want your life insurance policy to pay estate taxes or to set up a college fund for your children.

Over the years, life insurance policies have evolved from fairly straightforward contracts that provided one type of benefit into complex contracts that often include numerous types of benefits and features. New products have frequently been introduced in response to changing economic conditions and consumer preferences—and that trend will continue in the future.

> **If you don't have dependents, you probably don't need life insurance. But if you have dependents—a spouse, children, elderly parents—that rely on your income, you probably need to consider life insurance to pay expenses for them.**

You also may consider insuring the life of a spouse who is not earning money. That's because the spouse may be helping with family expenses by caring for children instead of putting them in child care.

Today, individual life insurance represents the greatest percentage of in-force business in the United States. It may be characterized as life insurance issued for face amounts of at least $1,000 (the face amount is what's paid when an insured person dies).

Life insurance is the only financial services product which guarantees that a specific sum of money will be available at exactly the time that it is needed. Bank savings accounts, mutual funds, stocks, bonds and other investments do not make such a guarantee.

Since the face amount of the policy is payable upon the death of the insured person, the element of risk to the insurance company is much different than it is for an automobile policy. When an insurance company issues an auto policy, it hopes that the insured person will be a safe driver and will never have an accident. When an insurance company issues a life policy, it knows it will someday be called upon to pay a claim because every human being dies eventually. For the company, the only unknown is whether the claim will be made in one year...or in 50.

The term *ordinary insurance* is sometimes used to describe individual insurance. There are three broad types of individual or ordinary life insurance—whole life, term life, and endowment policies. Life insurance costs vary based on your age, health habits and the amount of insurance.

A life insurance policy may offer a larger benefit when the death of an insured person is accidental. When twice the face amount of the policy is paid upon death occurring accidentally, the coverage is known popularly as *double indemnity*. However, as anyone who's ever read a detective novel can attest, an accidental death is sometimes hard to determine.

An insurance policy is a legal contract. The validity of life insurance policies as such has been established in the United States since 1815. As does any contract, a policy contains provisions setting forth the rights and duties of parties to the contract.

While it is necessary to look beyond the actual wording of the policy contract and into the statutes and court decisions for a full interpretation of policy provisions, they are the basis of the agreement between the company and the policyholder (and the beneficiaries and assignees of the policyholder).

There are no standard policies in life insurance—as there are in the property and casualty insurance field. However, many states have provisions that are required in all life policies so that some provisions have become more or less standard.

How Life Insurance Is Sold

Insurance companies have thousands of agents selling policies to business people and consumers. Some companies, however, seem to have a few staffers in the home office whose job it is to deny claims. Often, these denials maintain that the insured person lied on the insurance application.

> When companies deny claims, people who thought they had insurance coverage often contact lawyers. This results in litigation over insurance bad faith. There is so much of this going on that these cases have become a staple of the legal profession.

The 1997 federal appeals court decision *Vining v. Enterprise Financial Group* illustrates how lucrative a successful bad faith claim can be. Milford Vining bought a Jeep from a dealer in Oklahoma in 1992. Enterprise Financial, an insurance company, appointed a dealership employee as agent for the sale of credit life policies, which pay off loans if an insured person dies.

Nine years earlier, Vining had had triple bypass surgery. At the time he applied for insurance on the Jeep loan, he felt good and led an active life. During the previous year, Vining made one visit to a physician, not for treatment but to introduce himself to a new doctor. So, Vining certified on his insurance application that he was in good health. The insurance company issued the policy as guaranteed.

A little more than a year after Vining bought the Jeep and insurance policy, he died of a heart attack. At the time, the Enterprise policy had a payout value of about $10,000. The company immediately obtained records of Vining's introductory visit to a physician. When Enterprise received the doctor's notes, it rescinded the Vining policy.

Vining's widow, Billie, tried for years to handle the problem through state insurance authorities. Officials investigated, fined Enterprise $15,000, but did nothing to aid recovery on the policy. So Billie hired a lawyer and sued charging bad faith.

A jury found for Billie. It awarded $400,000 in actual damages, $400,000 in punitive damages, $163,000 in prejudgment interest and $94,224 in attorney's fees. That's a verdict of $1,057,224 handed down because the insurance company refused to pay a $10,000 claim. The verdict was more than 100 times the amount of the original claim.

Enterprise took the case to the U.S. Court of Appeals. The appeals court discovered some shocking things. Enterprise's claims examiner, back at the home office, said she denied 40 percent of all claims submitted.

When a customer died within two years of policy purchase, she turned down the claim. She didn't bother checking the facts. She never paid a claim if she had any reason to doubt that a health history was inconsistent with the required certification.

The claims examiner said she thought the single visit to a doctor and continued use of cardiac drugs were contrary to Vining's statement that he was in good health.

Enterprise's sales people emphasized that prospects need only be between 18 and 65 years of age to buy insurance. Company manuals said nothing about health or about salespeople gathering health information.

Enterprise's practices were highly profitable. The company denied so many claims that its loss ratio—the ratio of benefits paid to premiums received—was only about 16 percent. The normal loss ratio in the life insurance industry is about 50 percent, a level required by law in several states.

> **Insurance companies have a legal duty to deal fairly and in good faith with their policyholders. Bad-faith claims focus on the unreasonableness of the company's conduct.**

Nevertheless, an insurance company can litigate a claim when there is a legitimate dispute about coverage or amount of the claim. Enterprise wanted appellate judges to rule that its dispute in the Vining case was legitimate. The judges refused to agree.

The court ruled that Vining's widow had established a deliberate and willful pattern of abuse by Enterprise as it handled claims under its policies. The company ordinarily rescinded policies issued as guaranteed when insured people made claims. The company routinely canceled policies without finding out whether it had good cause to do so. That, said the court, is bad faith.

The only change that the appeals court made to the jury's verdict was to set aside the award of interest. Billie took home almost $900,000, or about $890,000 more than Enterprise would have spent had it just paid the claim.

If you come across a claim-denier, don't give up. Talk to a lawyer. That denial could turn out to be the best deal you ever had.

Different Types of Coverage

Life insurance comes in several varieties.

Term life insurance provides protection for a specified and limited period of time, typically from one to 20 years. Term life is temporary insurance

that essentially provides a death benefit only. The benefit is paid only if the insured person dies before the end of the specified term. If the insured person lives beyond the end of the term coverage, the policy simply expires.

A term policy does not build any cash, loan, or surrender values.

Since term insurance does not build cash values, an insured person only has to pay for the death benefit and policy expenses. For this reason, it is usually the least expensive form of life insurance. It may be used as an inexpensive tool to satisfy a variety of temporary insurance needs, such as a mortgage obligation or the need to protect insurability until an insured person can afford permanent protection.

There are different types of term policies. Level premium term provides a consistent amount of insurance. Decreasing term, which is a good type of insurance to cover a shrinking debt obligation (like a mortgage), starts with a specified face amount which decreases annually until it reaches zero at policy expiration. Increasing premium term provides a growing amount of insurance, but the need for this type of protection is rare.

Whole life insurance, sometimes called straight life or permanent life, is protection that can be kept as long as you live. With this kind of insurance, you can choose to pay a premium that doesn't rise as you grow older, averaging the cost of the policy over your life.

Whole life insurance has a cash value—a sum that grows over the years with taxes deferred. If you cancel the policy, you receive a lump sum equal to this amount (and you pay taxes only if the cash value plus any dividends exceeds the sum of premiums paid).

The face amount in a whole life policy is constant, and this amount is paid if you die at any time while the policy is in effect. The policy is designed to mature when you reach 100 years of age. At this point, payments end and the policy's cash value equals the face amount.

At maturity, the face amount of a whole life policy is usually paid—even if you are still living.

Although whole life policies are among the most common forms of life insurance sold, most individuals do not plan on paying premiums until age 100. More commonly, whole life insurance is used as a form of level protection during the income producing years. At retirement, many people then begin to use the accumulated cash value to supplement their retirement income.

This type of life insurance plays an important role in financial planning for many families. (We'll consider financial planning and how it affects claims in the next chapter.) In addition to the death benefit or eventual return of cash value, the policy has some other significant features. During a financial emer-

gency, policy loans may be taken and the full policy values may later be restored.

Ordinary policies may be participating (par) or nonparticipating (non-par). A *participating* policy is one in which the policyholders share in dividends (if a dividend is declared). A *nonparticipating* insurance company does not pay dividends to policyholders. It pays dividends to outside shareholders.

Par policies are issued by mutual life insurance companies. Non-par policies are issued by stock life insurance companies.

Universal life insurance is protection under which a policyholder may pay premiums at any time, in virtually any amount, subject to minimums. The amount of the cash value reflects the interest earned and premiums paid, minus the cost of the insurance and expense charges.

Universal life policies seek to compete in the term insurance marketplace. They offer standard rates that can be substantially cheaper—as much as 30 percent or more—than standard rates charged by term insurance companies for comparable coverage.

Some universal life policies feature progressive underwriting, which is meant to attract otherwise uninsurable consumers. These policies are usually structured so that, if policyholders pay the level minimum annual premiums, coverage won't lapse for 15 or 20 years.

Progressive underwriting means companies are aggressive in determining a person's true risk. Instead of evaluating risk on a by-the-book basis, they pursue questions to find out what's causing any abnormalities in a person's claims history.

Variable universal life insurance provides death benefits and cash values that vary according to the investment returns of stock and bond funds managed by the life insurance company. These policies also allow the policyholder significant discretion in the premiums paid each year. These policies allow the policyholder discretion to choose how funds are invested.

For many people, variable universal life is as much an investment tool as a true insurance tool. The cost basis of universal life becomes too uncertain because of the open-ended method of premium payment. There's trouble if the insurance company can't project costs. Target premiums are fixed in the first year but policyholders, because of the flexible nature of the products, are not contractually bound to pay those amounts in subsequent years.

In fact, target premiums for this kind of insurance are among the highest in the industry. This is why agents sell variable universal so aggressively—

because their commissions are often based on target premiums, they can make more selling this than other kinds of life insurance.

Who's Involved in a Life Insurance Contract

When a life insurance policy is issued, a number of parties may be involved with respect to contract obligations and benefits. Obviously, the insurance company is a party to the contract—in exchange for the premium payment, it agrees to pay benefits if the policyholder dies.

Since the insurance will pay a benefit if the insured person dies, it is also obvious that this person is a party to the contract. But there may be other parties. To identify these parties, we need to consider who owns the policy, whose life is insured, and who is entitled to the benefits. In the life insurance business, these parties may differ depending upon how the policy is issued and what rights are exercised.

The *insured* is the person whose life is insured. A death benefit will be paid if this person dies while the insurance is in effect.

The *owner of a policy* is the person who applies for the insurance, agrees to pay the premiums, and has certain ownership rights. Generally, the policy owner has the right to elect or change the beneficiary, to elect settlement options, and to assign ownership to another person.

A *beneficiary* is someone who is entitled to death benefits if the insured person dies. There may be one or more designated beneficiaries. There may be primary beneficiaries who are entitled to the proceeds if they are living, and contingent beneficiaries who are entitled to the proceeds if there is no surviving primary beneficiary when an insured dies.

Example: George buys life insurance on his own life and directs that the proceeds be paid to his spouse. George is the owner. George is the insured. George's spouse is the beneficiary.

The owner of a policy may or may not be the insured person, and may or may not be the beneficiary. The same person cannot be both the insured and the beneficiary, but the insured's estate can.

Example: Sally buys life insurance on her husband's life, Jim, and names herself as beneficiary. In this case, Sally is both the owner and the beneficiary. Jim is the insured.

The owner of a life insurance policy is entitled to certain valuable rights. These include the right to assign or transfer the policy, and the right to select

and change the payment schedule, beneficiary and settlement option. The owner also has the right to receive cash values or dividends and the right to borrow from the cash values.

Insurable Interest

You can't purchase life insurance on the lives of *anybody*. In order to purchase life insurance, you must have a legitimate insurable interest in the subject of the insurance. There must be a personal risk of emotional or financial loss, and a legitimate interest in preserving and protecting the life being insured.

Without a requirement for insurable interest, people might gamble on the lives of total strangers, particularly those who engage in high-risk activities. Additionally, the absence of insurable interest might actually put lives in danger—a person might act to cause another person's death or fail to exercise reasonable safety precautions to protect someone else if they had no personal risk of loss and stood to gain financially from the death.

> **Every person is presumed to have an insurable interest in his or her own life. However, this interest is not unlimited. If the amount of insurance applied for is disproportionate to a person's apparent needs, it will raise underwriting concerns on the part of the insurance company.**

Example: Dave, who has an annual income of $25,000 and very few assets, applies for $5 million of life insurance. Dave's economic status would not seem to justify such a large need for insurance, and his income is inadequate to pay the required premiums.

Upon investigation, the insurance company discovers that Dave has numerous outstanding gambling debts and other financial problems. He also has a wife and three children. This application would probably be turned down because of the extreme risk that Dave may be planning to stage his own death.

You also have an insurable interest in the lives of close relatives through blood or marriage. Usually this extends to those who could be considered immediate family members—such as your spouse, children, parents, and perhaps brothers and sisters.

The requirement for insurable interest becomes more difficult to justify when insurance is sought on the lives of more distant relatives, such as uncles, aunts, nephews, nieces, and cousins, but insurable interest certainly may exist in these cases—especially when these claiming relatives live in the same household as the insured person.

Insurable interest may also be established on the basis of business and financial relationships. Members of a partnership have an insurable interest in the lives of other partners. Lenders have an insurable interest in the lives of borrowers to the extent of the funds at risk. Any commercial enterprise, ranging from corporations to movie studios and professional sports organizations, may have insurable interests in the lives of individuals who make significant contributions to sales and profits.

In the life insurance business, insurable interest must exist at the time of application and inception of the policy and not necessarily at the time of death.

If a policy is valid when it is issued, the death benefit is payable even if insurable interest no longer exists at the time of the insured person's death. The requirement for insurable interest applies only to the owner of a policy. There is a greater flexibility allowed when it comes to the proposed insured's selection of a beneficiary.

Example: Roseanne purchased life insurance covering Tom, naming herself as beneficiary, when they were married. They never had children and divorced a few years later. Both remarried. Many years passed by, during which Roseanne and Tom had no communication with each other—but Roseanne continued paying premiums to keep Tom's life insurance in force. When Tom died and Roseanne read about it in the paper, she submitted a claim. The claim is valid because Roseanne had an insurable interest when she originally bought the policy.

In real life situations, people don't usually continue to pay life insurance premiums after an insurable interest has ended. When insurable interest no longer exists, ownership of a policy may be transferred or assigned to the insured person, his or her new spouse, children, or someone else who has a more current insurable relationship with the insured person.

The Life Insurance Application

In completing a life insurance application, you will usually be asked to provide some general information, including: your full name, address, phone number, social security number and billing address. You may also be asked to provide some more specific information, including: hobbies and whether or not they are considered dangerous (a hint: scuba diving, hang gliding, flying small aircraft and bungee jumping are) and medical history (if you've been previously declined or rated for life insurance).

In most cases you are also asked to take a physical examination, paid for by the company to which you are applying. All of this information is needed for the insurance company's underwriting process.

The insurance company wants to know exactly what type of risk you might be. It assesses all of your information concurrently to make a well informed decision. The risk it sees within the obtained information is all taken into consideration when the company makes a decision to offer you coverage or decline your request.

> **You may end up somewhere between insurable and not insurable. If so, the insurance company may offer you a rated policy for which you must pay a higher premium.**

At the time you complete the application, you sign and date it to confirm that all the information you have given is true to the best of your knowledge. Most companies have a clause regarding misstated information or a fraudulence clause. This gives the company the right to review its decision if you have provided false information or omitted information.

The contestability period—which usually lasts for two years—is the time within which an insurance company may deny a claim based on information you have stated in the application. After this period, the policy becomes incontestable and the company may not deny a claim even if fraudulent or concealed information is discovered. The insurance company may then deny a claim only on the ground that an insurable interest was not present between the insured person and owner at the time of application.

Upon receiving your policy, make sure you review the type of plan, owner, beneficiary, premium, face amount and schedule of future premiums thoroughly before accepting it. Be sure you understand the exclusions, length of time the policy will be in force and optional values. If you use an agent, he or she will usually provide a summary page that minimizes any confusion.

Be sure you understand what rights the company has to make changes and what assumptions were used.

Accelerated Benefits and Settlements

Buying the right policy is only half of the life insurance challenge. Making a claim successfully is the other—and probably more important—part.

During the insured person's lifetime, the owner may select from several different options for paying the proceeds of a life insurance policy to beneficiaries. The most common of these include:

- lump sum,

- interest only,

- total amount spread over several years,

- fixed amount every year for several years, or

- lifetime income.

This is important to consider where the beneficiary may not be experienced in investing large sums of money, where minor children are involved or when the identity of the insured is clear on specific goals.

In any of these situations, you may want to request one of the scheduled distribution plans.

A caveat: These provisions for payment following the death of an insured person only apply if there are guaranteed amounts unpaid. Nothing would be payable under the straight life income or upon the death of the last survivor under a joint life income annuity.

Structured settlements provide alternatives to receiving the policy proceeds in a lump sum. The policy owner has the right to elect one or more settlement options while the insured person is alive. If the insured person dies when no election is in effect, the beneficiary may elect a form of settlement.

The fixed period option may be a logical choice if your beneficiary needs temporary security and not a lifetime income if you die. If one or more children are named as the beneficiary, it might be desirable to only provide financial assistance until they finish their education, begin their own careers, and reach independence.

The life income option is designed to satisfy an entirely different need—the need for lifetime income. It is frequently elected as the form of payment for a death benefit to a surviving spouse, or for payment of cash values to an insured person who lives to retirement age.

The amount of the scheduled installments is based on the adjusted age of the payee when benefit payments begin and the remaining life expectancy (insurance companies calculate this by using something called mortality tables). The younger a person is when benefits begin, the smaller the amount paid—because the insurance company expects to continue paying longer.

The straight life income option continues to pay for as long as the beneficiary lives, but all obligations of the insurance company end as soon as that person dies. Under this method, a person could die after receiving a single installment, or live far beyond normal life expectancy and collect many times the amount of premiums paid in.

This option may also be elected with a guaranteed period (also known as a *period certain*), in which case payments will be guaranteed for a specified period of time even if the payee dies sooner.

A guaranteed period helps offset the concern of some people that they may die before receiving the insurance benefits paid for. But since the insurance company is no longer dealing only with life expectancy, it must set some funds aside to cover the possibility that it will continue payments beyond a person's death. For this reason, a guaranteed period will reduce the benefit payments—the longer the period guaranteed, the smaller the benefit.

Under the interest option, the insurance company holds the entire proceeds and makes period payments of the earned interest only. The interest rate may be flexible but a minimum rate of interest is usually guaranteed in the policy.

This option might be elected if a beneficiary, such as a surviving spouse, was financially secure and had little need for the proceeds. With the approval of the insurance company, you might specify that the proceeds will be paid to another person (such as surviving children) upon the death of the beneficiary.

Under the fixed amount option, you choose the dollar amount of the benefit payment. This fixed amount will be paid periodically until the entire proceeds are exhausted. Interest, at a minimum guaranteed rate, will be added to the proceeds annually.

> **Payments may be received under a combination of options. Elections of settlement options are made in the same manner as changing a beneficiary—a written notice to the insurance company. Election by an entity other than an individual (such as a trust or an estate) is allowed only if the insurance company consents.**

A number of miscellaneous provisions apply to settlement of the proceeds. Total proceeds of under $5,000 payable to any one person will be paid as a single sum. If scheduled payments would be less than $50, the payment period will be lengthened so that at least $50 will be paid.

The life income or joint and survivor income options apply only if the policy owner is the insured person or a beneficiary who has survived the insured. Proof of age is usually required when a lifetime income will be paid, because age affects the amount of the payments.

Generally, a beneficiary cannot assign installment or interest payments to someone else and may not withdraw proceeds which are to be held by the insurance company under the option selected. However, exceptions may be

permitted if requested by the policy owner and agreed to by the insurance company.

Example: If you elect the interest option for payments to a beneficiary, the beneficiary would receive interest only and never have a right to withdraw the principle of his or her benefit. But, if you direct that the beneficiary may be permitted to withdraw a specific dollar amount or percentage of the proceeds for special needs (such as education or purchase of a home) and the company agrees, the beneficiary would be permitted to withdraw some of the proceeds.

> **Under options which provide scheduled payments, the benefits may be paid monthly, quarterly, semi-annually, or annually. The fixed period option pays equal installments for a specified number of years—for example, 10 years or 20 years. Amounts to be paid are determined by the number of years selected and interest earnings on the unpaid balance at a rate specified in the policy. Naturally, the longer the payment period, the smaller the benefit because the proceeds have to last longer.**

Just about every life insurance policy contains settlement tables, which show dollar amounts per $1,000 of insurance for the option selected. These are simply rows of numbers representing periods of time, adjusted ages of insured people, and benefit amounts. We do not reproduce the tables here, but we will give you some examples.

Example: Under a 20 year fixed period option, the policy would pay a monthly installment of $5.51 per $1,000 of insurance. For a $100,000 policy, this would equal $551 in monthly income, or $6,612 annually, for 20 years.

The Effect of Misrepresentations

A common point of coverage dispute between life insurance companies and policyholders is misrepresentation on policy applications. These situations will usually involve issues—like reasonable reliance and bad faith refusal to pay—that we've seen elsewhere.

The January 1997 U.S. Court of Appeals decision *Virginia Kay Hays et al. v. Jackson National Life Insurance* dealt with alleged misrepresentations surrounding a life insurance claim.

In the fall of 1991, with the help of Jackson National's agent, Oklahoma resident James T. Hays completed an application for a Jackson National life insurance policy. Part Two of the application required Hays's responses to a

series of questions regarding his medical history. The agent filled out Part Two based on responses provided by Hays. Part Two contained the following pertinent questions and answers:

3. Have you, in the past five years:

a. Consulted or been treated by a physician or other medical practitioner? Yes

....c. Had an electrocardiogram, X-ray or other diagnostic test? No

d. Been advised to have any diagnostic test, hospitalization, or surgery which was not completed? No

Having answered "yes" to question 3.a., Hays provided these details: "3.a.1967— Ulcer operation—Dr. Meekly—Sacramento, CA."

The only other information disclosed on Part Two relating to Hays's medical history is the name, address, and telephone number of his personal physician, along with a notation that Hays had last consulted that doctor for a broken right foot.

Two days after Hays and the agent completed Part Two, Jackson National sent a paramedic to Hays's home to complete Part Three—the "Medical Examination Report." On Part Three, in response to the same questions posed on Part Two, Hays again mentioned the 1967 ulcer operation, explaining that it was a gastric resection which had required ten to twelve days in the hospital. He also stated that he wore corrective lenses; that in 1990 he sprained his knee skiing; that he had recently broken his right foot; and, finally, that in 1989 he had had a complete physical by his personal physician with normal results. Hays signed both Part Two and Part Three.

Jackson National issued Hays a $500,000 life insurance policy on November 8, 1991. Five months later, Hays was diagnosed with cancer of the esophagus. He died quickly—in August 1992.

Virginia Hays was James Hays's widow. After she and several family members made their claim on the policy, Jackson National discovered that Hays had not provided information on the application relating to the condition of his esophagus. Medical records showed that between 1989 and 1991 Hays had his esophagus examined on at least four occasions by three different doctors. During these examinations, Hays underwent an esophagram, three esophagogastroduodenscopies, and multiple biopsies of the esophagus. The examinations revealed an esophageal ulcer, and Hays was diagnosed with Barrett's Esophagus—a permanent change in the esophageal tissue resulting from long-standing reflux of gastric acid.

The biopsies had proved negative for cancer, but at least two different doctors informed Hays that regular surveillance of his esophagus would be required. (In fact, on the very day that Jackson National had issued the policy, one of the doctors apparently notified Hays that he was due for another EGD. It was this next EGD which revealed the cancer.)

> **Based on Hays's failure to disclose any of this information, Jackson National refused to pay benefits under the policy and returned all premiums to the family.**

Virginia and the family filed suit, claiming breach of contract, bad faith, outrage, and reformation. Jackson National moved for summary judgment, arguing that Hays's failure to disclose the information relating to his esophagus entitled it to refuse payment.

Jackson National argued that had it known Hays's true medical history, it would have denied coverage or issued a different policy, citing its underwriting manual which instructs that applicants with Barrett's Esophagus should have their applications rated, or denied, depending on the adequacy of medical follow-up.

Oklahoma law states, in relevant part:

All statements and descriptions in any application for an insurance policy or in negotiations therefor, by or in behalf of the insured, shall be deemed to be representations and not warranties. Misrepresentations, omissions, concealment of facts, and incorrect statements shall not prevent a recovery under the policy unless:

1. Fraudulent; or

2. Material either to the acceptance of the risk, Or to the hazard assumed by the insured; or,

3. The company in good faith would either not have issued the policy, or would not have issued a policy in as large an amount, or would not have provided coverage with respect to the hazard resulting in the loss, if the true facts had been made known to the company as required either by the application for the policy or otherwise.

In response, the family argued there were genuine issues of material fact precluding summary judgment. They asserted that Hays's response to question 3.a. (on Part Two) disclosed he had been treated within the last five years

in relation to his 1967 ulcer operation. They claimed Hays's esophageal problems were directly related to that ulcer operation. Therefore, they reasoned, the response to 3.a. was not a misrepresentation. In fact, it should have tipped Jackson National off that it should conduct its own investigation before issuing a policy.

In a connected argument, the family contended that the agent who filled out the application was a personal friend of Hays and knew more about Hays's health than disclosed on the application. They claimed the agent told Hays that his responses on the application were sufficient because Jackson National would contact Hays's personal physician and conduct its own investigation. Finally, they argued that in order for Jackson National to rely on Oklahoma law, it had to prove that Hays made the misrepresentations or omissions with an intent to deceive.

The trial court held that Oklahoma law did not require Jackson National to prove an intent to deceive. It held that Jackson National needed only prove Hays "knew or should have known that he omitted facts from his application which were material to Defendant's acceptance of the risk."

The trial court did not explicitly address the family's arguments relating to the agent's assurances that Jackson National would conduct its own investigation, or to the additional knowledge the agent allegedly possessed regarding Hays's medical history. Instead, the court turned directly to the significance of the omitted information. The court stated:

> [Hays] omitted any mention of his diagnosis of Barrett's esophagus on the application. When asked to list physicians who had treated him within the past five years, he did not include two physicians who examined him for this condition within the past two years. Although he underwent at least two diagnostic tests for the condition and was advised that more would be required, he did not report this in the space on the form which specifically asked him to list diagnostic tests. The court therefore concludes that no reasonable jury could find that [Hays] did not know or should not have known that this information was requested.

The court further found there was no question the omissions were material since "Defendant's policy notes that Barrett's esophagus is a precancerous condition and Hays did, in fact, die of cancer of the esophagus only months after obtaining the policy."

Having found Jackson National was entitled to refuse payment, the court dismissed the family's bad faith and outrage claims. It also dismissed plain-

tiffs' claim for reformation, noting that "there is no controversy arising out of the language of the policy itself, and therefore reformation is not available."

The family appealed.

The Court of Appeals held that:

- under Oklahoma law, finding that the insured person intended to deceive the company is necessary before misrepresentation or omission on the insurance application can serve as ground for avoidance of policy and nonpayment of a claim;

- material issue of fact existed as to whether the insured person intended to deceive the company when he omitted certain information regarding esophageal examinations, inasmuch as fact finder might infer that the insured person was relying on agent's statement that an insurance company would investigate his medical records;

- beneficiaries were not entitled to reformation of policy to amount of the insurance that would have been issued had the insurance company known of the insured person's true medical history; and

- the company's failure to conduct preissuance investigation into the insured person's health could not form basis for a claim of either bad faith or outrage.

Specifically, the appeals court wrote:

Having concluded that intent to deceive is required, we must reverse the dismissal of the breach of contract claim. Because this case comes to us on summary judgment, plaintiffs' evidence must be believed, and all justifiable inferences are to be drawn in their favor.

Still, the issue is close. We agree with the district court that Hays's application answers did not reveal a significant amount of material, requested information. Considering that Hays provided such comparatively unimportant information on Part III regarding a skiing injury, corrective lenses and a broken foot, we find it particularly suspicious that he somehow felt it unnecessary to reveal his esophageal examinations. Intent to deceive is a reasonable inference from the facts.

On the present record, however, we cannot say that intent to deceive is the only reasonable inference. Jackson National's

agent filled out the application, and he believed the response to question 3.a. revealed that Hays had been treated within the past five years for problems relating to his ulcer operation. The agent thought Jackson National would contact him...for further medical information, and he told Hays that [it] would conduct its own investigation. The agent also states that, at the time he filled out the application, he knew Hays had "stomach problems," and that Hays had been "checked out, and that the tests proved negative for cancer and ulcers."

So, the appeals court ruled for the Hays family.

Accelerated benefits

If you have a terminal illness, a life insurance policy may be your last substantial source of money. The life insurance benefits may be made available for medical expenses and living expenses prior to death through accelerated benefit provisions or viatical settlement agreements.

Accelerated benefits are living benefits paid by the insurance company which reduce the remaining death benefit. The government does not currently consider accelerated death payments to be taxable income, and the policy owner can get between 50 and 95 percent of the policy's face value.

Under a viatical settlement, the policyholder sells all rights to the life policy to a viatical settlement company, which advances a percentage (usually 60 percent to 80 percent) of the eventual death benefit. The viatical settlement company then receives the death benefit when the insured person dies.

Unlike accelerated benefits, proceeds from viatical settlements are considered taxable income by the government.

Accelerated death benefits require a life expectancy of one year or less. Viatical settlements are available for a person who has up to five years to live.

> **Long term care (LTC) insurance, which reimburses health and social service expenses incurred in a convalescent or nursing home facility, is often marketed as a rider to a life insurance policy. In many respects, this coverage resembles an accelerated benefit.**

LTC rider benefits usually include the following provisions:
- elimination periods of 10 to 100 days,

- benefit periods of 3 to 5 years or longer,

- prior hospitalization of at least three days may be required,

- benefits may be triggered by impaired activities of daily living, and

- levels of covered care include skilled, intermediate, custodial, and home health.

In addition, certain optional benefits may also be provided such as adult day care, cost of living protection, hospice care, etc.

The accelerated benefit or living needs clause combines life insurance and LTC benefits, drawing on the life insurance benefits to generate LTC benefits. In a sense, it's like borrowing from the life insurance to pay LTC benefits.

Under the LTC option, up to 70 to 80 percent of the policy's death benefit may be used to offset nursing home expenses. Under the Terminal Illness option, 90 to 95 percent of the death benefit may be used to offset medical expenses. Of course, payment of LTC benefits reduces the face amount of the life policy.

How the proceeds of a life insurance policy are paid is a common source of litigation. Issues involve everything from the terms chosen by the policy owner to misstatements made in an insurance application.

In recent years, though, the key issue that has been raised about life insurance proceeds has been making them available to policy owners before insured people die.

> Life insurance guarantees that a specific sum of money will be available at exactly the time you need it. On a personal level, life insurance can be used to provide financial security when it may be your last substantial source of money.

Conclusion

As we approach the end of the twentieth century, the increase in efficiencies created by telecommunications is spawning a wave of mergers and consolidations in the financial services industry. It is reasonable to expect that insurance companies will be consolidated and the smaller companies will be bought out—and the policies a person holds may be managed by new entities.

What does that mean for you as the consumer? Depending on the type of policy you have, does the company have the right to raise its administrative

expenses arbitrarily? One often-voiced concern is that if a large company acquires a smaller company, the larger company may raise internal charges to the policy in order to generate more revenues and to pay off the debt service of the acquisition.

While no one knows what the future will bring to the insurance industry over the next 10 or 20 years, it makes sense to consider the size and history of mortality experience, operating expenses and commissions as a percentage of revenue of the insurance company as important factors in your selection process.

Beyond this issue, the basics of life insurance are pretty simple.

The primary purpose of life insurance is to pay a death benefit, and a death benefit is the one feature that all forms of life insurance share in common. Death benefits are usually purchased and used to cover final expenses, pay outstanding debts, and provide income and security for survivors.

In addition to providing protection against premature death, life insurance attempts to protect against the risk of not dying early. Many life insurance contracts include cash values or savings features which make it possible to accumulate funds for education, retirement income, and other purposes on a tax-free basis.

Life insurance products have evolved in response to changing economic conditions and consumer preferences. All life insurance policies include some form of true life insurance protection. Many policies also include other types of insurance benefits and non-insurance elements.

Various parties may be involved in any life insurance contract. There is always a policy owner and an insured person. There may or may not be a designated beneficiary. Be aware of the tax consequences of these arrangements.

Chapter 11

Life Insurance as an Investment

The uses of life insurance extend beyond the original concept of a death benefit.

Some forms of life insurance—like variable life policies—can be used explicitly as investment vehicles. Investment-type insurance can pose some complicated claims issues. When an insured person dies, any unpaid amounts which are guaranteed will be paid as a single lump sum to the insured's estate—unless other arrangements have been made. This applies to the current value of any remaining installments under the fixed period option or life income with guaranteed period option of annuities and similar tools.

Example: A beneficiary who was receiving payments under a 10-year fixed period option dies during the sixth year, so the present value of the remaining payments will be paid to the beneficiary's estate.

Another example: If the same beneficiary had requested that upon premature death the remaining payments continue to be paid in installments to another person (a contingent beneficiary), and the insurance company approved, the remaining payments would be paid in this manner to the other person.

Many life insurance policies include other features, that make it possible to use the insurance to build capital—for accumulating assets or funds designed to serve specific purposes. Thus, some people use life insurance to accumulate funds for children's education, to provide retirement income, to create or add to an estate and for other purposes.

Many people question whether life insurance is the best method of getting access to capital. But there's not much question that it's one of the safest and most conservative methods. When a person borrows money for a real estate purchase, an investment opportunity or starting a small business, the

funds may not be available unless life insurance on the life of the borrower is purchased to protect the interests of the lender. Use of life insurance in this manner may in the long run help an individual to build personal assets and advance family security.

> In addition to death benefits, many life insurance contracts include other types of insurance benefits. These non-life insurance benefits may be included in a policy or may be attached as optional riders.

One of the most commonly found types of additional benefit is known as waiver of premium. This is actually a disability insurance benefit, which pays the life insurance premiums while an insured person is disabled.

Another type of benefit that is commonly attached to life insurance policies is a disability income benefit. This usually is provided as "waiver of premium with disability income," but it may be attached as a separate benefit. A disability income benefit pays a monthly income to an insured person who is totally disabled.

Dismemberment benefits may be attached to a life insurance policy, most frequently in the form of accidental death and dismemberment benefits.

As we've seen, the accidental death benefit pays an additional death benefit if an insured person dies because of an accident. The dismemberment benefit pays specified sums if the insured loses one or more limbs, or sight of one or both eyes, and in some cases hearing, as the result of an accidental injury. Since the insured person is still alive and this is not a death benefit, it is not—technically—a form of life insurance.

In recent years, the concepts of living or accelerated benefits and long-term care needs have begun to take hold in the life insurance field. They are increasingly showing up as benefits attached to life insurance contracts.

> In the case of living benefits, a portion of the proceeds that would otherwise be payable as a death benefit is advanced to an insured who has a terminal disease and a need for special medical care. It is widely acknowledged that this is a humane application of life insurance proceeds, because the funds are often used to ease pain, suffering and discomfort during the final period of life.

These benefits are usually provided without charge because the payment of a death claim is imminent.

Long-term care benefits pay for nursing care, home health care, or custodial care (assistance with the tasks of daily living, such as eating, bathing,

dressing, etc.) which may be needed following a period of hospitalization. This is actually a health insurance benefit which is often sold separately as part of a health insurance policy.

When sold as a separate benefit, an additional premium is charged and the benefit will not affect the policy's face value of cash value. When sold as part of an integrated plan, an additional premium is not charged for long-term care benefits which are simply borrowed from the life insurance benefits—and accordingly reduce the remaining face value and cash value.

Annuities

Annuities are not—strictly speaking—life insurance; but they are often sold by life insurance agents, so a basic understanding of how they work may be useful.

Life insurance is designed to protect against the risk of premature death. Annuities are designed to protect against the risk of living too long. This is why they are sometimes also called upside down life insurance.

The basic function of an annuity is to liquidate a sum of money systematically over a specified period of time. An annuity contract provides for a scheduled series of payments that begins on a specific date—such as when the recipient reaches a stated age—or a contingent date—such as the death of another person. The payments continue for the duration of the recipient's life or for a fixed period.

Usually, but not always, an annuity guarantees a lifetime income for the recipient.

The *annuitant* is the person who triggers payments. The owner of the contract may or may not be the annuitant. Unlike insurance, though, the annuitant is usually the intended recipient of the annuity payments.

> **Depending on the type of annuity and the method of benefit payment selected, a beneficiary may also be named in an annuity contract. In these cases, annuity payments may continue after the death of the annuitant for the lifetime of the beneficiary or for a specified number of years.**

There are two principal types of annuities: fixed and variable.

A fixed annuity is a fully guaranteed investment contract. Principal, interest and the amount of the benefit payments are guaranteed. Fixed annuity payments are considered part of the insurance company's general account assets (the conservative investment portfolio, not the stock market one).

There are two levels of guaranteed interest: current and minimum. The current guarantee reflects current interest rates and is guaranteed at the beginning of each calendar year. The policy will also have a minimum guaranteed interest rate—such as 3 percent or 4 percent—which will be paid even if the current rate falls below the policy's guaranteed rate. The minimum guarantee is simply a predetermined lowest rate.

A variable annuity, like variable life insurance, is designed to provide a hedge against inflation through investments in a separate account of the insurance company consisting primarily of common stock. A variable annuity is *not* a guaranteed contract. However, either a fixed or a variable annuity can guarantee expenses and mortality.

Any expense deductions made to annuity benefits are guaranteed not to exceed a specific amount or percentage of the payments made. And, as long as they're reasonable, these expenses can be worth absorbing. The guarantee of mortality provides for the payment of annuity benefits for life.

Variable annuities can be purchased like fixed annuities—single premium immediate or deferred and periodic payment deferred contracts.

Also, variable annuities include a variable premium feature, known as a flexible premium deferred annuity (FPDA) contract. Variable annuities offer the same annuity options for settlement of the contract as fixed annuities. Both types of annuities are primarily used as retirement vehicles.

The value of the annuity will vary in accordance with the daily performance of the separate account. Accordingly, during the annuity period, benefit checks issued to the annuitant will vary depending on the value of the annuity units at the time the monthly check is issued.

Occasionally, an annuitant may decide that it is in his or her best interests to purchase an annuity which offers some guarantees but also offers protection against inflation. This type of annuity is usually identified as a combination or balanced annuity. A single premium or single payment annuity is usually purchased by making one lump sum payment.

Example: You cash in a 20-year-old cash value life insurance policy soon after you retire. This generates a sizable lump sum of cash—say, a little over $100,000. You can use the cash to buy a single premium annuity that creates income for you and your spouse, if you should die first.

Annuities and Retirement Planning

Most often, the primary purpose of an annuity is to provide retirement income. Like life insurance policies, annuity contracts may include

nonforfeiture provisions to protect the contract holder from total forfeiture or loss of benefits if he or she stops making the required periodic payments, and surrender charges, or penalties for cashing in the annuity before the pay out period begins.

Annuities may be purchased on an individual basis to help solve individual retirement needs. In this case, the annuitant is the owner of the annuity. Often, annuities are purchased on a group basis covering a number of annuitants typically in an employment situation.

Group annuities are often used to fund an employer-sponsored retirement plan, with the employer as the contract owner. If the annuitant dies during the accumulation period, the money accumulated will be paid to a survivor.

A common illustration is the annual premium retirement annuity contract, in which the total accumulation is calculated based on an annual premium, an assumed interest rate and retirement age (usually 65).

During the accumulation period, the annuity contract is very flexible in that the annuitant may make payments or not make payments. In addition, the annuitant has withdrawal options whereby the money accumulated can be withdrawn totally, or in part, during the accumulation period.

Annuities may be used to fund individual retirement accounts (IRAs), in which case premium payments may be tax deductible. But, in this application, there are more restrictions on withdrawals (including tax penalties for withdrawals before age 59).

There are few guarantees associated with a variable annuity or other insurance-related investment vehicles.

These contracts will usually guarantee that expenses will not exceed a specific amount or percentage. In addition, they may also guarantee mortality—which means a benefit check will be guaranteed for the life of the beneficiary or annuitant. However, these investment tools do not guarantee the amount of the benefits at retirement nor do they guarantee principal or interest.

Considerable controversy has raged over the regulatory issue of whether variable annuities are really insurance products or equity investment tools. This is generally true of all investment-type insurance products.

Both the federal Securities and Exchange Commission (SEC) and state insurance departments regulate variable annuities. They are considered securities and have to comply with federal securities laws and regulations with certain limited exemptions. Regulation by state Insurance Departments includes licensing companies and agents to sell variable annuities and approving variable annuity contracts.

Buying life insurance or annuities as investments may make sense to some people as they plan for their retirement. If you're going to use these tools, though, you should think of them as an addition to your basic income-replacement life insurance coverage. In most cases, the investment-type policies entail a degree of risk—either in what you pay in or what you can take out—that make them a shaky foundation for your essential needs.

Endowment Policies and Annuities

Part of an endowment or annuity payment is taxable and part is not. The non-taxable portion is the expected return of the principal paid in. The taxable portion is the actual amount of payment minus the expected return of the principal paid in. Since these amounts would be difficult to calculate, the IRS makes up tax tables for this purpose.

By definition, cost base is money which has already been taxed. Tax base is money which is yet to be taxed. A person investing $1,000 in an annuity is investing $1,000 cost base. Any interest earned is tax base, but the taxes are deferred during the accumulation period.

> **The taxation of annuity contracts is based upon an exclusion ratio. The exclusion ration is the relationship of the total investment in the contract (cost base) to the total expected return under the contract (calculated based on average life expectancy tables). This ratio (expressed in a percentage) shows how much of each annuity payment is taxable, and how much is not.**

Once an annuitant recovers his or her cost base during the annuity period, the total payments received will be taxed at ordinary income tax rates.

If an endowment is paid as a death claim in a lump sum, the benefit is not subject to income tax.

If an annuitant dies and the balance of a guaranteed amount is paid to a beneficiary, the payment is not taxable as income until the investment in the contract has been received tax free. (The amount received by the beneficiary is added to the tax free amounts received by the annuitant, and only any amount which exceeds the total amounts paid in will be taxable.)

> **If an annuitant dies and payments continue to a surviving annuitant under a joint and survivor annuity, the same percentage that was excludable before the first annuitant's death will continue to be excluded from taxes.**

When a corporation owns a deferred annuity contract as an investment, it is usually not treated as an annuity contract for several purposes—all income and gains received or accrued during a tax year are taxed as ordinary income. This does not apply to annuities which are owned by a corporation for the purposes of funding pension plans, profit plans, and other plans which are treated differently under the tax laws.

There are special tax requirements for modified endowment contracts, including retirement income or semi-endowments. In a retirement income endowment policy, the amount payable upon survival (of the endowment period) is greater than the face amount, or cash value. The semi-endowment pays, upon survival, one half the sum payable if the insured person dies during the endowment period. Because the investment return may be greater than the amount invested, the tax considerations can be complicated.

When an Annuity Pays

If you buy an annuity with a single payment, the benefits may begin immediately or they may be deferred. If you buy an annuity with a series of periodic payments, then the benefits will be deferred until all payments have been made. (This second kind of annuity is commonly called a periodic payment deferred annuity.)

There are two periods of time associated with an annuity; the accumulation period and the annuity or benefit period.

The accumulation period is time during which the annuitant is making contributions or payments to the annuity. The interest paid on money contributed during this time is tax deferred. The interest earned will be taxed eventually—but not until the annuitant begins to receive the benefits.

The annuity period is the period after the accumulation of the annuitant's payments (principal and interest) during which benefits are received.

Annuity settlement options are the provisions of the annuity. Generally, when the annuitant decides to take money from the annuity, an annuity option will be selected as a method of disposing of the annuity's proceeds. It is not unusual for an annuity option to be elected at the time of application.

If you bought a single payment deferred straight life annuity, you would own an annuity, purchased with a single payment, which will provide a pay out for life. Even if an annuity option is elected at the time of purchase, it may (and probably will) be changed at the annuity period to reflect your changing needs. These changes usually have something to do with retirement or the death of a spouse.

> The amount of money available during the annuity period is determined by the annuity option selected, the amount of money accumulated by the annuitant and the life expectancy of the annuitant.

A life only or straight life option provides for the payment of annuity benefits for the life of the annuitant with no further payment following the death of the annuitant. There is a risk to the annuitant in the fact that he or she must live long enough once the annuity period begins to collect the full value. If an annuitant dies shortly after benefits begin, the insurance company keeps the balance of the unpaid benefits.

This option will pay the highest amount of monthly income to the annuitant because it is based only on life expectancy with no further payments after the death of the annuitant.

A refund option will pay the annuitant for life—but, if he or she dies too soon after the annuity period begins, there may be a refund of any undistributed principal or cost of the annuity.

The refund may take the form of continued monthly installments (an installment refund annuity) or it may be in one lump sum (a cash refund annuity), whichever has been elected by the annuitant.

This option assures the annuitant that the full purchase price of the annuity will be paid out to someone other than the company issuing the annuity.

If you live well beyond average life expectancy, then all of your investment in the annuity will probably have been paid and there will be no refund.

Life with period certain is basically a straight life annuity with an extra guarantee for a certain period of time. This option provides for the payment of annuity benefits for the life of the annuitant but, if death occurs within the period certain, annuity payments will be continued to a survivor for the balance of that period.

The period certain can be for just about any length of time—5, 10, 15 or 20 years. Most often, the period selected is 10 years because 10 years is approximately the average life expectancy of a male who retires at age 65. Thus, an annuitant retires at age 65, selects life with 10 years certain and dies at age 70, his survivor will continue to receive the monthly annuity payments for the balance of the period certain (five more years).

The joint-survivor option provides benefits for the life of the annuitant and the survivor. A monthly amount is paid to the annuitant and, upon the annuitant's death, the same or a lesser amount is paid for the lifetime of the survivor. The joint-survivor option is usually classified as joint and 100 percent survivor, joint and two-thirds survivor or joint and 50 percent survivor.

The joint-survivor annuity option should be distinguished from a joint life annuity, which covers two or more annuitants and provides monthly income to each annuitant until one of them dies. Following the first annuitant's death, all income benefits cease.

Relevant Tax Issues

Generally, life insurance proceeds are received federal income tax-free if taken in a lump sum. This is true whether the policy is an individually owned contract or a business owned policy. Thus, a beneficiary pays no federal income tax on life insurance proceeds and neither does a corporation.

If the life insurance proceeds are taken other than in a lump sum by the beneficiary, part of the proceeds will be tax-free and part will be taxable.

The basic concept is that the principal (face amount) is returned tax free. However, the installment received is part principal and part interest. Therefore, the interest portion of the installment is taxable. All interest is taxable as income.

Federal estate tax is a tax on the transfer of property upon the death of an individual, and may range from 0 percent to 55 percent of the adjusted growth estate. Life insurance proceeds are subject to inclusion in the deceased's estate for federal estate tax purposes if:

- the estate was the named beneficiary,

- the deceased was the policy owner, or

- the deceased transferred the policy to another person within three years of death.

Thus, a corporate-owned life insurance policy on the company's president with the corporation as the president's beneficiary would not be included in the deceased president's estate since the corporation was the owner and beneficiary.

Premiums paid for life insurance are generally not tax deductible. For individuals, they are considered a personal expense and not deductible.

When businesses buy life insurance to perpetuate the continuation of the business, the premiums are considered to be a capital investment, and—for this reason—not deductible. However, when a business buys group term insurance for its employees, premiums are generally considered a necessary business expense and are deductible. Employer contributions for permanent life insurance are treated as taxable income of the employee.

Minimum deposit life insurance is a high cash and loan value whole life form, usually offering a loan immediately upon payment of the first premium (instead of at the end of the first year). Such policies were devised in the late 1950s to take advantage of the fact that, at the time, Internal Revenue allowed the interest paid on a policy loan to be deducted in full for income tax purposes.

Since that time, however, Internal Revenue has placed restrictions on the interest deduction when the loan is to finance insurance so that the popularity of the form has diminished.

A third party ownership arrangement usually offers a tax advantage to the insured person. If the insured person has no incidence of policy ownership, then the proceeds would not be included in his or her estate—thereby possibly reducing the federal estate tax liability.

> **Life insurance proceeds may not be exempt from income taxes if the benefit payment results from a transfer for value. If the benefits are transferred under a beneficiary designation to a person in exchange for valuable consideration (whether it be money, an exchange of policies or a promise to perform services), the proceeds would be taxable as income.**

Taxation under the transfer for value rules does not apply to an assignment of benefits as collateral security, because a lender has every right to secure the interest in the unpaid balance of a loan. Nor does it apply to transfers between a policy owner and an insured person, transfers to a partner of an insured person, transfers to a corporation in which the insured person is an officer or stockholder, or transfers of interest made as a gift (where no exchange of value occurs).

If a policyholder surrenders the policy for cash value, some of the cash value received may be subject to ordinary income tax if it exceeds the sum of the premiums paid for the policy (this is known as the Cost Recovery Rule).

Example: Mary surrenders her whole life policy and receives $5,000 in cash. Total premiums paid into the policy were $4,700. Mary owes federal income tax on $300.

In accordance with section 1035(a) of the Internal Revenue Code, certain exchanges of insurance policies (and annuities) may occur as nontaxable exchanges. Generally, if a policy owner exchanges a life policy for another life policy with the same insured person and beneficiary and a gain is realized, it will not be taxed.

Dividends are considered to be a return of excess premium paid by the policy owner. They are not included as income for tax purposes. However, interest earned on dividends and accumulated by the insurance company or paid to the policy owner is taxable in the year received.

In November 1988, Congress passed the Technical and Miscellaneous Revenue Act (TAMRA) which makes any withdrawal, loan, or collateralizing of the cash in certain policies taxable. In fact, depending on the policy owner's age, the amount may be taxable and subject to a 10 percent penalty.

In order to avoid the taxation and subsequent penalties, the policy owner must limit his or her investment according to the seven pay test established by the government, which limits the amount that may be paid into the policy during the first seven policy years. This information should be provided to a policy owner by his or her insurance company.

Estate Tax Issues

Whether the life insurance proceeds will actually be taxed in a accordance with federal state tax laws will be dependent on the deceased's estate status.

There are deductions and exemptions which may be applied to adjust a person's estate for tax purposes. For example, there is a unified tax credit of $192,800 (which roughly equals a $600,000 exemption), which is a dollar-for-dollar reduction in gift and estate taxes due.

Other estate planning techniques, such as the use of trusts and gifts, can also reduce the size of a person's taxable estate.

Since 1916, the federal government has levied a tax against the estate of any individual who has recently died. Currently, the maximum amount of the that tax is fifty percent. One exception to this is the marital deduction. An entire estate may be left to a surviving spouse with no tax consequence.

A variety of special tax rules apply to life insurance product which are provided as benefits to employees. Generally, the cost of the first $50,000 of group term life insurance coverage provided to an employee by an employer is not taxable to the employer. The cost of life insurance coverage in excess of $50,000 is taxable as income to the employee.

To the extent that an employee is taxed on the cost for incidental life insurance, the employee only pays a tax on the cost for pure protection.

For cash value insurance, the taxable cost would be the one year term rate for the amount of protection at risk (face value minus accumulated cash value), regardless of the premium actually being paid by the plan. For term

insurance protection, the entire actual cost for protection would be taxable to the employees, because that is the cost for pure protection.

Deferred compensation is an executive benefit which enables a highly paid corporate employee to defer current receipt of income such as an executive bonus and have it paid as compensation at a later date (retirement, death or disability) when—presumably—the employee will be in a lower tax bracket. Generally, the employee will enter into an agreement with the employer which specifies the amount of money to be paid, when it will be paid and the conditions under which the deferred compensation may not be paid.

The agreement will specify that the amount deferred will be paid as a retirement benefit or in the event of the premature death or disability of the employee. It will further indicate that the individual will forfeit the right to this sum of money if he or she leaves the employer except for retirement, death or disability.

The advantage of this agreement for the employee is avoidance of current taxation since receipt of the money is deferred. This is allowed by IRS Section 457. However, there are some disadvantages. Usually, deferred compensation is a nonqualified plan and as such, it may be funded or unfunded.

Another use of life insurance is for charitable purposes. In accordance with tax laws, a policy owner may purchase a life insurance contract on his or her life, pay the premiums and designate a charitable organization as the beneficiary; such as a church, school, hospital or similar organization. Generally, the premium paid by the insured person is tax deductible.

If insurance proceeds are included in an estate, they increase the value of the estate subject to taxation. When choosing an amount of insurance to protect your estate, it is important to have a basic understanding of how taxation may affect your life insurance. This chapter went over a few reasons why it is important to consider taxes when purchasing a life insurance policy.

Life Insurance and Retirement Planning

Life insurance and related annuity products are frequently used to provide the funding for retirement plans and other types of plans. Some of these plans may also be funded with other products such as mutual funds, certificates of deposit, stocks and bonds, cash held in bank accounts, etc.

A retirement income insurance policy accumulates a sum of money for

retirement while providing a death benefit. Upon retirement, the policy pays an income such as $10 per $1,000 of life insurance for the insured person's lifetime—or for a specified period. Once the cash value in the policy becomes greater than the face amount, that cash amount becomes the death benefit.

These policies are expensive, and cash value accumulation is high to pay for the monthly income.

Retirement plans that include insurance and other corporate and individual plans may be described as qualified or nonqualified. All plans must be in writing and be communicated to the participants—beyond these similarities, there are many differences.

Some of the characteristics of qualified plans include:

- the plan must be filed and approved by the IRS;

- the plan cannot discriminate as to participation (all eligible employees must be included);

- the plan is usually established by an employer for the benefit of employees (there are a few exceptions);

- the employer will receive a tax deduction for plan contributions;

- employer contributions on behalf of the employee are generally excluded from the employee's gross income—no tax is due until benefits are actually distributed to the employee; and

- investment income realized by the plan is tax deferred until it is received by the plan participants.

Some of the characteristics of nonqualified plans include:

- the plan is not filed with the IRS;

- the plan may discriminate as to participation—it may be selective as to who is covered; and

- the employer does not receive a current tax deduction for any contributions made.

The fact that a nonqualified plan is not approved by the IRS does not imply that is illegal or unethical. A nonqualified plan is a legal method of accumulating money for retirement funds and other purposes.

Example: A person buys an individual annuity for the purpose of accumulating his or her own retirement benefits. When this person pays the annu-

ity premium or payment, there is no tax deduction for the payment of the premium. The annuity is not filed with the IRS.

> **Pension plans and other qualified plans may include incidental life insurance benefits, but these must be incidental to the purpose of the plan. The primary purpose of the plan must be to provide retirement benefits.**

In order to stay within the requirements established by the IRS, qualified plans must satisfy the incidental limitation rule, which requires that the cost for life benefits provided by a pension plan (or profit sharing plan), must be less than 25 percent of the cost of providing all benefits under the plan.

Generally, the cost for insurance protection under a pension or profit sharing plan is taxable as income to the employee to the extent that any death benefit is payable to the employee's beneficiary or estate. The cost for any protection for which the proceeds are payable to and may be retained by the plan, trustee or employer is not taxable as income to the employee.

Example: An executive insured under a key person life policy does not have to pay tax on the cost of that coverage.

Retirement Options With Cash Value

When you retire, you can use a cash value life insurance policy in several ways. You can borrow cash values or annuitize payment plans. Both will allow you to use your money for retirement, but each has distinct pros and cons which have to be assessed individually.

If you have accumulated cash value in a life insurance policy when you retire, you can begin withdrawing the money on a tax free basis. On the other hand, money that you withdraw from qualified retirement plans like Keoghs or IRAs will be taxed as income.

Borrowing allows you to avoid income taxes on the income borrowed. This is the good news. However, if you borrow all of your cash value and the policy terminates, you will be hit with capital gains tax on the growth in excess of premiums—for money you spent years ago. That's the bad news.

This kind of capital gains tax can be a nasty surprise at age 80 or 85, when most people are busy worrying about health coverage or estate taxes.

Depending on the individual policy characteristics (the crediting rate, the dividend, etc.) and the actual amount you decide to withdraw, you may be able to avoid paying back a policy loan. If you carefully keep enough cash in

the policy to keep it in force, upon your death the life insurance proceeds will pay off the loan.

> A caveat: Be very careful in what rates you assume when figuring how much money you can take out. Overzealous agents will sometimes show illustrations leading to a big retirement benefit. You have to remember that illustrations are based on the assumption that the company will continue to credit the cash value of the policy at a certain rate.

Many people lost a lot of money on these investments in the 1980s, when interest rates fell and policies weren't performing the way they expected.

Perhaps the highest-profile failure of any life insurance company in recent years was the 1991 insolvency of California-based Executive Life Insurance Co.

Executive Life had invested heavily in junk bonds and other high risk securities to finance the high interest rates it had promised policyholders. When the junk bond market crashed, Executive Life became technically insolvent—even though it was still paying claims.

When California insurance regulators seized Executive Life, its policyholders didn't know how much of their money they would ever get back. Indeed, regulators remained unable to sort out the company's liabilities, making it difficult for them to calculate how far Executive Life's remaining assets—plus money promised by several competing rescue plans—would go.

Most policyholders ended up getting close to the full value of their policies; but some holders of large policies (and tricky investment vehicles like guaranteed investment contracts and single-premium deferred annuities), which weren't completely covered by state insurance guaranty funds, got less than 70 percent of the face amount of their policies.

Federal Rules v. State Rules

In the spring of 1997 the Supreme Court split five to four in the decision *Boggs v. Boggs*—to find state property law preempted by federal rules.

In Boggs, the sons of a first marriage sought to obtain property willed to them by their mother, who died before their father. Her will purported to convey to her sons her interest in their father's qualified plan retirement annuity payments and IRA and ESOP accounts. After their father died, the sons sought to enforce their rights to the property in state court under Louisiana's community property estate law. Wife number two, who married the father after the

mother's death, sought a declaratory judgment in federal court, arguing that she was entitled to the estate under ERISA and that the Louisiana law was preempted. The district court granted summary judgment in favor of the sons, and the Fifth Circuit affirmed.

The Supreme Court reversed on two grounds. As to future annuity payments under the qualified plan, the Court held that the sons' rights under state law were inconsistent with, and therefore preempted by, ERISA's extensive requirements for qualified joint and survivor annuities. As to the sons' remaining interests under state law, the Court held that the sons were not beneficiaries as defined by ERISA, that the will was not a qualified domestic relations order (QDRO), and that Congress clearly intended to restrict the state-law rights of non-beneficiaries to benefit payments.

As Boggs illustrates, applying the analytic approach of the Limiting Decisions to Cause of Action Laws is not necessarily easy or certain. This is particularly so with respect to welfare plans where, unlike the retirement income plan annuity or other pension distribution requirements at issue in Boggs, ERISA imposes few substantive benefit requirements.

Additionally, the equitable remedies available under ERISA often provide less recompense than do damages available under most state laws. Thus, the Limiting Decisions' analytic approach may be distorted due to concerns that misconduct will escape appropriate punishment.

In *Arizona State Carpenters Pension Trust v. Citibank*, a federal ERISA-covered pension plan sued a bank that maintained custody of plan assets for failure to notify plan trustees that investment managers retained by the plan had defaulted on payments due on plan investments. The trustees alleged fiduciary breach violations under ERISA and state law contract, common law duty, negligence, and fraud claims. The district court held that the bank was a custodian and not a fiduciary and granted the bank summary judgment on the ERISA claims. The district court also held that the state law claims were preempted.

The Ninth Circuit, on a motion for reconsideration from its original decision, affirmed as to the ERISA claims but reversed on preemption of the state law claims. The court's analysis began with a direct reference to Justice Souter's observation in Travelers that there have to be limits to ERISA preemption and that there is no logical limit to the "relates to" test.

With that in mind, the Ninth Circuit decided that the state law contract, common law duty, negligence, and fraud claims were outside the realm of benefit administration; did not mandate benefits structures; and did not provide an alternate enforcement mechanism. Although the plan alleged that the

bank was a fiduciary, that mischaracterization did not change the fact that "the claims here do not affect the relations among the principal ERISA entities." It thus allowed the plan to proceed with its state law claims.

Although the state law claims, if successful, would not have mandated a benefits structure, the rest of the Ninth Circuit's reasoning is somewhat suspect. In speaking of ERISA entities, the court referred to plan, participant, and employer.

Yet directed trustees, which the bank admittedly was, are "ERISA entities" (because ERISA Section 403(a)(1) specifically provides that plans may have directed trustees and because the bank was a party in interest under ERISA). Although the claims based on state law would not have provided participants with an alternative enforcement mechanism, the plan's enforcement rights under state law were clearly an alternative enforcement mechanism to its rights under ERISA.

The dismissal of the plan's ERISA case against the bank meant that, if state law claims were preempted, the bank could have breached its contract and engaged in other improper behavior with impunity.

Life Insurance as an Estate Planning Tool

Life insurance can create an immediate estate for the insured person and provide funds that will help preserve the greatest amount of value in the estate. The field of estate planning is very complicated. It requires expertise in the areas of wills, taxes, law and life insurance.

In a nutshell, the object of estate planning is to avoid lengthy—and expensive—probate. Although most people have heard the term probate and some have experienced it, the definition eludes them. In it's most simplified form, probate is the process of:

- viewing and understanding a will;

- determining the location and valuation of all properties;

- determining creditors and paying them;

- determining the identity of heirs;

- resolving controversy between concerned parties;

- paying the agent and attorney for probate fees

- filing and paying current and past tax returns;

- appointing guardians, if necessary;

- appointing money management for minors, if necessary; and

- distributing any remaining property.

A long probate can cause all kinds of problems—including big tax liabilities.

> **Federal estate tax is a tax on the right to transfer property. It is based on the fair market value of your property and is usually due within nine months of death. The tax must be paid before your beneficiaries receive their inheritance.**

(As we've seen before, this tax does not apply to insurance proceeds—only the rest of the things you leave to people when you die.)

One of the biggest reasons that people create wills and trusts is to eliminate any family conflict regarding the distribution of money.

Example: Jamie and Tina have children ages 2, 12, and 18. The couple themselves are in their 40s. The distribution of assets needs to include the stipulation that money be available to guardians on a monthly basis and in lump sums for college expenses. Monies remaining would be distributed equally when each child reached the age of 21. Tina was concerned that no one particular child feel less important than the others. She and her husband decided that, at age 21, the children were to receive 10 percent of their designated lump sum. This required a document which set out the terms for paying out the money in the right way. Simply said, that money is an estate and that document is a trust.

The first step in the estate planning process should be an ongoing analysis of your needs and objectives with emphasis on the changing needs of your beneficiaries and what property is, was and will be part of the estate.

This process is important because the needs and objectives of an estate are constantly changing. What is true of an estate plan today may certainly not be valid tomorrow.

After analysis, a plan should be created that meets your needs and objectives, is beneficial to your heirs, and reduces or eliminates the possibility of estate shrinkage.

There are two methods of distributing the estate; inter vivos transfers or testamentary transfers.

Inter vivos transfers are made while the estate owner is still alive. Testamentary transfers are made by will after the death of the estate owner. More specifically, transfers can be made as wills, gifts, trusts or policy ownership under rights of survivorship.

Trusts and Estates as Beneficiaries

A trust is formed when the owner of property (the grantor) gives legal title of that property to another (the trustee) to be used for the benefit of a third individual (the trust beneficiary). This fiduciary relationship allows the trustee to manage the property in the trust for the benefit of the trust beneficiary only. The trustee legally must not benefit from the trust.

> When a trust is designated as the beneficiary of a life insurance policy, the policy proceeds provide funds for the trust. Upon the death of the insured person, the trustee administers the funds in accordance with the instructions set forth in the trust provisions.

While there are many benefits in naming a trust as beneficiary of an estate or a life insurance policy—particularly for minor children—there are drawbacks as well. A trustee will charge a fee for managing a trust.

The way the trust's property is managed is often left up to the trustee, leaving the trust beneficiary powerless to intervene if the trust is poorly managed. Also, the trustee may not provide resources for the trust beneficiary as he or she or even the grantor would have wanted; the trust beneficiary must request resources from the trustee, he or she cannot make free use of the property in the trust.

Trusts frequently own policies, as well—especially when avoiding estate taxes is an important priority.

An insured person's estate can be named as beneficiary of an insurance policy. An insured person who is also the policy owner may direct that the policy proceeds be payable to his or her executors, administrators or assignees. Such a designation might be made in order to provide funds to pay estate taxes, expenses of past illness, funeral expenses, and any other debts outstanding prior to the settlement of the estate.

> Designating your estate as beneficiary aids in the settlement of the estate by avoiding the need to sell other assets of the estate to pay these last expenses.

On the other hand, it's sometimes not desirable to name the estate as beneficiary because the insurance proceeds are then subject to the claims of creditors. This situation may not be what you intend when naming the estate as beneficiary. One of the unique features of life insurance is that the life insurance proceeds are exempt from the claims of the insured person's credi-

tors as long as there is a named beneficiary other than the insured person's estate. Even the cash value of a life insurance policy is generally protected from creditors.

The typical upwardly mobile family has several hundred thousand dollars of life insurance. If both parents were killed together, the children inherit the total estate and the life insurance cash on their eighteenth or twenty-first birthday, depending on the state.

Most children are not prepared for this responsibility. Among the typical problems young people fall into is that:

- they may squander the money;

- they may marry, get divorced and lose half of the inheritance in a divorce settlement;

- they may entangle the money in poor investments, judgments, IRS liens, etc.

To allow hundreds of thousands of dollars to be controlled by inexperienced decision-makers is irresponsible estate planning. A better approach is to structure the distribution. This allows the inheritance to coincide with greater maturity.

If insurance proceeds are held in a trust, they are less likely to be included in a divorce settlement, bankruptcy, or lawsuit. While these unhappy events can happen at any age, they're more likely to be more costly when they happen early. One would hope that by the time a child has reached his or her 30s he or she had become more aware of risks.

As we've seen, if you make arrangements for the proceeds of insurance or other assets to be put into a trust, a trustee will manage the funds. You'll usually designate a professional money management firm, bank trust department or worthy individual as trustee. An attorney specializing in estate planning can draft a trust document to accomplish any special instructions you may have.

Example: You designate your brother as the trustee of your estate because he is financially prudent and reliable. He will have a set limit (chosen by you) of monthly funds to accommodate your children's personal needs and expenses. You can also designate other amounts to be used for special needs as the children grow—such as buying a car, going to college or getting married.

The person you designate to manage the money is not necessarily the person you have to choose to raise your children. You may know a person

who is great at financial matters but not good with children. You also may know someone who would be perfect with children but unable to afford it. You can solve this problem by choosing different people for different tasks.

> **A caveat:** In most states minors are under court supervision until they reach a legal age. In some states, the proceeds of your estate may be waylaid in a court-imposed custodianship until your child reaches 18 or even 21 in some states. To avoid this, you can leave your proceeds to a living trust created for the benefit of your minor beneficiaries. By designing and imposing this trust your proceeds will avoid probate.

Conclusion

A simple estate with limited assets and no controversy may be probated in one to two years. However, properties, businesses, multiple beneficiaries and family conflicts cause probate to be an expensive, long and drawn-out process. The primary complaints against the probate system is that it is public, time consuming, expensive, and puts control in the hands of the courts.

A revocable living trust eliminates the long drawn out time and expense of probate. Revocable living trusts are created during ones lifetime (hence living) and are revocable (can be changed). The revocable can be thought of as a pot into which you put property life insurance of any other assets. These assets can be put into the trust during lifetime or upon death.

If you're concerned about having enough money to pay any estate taxes that the Feds will levy against the things you want to leave heirs, you should consider setting up an unfunded irrevocable life insurance trust. This mechanism allows you to move some cash out of your estate and use it to leverage protection by means of a life insurance policy that benefits your estate.

Just make sure you don't have any angry creditors roaming at large when you pass on.

Part Five:

Your Ability to Earn a Living

Chapter 12

Disability Insurance Claims

Thirty-something workers are three to four times more likely to become disabled than they are to die. And the vast majority of disabilities are temporary, spanning a year or two, so Social Security and pension benefits never kick in.

Disability is usually a financial blow even with disability coverage. Most policies make you wait up to six months before drawing benefits. Then they replace half to three-fourths of your former income. So it's important to make sure you have enough cash to carry you from the end of sick pay to the start of disability.

Adjusting for the wait is the first step in making apples-to-apples comparisons.

The May 1997 federal court decision *A. Shannon Hamner v. UNUM Life Insurance* dealt with a drawn out long-term disability claim dispute.

In the early 1990s, UNUM issued a group long-term disability insurance policy to Centex Telemanagement. In May 1994, A. Shannon Hamner, a former executive of Centex filed a claim for benefits under the policy.

UNUM approved the claim and set Hamner's monthly benefits at $10,749.98. (The figure was later reduced to $9,474.98 due to an offset of Social Security benefits received by Hamner.) Hamner, however, disputed the amount, claiming that UNUM inappropriately excluded two large payments from the calculation.

UNUM reviewed Hamner's objections, but upheld its decision to exclude the two payments from the benefit determination and paid him $375,000 in connection with his efforts in preparing for the sale of Centex.

As a result, Hamner sued UNUM alleging that he had been wrongfully denied long-term disability benefits under Centex's ERISA plan.

According to the terms of the long-term disability policy, benefits are to be set at 60 percent of an employee's average monthly earnings over the 12 months preceding the disability. The policy also includes a cap of $15,000 a month for benefits based on a disability caused by a preexisting condition.

Typically, a determination that denies benefits under an ERISA plan is reviewed *de novo* "unless the benefit plan gives the administrator or fiduciary discretionary authority to determine eligibility or to construe the terms of the plan." Where the benefit plan does confer discretion upon the administrator or fiduciary, the exercise of that discretion is reviewed under an abuse of discretion standard.

> In general, federal courts liberally construe benefit plans as granting discretionary authority. A benefit plan confers discretion where it "includes even one important discretionary element, and the power to apply that element is unambiguously retained by its administrator."

In other words, if the plan administrator has the authority to determine eligibility for benefits, that inherently confers discretion upon him.

In this case, the court ruled that it was not immediately apparent whether the benefit plan conferred discretion upon the administrator.

When interpreting the terms of an ERISA plan, a court looks first "to the terms of the plan itself."

The interpretation of the terms is to be done "in an ordinary and popular sense as would a [person] of average intelligence and experience." When a plan is ambiguous a court may, and usually does, consider extrinsic evidence to interpret it. If ambiguities remain after resorting to extrinsic evidence, the plan must be construed in favor of the insured.

According to UNUM, the language of the policy that granted it authority to determine eligibility under the policy states:

> When the Company receives proof that an insured is disabled
> due to sickness or injury and requires the regular attendance of
> a physician, the Company will pay the insured a monthly ben-
> efit after the end of the elimination period.

According to UNUM, the proof submitted must satisfy the administrator of the reality of the facts alleged by the insured.

If this is correct, said the court, the plan administrator is given discretion to determine eligibility. However, the UNUM policy does not state that the

plan administrator must consider the proof to be satisfactory. In fact, the plain language of the policy appears to indicate that any proof of disability would be sufficient to require payment of benefits.

According to the court, requiring proof of disability before benefits will be paid implies that the proof satisfactorily demonstrates that the individual is disabled. It stated:

> Simply allowing the administrator to require "satisfactory proof," however, does not give the insurance company discretionary authority; instead, such language most reasonably creates an objective standard-proof "satisfactory" to a reasonable person. Consequently, even if the requirement of the submission of proof of disability implies that the proof be satisfactory, the language does not imply that the proof must be satisfactory to the administrator.

The policy stated that UNUM must receive proof of disability before benefits are paid. Such language simply does not put employees on notice that the company has discretionary authority to determine eligibility for benefits.

An ERISA plan that states "[w]hen the Company receives proof that an insured is disabled due to sickness or injury and requires the regular attendance of a physician, the Company will pay the insured a monthly benefit ...," said the court, does not unambiguously grant to the plan administrator the discretionary authority to determine eligibility for benefits.

Accordingly, the court made a *de novo* review of UNUM's decision to exclude some of Hamner's compensation in its determination of benefits under the disability policy.

UNUM, however, asserted that the disputed bonuses were "one-time payments made due to the sale or change of control of the business" and therefore should not be included in the disability benefits computation.

The court noted that a significant portion of Hamner's May 1994 bonuses were not representative of a "typical" bonus month, but were occasioned by the contemporaneous buyout of Hamner's company. The court also noted that Hamner took his disability leave within days of receiving these large bonuses. But as unusual as the bonuses may have been, there is no indication on the face of the policy that they should be excluded from the disability benefit calculation.

The policy language indicated that all of an employee's earnings, with one exception for earnings from stocks, are to be included when determining the level of benefits. Furthermore, the policy explicitly states that earnings from bonuses will be included in the calculation.

The relevant portion of the policy stated:

Definition of Basic Monthly Earnings For Executives:

"Basic monthly earnings" means the insured's average monthly earnings as figured:

a. from the W-2 form (from the box which reflects wages, tips and other compensation) received from the employer for the calendar year just prior to the date disability begins; or

b. for the period of employment if no W-2 form was received.

It includes earnings from bonuses, but not earnings from stocks. Bonuses will be averaged for the lesser of

a. the 12-month period of employment just prior to the date disability begins;

b. the period of employment.

UNUM relied on the use of the words "basic" and "average" to support its assertion that the benefit plan only covers run-of-the-mill bonuses.

According to the court, neither word carried the weight that UNUM urged. The phrase "basic monthly earnings" carried no independent meaning in the policy because the policy subsequently defines the phrase.

UNUM argued that "[t]he intent of disability insurance in general and the intent of the Policy at issue here is to replace ongoing 'average' or 'basic' earnings in the event of a disability, not one time payments made due to the sale or change of control of a business." The court ruled that UNUM failed to demonstrate that the intent of this policy requires exclusion of the disputed bonuses. Furthermore, UNUM presented nothing, except the one concluding sentence, demonstrating that the intent of disability insurance in general would have the disputed benefits excluded.

Hamner was entitled to a basic monthly earnings calculation of $49,166.65. And, 60 percent of his basic monthly earnings was well over the $15,000 cap the policy places on disabilities caused by preexisting conditions. Hamner was therefore entitled to monthly benefit payments of $15,000 offset by Social Security. Thus the appropriate monthly benefit was $13,725.

The Complex Language Is Key

Suppose a postman is hit by a car and is no longer able to walk. The claim may seem like a no-brainer, but some disability policies would pay only briefly if they applied the broader definition of disability.

> **Disabilities often aren't self-evident. Insurance companies may challenge back problems and other soft-tissue injuries, and they may dispute the severity of chronic illnesses.**

"They're among the most difficult policies we handle," said Andy Salmon, the Texas Insurance Department's director of life and health complaints. "The language in [disability policies] can be very, very important as to how they define disability," he said.

"Does it protect the ability to perform your job, or the ability to perform any job for which you are qualified?" Salmon said. "There are a lot of things you can do sitting down," Salmon said.

Make sure your contract spells out how to appeal decisions with which you disagree. Policyholders almost always have the right to an independent medical examination, Salmon said. Some insurance companies are more forthcoming than others.

Stay on top of things if you need your disability coverage. In some cases, doctors who can't keep track of the paperwork *cause* the disability problems.

> **Be mindful of creating side issues. For example, most disability policies limit benefits to two years in cases of mental disorders. Claimants seeking psychological treatment must make it clear that the problem is the result of the disability rather than the cause.**

"If a person is treated for depression, some companies will want to go with that because the policy defaults to two years maximum," Salmon said.

"It's always a difficult claim," he said. "It's not like life insurance where there isn't much question about whether or not you are dead."

The March 1998 federal district court decision *Lisa L. Clarke v. UNUM Life Insurance* dealt with the issue of when a disability claim has to be filed.

In June 1994, attorney Lisa Clarke began exhibiting bizarre behavior. Her behavior would fluctuate between periods of severe depression, in which she was unable to leave her home, and periods of mania, where she was unable to stop moving and would go for days without sleeping.

Clarke was diagnosed as having a bipolar affective disorder, also known as manic depressive illness. The disorder affected Clarke's judgment and ability to manage her affairs and eventually forced her to stop practicing law. Clarke was hospitalized for her condition from June until August 1994. Following her hospitalization, Clarke began seeing Dr. Jeffery Rausch, who monitored her disorder on an out-patient basis.

Clarke was soon able to function normally, controlling her condition with a number of prescriptions.

On October 29, 1996, Clarke filed a claim under the disability insurance policy purchased from UNUM Life Insurance by her former law firm. The insurance policy was an employee welfare benefit plan governed by the Employee Retirement Income Security Act of 1974 (ERISA). Clarke was covered by the policy as a former partner in the law firm.

UNUM rejected Clarke's claim, stating that it was untimely. Clarke brought action under ERISA to recover benefits allegedly owed under the policy.

UNUM moved for summary judgment.

UNUM's policy contains the following language regarding notice and proof of loss:

Notice

a. Written notice of claim must be given to the Company within 30 days of the date the disability starts, if that is possible. If that is not possible, the Company must be notified as soon as it is reasonably possible to do so.

b. When the Company has the written notice of claim, the Company will send the insured its claim forms. If the forms are not received within 15 days after written notice of claim is sent, the insured can send the Company written proof of claim without waiting for the form.

2. Proof

a. Proof of claim must be given to the Company. This must be done no later than 90 days after the end of the elimination period.

b. If it is not possible to give proof within these time limits, it must be given as soon as reasonably possible. But proof of claim may not be given later than one year after the time proof is otherwise required.

The elimination period is defined as a period of consecutive days of disability for which no benefit is payable.

Under UNUM's policy, the elimination period begins on the first date of disability and runs for 90 days thereafter.

According to UNUM, Clarke failed to provide notice of her condition in accordance with the terms of the policy. The policy requires that notice and proof of claim be submitted no later than one year and 180 days after the date the disability began. Clarke should have made her claim by December 28, 1995. However, she did not file the claim until October 29, 1996, more than a year after the disability began.

According to Clarke, her mental illness prevented her both from comprehending that she was disabled and from making a timely claim. Clarke also claimed that the language of the policy was ambiguous and that under her reading, she had provided timely notice. The court disagreed.

> **Most insurance policies contain a notice provision, which "is to enable the insurance company to inform itself promptly concerning the accident, so that it may investigate the circumstances, prepare for a defense, if necessary, or be advised whether it is prudent to settle any claim arising therefrom."**

Several courts have recognized that the "mental or physical incapacity of the insured to give notice is a valid excuse for not giving notice of claim within the period specified or required in a disability insurance policy or clause."

Clarke was unable to exercise appropriate judgment during this period, even to the point of failing to enlist others to assist her in managing her affairs. In fact, Clarke lost nearly all of her belongings, including her home, her cars, and her boat for this very reason.

According to the district court, Clarke did not comprehend that she had a disability, much less a claim. It went on, in detail:

> [t]o require a person who is described by some as being "insane" or "mentally incompetent" to do something that his disability prevents him from doing places that person in what some would refer to as a "Catch-22" situation. Thus, it is that we agree with the proposition that it would be unreasonable to assume that an insane or mentally incompetent person could accurately assess the nature and degree of his ailment.

UNUM also argued that someone else could have filed the claim for Clarke. The court disagreed.

According to the court, there was no evidence that Clarke continued to communicate with her partners or that her family was even aware of the insurance policy. Also, the court found no provision in the contract which imposes a duty on a third party to file the claim if the insured is unable to do so.

Short-Term Disability (STD)

Most group short-term disability policies provide for short elimination periods (usually 30 days or less) and short benefit periods. The benefit period is usually between six months and one year. The benefit amount is limited to a percentage of your pre-disability earned income—such as 60 or 70 percent.

The claims process for STD benefits is fairly simple. You need an attending doctor's affidavit that you are injured seriously enough that you can't work. You'll also need to fill out a simple claims form—mostly attesting to the fact that workers' comp or other coverages don't apply.

One of the rationales for STD has been that if you are injured you should be eligible for Social Security disability benefits after the five-month Social Security waiting period. In reality, this may or may not be true—depending on whether you can meet the strict definition of Social Security disability.

If you do qualify for benefits, the first benefit check will likely not be received before one year from the onset of disability. In any event, STD benefits were designed to fill the gap until Social Security begins paying benefits.

Long-Term Disability (LTD)

Long-term disability policies provide for longer elimination and benefit periods than short-term. Typically, the elimination period will be 90 days or six months. Most often LTD policies provide benefits to age 65—sometimes they provide benefits for the rest of your life.

The amount of the long-term benefit is also limited to a percentage of your pre-disability earned income—from a low of 60 percent to a high of 75 percent, depending on the policy and insurance company.

> The claims process for LTD benefits is a little more complicated than for STD benefits. Normally, you and an attending physician must complete a claims form periodically—every month, once a quarter, etc.—for the duration of the claim.

This will be in addition to the initial claim form you'll need to complete when you first notify the company that you've been injured.

A caveat: Make sure that you inform the disability insurance company as soon as possible when you've suffered a disabling sickness or injury. In many cases, the company won't begin the elimination period until it has been informed—so benefits don't start until six months or a year after that.

Insurance companies paying LTD benefits may also look more carefully into the status of the claim. (They are supposed to use the elimination period to do this, though many don't start their investigations until they've started paying benefits.)

Your insurance company will look for anything about the claim which might disqualify it under the exclusions section of your policy. Common objections include:

- a claim has arisen from or occurred in the course of work—and therefore should be covered by workers' comp;

- the policyholder did not inform the company about the injury or sickness in a timely manner;

- the person making the claim is not totally disabled—as this term is defined in the policy; and

- other available insurance reduces the benefits it must pay to small percentage of previously earned income.

This last issue can raise all kinds of problems. LTD policies usually provide for integration of plan benefits with additional disability income benefits. The LTD benefit may be offset by any of the following:

- any benefits provided by another formal employer plan;

- benefits payable under workers compensation or any similar statutory program; and

- any benefits payable under Social Security.

The purpose for having integration with other sources of disability income is to prevent overinsurance on the part of the insured.

The claims process is usually simplified with presumptive disabilities—like loss of vision or a limb. For this kind of claim, there is a single claims form completed at the onset of the claim. Due to the severity of the disability, no further claims forms are usually needed.

The 1996 federal court decision *Sam J. Walters v. Monarch Life Insurance* illustrates how complicated a dispute over disability benefits can get.

Monarch issued two disability insurance policies to Walters that were in effect during the late 1980s and early 1990s. Walters, a chiropractor, made claims on those policies because of injuries that prevented him from working. Monarch began to pay the benefits but eventually stopped because, it claimed Walters hadn't paid his premiums before making the claims.

Walters sued Monarch in 1993, alleging breach of contract. He sought more than $176,000 in damages. The case was tried in front of a jury, which entered a verdict for Walters in the amount of $44,066.

After trial, Monarch asked the court to overturn the verdict because Walters's disability policies had lapsed due to non-payment of premiums. Walters asked the court to establish—for the record—that he had paid the premiums. He also asked that the court reinstate his disability policy. The trial court denied all of these requests.

In yet another post-trial motion, Walters argued that—based on the jury's conclusion that he had suffered some total disability—he was entitled to damages totalling $176,265 (the amount he'd originally sought). The court denied this request, too—concluding that it was within the evidence of the case for the jury to find that he was not continuously, totally disabled for the full time period at issue.

When the legal dust had finally settled, Monarch and Walters both appealed the trial court's decision. In fact, they each filed multiple appeals.

In June 1994, the Tenth Circuit Court of Appeals consolidated four different appellate case numbers issued in response to the various notices of appeal and cross-appeal.

Because of all the confusion that led up to this point, the appeals court invited Walters to file a supplemental brief clarifying some of his arguments. In a move uncharacteristic of the dispute, he declined to do this.

A year later, in June 1995, the appeals court issued its decision, sorting through all of the claims and counterclaims:

- it declined to address the issue of whether Walters was entitled to reinstatement of the policy;

- it questioned whether Walters could establish continuing coverage under the disability policy in the absence of having paid premiums when not disabled—so it rejected this part of Walters's appeal;

- it denied Walters's petition for rehearing on the issue of reinstatement because he failed to bring the district court's order to its attention;

- to the extent that both parties sought relief from the court's prior ruling, it was denied.

The appeals court concluded:

> The parties had every opportunity to litigate these issues to the court and on appeal to the Tenth Circuit. The court concluded

that the parties failed to raise any issues or facts that persuade
the court to grant relief from judgment.

So it let the lower court's verdict and rulings stand.

Occupational v. Non-Occupational

Both short-term and long-term disability income policies may be occupational or non-occupational.

Occupational coverage provides payment for disability arising out of accidents occurring on or off the job. Non-occupational coverage provides payment only for disability that is not work-related.

Usually, group health insurance policies do not include occupational coverage because it is covered by workers' compensation insurance. An occupational policy pays benefits whether or not the disability is covered under workers' comp; a nonoccupational policy does not pay if workers' comp pays.

Calculating Benefits

You have one critical piece of control over how your disability income benefits are calculated. Because the size of the check the insurance company sends you is based on what percentage of your pre-disability income you're making, you have significant influence. Within some limits, you can decide whether or not—or how quickly—to return to work.

But, aside from the issue of how quickly you return to work, the insurance company controls most of the process.

Because of the numerous other factors influencing any disability claim, insurance companies can use some subjective judgment in determining the size of benefit they will pay in any given claim. But this discretion isn't absolute. The company's calculations have to follow the rules established in the policy.

A key issue in this calculation: residual benefits. A disability income policy that pays residual disability benefits provides an incentive for you to return to work, because it pays proportional benefits. A total disability only policy implies that you cannot return to work for any length of time without losing all benefits.

Example: You have a disability income policy with a 30-day elimination period, a $2,000 monthly income benefit for total disability and a benefit period to age 65. You become totally disabled on January 1 and are unable to

work for three months. You return to work on a part-time basis on April 1. You are able to earn 40 percent of your pre-disability compensation during the month of April. In May, you earn 60 percent of your pre-disability income. By June 1, you are working full time and earning 100 percent of your pre-disability income.

How will the benefits differ under a policy that provides total and residual disability coverage and a policy that provides only total disability coverage? An insurance company offering only total disability coverage might seem to pay less (by terminating benefits as soon as you returned to work on a part-time basis in April). However, it might actually end up paying more than the policy providing residual benefits (because without partial benefits you might not return to work until you are fully recovered).

Residual policies may require a minimum loss of 20 percent of pre-disability income before benefits are provided. So, a five or 10 percent loss of pre-disability income would not result in any residual benefit.

Conversely, many insurance companies will pay 100 percent of the total disability benefit if you have suffered more than an 80 percent loss of pre-disability earnings. So if you have a 90 percent loss of pre-disability income, you would receive a residual benefit equal to 100 percent of the total disability benefit.

In terms of claims, an important factor is how the insurance company views pre-disability income. Generally, a company may require evidence of income by means of tax returns or copies of W-2s. This solves the problem of what is meant by income.

On the other hand, tax forms don't always tell a complete story. Certain kinds of employees—commissioned sales representatives are a good example—have earnings that fluctuate. In these situations, pre-disability income may be defined as the average earned income for a specified period (such as two years) prior to the onset of a disability.

Lump Sum Benefits

Lump sum benefits under disability income insurance policies were once paid more frequently than they are today.

With modern safety measures and enforcement, accidents in the workplace are less frequent. With the increase in medical technology total and permanent disability occur less frequently. Therefore, installment disability income payments are more frequently used to pay disability income benefits.

Lump sum benefits will usually be paid under presumptive disability— or under special policies covering a company's buy-sell agreements.

A Benefit Calculation Chart

Month	Income Loss	Total and Residual Benefit Policy	Total Disability Only Policy
January	100%	None—satisfying the elimination period	None—satisfying the elimination period
February	100%	$2,000—100% of the total disability benefit	$2,000—total disability benefit
March	100%	$2,000—100% of the total disability benefit	$2,000—total Disability benefit
April	60%	$1,200—60% of the total disability benefit	None—performing occupational duties
May	40%	$800—40% of the total disability benefit	None—performing occupational duties
June	0	None—no loss of income	None—performing occupational duties

Life Insurance Claims

Life insurance claims related to lost income take two forms: disability riders to life insurance policies and accelerated or living needs benefits.

Disability income riders typically follow the claims processes used by standard disability income policies.

The accelerated or living needs benefits are more like life insurance benefits. This means they're sometimes easier to claim than disability benefits. Most importantly, they leave relatively little to the discretion of the insurance company.

If you qualify for accelerated benefits, the company has to give them to you when you file the appropriate claim. (The same is true for loans on accumulated cash value and other life insurance-related procedures.)

> A caveat: This doesn't mean accelerated benefits are the best tactic. They usually come with a steep discount from the face value of your policy. If you have a whole life policy with a face value of $100,000, you may only be able to get $70,000 in accelerate benefits—and as little as $5,000 or $10,000 in a policy loan.

Long-Term Care Claims

The main concerns people have when they make long-term care insurance claims are tax-related.

While disability income benefits under individual policies are received tax-free, LTC benefits are currently taxable in most cases. The debate over the nature of LTC insurance is not fully resolved.

Many of the services provided (housing, meals, etc.) do not reflect medical care or treatment, but other services (nursing care, home health care, and physical therapy) include elements of medical treatment or may require a certification of medical necessity. Some lawmakers are arguing that LTC insurance should be treated more like medical coverage and that the tax laws should be changed.

Disputes Over Claims Administration

In October 1998, the Supreme Court agreed to decide whether federal law overrides a state's rules limiting claims-filing deadlines imposed on people who make disability insurance claims.

The court said it will use a California dispute to study the scope of the much-litigated federal law protecting pensions and other employment benefits, the Employee Retirement Income Security Act (ERISA). Federal appeals courts have split on the issue of how ERISA affects a state's efforts to relax the claims-filing deadlines imposed by most insurance companies.

The June 1998 federal appeals court decision *Edward J. Zavora v. Paul Revere Life* considered how ERISA affects disability claims.

Edward J. Zavora purchased a disability insurance policy from Paul Revere Life Insurance Co. through his employer, Decorative Carpet, Inc. Shortly thereafter, Zavora allegedly suffered an injury to his eye that disabled him and submitted a claim to Paul Revere—which denied it.

Zavora sued Paul Revere in state court, alleging breach of contract, breach of the covenant of good faith and fair dealing, breach of fiduciary duty, negligence and fraud. Paul Revere removed the case to federal court, asserting

both diversity of citizenship and federal question jurisdiction, contending that Zavora's claims, properly pleaded, amounted to an ERISA claim because the disability insurance was an "employee welfare benefit plan."

The district court agreed, and granted summary judgment dismissing Zavora's state-law claims as preempted by ERISA.

Zavora amended his complaint to state an ERISA claim and the district court granted summary judgment in favor of Paul Revere on that claim, asserting that Paul Revere did not abuse its discretion as an ERISA plan in denying the claim. Zavora appealed.

The first point of contention was whether Paul Revere's disability insurance is, as a matter of law, an "employee welfare benefit plan."

ERISA broadly preempts state law that relates to "any employee benefit plan" as described in the statute. Insofar as relevant to this case, an employee welfare benefit plan is a plan, fund or program "established or maintained by an employer" to provide benefits in the event of illness, disability or certain other conditions.

The Secretary of Labor issued an interpretive regulation that creates for certain employer practices a "safe harbor" from ERISA coverage. In pertinent part, the regulation provides:

> [T]he terms "employee welfare benefit plan" and "welfare plan" shall not include a group or group-type insurance program offered by an insurer to employees...under which
>
> (1) No contributions are made by an employer;
>
> (2) Participation [in] the program is completely voluntary for employees;
>
> (3) The sole functions of the employer...with respect to the program are, without endorsing the program, to permit the insurer to publicize the program to employees...to collect premiums through payroll deductions...and to remit them to the insurer; and
>
> (4) The employer...receives no consideration in the form of cash or otherwise in connection with the program, other than reasonable compensation, excluding any profit, for administrative services actually rendered in connection with payroll deductions.

According to Paul Revere, Decorative Carpet endorsed the plan and exercised functions beyond collecting and remitting premiums. Zavora submit-

ted an affidavit from a Decorative Carpet employee most familiar with the program, asserting that the company engaged in no administrative activities beyond those specified in the "safe harbor" regulations or necessarily incident thereto: publicizing the plan, deducting and remitting premiums, and distributing certificates of insurance.

Decorative Carpet applied for the insurance on a form supplied by Paul Revere, which recited certain ERISA requirements and stated that the applied-for coverage provided benefits under ERISA, "unless otherwise exempted by law." The application also included a box checked to indicate that Decorative Carpet requested Paul Revere to provide the plan summary along with the certificates of insurance. The plan summary, stated that it was a summary plan description under ERISA, and it showed Decorative Carpet as the plan administrator, plan sponsor and agent for service of process. These facts alone, according to Paul Revere, establish Decorative Carpet's endorsement of the plan as a matter of law.

According to the court, the fact that Decorative Carpet does not fall within the "safe harbor" precludes a summary judgment in Zavora's favor based on the regulation alone. But, the ultimate issue is whether this plan is "established or maintained" by Decorative Carpet for its employees.

The application for insurance gave Paul Revere the "full, final, binding and exclusive discretion to determine eligibility for benefits and to interpret the policy." The Plan Summary was prepared by Paul Revere, not Decorative Carpet, and its title page bore Paul Revere's name in large print (although it did list Decorative Carpet as the employer). That title page states: "This Benefit Summary replaces any and all information previously received on this Paul Revere benefit."

Under "Miscellaneous Provisions," the Plan Summary states:

> THE EMPLOYER IS OUR AGENT FOR LIMITED PURPOSES
>
> Your employer is considered to be our agent only for these two events:
>
> 1. collecting premiums; and
>
> 2. giving out certificates of insurance.
>
> No agent has the power to change or waive anything in the Group Policy.

These provisions, said the court, could lead a reasonable person to find that Decorative Carpet served no function other than that of a conduit with

regard to Paul Revere's insurance. Thus, Decorative Carpet did not establish or maintain an ERISA plan for disability insurance.

Paul Revere argued that the mere designation of Decorative Carpet as plan administrator imposed certain duties and fiduciary responsibilities upon Decorative Carpet, under ERISA. Assuming, of course, that an ERISA plan has been established. If there is no ERISA plan, ERISA imposed no duties on an administrator.

Paul Revere also argued that Decorative Carpet actively interpreted and applied the policy in determining which employees were eligible. Paul Revere does not cite the record in so arguing, but if the reference is to the fact that Decorative Carpet verifies full-time employment status to Paul Revere, it is clearly a ministerial function that is ancillary to other activities that create no ERISA plan under the safe harbor regulations.

The court concluded that Zavora raised a triable issue of fact concerning the existence of an ERISA plan and reversed the summary judgment holding that an ERISA plan existed and preempted Zavora's state-law claims.

The court ruled:

> Because the possibility remains that, on remand, an ERISA plan will be found to exist, we address the summary judgment upholding Paul Revere's exercise of discretion in denying Zavora's claim. We conclude that, on the evidence before Paul Revere when it denied Zavora's claim, the denial was an abuse of discretion.

By the time of its final decision denying Zavora's claim, Paul Revere had before it two letters from David Fett, the ophthalmologist who treated Zavora for his thorn injury. One of the letters memorialized a telephone conversation with a claims employee of Paul Revere. The letters stated that Zavora's disability resulted from the thorn becoming buried in the back of his eye after the effective date of the insurance.

Fett stated that the disability would not have occurred but for the thorn injury, which was the cause of the disabling pain. Paul Revere referred the file to its medical personnel, none of whom the record shows to have been an ophthalmologist. Without conferring with Fett or examining Zavora, see id., they concluded that Zavora's disability was caused by his pre-existing dry-eye problem, for which he was still obtaining treatment. That condition had never been disabling before Zavora's thorn injury. Paul Revere therefore denied Zavora's claim, on the grounds that his disability was caused by his pre-existing condition and that the thorn injury would not have caused a period of disability sufficiently long to trigger coverage.

The court noted:

> Although we recognize that an ERISA administrator is entitled to substantial deference, it still must have some reasonable basis for its decision denying benefits. This record is insufficient to support the discretionary denial of Zavora's claim because it was based on inadequate investigation and reliance on non-experts in opthamology.

Although Paul Revere acknowledged the reports of Fett, they rejected their conclusions without a sufficient evidentiary basis for doing so. The denial was an abuse of discretion.

The summary judgment in favor of Paul Revere on Zavora's ERISA claim was reversed, and remanded for further proceedings in the event that the district court finds an ERISA plan to exist.

Congress intended ERISA to supersede state laws relating to employee benefit plans, but exempted any law "which regulates insurance." The 9th Circuit court has adopted a more liberal interpretation than other federal appeals courts when determining whether a particular state law regulates insurance and should be exempt from the federal law's superseding power.

In *UNUM v. Ward*, the court of appeals revived the lawsuit of a Californian who unsuccessfully sought disability insurance from his insurance company.

John E. Ward was president and chief executive officer of Management Analysis Corp. before being disabled by diabetes.

UNUM's Supreme Court appeals were supported in friend-of-the-court briefs submitted by the insurance industry. They said the 9th Circuit court's rulings, if not reversed, would "increase the complexity and cost of administering (benefit) plans to conform with varying state rules, thus making it likely that employers will decide either not to offer these types of benefits to employees or to offer benefits on a less generous basis than they currently do."

The high court agreed to hear an appeal by a UNUM Corp. unit, which says a lower court should not have invoked a California law giving claimants more time to file for benefits. The lower court rebuffed UNUM's arguments that federal law prevents states from tinkering with plan deadlines.

Insurance companies want their plans to have the same meaning in every state so that they don't have to contend with conflicting, and often claimant-friendly, local rules. Companies fear state laws could force them to spend more to insure the 160 million-plus Americans covered under health, disability, life and other plans.

"On the one end, it means increased administrative costs," said Phillip Stano, a lawyer for the American Council of Life Insurance (ACLI), which filed papers in support of UNUM. "On the other end, it means less predictability and more risk. You're getting hit from both sides."

The case involves a worker who filed a disability claim after the required time limit under the policy.

A federal appeals court, however, said California insurance law gave the worker additional time to file. The high court must now decide whether that law applies or is preempted by the federal law governing worker benefits.

The dispute has drawn wide attention in the insurance industry. Several trade groups, as well as Aetna Life Insurance Co., Cigna Corp. and Standard Insurance Co., urged the high court to consider UNUM's appeal.

The justices agreed to hear oral arguments and rule before their 1998-99 term ends in late June or early July.

At the same time the court agreed to hear the UNUM case, it refused to review whether an appeals court used an overly stringent standard when it denied Aetna Life Insurance Co. a new trial in an Alaska insurance case.

The Alaska case stems from a jury's conclusion in 1996 that the Aetna Inc. (AET) unit acted in bad faith when it denied long-term disability benefits to Sherrie Ace, a state loan examiner covered by an Aetna policy. The jury, after a seven-day trial, awarded Ace $16.5 million in punitive damages.

In response to post-trial motions from Aetna, the district court upheld the jury's finding of bad faith and its award of compensatory damages, but set aside the portion of the verdict finding the insurance company liable for punitive damages. The district court also ordered a new trial on Aetna's punitive damages liability.

Both Ace and Aetna appealed. The Ninth U.S. Circuit Court of Appeals found that the district court erred in setting aside the punitive damages portion of the verdict, and reversed the conditional order granting a new trial.

The circuit court, however, did deem the award excessive under Alaska law and sent the case back to the district court with instructions to determine the appropriate amount. Those proceedings are still pending.

Aetna, in urging the justices to review the case, said the appeals decision would deny federal trial judges the traditional flexibility to evaluate evidence and set aside verdicts that appear extreme.

"In punitive damages cases, the trial court has a unique position to view the evidence and to serve as a judicial check on unwarranted or excessive punishment," attorneys for Aetna said in a brief.

Aetna argued that a trial court can grant a new trial if the verdict appears to be against "the weight of the evidence." The appellate court in turn is limited to reviewing that assessment for "abuse of discretion," Aetna said. Instead of following that approach, the Ninth Circuit erred by applying a more stringent standard, Aetna argued.

Ace injured her knee while sledding in 1986. When her short-term disability benefits lapsed, she applied for long-term benefits. Aetna denied the claim, saying Ace was still capable of performing her job as a loan examiner.

Social Security Claims

The claims issues relating to Social Security disability income coverage relate mostly to the strict definition of disability under the program.

Statistically, only about one in three Social Security disability claimants ever collects benefits. This is true for several reasons.

Eligibility requires the following:

- you have fully insured and disability insured status;

- you are under age 65;

- the disability is expected to last for at least 12 months and/or end in death; and

- you have satisfied a five-month elimination period followed by submission of an application for benefits.

The under age 65 requirement is due to the fact that, at age 65, any disability benefits being paid become retirement benefits. Thus, the disability must begin prior to age 65; when a recipient turns 65, disability benefits cease and retirement benefits begin.

In addition to the age and status requirements, a worker must also satisfy the Social Security definition of total disability. Total disability is defined as:

> The inability to engage in any substantial gainful activity by reason of any medically determined physical or mental impairment which can be expected to result in death or last for at least 12 months.

This definition is very restrictive. It obviously eliminates benefits for any short-term disability or a relatively insignificant, non-life threatening disability.

Generally, an application for benefits will be filed sometime during the fifth month of disability, because there is a five-month elimination or waiting

period. Claims applications may be submitted retroactively up to 12 months after the onset of the disability.

Under the system, a disability must be so severe that a person is unable to engage in any employment which exists in the national economy.

In addition to meeting the eligibility requirements of an employee and paying Social Security taxes, eligibility for Social Security benefits is determined by your insured status.

There are basically three forms of insured status:

- fully insured;

- currently insured; and

- disability insured.

The following chart illustrates the concept of insured status.

Status	Eligibility Requirements	Benefit
Currently Insured	Six quarters of coverage out of the 13 quarters preceding a claim	Dependent survivor benefits and lump sum death benefit
Fully Insured	Forty quarters of coverage (payment of Social Security taxes for 10 years	Retirement and survivor benefits; usually disability benefits
Disability Insured	Fully insured status and 20 quarters of coverage out of 40 quarters ending with the quarter of disability	Disability benefits

The actual disability benefit is equal to your primary insurance amount (PIA). The PIA is based on the average earnings history upon which Social Security taxes have been paid. In addition, the actual disability benefit is affected by your age at the onset of the disability and your dependent status.

Disability benefits may be reduced to offset benefits received from workers' comp and any statutory disability plan such as a federal or state disability plan.

This reduction in benefits will be made if the Social Security benefits plus the statutory plan benefits exceed 80 percent of your predisability average earnings.

Certain benefits are not subject to this offset rule. For example, Veterans Administration (VA) benefits are excluded; as are private pension or insurance benefits.

The summary judgment in the 1995 federal district court case *Virginia Rommel v. First Unum Life Insurance Co.* dealt with whether or not First Unum could deduct the amount of Social Security disability benefits Rommel received from the amount of benefits it paid to her under a long-term disability insurance policy. Rommel argued that it could not, and this deduction constituted a breach of contract.

In October 1990, Rommel was injured in an automobile accident. At the time, she had been employed by Utica Mutual Insurance Co. in New Hartford, New York, for about 18 years. Her employer purchased long-term disability insurance for its employees from First Unum. Although Rommel briefly returned to work part time in early 1991, she completely stopped working in May 1991.

After exhausting her short-term disability insurance benefits, which Security Mutual paid, Rommel began receiving long-term disability insurance benefits from First Unum in April 1992. She also received benefits from Allstate, her automobile insurance carrier, under her policy's no-fault lost wage and personal injury protection provisions.

Rommel applied for disability benefits from the Social Security Administration as required by her insurance companies. Although Social Security initially denied her claim, the agency granted Rommel's appeal. In a decision dated June 1992, Social Security awarded Rommel total disability benefits retroactive to May 1991. She received an award letter from the agency in mid-July 1992.

After Rommel began receiving Social Security, each of the companies deducted the social security benefit amount from the amount of money it was paying her under its respective policy. The companies also demanded reimbursement for certain benefits they overpaid between May 1991 and June 1992, because the retroactive Social Security award covered that period.

Rommel attempted to resolve the dispute through arbitration in early 1993, but only Allstate participated in the proceedings. She subsequently commenced a lawsuit in New York State Supreme Court in October 1993.

Rommel requested a declaratory judgment to determine what benefits each insurance company should pay her. She also claimed that the offsets of her Social Security benefits by First Unum and Allstate breached her insur-

ance contracts. Security Mutual raised a counterclaim against Rommel for reimbursement of $3,599.34 in benefits paid that should have been offset by Rommel's social security benefits.

First Unum removed the action to federal court on January 5, 1994. In its motion for summary judgment, First Unum contended that Rommel's state law claims against it were preempted by the Employee Retirement Income Security Act (ERISA).

Rommel contended that preemption would be inappropriate because "there is absolutely no language concerning my rights under ERISA as alleged [by defendant]." However, the versions of the insurance policy provided to the court by Rommel and First Unum each contained identical cover pages with an explicit reference to ERISA. Further, the court determined the trigger for ERISA preemption generally is:

> a state law or cause of action having "an effect on the primary administrative functions of benefit plans, such as determining an employee's eligibility for a benefit and the amount of that benefit."

Since Rommel's state law claims clearly relate to the calculation of her long-term disability insurance benefits, the court concluded that they were preempted by ERISA. Therefore, she was limited to the remedies afforded by the statute's civil enforcement provisions.

The court pointed out:

> Importantly, ERISA does not mandate particular benefits but instead "governs plan operations, provides rules of fiduciary responsibility and sets forth disclosure requirements to further ERISA's policy of protecting the interests of plan participants in the benefits that employers do elect to provide."

> ERISA provides that a plan participant or beneficiary may bring a civil action "to recover benefits due to him under the terms of his plan, ... or to clarify his rights to future benefits under the terms of the plan." A plan participant or beneficiary also may bring a lawsuit under ERISA "to enjoin any act or practice which violates any provision of this subchapter or the terms of the plan."

> Finally, ERISA provides a cause of action for breach of fiduciary duty.

At this point, First Unum contended it was entitled to summary judgment because the policy language unambiguously permits the insurance company to set off Social Security benefits from long-term disability insurance payments. First Unum also contended that Rommel's claims must be dismissed as premature because she failed to exhaust required administrative remedies.

Rommel responded that First Unum breached its fiduciary duty to her under ERISA.

While Rommel complained that it was improper for First Unum to offset her social security disability benefits from the amount of benefits the company paid her, the court found that "under the clear language of the First Unum policy, such deductions are permissible." Thus, the court determined that Rommel was not entitled to greater benefits from First Unum, and the company's actions did not violate the terms of the plan—nor did they breach any fiduciary duty by implementing the plan.

While Rommel's counsel argued that imposing the offsets was unfair in Rommel's "particular situation," thereby giving rise to a fiduciary breach, the court did not agree:

> [J]ust as ERISA does not mandate the provision of specific benefits, the statute does not require plan fiduciaries to renegotiate plan benefits on an individual basis. Moreover, it may be a fiduciary breach if plan administrators treat beneficiaries differently from one another in variance with the plan's provisions.

The court decided that summary judgment was appropriate on these grounds, and granted it.

Medicare Claims

Medicare eligibility based on disability means that you are totally disabled and collecting Social Security disability income benefits or have a major kidney problem requiring dialysis. Specifically, you must have been collecting Social Security disability income benefits for at least 24 months in order to attain Medicare eligibility. (This means 24 months of compensable disability plus the five-month waiting period. So, after 29 months of disability, you are eligible for Medicare.)

(There's one exception: Eligibility due to kidney failure or transplant requiring dialysis is effective with the first day of the third month following

the month in which dialysis began. In essence, this means there is a three-month waiting period.)

Finally, Medicare benefits are influenced greatly by whether or not your doctor is a participating physician. A participating physician is one who has been approved to receive payment directly from the Social Security Administration. He or she has agreed to accept the amounts paid by Medicare. A non-participating physician is not approved by Medicare for direct payment and may charge more for services. Medicare will only cover these charges up to its predetermined limit.

> **A caveat: A disabled person on Medicare may have to pay excess charges if his or her doctor is a non-participating physician.**

Conclusion

Making a disability insurance claim can be difficult because the amount of money involved can be substantial over a long period of time. Be prepared to deal with a bureaucracy when you make a claim—it's how the system weeds out fraudulent or questionable claims.

You'll have to file initial claims forms and maintain regular status updates in order to keep long-term benefits coming in.

The process can get even more difficult if you're relying on one of the statutory programs—workers comp, state unemployment insurance or Social Security—for coverage. These programs are even more bureaucratic. And they offer even smaller benefits.

While you may choose to use a statutory program or some other alternative to insure your disability, the claims process makes one point strongly: The best way to have a claim paid promptly and well is to make it on an individual LTD policy.

Part Six:

Medical Care, Your Health and Well-Being

Chapter 13

The Mechanics of Health Insurance Claims

In 1999, U.S. health care consumers will make more than 35,000 complaints to state insurance departments about managed care plans and other health care insurance companies, estimates the National Association of Insurance Commissioners.

The most frequent complaints involve claim denials, disputed claims, slow payments by insurance companies and premium-related matters.

The volume of problems has prompted the government and the national insurance association to step up their consumer help.

The 1990s have seen increasing insurance litigation fueled by more aggressive attempts by insurance companies to challenge or reject claims, and a public backlash against the industry's shortcomings, especially with managed care plans.

In August 1998, Senate Republican and Democratic leaders agreed to put off consideration of patient protection legislation until after Congress returns in September from its summer recess.

The delay occurred after the two sides could not agree on rules to debate the legislation. Without an agreement, the issue could be endlessly debated.

Republican and Democratic patient protection bills—competing versions of a so-called "Patients' Bill of Rights"—before the Senate share certain common elements, including giving patients direct access to certain specialists, expedited reviews of disputed claims and greater assurance that emergency room care treatment would be covered.

A key difference in the two bills is that the Democratic bill would open up group plans and employers to state damage awards in coverage dispute suits, while the Republican bill would not.

Meanwhile, trying to find a center ground, Rhode Island Senator John Chafee, unveiled a so-called centrist patient protection bill that would amend the Employee Retirement Income Security Act (ERISA) to allow health care plan enrollees to recover compensatory damages. ERISA now limits awards to actual losses.

Chafee said that if Congress wants to pass a patient protection bill, "here it is," referring to his measure, which so far has been backed by four other senators. The House of Representatives earlier passed patient protection legislation, which also doesn't allow state damage awards in coverage suits.

"Fundamentally, the problem is inherent conflict of interest. By not paying claims, the insurers make more money," says Peter Sullivan, executive vice president of the Nassau Suffolk Hospital Council. "Where there is conflict of interest, there may not be abuse, but you have to pay attention."

"The first thing the individual needs to do is to know what type of health plan or coverage they have," says Carolyn Morris, director of the Consumer Services Bureau for the Pennsylvania Insurance Department. Read the handbook that you received when you enrolled. "It's important for consumers to have an idea of what's covered and what's not and to keep their member handbooks or employer handbooks."

> **Resolving disputes starts by contacting your insurance company, who must follow the dispute procedures outlined in your policy (another reason why it's so important to hang onto your insurance documents).**

If the dispute is not resolved by the insurance company, you may appeal to the proper state or federal agency—the state Insurance Department; the state Department of Health for managed care plans; the federal Health Care Financing Agency for Medicare managed care plans; and the state Department of Public Welfare for Medicaid managed care plans.

Regardless of type of insurance, the Insurance Department handles complaints involving the way the policy was sold, return of premium and coordination of benefits.

"It's really important that the first thing they do...is find out if they have an internal grievance mechanism with that plan," Morris said.

Common Health Claim Disputes

You have cataract surgery on your right eye. Three days later you begin experiencing pain and loss of vision in your right eye. You call your

optomologist, but because it's Sunday, the answering service refers you to the physician on call. The on-call physician determines that the condition in your right eye is an emergency and calls another doctor, who determines that you have a severe staph infection and must immediately undergo surgery to save your eye.

Shortly thereafter, you learn that the surgeon who performed the surgery was not on your insurance plan. So, your insurance company won't pay the bill. You thought you were referred correctly. Your plan manual, states that emergency services do not require primary care physician approval and that a person could proceed to the nearest medical facility.

However, you learn later that the surgeon's office did not receive an explanation of benefits with the payment to close the account. As a result, your account could not be credited and closed. Because of an oversight on the insurance company's part, you were never notified of this.

> **When it comes to solving health insurance disputes, you are your best advocate. But standing up for your rights requires understanding your policy, keeping careful records and following procedures, including appeals to the proper state and federal agencies.**

The June 1997 federal district court decision *Eddie Lambros, Amanda Lambros, at al. v. PFL Life Insurance* showed why health coverage is worth fighting for.

Insurance agent Jonathan Kaplan entered into an "independent agent contract" with United Group Association, Inc. (UGA), to sell PFL insurance products. While Kaplan was not directly compensated by PFL, PFL paid UGA, which paid Kaplan. In 1994, Kaplan contacted Eddie Lambros by telephone and requested that Lambros consider a new hospitalization insurance policy.

According to Lambros, Kaplan said he was an agent for PFL, and gave him an application, which bore the title "Enrollment Application to: PFL LIFE INSURANCE COMPANY." The application included a number of questions regarding medical history. Lambros gave his health history and then signed the application. However, many of the health history questions were left blank with regards to his wife and daughter.

Kaplan told Lambros that if no medical problems surfaced regarding his wife and daughter, the policy would be issued, and if some problems did surface, the policy could be issued with appropriate riders.

The Lambros family was subsequently issued a hospitalization expense policy. In December 1994, Karen Lambros was hospitalized in the Tri-City

Health Care medical facility. In January 1995, The Lambros' daughter Amanda was also hospitalized in the same facility.

The family sought payment from PFL for the hospitalization costs, which totaled over $104,000. However, when investigating the claim, PFL discovered that many of the medical history questions in the Lambros' Application were answered falsely and that many of the women's health problems had not been disclosed. As a result, PFL denied the claims and canceled the policy.

The Lambros family assigned the benefits of the insurance policy to Tri-City, and sued PFL and Kaplan, raising claims of breach of contract, breach of the duty of good faith and fair dealing, negligence, gross negligence, negligent and fraudulent misrepresentations, and violations of the Fair Business Practices Act and the Uniform Deceptive Trade Practices Act.

PFL moved for summary judgment.

According to PFL, as a matter of law, Kaplan was not its agent. Thus, PFL is not estopped from denying coverage based on the misrepresentations in the application, and PFL cannot be held vicariously liable for the actions of Kaplan.

Lambros contended that the Georgia statute defining an "agent" for the purposes of licensing demonstrates that Kaplan was an agent of PFL.

However, Lambros and Tri-City have also argued that there is a genuine factual dispute as to whether Kaplan was actually an agent of PFL.

PFL claimed that there is a difference between a "mere independent soliciting agent" and "an agent who has the authority to bind a principal," and that Kaplan was only a soliciting agent with no authority to bind PFL.

In support of this argument PFL asserted that: (1) Kaplan entered into an independent agent agreement with UGA, not PFL, and UGA had only an independent contractor agreement with PFL; (2) PFL did not control the time or manner of Kaplan's work; (3) The application for insurance disclaimed any authority Kaplan had "to accept risks or to make, alter, or amend coverage" and stated that any policy would not take effect until approved by PFL; and (4) Both Kaplan and PFL deny the existence of an agency relationship.

In addition, said PFL, as the principal, it did not commit any acts to hold out Kaplan as its agent.

In response, Lambros and Tri-City contended that: (1) Kaplan is clearly an "agent" as defined by the insurance code of Georgia; (2) Kaplan identified himself to Lambros as an agent of PFL; (3) Kaplan gave Lambros a business card with Kaplan's name and PFL's name and address on it, which would create an inference that Kaplan was PFL's agent; (4) Kaplan did not solicit an application from any other insurance company; (5) The application which

Kaplan gave Lambros was entitled "Enrollment Application to: PFL LIFE INSURANCE COMPANY"; (6) Language on the application and the medical history release repeatedly referred to Kaplan as "agent" or PFL's "representative"; (7) Kaplan collected a sum of money from Lambros at the time of application; (8) Kaplan's name was printed at the bottom of PFL's internal file on Lambros; and (9) PFL applied to the Georgia Commissioner of Insurance for Kaplan to be licensed to sell PFL policies in Georgia.

According to the court, genuine factual disputes existed as to whether or not Kaplan was an agent with authority to bind PFL and as to whether Kaplan had apparent authority to bind PFL due to PFL's holding him out as its agent.

The court held that an insurance company cannot be permitted to obtain the services of an agent and at the same time designate him as an independent contractor. "Given the evidence presented at summary judgment, it is unclear exactly what kind of organization UGA is, and it is entirely possible that the PFL-UGA structure exists (in preparation for lawsuits like this one) to insulate PFL from direct contact with its agents nationwide," said the court.

Further, "Kaplan solicits applications for PFL and is paid a commission for enrolling people in PFL policies. PFL has provided him with applications with the company's name on them, and the company allows him to put the company's name on his personal business cards. PFL petitioned for Kaplan's license in Georgia and has thus specifically ensured that Kaplan will be peddling its policies to Georgia residents. Clearly there is evidence from which a jury could conclude that Kaplan was an agent of PFL or had apparent authority to bind PFL."

PFL was not entitled to summary judgment on this issue. And because there is a genuine issue of fact as to whether Kaplan was an agent of PFL, the court could not find that PFL is entitled to summary judgment on the negligence, gross negligence, and misrepresentation claims. "If Kaplan was an agent of PFL, then his representations could bind PFL and his actions could be attributed to PFL. Therefore, any determination of these claims without a factual finding on the agency issue would be premature," said the court.

In addition, said the court, it could not grant summary judgment for PFL on the Fair Business Practices Act and Uniform Deceptive Trade Practices Act claims because there was a factual dispute as to whether Kaplan was an agent of PFL. If he was PFL's agent, his representations could be imputed to PFL, and PFL could be held liable on either or both of these claims.

Under Georgia case law, an applicant for insurance is *prima facie* charged with knowledge of the contents of an application signed by him, but if an applicant tells the truth to an agent who mistakenly or fraudulently records

them on the application without the applicant's knowledge, the company will be estopped from avoiding liability for misrepresentation and from seeking rescission of the policy.

PFL said that it was not estopped from seeking rescission of Lambros' policy because the application contained materially false statements.

However, the court ruled that there was some behavior by Kaplan that prevented Lambros from knowing about the misstatements. In fact, Kaplan told Lambros that he need not answer the parts of the application regarding the medical history of his wife and daughter and that he need only provide Kaplan with the women's physician's name to complete the application. Given the language on the medical release stating that such authorization would "be used by PFL to determine eligibility," it would have been entirely reasonable for Lambros to sign the application with several answers left blank, said the court.

Because there was a genuine factual dispute as to whether Kaplan was an agent of PFL, and because there is a genuine factual dispute as to whether Kaplan prevented Lambros from discovering the falsity of several answers on his application, said the court, PFL was not entitled to deny Lambros's claim because of the false statements.

One State's Example

Pennsylvania's Act 68 is a state law that spells out how the claims process will work for managed care plans. Act 68 distinguishes between complaints (issues not related to a medical necessity) and grievances (issues of medical necessity).

The complaint procedure still begins with a two-step review at the company level. The grievance process includes the two-step review but adds an expedited review for urgent situation. And, the new law allows providers to pursue grievances.

For example, a physician could file a grievance if he or she wanted to provide treatment that the consumer's plan would not cover.

At the Health Department level, grievance appeals are now assigned on a rotating basis to a certified physician, licensed psychologist or group of physicians or psychologists for a decision. The Health Department will make certain they don't have a conflict of interest.

Before filing a claim, the National Association of Insurance Carriers suggests you review your policy or employee booklet carefully to make certain the service in question is covered.

In addition, follow any managed care rules, including pre-certification requirements and use of network providers. If you are uncertain whether a provider is in your network, call your managed care plan representative. (And obtain referrals if necessary.) Give claim forms to the provider, with your policy number and other identifying information.

According to the association of insurance carriers, when submitting your claim you should do the following:

- Find out if your provider submits the claim or if you need to.

- If you need to do it, review the information to be sure it is complete and correct.

- File the claim as soon as you are billed by the provider.

- Send the claim to the correct address.

- Keep a copy of all documents for your records.

Understand How Your Claim Will Be Paid

It is always good to understand how your claim will be paid.

For example, if you assigned benefits to the provider, the check will be sent to the provider. You will pay any deductibles and co-insurance. But if you did not assign benefits, the check will come to you and you will pay your providers the entire amount.

If your claim is denied, don't panic. Read your explanation of benefits to find out the reason for the denial.

If you disagree with your insurance company's reasons for denial, check your policy or employee booklet for information on appeal procedures. You might even want to contact a representative of your insurance company for procedural information.

If you decide to appeal, make your appeal in writing and include copies of any physician records.

The April 1997 federal appeals court decision *Cypress Fairbanks Medical Center v. Pan-American Life* highlights a very clean health insurance claim gone awry because of the lengthy and often convoluted claims process. In this case, the consumer let the hospital chase payment.

In December 1993, Deborah J. Meyer established an employee welfare benefit plan, which provided group health insurance for her employees and

their families. The plan was funded through insurance purchased from Pan-American Life Insurance Company. National Insurance Services acted as Pan-American's agent.

Jack Schwartz, an employee of Meyer's, was admitted to Cypress Hospital and ran up a bill of $178,215.44 in medical services related to a respiratory ailment. Prior to admitting Schwartz, the hospital was informed by National, that Schwartz was covered by Meyer's plan. However, Schwartz was not covered by the plan. National incorrectly informed Cypress about Schwartz's status under the ERISA plan.

Cypress submitted a bill for services to National, and National refused to pay on the ground that Schwartz's "coverage [was] rescinded as of [the] effective date."

As a result, Cypress brought suit against Pan-American and National in Texas state court alleging a violation of Texas's Insurance Code. Specifically, it alleged that the two negligently misrepresented Schwartz's coverage under the health insurance plan, and as such, were liable for deceptive and unfair trade practices.

The case was eventually removed to federal court on the basis of federal question jurisdiction and Pan-American and National filed a motion to dismiss, or in the alternative, a motion for summary judgment, arguing that Cypress's claim was preempted by Employee Retirement Income Security Act (ERISA). The district court agreed and entered a take-nothing judgment against Cypress. The hospital appealed.

On appeal, Cypress relied on the court's 1990 ruling in *Memorial Hospital System v. Northbrook Life*, in which it held that a state-law cause of action for negligent misrepresentation brought pursuant to Texas Insurance Code was not preempted by ERISA.

The district court had not relied on or cited the decision in *Memorial*. On the contrary, it concluded that "Cypress's claims are indistinct from a participant's claim that his employer misrepresented the plan benefits.... It does not matter whether it was the employee or his hospital that was misled by the benefit plan-related entities. Extensions of coverage, however sought, are not the plan; the preemption works like a [*sic*] omnipotent parole evidence rule to block all extension of amounts recoverable from entities whose involvement is related to plan benefits."

Pan-American and National argued that *Memorial* does not control this case because in its pleadings, Cypress admitted that it was inquiring about the extent rather than the existence of coverage for Schwartz. Pan-American and National also argued that because an ERISA plan was in place and Schwartz

was enrolled in the plan, Cypress's state-law claim should be preempted by ERISA. Because Pan-American and National erroneously concluded that *Memorial* was inapplicable to the case and that the district court erred in not applying the 1990 ruling, the court reversed the district court's holding that Cypress's claims were preempted by ERISA.

Evidently, Pan-American's and National's position was unavailing because Schwartz, although enrolled in the plan, was not covered by the plan. It is undisputed that National refused to pay Cypress because "coverage [was] rescinded as of [the] effective date." However, the record is unclear as to the meaning of this phrase. And it is unclear why National's refused to pay for Schwartz's services. Nonetheless, said the court, neither National, Pan-American, nor the record suggest that "coverage rescinded" means anything else than Schwartz was not covered by the plan at the time of his hospitalization. So, the court ruled, "Cypress's cause of action does not relate to ERISA, but rather arises under state law. Memorial is therefore triggered. Cypress's state-law claim under s 21.21 for misrepresentation is not preempted by ERISA."

Finally, the district court's reasoning that for ERISA purposes, third-party providers such as Cypress are on no better footing than first-party beneficiaries was rejected because it was rejected in *Memorial*, as follows:

> We have held under different circumstances that ERISA pre-emption may occur even though ERISA itself could not offer an aggrieved employee a remedy for alleged misrepresentations. That principle should not be extended, however, to encompass third-party providers, particularly when to do so would run counter to one of Congress's overriding purposes in enacting ERISA.

Because the district court erroneously determined that Cypress's state-law cause of action for violating the Texas Insurance Code was preempted by ERISA, the court reversed the district court's decision. "In addition, the district court's jurisdiction to hear this case was based on the federal question presented by ERISA preemption, and because we hold that ERISA is not implicated, we remand this case to the district court with directions to remand Cypress's claim to Texas state court.

Filing a Complaint or Grievance

In most states, the company's review of your denial includes two steps—an informal review followed by a formal review if you remain dissatisfied after the informal review.

If you appeal to a state or federal agency, include your name, address and daytime phone number with any complaint.

It might be good to use the Insurance Department complaint form. To obtain a copy of the form you can usually call the state Insurance Department's hotline number.

> **State your case briefly, giving a full explanation of the problem. Include the name of your insurance company, policy number and the name of agent or adjustor involved. You may want to supply any documentation you have to support your case, including phone notes (i.e. who you talked to and what was discussed).**

Another tactic used by insurance companies (as discussed earlier) is the unjustifiable delay in payment of claims. Despite laws requiring insurance companies to pay unquestioned medical claims within 15 working days, some companies take up to six months or even longer to compensate patients.

"If hospitals delayed care the way insurance companies delayed payment, we would have a lot of dead patients on our hands," said a lobbyist for the Georgia Hospital Association.

Though several insurance companies acknowledge that recent mergers of companies may have caused some delays, the industry as a whole has a tendency to dismiss the problem, claiming that they are isolated incidents.

"On the whole, claims are paid in a fairly expeditious manner," said Richard Coorsh, a spokesman for the Health Insurance Association of America.

According to Coorsh, a 1996 survey of 53 members found that 90 percent of claims were paid within 14 days. However, a survey by the Georgia Hospital Association found that private insurance companies took an average 69 days to pay a "clean claim"—that is, one requiring no additional information from the provider or patient.

The survey also reported a number of claims took anywhere from 40 to 169 days to get a clean claim paid. And, self-insured plans by large companies, which are exempt from the 15-day requirement, presented a particular problem.

In 1998, three Florida-based physician organizations—a prominent 30-member ob-gyn group in Jacksonville, the 4,000-member Florida Physicians Association and the 16,000-member Florida Medical Association—filed a class action lawsuit against Prudential Health Care Plan, Inc., accusing the company of systematically denying and delaying payment on large claims and losing others. The physicians want to stop the alleged practices and recover interest on the claims and damages that they say may exceed $10 million.

The organizations had internal documents that proved Prudential made a policy of automatically rejecting claims once the insured person submitted more than $1,000 in medical bills on the basis that the covered person had other insurance, even though the plan had no knowledge of such co-insurance. In fact, Prudential officials acknowledged that only 5 percent of its members had such dual coverage arrangements as those that exist when a husband and wife are covered by separate health plans, according to the physician organizations.

"Florida law specifically requires that when there is a coordination of benefits issue that the insurance companies involved have to pay the provider 100 percent of the claims and then hassle out which company is supposed to pay what," said Donald Weidner, Florida Physicians Association's executive director and general counsel. "If Prudential thinks there is other insurance, they certainly have the right to go to the patient or the doctor [and ask for the name of the other company]. But they certainly do not have the right to refuse to pay the physician in the meantime," Weidner said.

The groups also charged Prudential with knowingly losing claims that were filed electronically.

Prudential had little to say about the suit. In a four-paragraph statement, the company asserted it had an excellent track record on claims payments in the state, paying 92.3 percent of all claims within 30 days, 97.9 percent within 45 days and 98.9 percent within 60 days..

Prudential also defended its practice of requiring proof of dual coverage. "It is standard industry practice to coordinate the payment of benefits. When we have the information we process those claims routinely. When we don't have that information we request that information to make sure we are paying the claim properly and not duplicating payments," said Julie Chalpan, public relations manager for Prudential's southeast division.

The Bureaucratic Barriers

Claims-related administrative burdens on physician offices are driving up costs for physicians.

According to Mary Valdez, the manager of patient accounts for the Indianapolis Women's Health Partnership (WHP), despite "doing everything we can to automate everything we can," WHP still faces a cost of $7.42 to get paid for a single claim. And, the problems are industry-wide.

"When I switched from the banking industry to health care, I was alarmed at the lack of sophistication of the computer systems and the lack of industry

benchmarks. I was used to moving hundreds of millions of dollars in a matter of minutes. I was amazed to have to send a $10 claim to an insurance company three times to get it paid," said Valdez.

"Electronic Data Interchange (EDI) has cut two weeks off our claim payment cycle. Instead of two and a half months for the average claim to be paid, it now takes two months. Even with EDI, and an intense focus on sending a clean claim, 30 to 35 percent of all WHP's claims are denied for some reason," said Valdez. And, claim rejection rates were compounded by problems with electronic claims systems.

Technology Advances

In 1998, Aetna U.S. Healthcare introduced a new electronic claims filing system to speed up payments to physicians and reduce paperwork and annoying errors for employees.

Under the system, called E-Pay, physicians can file claims using an in-office computer with special software provided by Aetna. A claim submitted will be reviewed and payment made within 15 days, the company said, compared with an industry average of 45 days and its own 30-day average.

"We believe that E-Pay will improve HMO claim turnaround time, leading to more predictable cash flows for physician practices and, therefore, higher satisfaction levels among our participating physicians," Michael Cardillo, president of Aetna/U.S. Healthcare, said in a written statement. "And as we convert the majority of claims to electronic processing, our overall service quality will greatly improve for employers and members."

Aetna officials also said the new system will reduce errors in claims and duplicate claim submissions. Although the company had no statistics on the percentage of claims filed on paper that contain errors, it said 40 percent of paper enrollment forms included mistakes. But when Aetna moved to electronic enrollment last year, the error rate dropped to under 1 percent.

But some consultants don't share Aetna's enthusiasm for E-pay. They claim that an electronic linkage between doctors and the HMO is good, but are disappointed more is not being done with it, such as data collection and electronic payments to doctors.

Paying claims faster helps employers by having a better plan for their employees. It also reduces the reasons for doctors to vent frustration on the patient, causes them send out fewer late-payment notices and make fewer phone calls to patients seeking payment.

But Aetna said the main benefit to employees is the expansion of the existing electronic referral system. With E-Pay, a primary care physician can file electronically with Aetna a referral to a specialist, eliminating the need for a member to obtain a paper referral. The referrals can be made by telephone into a voice response system or using a swipe box similar to those used for credit cards.

Overuse of Treatments

Another tactic used by insurance companies to try to get out of paying a claim is the overuse of treatments defense.

The case *Andrews-Clarke v. Travelers Insurance Co.* presents a particularly wretched example of this problem. Richard Clarke, the plaintiff's deceased husband, was a severe alcoholic and was admitted to the hospital for inpatient detoxification treatment.

Although the Travelers policy authorized up to 30 days of inpatient alcohol-related treatment annually, the third-party administrator (TPA) retained by Travelers authorized only a five-day stay. Clarke was discharged but remained alcohol-free only briefly. He admitted himself to another hospital, but the TPA authorized only eight days of treatment. Almost immediately after discharge, Clarke resumed drinking, took cocaine and an overdose of prescription drugs, and attempted suicide.

After he was revived, a state court ordered him committed for 30 days. The "Court Clinic" sought approval from the TPA to admit Clarke to a private hospital. The TPA refused to approve any treatment. Clarke was therefore committed for treatment to a state prison, where he was raped and beaten—but not treated for his addiction.

After his incarceration, Clarke tried to return home but only resumed drinking. After a long binge Clarke was placed in police custody and, shortly after his release, committed suicide.

Clarke's widow and children sued Travelers and the TPA in state court for violations of state law. Travelers and the TPA promptly removed the case and moved to dismiss for failure to state a claim on the grounds that ERISA preempted the state law claims. After a long analysis and argument for a change in the law, the court dismissed the state law claims.

The district court noted that all the state law claims arose from the allegation that the claims for benefits under the Travelers policy were improperly handled. Because there is no recovery under ERISA for wrongful death, personal injury, or other damages caused by the improper refusal to authorize

treatment, the court also noted that a decision that the state law claims were preempted would "immunize Travelers and [the TPA] from any potential liability for the consequences of their denial of benefits."

Because the state law claims were intimately related to plan administration and would have created an alternative set of rights against the plan, the court believed it had no other choice. The interest of the plans in preventing overuse of treatment trumped the interest of the people counting on benefits.

A COBRA Dispute

The Consolidated Omnibus Budget Reconciliation Act of 1986 (COBRA) is a federal law that defines how medical coverage can be extended to people who leave a job that provided health insurance. The law says that, if a former employee pays premiums personally, he or she can keep the coverage for up to 18 months in most situations. But the law gets much more complicated in its execution.

The February 1998 federal district court decision *Kevin and Janet Kerr v. Chicago Transit Authority* dealt with a dispute over a COBRA claim.

Kevin Kerr began working for the Chicago Transit Authority (CTA) on March 19, 1985. Sometime between April 7, 1986 and January 1, 1987, the CTA included a notice in employee payroll envelopes describing COBRA health insurance continuation rights. Kevin Kerr enrolled in the CTA's group health insurance plan on March 19, 1987.

In September 1990, Kevin Kerr married Janet Kerr. Although Janet Kerr's employer offered health insurance, Janet Kerr enrolled in the CTA's plan.

In early 1991, the CTA shipped a booklet describing "Travelers PPO" benefits to CTA workplace locations. These booklets were either "personally distributed ... or left in a location where they [could] be taken by anyone who want[ed] one," according to the CTA. The booklet described COBRA benefits but did not describe the Kerrs' particular HMO plan.

Janet Kerr was diagnosed with cervical cancer in August 1994.

On August 5, 1994, Kevin Kerr stopped working for the CTA and the Kerrs immediately enrolled in the Principal Mutual Insurance Company heath insurance plan offered by Janet Kerr's employer.

Later that month, the Kerr's received a letter from the CTA describing the "Continuation of Group Heath Coverage under ... COBRA." The letter stated that:

> You are eligible to continue your Health and Dental coverage
> under COBRA for a period of 18 months. As a result of your

benefits being terminated, you have the right to continue the same coverage for yourself and your dependants if any.... Please contact [the human resources department] before September 09, 1994 for your application. If you fail to contact [us], the CTA will assume you are not interested in continuing your health and dental coverage under the COBRA Act.

The Kerrs submitted a claim to Principal Mutual. However, Principal Mutual declined to pay the medical expenses incurred for Janet's cancer treatment from August 1, 1994 to August 1, 1995 based on an exclusion for preexisting conditions.

Janet Kerr then called CTA's COBRA Compliance Department and requested to continue her health insurance coverage. However, CTA said that it would have to look into the matter because her election period had expired.

Janet followed up with a letter requesting COBRA continuation coverage. The letter stated, in part, "[w]e hope that we will be able to buy back this coverage although we have gone only a few days over the time limit." In response, CTA informed Janet Kerr that her COBRA election period expired before October 28, 1994 and that CTA, therefore, would not continue her health insurance coverage.

On March 28, 1995, the Kerrs filed suit against the CTA and the Healthcare Service Corporation seeking a declaratory judgment and $150,261.58 to pay the medical expenses incurred for the treatment of Janet Kerr's cancer. Both parties brought motions for summary judgment.

According to the Kerrs, they elected to continue Janet Kerr's health insurance coverage in a timely manner and CTA violated COBRA's notice requirements. CTA claimed that Janet Kerr's election came too late and that its August 24, 1994 letter provided proper notice of her COBRA rights.

> **COBRA requires employers to offer continued health insurance coverage for covered employees and their qualified beneficiaries after a "qualifying event," such as termination for reasons other than gross misconduct.**

Kevin Kerr was a "covered employee" because he "was provided coverage under a group health plan by virtue of the performance of services" for the CTA. Janet Kerr, as Kevin Kerr's spouse, was also a "qualified beneficiary."

CTA was the "plan administrator" and was, therefore, required to notify covered employees and qualified beneficiaries about their right to continued coverage after a qualifying event.

> **A qualified beneficiary is entitled to elect to continue insurance coverage within the election period.**

Typically, an election period: (A) begins not later than the date on which coverage terminates under the plan by reason of a qualifying event, (B) is of at least 60 days' duration, and (C) ends not earlier than 60 days after the later of—(i) the date described in subparagraph (A), or (ii) in the case of a qualified beneficiary who receives notices under this title, the date of such notice.

> **Once a qualified beneficiary elects continuation coverage, the plan administrator must provide coverage for a specified time period. The person electing coverage must pay up to 102 percent of the premium.**

Both parties disputed the date that triggered the 60-day election period.

According to the CTA, the election period begins on the date a requisite notice is mailed to the beneficiary. Thus, the CTA contended that the election period in the Kerr's case began on August 24, 1994, the date it sent the letter discussing COBRA continuation rights. However, the Kerrs maintained that the election period begins on the day that the notice is received.

The court agreed with the Kerrs reading of the election period.

"Other courts have held that the election period begins on the day the qualified beneficiary receives the notice," said the court. In fact, said the court, legislative history also supports this result. Congress enacted COBRA "to provide continued access to affordable private health insurance."

According to the court:

> Contrary to the CTA's assertion, Congress did not specify that the election period begins on the date the notice is mailed or on the date shown on the notice letter itself. Indeed, Congress did not contemplate that any of the 60 days would be lost to the mailing or delivery processes. [A]dding requirements not contained in the plain language of the statute is inappropriate. Thus, we find that the election period begins on the day that the qualified beneficiary receive notice of her continuation rights.

The Kerrs received notice of their COBRA continuation rights on August 30, 1994. Accordingly, Janet Kerr had until October 29, 1994 to elect continuation coverage. Janet Kerr talked to CTA's compliance department on October 28, 1994, one day before the election period expired. At that time, Janet Kerr elected to continue her health insurance under COBRA. Because the CTA accepts oral election, Janet Kerr elected coverage before her 60-day election period expired.

Therefore, the CTA had to provide continuation coverage under the terms and conditions of COBRA.

Chapter 14

HMO Coverage Disputes

For years, doctors and hospitals have complained that health maintenance organizations fail to pay them in a timely manner. State insurance departments have collected such complaints on nearly every major HMO in the United States.

HMOs cite a series of reasons for the problem, including, but not limited to, their computers, the status of plan members, and doctors and hospitals that file incomplete or inaccurate claim forms.

In Florida, the state Agency for Health Care Administration and the Insurance Department met with the HMOs and health care providers to address the issue. As expected, they didn't agree on much. So, the doctors and hospitals went to the legislature for help. The result: a new law that would require HMOs to pay 10 percent interest per year for any claim that is not paid within 120 days. The rest of the law merely codifies existing state regulations.

The HMO lobby, which has shown the ability to kill or at least water down any bill it doesn't like, did not fight the proposal.

"The HMOs seem to control the process, especially in the Senate," said Scotty Frazier, a long-time lobbyist for the Florida Medical Association, which represents 16,000 doctors.

Regulatory Corrections

In January 1999, the New York State Insurance Department levied fines totaling $72,200 against 12 health insurance companies and HMOs for violations of New York's prompt-pay law, the first such action taken under the year-old statute.

The law requires insurance companies to pay undisputed claims within 45 days or face fines as high as $500 per claim per day, capped at $5,000 per claim. In this first round of violations, insurance companies that had 10 or more confirmed violations between April and September 1998 were only penalized $100 per claim paid late.

The fines effectively put payers on notice that the state will not tolerate tardy payment, said Allison Klimerman, director of public affairs for the Insurance Department.

The hardest-hit company was Connecticut-based Oxford Health Plans, which was fined $40,900. Among payers, Capital District Physicians' Health Plan (CDPHP) was fined $4,200; Community Health Plan, part of Kaiser Permanente Northeast Division, was fined $2,700; HUM Healthcare Systems (parent of Partners Health Plans) was fined $2,000; and WellCare of New York Inc. was fined $2,600. Dan Colacino, vice president of marketing for CDPHP, said the Latham-based HMO was slow to pay a certain type of claim between April and September. The claims were related to a medical code that requires a review before payment, and the reviews were taking too long—a situation CDPHP has corrected, he said.

The HMO checked into the complaints against it and found that its records supported five of the 42, Colacino said. When the Department declined to rescind the remaining fines, CDPHP agreed to pay the full amount.

Even if the larger number of payments were made late, they would represent a tiny portion of the claims CDPHP processed and paid during the six months the Department considered, Colacino said. The HMO handles about 2.2 million claims annually for the 210,000 people it covers.

In Texas, health plans were being told to pay on time or face penalties, as a result of an investigation by the Deptartment of Insurance in January 1998.

According to Texas Insurance Commissioner Elton Bomer, the investigation concluded that major managed care plans in Texas, including Aetna/U.S. Healthcare, Cigna, Humana, PacifiCare, Prudential and Blue Cross Blue Shield, are not consistently complying with a new law requiring them to pay doctors, hospitals and other health providers within 45 days of receiving a clean claim. The law also requires HMOs to pay primary care physicians within 60 days after a patient selects his or her doctor.

The Department has received hundreds of complaints from doctors about slow payments from health plans, said Texas Insurance Department representative Mark Hanna.

Phil Berry, an orthopedic surgeon in Dallas and president of the Texas Medical Association, estimates it takes from four to six months to receive

payments on some claims. Often, he said, his office sends in a claim to a health insurance company with all the questions answered and the appropriate documentation attached, only to get the claim back without the attached documents, along with a letter stating that the claim is missing information. "You can still see the staple marks where we attached the documentation," said Berry.

Robert Gunby, an obstetrician-gynecologist and president of the Dallas County Medical Society, estimates that his practice has at any given time about $80,000 to $90,000 in unpaid claims. Frequently, three months elapse between the time a patient is treated and the claim is paid, Gunby estimates.

> **Most delays in processing claims are caused by errors by the group submitting the claim, such as sending in claims with incomplete or inaccurate information. Claims often are missing code numbers or are filled out in such a way that the computer cannot scan the form.**

Physicians suspect other reasons. Many believe insurance companies deliberately stall on paying claims to earn more interest on their money. Insurance companies that don't pay on time will face penalties ranging from fines to revocation of their licenses.

Some state regulators suspect some companies were deliberately stalling because of financial problems.

In 1998, Empire Blue Cross and Blue Shield was accused in a class-action lawsuit of deliberately delaying and refusing to pay valid claims by policyholders.

The suit was filed by a former Nynex employee who lives in Massachusetts. In the suit, the man claims he was forced into bankruptcy by Empire's alleged tardiness. Empire denies the charges.

Guidelines from the Other Coast

In California, managed care health plans, which were battered in the court of public opinion, have lost ground in the court of legal opinion as well.

Several key judicial rulings during the late 1990s—coupled with a new state law and heightened scrutiny of health insurance companies by the chief justice of the California Supreme Court—promise to provide patients with significant new ammunition when they wind up in disputes with their HMOs.

Some of these developments have gained considerable attention. Others have gone more unnoticed. When taken together, experts say, they mark an

unmistakable power shift in favor of consumers in the continuing struggle to sort out a critical question: Does the playing field need to be leveled when patients battle their health plans over denied benefits?

"The pendulum has reached its peak and is swinging back in the other direction in favor of the insured," says Jay Taylor, a Los Angeles attorney, who just a few weeks ago won the latest major court ruling that bolsters the rights of plan members.

Taylor's victory came when the state's Second District Court of Appeals in Los Angeles ruled that he could proceed with his efforts to establish a class-action arbitration against Blue Cross of California. The insurance company, a unit of Wellpoint Health Networks Inc., had argued that it should be able to handle disputes one at a time—and not have to face a larger group of patients who had banded together.

The court's decision is important because it will allow many more health plan enrollees to pool their resources for what might otherwise be prohibitively expensive arbitration proceedings.

Under the arbitration system, conflicts that arise between the patient and the health plan are taken to an individual or panel of arbitrators for binding resolution.

Delay Tactics and the Right to Sue

Some health insurance companies withhold payment of an entire claim when they're disputing only part of it.

As a patient, should you have the right to sue if your insurance company makes a damaging error?

Several consumer groups claim that they have found new evidence to boost their case that patients need more protections. The evidence is an Aetna training video that implies the company gives more attention to cases in which patients already have the right to sue.

"We released this to fuel the HMO debate and to tell Congress it's absolutely outrageous that they would adjourn without dealing with this," said Jamie Court of Consumers for Quality Care, which has lobbied for the "patients' bill of rights."

Consumer groups long have said that insurance companies will be less likely to deny legitimate claims if they fear a big lawsuit.

On one side are many Democrats, consumer advocates and trial lawyers, who want to give injured people new rights in court. On the other side are most Republicans, and business and insurance companies, who say more law-

suits will drive up the cost of insurance.

Under current law, courts have said the federal law does not allow lawsuits for damages. So if, for example, an HMO denies a lung X-ray, and it turns out the patient had undetected lung cancer, the patient can sue to recover the cost of the X-ray but cannot win money for the damage caused by delay.

In the Aetna video, company attorneys are training case managers in how to handle claims. The topic is long-term disability claims, not health insurance, but the company says its policies do not differ.

Throughout the video, Aetna attorneys discuss the differences between ERISA and non-ERISA cases—those where the company faces federal rules that prohibit lawsuits, and those governed by state laws that allow suits.

At one point, company attorney Jeffrey Blumenthal is explaining the importance of having accurate information in determining whether to deny a claim when a wrong decision could lead to a big judgment.

"We have an obligation, certainly in a non-ERISA setting, under state law, to conduct what's called a reasonable investigation," he says. "We could be subject to... bad faith damages, to punitive damages, to a whole range of extra-contractual liability that could be many, many millions of dollars."

"The lawyers are implicitly and explicitly saying patients with different types of liability exposures should be treated differently," said consumer advocates.

Aetna spokesman Fred Laberge said the company does put more time and money into cases not governed by the federal law—that is, "non-ERISA cases"—but only as part of the legal review that follows an initial decision whether to pay a claim. All cases get adequate attention from company officials who determine, on the merits, whether to pay for a certain insurance claim, Laberge said. And he said the differences do not affect whether a claim will be paid.

The Mechanics of HMO Claim Settlements

Most HMO disputes are handled—at least initially—by arbitration. The arbitration body is paid a daily rate that typically ranges from $750 to $1,200, with the process itself usually lasting from one to three days. All parties agree to abide by the decision instead of litigating.

But patients-rights advocates contend that many times, consumers don't even realize that they've locked themselves into arbitration. And increasingly, the courts have shown that they, too, are concerned about the fairness of forced arbitration in managed care contracts.

"When it comes to negotiating an agreement, individual consumers are not in the same place as large health plans" and often simply swallow whatever is written into a standard contract, says Peter Lee, an attorney and director of consumer-protection programs at the Los Angeles-based Center for Health Care Rights.

So, he explains, the courts and others are now looking for ways "to have those scales more balanced."

In June 1997, in a case involving Kaiser Permanente, the state Supreme Court ruled 6-1 that HMO members can file lawsuits if they demonstrate that their health plan's arbitration system is unfair. In a blistering decision, the court attacked Kaiser for intentionally delaying the selection of arbitrators and otherwise manipulating the process for its benefit.

Among other things, the court pointed to one of Kaiser's own surveys, which showed that in the mid-1980s, an arbitrator wasn't appointed for an average of 674 days—almost two years after the enrollee had asked for one. In its contracts, Kaiser had promised to name an arbitrator within 60 days of a patient's demand.

In response to the ruling, Kaiser earlier this year announced an overhaul of its arbitration system. The company, which for more than two decades had operated an in-house arbitration process, began using an independent system like those used by competing health plans. Kaiser is the state's largest HMO, with more than five million members.

A Useful Example

In June 1998, the Second District Court of Appeals upheld an earlier ruling that it had made against Cigna HealthCare of California, a unit of Philadelphia-based Cigna Corp., allowing the mother of a baby born with brain damage to sidestep arbitration and sue the HMO in court.

The reasoning? The mother, Keya Johnson, wasn't alleging medical malpractice by Cigna—the type of claim that would have been relegated to arbitration. Rather, she said that her baby was denied the quality of care promised in Cigna's advertising, and thus those ads were "deceptive and misleading."

Cigna spokesman Jim Harris says the HMO was disappointed by the unanimous decision but was pleased last month when the state Supreme Court agreed to hear the company's appeal.

Arbitration "is under attack by the trial lawyers, and more cases challenging it have reached the courts," Harris says. But Cigna will continue to defend it as "a fair and equitable process."

Former California Governor Pete Wilson signed legislation that for the first time would require health-plan arbitration decisions—and the reasoning behind them—to be made public.

The new law is an attempt to make the arbitration process fairer and "help protect consumers" by increasing access to dispute-resolution information. While it didn't oppose the legislation, the managed care industry questions the need for publishing arbitration results.

"We didn't see it as a pressing problem or complaint by HMO members," says Maureen O'Haren, executive vice president of the California Association of Health Plans. The group represents 37 HMOs covering 20 million Californians.

The chief justice of the state Supreme Court, Ronald George, appointed a task force to conduct a two-year study of the impact private judging is having on the state courts and the public.

While "a lot of it is very good," he says, "there's a dark side to it, too." The chief justice says he is particularly worried about "the gross disparity in bargaining power" between large health care companies and individual consumers.

Despite the agreements they sign, "people don't know they are agreeing to arbitration in fine print," Justice George said. "I do feel that we need to make some adjustment to it."

So did Elizabeth Farquhar. Toward the end of her pregnancy in 1996, Farquhar admits, she began thinking in a "morbid way." Though her first pregnancy had been uneventful, the California homemaker began wondering whether she would develop some complications this time. Nothing too serious, she hoped. Just something like a Caesarean delivery, something that would save her thousands of dollars.

How? Her insurance company, Blue Cross of California's Prudent Buyer Plan, had agreed to cover those kinds of costs. But it wouldn't pay for a routine delivery; Farquhar would have to take care of that out of her own pocket—something she says she didn't realize initially when she had signed her contract with Blue Cross several months earlier.

In fact, the contract featured two clauses that denied certain coverage to new enrollees: One was for pre-existing conditions, including pregnancy; the other required a 12-month waiting period for 10 common procedures, including the normal delivery of babies.

In December 1995, a screaming and healthy Lukas Farquhar arrived with no complications. That left Farquhar and her husband, Kyle, with nearly $8,000 in prenatal, maternity and nursery bills. But the couple soon learned that other

families were in the same predicament—and that Taylor was challenging the legality of including both clauses in the policy.

As it turned out, the Prudent Buyer Plan contract was silent on the question of whether a class-action arbitration could be brought. An associate at Ivie, McNeill & Wyatt interpreted that silence as a green light. But Blue Cross saw it as just the opposite: Since there was no express provision for a class action, it petitioned the Court of Appeals to compel individual arbitration.

But in a unanimous decision, the court ruled that a class-action arbitration is indeed permitted under state law and is not preempted by the 73-year-old Federal Arbitration Act.

"It's a boomerang that has come back and hit Blue Cross in the back of its head," says Jamie Court. "By forcing people into arbitration, under the pretense of expediency and judicial economy, Blue Cross now has a hard time arguing that patients shouldn't be able to arbitrate these cases in the most economical and expedient ways."

Though there's still a long way to go before any ruling emerges on the merits of their case, the Farquhars already feel emboldened by the appellate court's decision. It shows "you can stand up for your own rights," Farquhar said. "You have to—or somebody will take advantage of you."

Lifestyle Coverage Disputes

In July 1998, 77-year-old Mouis Marcil filed a lawsuit against Kaiser Permanente for refusing to cover Viagra, the impotence drug introduced in March 1998 by Pfizer.

The lawsuit was filed in Los Angeles Superior Court on behalf of Marcil, a retired sales manager living in Burbank, Calif., who is a client of Kaiser's Senior Advantage program. Marcil claims to have become impotent in 1996 due to radiation treatment for prostate cancer. Marcil said he received a prescription for Viagra in April from his Kaiser urologist but was told the HMO would not cover the $10-per-pill cost.

Kaiser Permanente, based in Oakland, California, excluded Viagra from its regular benefits contracts. The HMO, however, said it would pay for the drug if supplemental benefits coverage was purchased.

Kaiser's main concern was that covering the drug would raise policyholder premiums. It estimated that full coverage of Viagra would cost at least $100 million annually.

The suit charged Kaiser with fraudulent and unfair business practices and said that Kaiser's contract provides for coverage for prescription drugs

without excluding any particular class of drug except those used solely for cosmetic purposes.

According to Marcil's lawyer, Frank N. Darras, Kaiser's marketing materials for Senior Advantage claim it will cover customers' prescription needs for at least 100 days. "Kaiser promised to cover all their health care needs," said Darras. "When it came time to pay for Viagra, they would not honor the words of their contract."

Kaiser has been paying for Viagra coverage for a small number of patients for whom a doctor has deemed it a medical necessity, said spokesman Jim Anderson. He would not quantify whether the HMO is paying for all, most or some of those for whom it is deemed necessary and did not speak specifically about the case.

Marcil, who had been married 52 years, said he had been purchasing the drug himself and finds it effective. He was suing for the $50 he had spent on the five Viagra pills he'd purchased so far and for emotional distress. No dollar figure had been set for the emotional distress element of the suit, as per California law.

Darras said the suit could take about a year to settle but could be resolved as early as the end of summer.

> In another case involving prescription drugs, NYLCare Health Plans of the Mid-Atlantic Inc. was accused of non-compliance with a law that entitles certain patients to a 90-day supply of prescription medication.

In 1997, the Maryland Insurance Administration brought a sanction against the company after it received complaints between April and September that NYLCare denied members covered by its prescription drug rider the 90-day supply, according to the order signed by Maryland Insurance Commissioner Steven Larsen.

Under the Maryland law, health plan members who require maintenance medication for chronic conditions are entitled to a 90-day supply each time a prescription is refilled. The 90-day supply cannot be limited to purchase through a mail-order program.

NYLCare contended that it had complied with the law by making 90-day supplies available exclusively through its mail-order service. The HMO said administrative problems prevented it from providing wider access to members whose plans were effective prior to July 1998.

It didn't prevail.

Chapter 15

Medicare, Medicaid and Other Government Program Claims

Medicare, the government-administered health care plan for the elderly, dominates the market for many medical services. Some insurance experts argue that to dominate the way that the *entire* health care market pays claims.

The Health Care Financing Administration (HCFA), the government agency responsible for administering Medicare, uses six regional claims processing contractors (which are insurance companies) to process and pay home health claims.

These contractors pay the claims submitted by home health agencies on the basis of the costs they incur, subject to predetermined payment limits. They are also responsible for ensuring that Medicare does not pay claims when beneficiaries do not meet Medicare's coverage criteria, when services claimed are not reasonable or necessary, or when the volume of services exceeds the level called for in an approved plan of treatment. They carry out these responsibilities through medical reviews of claims, performed either before or after a claim is paid, and occasionally through site visits to the agencies.

In August 1998 congressional testimony, William J. Scanlon of the General Accounting Office said:

> Whether the payments to individual agencies will reflect legitimate differences across agencies is more difficult to determine. Costs vary widely across agencies, which reflects differences in patient mix and levels of efficiency. In protecting legitimate cost differences across agencies, the interim system may unavoidably reward some inefficient agencies. Further-

more, the interim system may also be too restrictive for agencies with costs that legitimately increase more rapidly over time. Because the interim payment system will be used for a longer period than originally intended, we believe it is even more important to better take account of appropriate variation in agency costs.

In a study last year, we selected a sample of high-dollar claims that had been paid without any review. After they were examined by an intermediary at our request, it turned out that a large proportion of them should not have been paid. More recently, the Office of Inspector General in its annual audit of HCFA estimated that 12.5 percent of Medicare home health spending in fiscal year 1997 was inappropriate because the services were not medically necessary or lacked supporting documentation.

So, if anything, the bureaucrats who run Medicare feel they need to crack down even more strictly on claims. This isn't good news for the growing number of the people in the system.

Medicare Deductibles

One of the biggest issues facing people who have to make claims under Medicare is the deductibles that they have to pay as part of the system. Depending on a person's health and geographic location, these deductibles can tally to tens of thousands of dollars a year.

As a result, various private insurance companies offer Medicare Supplemental insurance (also known as "Medigap" policies), which cover Medicare deductibles and certain kinds of medical care not covered by the government program.

But Medigap policies can, themselves, be quite complex. The March 1999 federal appeals court decision *Vencor Hospitals v. Blue Cross/Blue Shield of Rhode Island* examined the interpretation of certain terms in a standard Medigap insurance contract.

Blue Cross/Blue Shield of Rhode Island (BCBS) issued Medigap policies to Martha Butler and Aniello Esposito. Butler and Esposito were both admitted to Vencor Hospital in Ft. Lauderdale, Florida, and required care for a period exceeding their Medicare coverage. During the period of Medicare

coverage, Vencor charged Butler and Esposito only the co-payment or de-ductible required under Medicare (which, in turn, was paid for by BCBS un-der the Medigap policy). At first, Vencor's costs were reimbursed by Medi-care. But, when the Medicare coverage expired, Vencor began charging But-ler and Esposito its ordinary rates, which included a substantial amount of profit greatly in excess of the amount Vencor had received as cost reimburse-ment from Medicare.

After their hospital stays, Butler and Esposito sought payment from BCBS. Their Medigap policy provided for coverage as follows:

> Upon exhaustion of all Medicare hospital inpatient coverage ... we will cover up to ninety percent (90%) of all Medicare Part A Eligible Expenses for hospitalization not covered by Medicare....

According to BCBS, the policy covered 90 percent—$240,582.13—of what Medicare would have paid (i.e., cost reimbursement) for any necessary treatment; thus, Vencor was entitled only to that amount and not to 90 percent of its ordinary charges. However, Vencor interpreted the policy somewhat differently and filed suit in the United States District Court to recover the remaining money—some $570,000—it believed was due.

The district court granted summary judgment for BCBS on the ground that the policy unambiguously limited payment to 90 percent of what Medi-care would have paid.

Vencor appealed.

First, BCBS argued that its contracts were with Butler and Esposito—not Vencor—and therefore only Butler and Esposito had standing to sue for any breach.

However, the court noted that Vencor was a third-party beneficiary of the contracts between BCBS and Butler and Esposito, and therefore had the right to sue for breach of the insurance contract.

The Medigap policy held by Butler and Esposito stated, "Benefit pay-ments may be paid to the doctor, hospital or to you directly at our discretion." By providing for payment directly to the hospital, the contracting parties showed a clear intent to provide a direct benefit to Vencor (or any other ser-vice-providing hospital), so Vencor had standing to bring suit.

The court further ruled that a genuine issue of material fact existed re-garding whether Vencor was entitled to payment based on its ordinary charges and remanded the case to the district court for further proceedings.

Under the BCBS policy, Vencor was entitled to ninety percent of "all

Medicare Part A Eligible Expenses for hospitalization not covered by Medicare." Eligible expenses were defined as "the health care expenses covered under Medicare which Medicare has determined are reasonable and medically necessary."

> **The debate between Vencor and BCBS turned on whether the phrase "health care expenses" referred exclusively to types of expenses—in other words, forms of treatment—or also included amounts of expenses.**

The record also contained an "Outline of Coverage" that was highly ambiguous in is reading of the policy's coverage, said the court. And, if this outline is considered part of the contract, then the contract is ambiguous regarding the contested issue, and that ambiguity must be resolved in favor of Vencor.

One reason for this was that under state law, BCBS was required to provide such an outline to Butler and Esposito to provide more clarity than the ordinary insurance policy. But if the outline is not part of the contract, then the regulatory scheme would do nothing more than create additional evidence of the fraud that the legislature intended to prevent.

BCBS claimed it owed Vencor the amount Medicare would have paid for Butler's and Esposito's treatment. However, the court noted:

> that amount varies according to the stage of the reimbursement process. During the year, Medicare advances payment to Vencor based on an approximation of Vencor's costs. At the end of the year, Vencor submits a cost report to Medicare and either receives more payment or returns some of the previous payments depending on how the actual year-end costs compare with the estimated amounts previously advanced. Medicare also sets a target amount for annual costs, forcing Vencor to absorb costs that exceed this amount. However, Vencor receives a bonus if its costs are below the target amount.

Therefore, Vencor argued that BCBS's claim that it owed Vencor only the amount that Medicare would have paid, is unclear about whether the amount is based on the preliminary advance, the final accounting, or the final accounting plus or minus some amount related to Vencor's deviance from its annual target.

BCBS argued that, even if Vencor would otherwise be entitled to payment of its ordinary charges, each of Vencor's claims was barred by the affirmative defense of accord and satisfaction.

BCBS sent a check directly to Butler in the amount BCBS felt it was obligated to pay and a letter stating that it represented full payment of the claim. Butler gave the check minus the cover letter to Vencor, which endorsed and deposited it. According to the court, this showed that BCBS reached an accord and satisfaction with Butler. This type of agreement had no effect on Vencor's rights under the policy. Thus, BCBS's accord and satisfaction defense failed in regard to Butler's claim.

On the other hand, the Esposito claim payment was made directly to Vencor. According to BCBS's Director of Provider Reimbursement, BCBS negotiated an agreement with Vencor under which BCBS would pay $37,535.45 as full payment of the claim. Therefore, genuine issues of material fact exist regarding whether there was an accord and satisfaction on this claim. If BCBS and Vencor had reached a settlement agreement, then such an agreement would constitute an accord and satisfaction.

As a result, the judgment of the district court was vacated and the case was remanded back for trial.

In other situations, the claims problems related to Medigap policies have to do with unscrupulous salespeople to convince consumer to buy the wrong kind of policy.

In March 1998, a Las Vegas couple filed a lawsuit in Clark County District Court seeking to collect damages for 350,000 customers of Columbia/HCA Healthcare Association nationwide.

The lawsuit stemmed from allegations that the National Association of Senior Friends, a nonprofit group affiliated with Columbia/HCA, sold memberships that promised Columbia/HCA would waive charges for deductible expenses for Medicare patients.

Joseph Miller and his wife, Hazel, claimed that they had paid the $25 annual membership fee in April 1997. The membership was supposed to entitle them to a waiver of Medicare deductible payments—but Columbia Sunrise MountainView Hospital refused to honor the promise.

The Millers's attorneys claimed breach of contract and unjust enrichment. They also sought class-action certification, so they could represent 350,000 other people who had been sold Senior Friends memberships.

"If there's a theme to this, it's giving old people the expectation that they're protected and leaving them empty-handed," one of the lawyers said. "In my opinion, it's putting their hands in the cookie jar."

Pamela Carnevale, director of Senior Friends' local chapters, said Columbia/HCA lawyers interpreted provisions of a federal health care reform law to prevent hospitals from waiving the deductible payments.

Columbia/HCA stopped waiving the payments from Senior Friends members in January 1997. The hospital company had since received a legal clarification from a federal health care agency and planned to resume waiving the payments.

> **Federal law never contained any requirements that forced hospitals to stop waiving deductibles for Senior Friends members. It was the hospitals' choice to say no.**

"We're just thrilled that it's (the waiver program is) back again," said Mark Howard, chief executive of Sunrise MountainView. "Was it a great benefit? Absolutely."

One Alternative: Medicare HMOs

In October 1998, the Health Care Financing Administration sent information to 38 million Medicare beneficiaries in five pilot states, consisting of a comprehensive handbook entitled *Medicare and You*. (Medicare beneficiaries in the other 45 states received a briefer version of the handbook.)

The purpose of the handbook was to clarify new options under the Medicare+Choice managed care plan to participants.

When managed care was first introduced to consumers, it was widely agreed that the only way to convince reluctant people to try a new HMO plan was to give them enough information so they would feel comfortable choosing a physician and using the plan appropriately, thereby reducing their own out-of-pocket costs.

The issue became even more urgent when applied to retirees and the potentially bewildering array of Medicare+Choice options available to them. Added to the mix is the reality that many seniors, especially those who retired before managed care became a household word, were uninformed about and unaccustomed to managed care plans.

The *Medicare and You* handbook included:

- generic Medicare information, including eligibility Medicare basics (what's covered, what's not, and the out-of-pocket expenses associated with original Medicare);

- new preventive services covered under Medicare;

- an overview of all types of Medicare+Choice options and points to consider when making a decision;

- enrolling and disenrolling information and procedures;

- phone numbers by state for answers to questions;

- information about Medigap policies; and

- a worksheet for comparing various Medicare and Medigap health plans.

Also included in the handbook: a geographically personalized insert, based on the individual's ZIP code, of the Medicare+Choice plans available—including benefit plan designs, supplemental benefits, cost and quality measure comparisons.

For its part, HCFA learned many lessons during the 1990s about the challenges associated with communicating complicated managed care rules and regulations to an unsophisticated elderly population. Countless enrollees on fixed incomes have confronted the daunting prospect of paying out of pocket for medically unnecessary care or treatment received without proper referrals. (Medicare HMOs have not been shy about denying payment when rules and procedures are violated.)

> **Some health plans have adopted compassionate procedures that permit payment for first-time noncompliant offenses. But other health plans are not so understanding.**

The result can be devastating. When a health plan decides to deny coverage for a medically unnecessary hospital emergency room visit, the enrollee may be financially responsible for $1,000 or more in billings.

Even the most comprehensive, onerous disclosure regulations will never prevent misunderstandings on the part of some individuals. This is especially true for a Medicare beneficiary population that was not raised under managed care. However, the new regulations, by creating common industrywide disclosure, protect the interests of the 5.8 million current managed care enrollees and the one million new enrollees each year.

HCFA mandates that Medicare+Choice plans publish clear, standardized forms to disclose a variety of programmatic aspects during initial enrollment and at least annually thereafter. Some items must be routinely disclosed to all enrollees. These items—key to how claims are paid—include:

- service area;

- number, mix and distribution of participating providers;

- out-of-network coverage;

- prior authorization and review rules;

- quality assurance program description;

- emergency coverage, including definition of "emergency;"

- supplemental benefits (mandatory and optional) with related premiums;

- grievances, organization determinations and appeals;

- inpatient hospital treatment; and

- disenrollment rights and responsibilities.

Other items are usually disclosed to consumers only when requested. These—which are also both important to understanding how the plan will pay claims—items include:

- utilization management procedures; and

- a physician compensation plan.

We will consider each of these items in detail through the remainder of this chapter.

Mechanics of Medicare Managed Care

There are two classes of Medicare+Choice benefits, according to HCFA's definitions: Basic benefits and supplemental benefits.

Basic benefits include all Medicare-covered benefits except hospice care. Medicare+Choice plans must provide at a minimum all original Medicare basic benefits and what HCFA refers to as "additional benefits." The Medicare+Choice plan may be required to offer additional benefits without additional charge to enrollees when HCFA's average payment rate would produce excessive profits. By enriching covered benefits, enrollees gain economic advantage, health plans increase market appeal, and HCFA secures more managed care enrollment.

Medicare+Choice plans can choose to offer supplemental benefits or health care items and services beyond basic/additional benefits. Supplemental benefits may be mandatory or optional. Mandatory supplemental benefits must be purchased by all enrollees. Optional benefits, as the name implies, may be purchased by an enrollee at his or her option.

Each Medicare+Choice coordinated care plan is approved for a specified service area. In establishing the approved service area, HCFA considers where people obtain medical care in the community, the types of providers available in the community and reasonable travel times to obtain care. Counties and ZIP codes are used to delineate the approved service area. The plans may not enroll individuals who reside outside the approved service area.

Many Medicare beneficiaries look forward to extensive travel during retirement years. As a result, some seniors enrolled in Medicare+Choice plans will need medical treatment outside the plan's defined service area. Generally, emergency care services can be obtained out of the area from any medical provider without any reimbursement penalty—but this is an issue that needs to be raised specifically before you join a Medicare HMO.

Medicare+Choice plans must reimburse for "urgent" but nonemergency services received outside the health plan's service area when services are immediately required because of unforeseen illness, injury or condition. On the other hand, routine medical care received outside an HMO or POS service area will likely be denied. In these cases, you should check with your plan before undergoing significant medical treatment.

The biggest worry for many people contemplating enrollment in a Medicare+Choice plan is access to their medical providers of choice.

Many people have the mistaken impression that the plans are typically staff model, with a limited choice of participating providers. In fact, independent practice association (IPA) and group model Medicare risk plans—which include thousands of physicians and specialists and dozens of acute care hospitals—make up more than 90 percent of all Medicare managed care plans.

Of course, even a large number of network providers may not include a specific physician or hospital.

Some people may wish to continue existing relationships with medical providers having skill sets attuned to their particular needs. In these cases, the consumer may have to pay out of pocket for the services.

It has become increasingly common for Medicare+Choice plans to capitate—that is, limit the amounts that can be charged by—participating providers. Some of these arrangements restrict patient referral patterns to specialists, hospitals and other ancillary providers (e.g., podiatrists, laboratories, freestanding radiology centers) affiliated with an integrated delivery system.

The choice of a primary care physician can limit which cardiologists, orthopedists or other specialists (or hospitals) will provide subsequent treatment. So, a Medicare+Choice plan may advertise a network of several thou-

sand medical providers when, in fact, each individual patient can access only a small portion of them. This is a complicated concept for the typical consumer.

Factors that Impact Claims

Each Medicare+Choice organization must provide summary descriptive information about its physician compensation plan to enrollees when requested. This requirement stems from a long-standing concern among some members of Congress that certain physician compensation plans may act counter to the best interests of the enrollee. For example, health plan payment schemes that financially reward a physician for achieving below-average specialty referral rates, hospital admission levels or pharmacy benefit costs could create a perverse incentive to withhold medically necessary care.

In recent years there have been several high-profile legal suits against HMOs with capitated physicians when a plan member was not referred for a costly diagnostic test—with dire consequences. HCFA has rules governing physician compensation in managed Medicare plans. In effect, health plans cannot use specific payments as a disincentive to provide services to an individual enrollee. Provisions also exist that place limits on the transfer of substantial financial risk for referral services to physicians or physician groups.

An additional informational burden placed on Medicare+Choice organizations is providing to Medicare+Choice private fee-for-service enrollees an explanation of benefits (EOB) for each claim filed by the enrollee. The EOB must include a clear statement of the enrollee's liability for deductibles, coinsurance, co-payment and balance billing.

Medicare+Choice plans are required to have a quality assessment and performance improvement program that can demonstrate improvement in significant aspects of clinical and nonclinical care areas. It must be structured to improve health outcomes and enrollee satisfaction. In the clinical area, HCFA looks at effectiveness of care, enrollee perception of care and use of services.

The nonclinical areas include indicators such as access to services, appeals and grievances.

Consumers who exercise their rights to request quality assurance program information should be able to differentiate between Medicare+Choice plans committed to improving quality and those that pay only lip service to the concept.

Few people may care to learn about a Medicare+Choice plan's written protocols for utilization review and mechanisms to detect underutilization and overutilization of services—but these are critical factors in determining

how claims are paid.

Medicare+Choice plans that terminate a contracted provider must make a good faith effort to provide written notice of the termination within 15 working days to patient enrollees of that provider.

Medicare+Choice plan beneficiaries have the right to maintain access to network specialists terminated without cause until current treatment is completed. The plan must also notify enrollees of other Medicare+Choice plans in the area that contract with the terminated specialist and an explanation of the process to follow to return to original Medicare.

Grievances, Complaints, Appeals, etc.

Medicare+Choice guidelines spell out detailed time limits for health plans to respond and resolve grievances and appeals filed by or on behalf of enrollees. There are also provisions for enrollees to access independent entities to represent their interests in disputes with Medicare+Choice plans.

Grievances cover comparatively minor issues. An example of a grievance would be an enrollee's complaint to the health plan about the demeanor of a medical provider or office staff or the physical condition of the office.

Organization determinations involve whether an enrollee is enrolled to receive a health service, the amount the enrollee is expected to pay for that service, or the medical necessity of the service or its setting.

Reconsiderations deal with review of adverse organization determinations. Standard reconsiderations may be filed with the Medicare+Choice plan or a Social Security agency office.

Enrollees have the right to appeal disagreeable organization determinations. Provisions exist for several levels of appeal. In the language of the interim final rules, appeal "means any of the procedures that deal with the review of adverse organization determinations." The first level is a simple reconsideration by a group internal to the health plan. If enrollee satisfaction is not achieved at this level, the next step would be to have a hearing before administrative law judges (ALJs), then reviews by the Departmental Appeals Board. The final step would be instituting judicial review.

Enrollees are to receive complete, as well as timely, appeal decision disclosure. If a Medicare+Choice organization decides to deny any service or payment, it must provide written notice of the determination. It must:

- state the specific reasons for the denial in understandable language;

- inform the enrollee of his or her right to a reconsideration; and

- describe the standard in expedited reconsideration processes.

Only enrollees have the right to a hearing before an ALJ—the Medicare+Choice organization does not have the right. The final step in the appeals process is a Departmental Appeals Board, where an enrollee dissatisfied with the ALJ hearing decision may request review.

An enrollee or physician may request an expedited organization determination for services. The request may be oral or written. The Medicare+Choice organization must document all oral requests and maintain documentation. If the Medicare+Choice organization denies a request for expedited determination, it must automatically transfer the request to the standard 14-day time frame and make determination within that period.

The Medicare+Choice organization must also give the enrollee prompt oral notice of the denial and follow up within two working days with a written letter that outlines the terms of the grievance process.

One of the greatest fears of many Medicare managed care enrollees is denial of further inpatient hospital treatment once they've been admitted to a hospital. This problem comes to a point when an attending physician and the health plan disagree about the need for further inpatient care. Should you follow your doctor's advice and run the risk of denied claims and devastating out-of-pocket costs? Or should you ignore the doctor—and risk possible medical complications?

There is a quick solution. You have the right to request immediate review of noncoverage of inpatient hospital care by an independent professional standards review (PRO) organization. An enrollee who requests immediate PRO review may remain in the hospital with no additional financial liability. An enrollee who fails to request immediate PRO review and instead relies on the Medicare+Choice plan's expedited reconsideration is liable for payment of nonmedically necessary days.

The PRO must notify the Medicare+Choice plan on the day it receives the request. The Medicare+Choice plan must supply information needed by the PRO to process the review. The hospital must submit medical records or other pertinent information to the PRO by the close of business on the first full working day.

The PRO then makes a determination and notifies you, the hospital and the Medicare+Choice plan by the close of business on the first working day after it receives all necessary information from the hospital and the Medicare+Choice organization.

Conclusion

Today, the original Medicare population experiences about 2,600 annual inpatient days per 1,000 covered beneficiaries. Some Medicare HMOs have successfully reduced this to less than 1,000 annual inpatient days per 1,000 covered enrollees. The industry average is about 1,400 annual inpatient days per 1,000—nearly 50 percent below original Medicare.

To the casual observer, lower managed care use rates imply denial of care. Actually, by substituting an array of outpatient and home health care services for more costly (and dangerous) inpatient care, Medicare+Choice plans can improve quality of care.

Medicare spending for home health care has risen dramatically during the 1990s. By 1996, this benefit consumed 9.3 percent of Medicare expenditures, up from 2.5 percent in 1989. These changes have not only resulted in higher costs—but also a shift from an acute-care, short-term benefit to a chronic-care, longer-term benefit with related changes in patient mix, treatment patterns and claims issues.

The growth in spending was due primarily to an increase in users and in visits per user, rather than rising payments per visit. In 1989, 50 Medicare beneficiaries per 1,000 enrollees received home health care. The average user in that year received 27 visits. By 1996, 99 beneficiaries per 1,000 used home health care and received an average of 76 visits. The payment per visit went from $54 to $62 over this period. Changes in Medicare eligibility and coverage rules played an important role in the increased use of this benefit.

Not surprisingly, this growth in use has been accompanied by a rapid rise in the number of home health agencies. By 1994 there were almost 8,000 home health agencies, about 40 percent more than in 1989. And, by 1996, there were almost 10,000 Medicare-certified agencies. For-profit providers contributed disproportionately to this growth so that by 1994 they represented 48.5 percent of the total, up from 35.3 percent in 1989.

> **The increased use of home health care has not been matched by a commensurate rise in spending for claims review and program monitoring. As a result, some of the visits provided and people served may not meet Medicare's coverage criteria.**

To qualify for Medicare home health care, a beneficiary must be confined to his or her residence (that is, "homebound"); require intermittent skilled nursing, physical therapy or speech therapy; be under the care of a physician;

and have the services furnished under a plan of care prescribed and periodically reviewed by a physician. If these conditions are met, Medicare will pay for part-time or intermittent skilled nursing; physical, occupational and speech therapy; medical social service; and home health aide visits. Beneficiaries do not pay any coinsurance or deductibles for these services.

Part Seven:

Liability—Personal and Work-Related

Chapter 16

Workers' Compensation and Employers' Liability Claims

Under a workers' compensation program, disability income benefits compensate you for lost or reduced earning capacity that results from a compensable injury or occupational disease. The benefits are paid—without much discretion on the insurance company's part—when you are unable to perform all or part of your regular duties.

> **A caveat: The one piece of control insurance companies have over workers' comp disability benefits is evidence that a claim is fraudulent (and there are quite a few of these). If you're making a disability claim under one of these plans, be prepared to report your status on a regular basis and to deal with skeptical claims reps.**

Workers' comp benefits are paid in four designated classes of disability, as follows:

- permanent total;
- temporary total;
- permanent partial; and
- temporary partial.

A waiting period (usually three to seven days) applies before benefits for loss of wages begin. If the disability continues beyond a longer period (usually two to four weeks), retroactive benefits will be paid for the initial waiting period. For permanent total disability or temporary total disability, the benefit is a percentage of your weekly wages before the injury. This amount is subject to stated minimum and maximum dollar amounts. Within each state, the

percentage is the same for either type of total disability (66 and 2/3 percent is most common).

However, for permanent total disability the dollar maximum and the benefit period are usually greater. Benefits for permanent total disability often continue to age 65, while benefits for a temporary total disability may be limited to a maximum number of weeks.

If you have a partial disability and are able to perform some work, some laws provide a benefit equal to a percentage of the wage loss (difference between earnings before and after the accident). In addition to benefits for lost wages, the state provides scheduled benefits for specific permanent partial disabilities, such as loss of limbs, sight or hearing. Usually these benefits are paid in addition to any other income benefits.

The March 1998 Louisiana appeals court decision *Sandra Bolton v. Grant Parish School Board* is a great example of a person fighting hard to get her claim paid.

Sandra Bolton, a cafeteria worker at Dry Prong Junior High School in Dry Prong, La., had been employed with the Grant Parish School Board since August of 1989. On or about October 29, 1991, Bolton slipped and fell in the cafeteria kitchen, hitting a steel table with her back and striking her head on the floor.

Bolton reported the accident, and the school board accepted and commenced payment of her Temporary Total Disability benefits (TTD).

While waiting for the claim to be paid, Bolton sought treatment from Stewart Phillips, a New Orleans orthopedic surgeon. Bolton was also examined by Clifton Shepherd at the request of the Grant Parish School Board.

Due to several discrepancies between medical records and the reports of both doctors, the Office of Workers' Compensation appointed John T. Weiss to perform an independent orthopedic medical examination.

In June of 1995, Mark Goldich of Crawford and Company, the adjuster handling Bolton's claim, sent a job description of a position as an office receptionist to each of the three physicians. This position offered consisted of a three-hour work day. Each physician approved the job description, and Bolton attempted to return to work at the Grant Parish School Board Office in Colfax, La., on July 10, 1995. However, she was informed that she was expected to work four hours per day instead of three. Bolton was only able to work two hours each day on July 10th and 11th due to the pain in her back. After the second day of work, Bolton decided that her condition had not improved enough for her to handle the position as office receptionist.

However, when Bolton attempted to work as a part-time receptionist,

her weekly workers' compensation benefits had been terminated. The school board made no attempt to determine the difference in weekly income between the part-time job and the amount that she had received before the injury. Thus, Bolton had not been receiving income or workers' compensation benefits since July 10, 1995.

On July 20, 1995, Phillips recommended that Bolton seek psychological treatment and sent her to James Quillin, a neuropsychologist, who, after performing psychological testing, determined that Bolton was suffering from depression and that her subjective pain severity ratings did not appear to be exaggerated.

After receiving the psychological evaluation, Phillips suggested that Bolton have surgery. However, the school board denied the request for approval of surgery.

Bolton then filed a claim for workers' compensation benefits. The workers' compensation judge denied her claim for benefits, finding that she was able to engage in part-time work and that she had refused to accept a position made available to her.

The judge said Bolton was able to engage in restricted work activity as of July 10, 1995, and that she was not entitled to Supplemental Earnings Benefits (SEB) since she refused her employer's offer of a light-duty position. He further found that the school board was not liable for further psychological treatment and that Grant Parish was not arbitrary or capricious in its termination and payment of indemnity or medical benefits. Bolton appealed.

On appeal, Bolton alleged that the judge had erred in relying upon the opinion of a physician hired for litigation purposes only, rather than relying on the opinion of her treating physician. She also claimed that Grant Parish was arbitrary and capricious in terminating her weekly workers' comp benefits, as well as in its refusal to provide vocational rehabilitation benefits.

Shepherd, the physician chosen by Grant Parish, opined that Bolton should be released from medical treatment and could return to regular activities. Because this opinion differed from the findings of Phillips, it was within the workers' comp judge's discretion to appoint an independent physician.

However, the workers' comp judge overlooked or ignored the fact that the position approved by the doctors consisted of only a three-hour work day. After the school board's adjuster obtained approval of the three-hour-per-day job, the actual position turned out to be four hours per day—nearly 33 percent longer than the job initially approved by the physicians. "We find this difference to be quite significant," said the appeals court, "especially considering the nature of [Bolton's] injury, as well as her continuous complaints of pain.

The workers' compensation judge's failure to consider this discrepancy amounted to manifest error."

Since the job description did not coincide with the actual position provided, the appeals court added, we find that her temporary total disability benefits were improperly terminated. As such, Bolton was entitled to reinstatement of the weekly temporary total disability benefits, as well as a credit for all unpaid benefits.

Bolton also claimed that Grant Parish arbitrarily and capriciously terminated her workers' comp benefits on July 10, 1995, the date she attempted to return to part-time work. The appeals court agreed. But according to the court, this alone, did not amount to arbitrary and capricious behavior. Even if the school board would have been proper in terminating TTD benefits, said the court, there was no basis for terminating all benefits.

Under Louisiana law, a claimant who is unable to earn wages equal to or greater than 90 percent of her pre-injury wages should receive SEB equal to 66 and 2/3 percent of the difference of what she is earning monthly at the present time and what she earned monthly prior to her injury. When an employer arbitrarily fails to provide such benefits, Louisiana law provides:

> **Any employer or insurance company who discontinues payment of claims due and arising under the law, when such discontinuance is found to be arbitrary, capricious or without probable cause, shall be subject to the payment of all reasonable attorney fees for the prosecution and collection of such claims.**

Bolton's pre-accident weekly wage was $148.75. Her part-time position rate of pay would have been $5.33 per hour, which, assuming she had worked 20 hours per week, would have resulted in a weekly wage of $106.60. Since this rate clearly falls below 90 percent of her previous weekly wage, Bolton was entitled to continue receiving SEB to make up for this difference. Accordingly, Bolton was entitled to an award of attorney's fees in the amount of $7,500.00. In addition, she is entitled to penalties in the amount of 12 percent of the unpaid TTD benefits due or $50.00 per calendar day, whichever is greater, for each day benefits remain unpaid. This $50.00 per calendar day penalty, if applicable, shall not exceed $2,000.00 in the aggregate.

Bolton also claimed that Grant Parish was arbitrary and capricious in failing to provide vocational rehabilitation services and, as such, is responsible for penalties and attorney's fees.

The court declined to rule on this issue because Bolton failed to make a claim for rehabilitation services prior to appeal. This claim was not included

in her disputed claim for compensation, nor was this claim addressed at trial. As such, this claim must first be addressed by the Office of Workers' Compensation, said the court.

The holding of the workers' comp judge was reversed. Bolton's weekly benefits were reinstated, and she was awarded unpaid TTD benefits due, as well as penalties and attorney's fees.

Fraud

Leland Hofeling, manager of Wasatch Crest Mutual Insurance's special investigations unit in West Valley City, Utah, claims that he has seen injured employees perform great physical feats. Usually it's because they aren't hurt—they are taking advantage of a fraudulent workers' compensation claim.

Take the Utah deer hunter who filed a claim, saying he sprained his back at work. He stayed home and collected insurance payments, says Hofeling, but a surveillance camera caught the man hunting, carrying a rifle through a foot of snow, riding a three-wheeler over rough terrain and jumping from a pickup tailgate.

"Aside from income-tax evasion, it [insurance fraud] is probably the biggest white-collar crime in Utah," says David Lattin, director of the Insurance Fraud Division of the Utah Department of Insurance, where more than a third of the Department's reported fraudulent claims are driven by workers' comp.

About 90 percent of investigations the Insurance Fraud Division undertakes are prosecuted, Lattin says. During its three-year existence, the Department has filed criminal charges in 156 cases.

The number of suspicious workers' compensation cases is due largely to an increase in the number of businesses and employees who report suspected fraud, he says.

"We find a higher level of [comp fraud] activity in the construction industry, but no industry is immune," says Tom Callanan, senior vice president of the Workers' Compensation Fund of Utah.

A number of states have taken the matter into their own hands. In fact, over the past few years, the Workers' Comp Fund has dramatized workers' compensation claimant fraud advertising.

> **Nationwide, insurance companies paid some $60 billion in fraudulent workers' comp claims—more than any other type of fraudulent insurance claim—between 1985 to 1994, according to A.M. Best and Conning Insurance Research and Publications.**

The Workers' Comp Fund paid out more than $70 million in workers' comp payments in 1997. The Fund's investigative unit is estimated to have saved $11 million in fraudulent claims between 1992 and 1997.

Suspicious claims are investigated every day.

Investigations are based on "what we call red flags," says Hofeling. "We look at the description of the accident and the nature of the injury to see that they are consistent." Co-workers and employers are also interviewed, Hofeling says. "In a rare case, we might engage in surveillance or some other form of an activity check."

The Exclusive Remedy

In January 1998, the Supreme Court of Mississippi ruled that a general contractor and subcontractor were entitled to immunity from suit under the exclusive remedy provision of the workers' compensation law in a suit by an employee of a subcontractor that had workers' comp insurance.

Brasfield & Gorrie General Contractor Inc. was the general contractor for the construction of a mall. Brasfield subcontracted the structural steel work to FaBarc Steel Supply Inc. Thereafter, FaBarc contracted with Model City Erection to do portions of the steel work. Brasfield contractually required FaBarc to obtain workers' compensation coverage for FaBarc's employees. FaBarc, in turn, required Model to purchase such insurance for Model's employees.

David Crowe, an employee of Model, was injured on the project. He filed a workers' comp claim and received benefits from Model's insurance company. Crowe then filed a negligence suit in a federal court against Brasfield and FaBarc. The defendants sought to have his suit dismissed on the ground that workers' compensation was his sole remedy. The federal trial court ruled against Crowe and dismissed his negligence suit. The 5th U.S. Circuit Court of Appeals, however, requested the Supreme Court of Mississippi to rule on the immunity-from-suit issue.

The state Supreme Court held that the exclusive remedy provision of the state's workers' compensation act does protect the general contractor and the subcontractor when the subcontractor has workers' compensation insurance for its injured employees. One judge dissented, concluding that state law granted an employee or his dependents the right to sue at law "any other party."

In a similar case in 1997, the Massachusetts Supreme Court ruled that requiring workers' compensation companies to defend civil actions outside

the workers' compensation system would represent an unwarranted expansion of coverage.

The ruling came in a coverage dispute over a $145,000 arbitration award in a sexual harassment and wrongful termination case.

The coverage dispute, *HDH Corp. v. Atlantic Charter Insurance Co.*, was filed in Massachusetts Superior Court by Boston-based HDH after its insurance company refused to defend the civil action because it fell outside the exclusive remedy of the workers' comp system.

Atlantic argued that by failing to assert the exclusivity defense and to file a notice of claim for workers' comp benefits with the state Department of Industrial Accidents, HDH had waived its rights to coverage under part one of its workers' comp policies.

The insurance company also argued that part two of the workers' comp policy—employers' liability—expressly excluded coverage for damages arising out of the discharge of, coersion of, or discrimination against any employee in violation of law.

After the Superior Court granted summary judgment in Atlantic's favor, an appellate court in part overturned the Superior Court, finding a duty to defend under part one of the policy and remanding the case for further proceedings against Atlantic.

In affirming the granting of summary judgment, the Supreme Court ruled that "as a matter of law, workers' comp benefits cannot be recovered by instituting a civil action. A claim for benefits must be brought before the department and adjudicated through the statutorily prescribed workers' comp system."

In an opinion written by Justice Ruth Abrams, the high court further stated that the distinction between a claim for workers' comp benefits and a civil suit is not merely a procedural matter of bringing an action in the wrong forum.

"As amici point out, there are fundamental differences between a claim for workers' comp benefits and a lawsuit seeking civil damages. The legislature intended that the workers' comp system supplant the common law tort system as a means for compensating injured employees," the court said.

In her opinion, Justice Abrams also noted that the high court's decision in the HDH case was bolstered by courts in other jurisdictions, which have in similar circumstances interpreted virtually identical language in workers' comp and employers' liability insurance policies as providing no duty to defend in civil litigation.

Several insurance groups that had filed amicus briefs, including the Na-

tional Association of Independent Insurers, the Alliance of American Insurers and the Independent Property-Casualty Insurers of Massachusetts, hailed the decision as a victory for insurance companies.

In the Course of Employment

An Ohio appellate court awarded workers' compensation benefits to an employee injured while he was answering an electronic page from his employer while on call.

Darrell Durbin was employed by American Sentry Protection Service as a security guard. He was assigned to the "R&R reserve team" and as such did not have a fixed, permanent assignment or job location. He was on call for periods of each day, seven days per week, to fill various shifts and assignments that became open due to sickness or emergencies. He received notice of assignments from an electronic pager supplied by his employer.

On Dec. 18, 1992, while Durbin was within paging range, and while returning from a personal trip during an on-call period, he received a page from his employer. He exited the highway to reach a pay telephone. While stopped in traffic, he was struck in the rear by another automobile and injured. He filed for compensation, but the Industrial Commission denied him benefits. The trial court also denied benefits.

Durbin appealed.

The appellate court concluded that Durbin's injuries, received while answering a page from his employer during an on-call period, were sustained in the course and arose out of his employment. The court rejected the employer's argument that the injuries were excluded from benefits because they occurred while he was going to or coming from work. The court emphasized that here Durbin was not simply going to or coming from work. "His 'on-call' status," the court said, "meant he was in effect at work while responding to an employer page during those periods." The court noted that Durbin's leaving the highway to answer the employer's page was a substantial part of the service for which he was employed. Durbin was awarded benefits.

Payments Have to Be Made in Time

The May 1997 Louisiana appeals court decision *Scott Jeffcoat v. McCann's Seafood* followed an employee who had to deal with an employer that was playing hardball.

On August 29, 1994, Scott Jeffcoat injured his knee in an accident while employed with McCann's Seafood. McCann's paid Jeffcoat's workers' compensation benefits and medical expenses. However, Jeffcoat's knee was not healing, so his treating orthopedist, Dr. Vanda Davidson, referred him to Michael Brunet, an orthopedic surgeon at the Tulane Medical Center in New Orleans.

Brunet sent a report and recommendation for surgery to McCann's insurance company in April 1995. Jeffcoat notified McCann's of the date of surgery.

But, in order for Jeffcoat to undergo surgery, he needed to travel from his home in Alexandria to New Orleans. And, since Jeffcoat's workers' comp benefits constituted his income, he could not afford to pay his travel expenses—which included an overnight hotel stay.

On June 19, the day before he was to undergo surgery, Jeffcoat requested that McCann's either pay for his travel expenses in advance or guarantee payment of his travel expenses. McCann's authorized payment for the mileage traveled by Jeffcoat but did not mention authorization of Jeffcoat's hotel expenses.

Jeffcoat had to reschedule his appointment for surgery because he was unable to afford the travel and accommodations.

In a letter dated October 17, 1995, Jeffcoat requested advanced payment or authorization of travel expenses associated with his surgery. No response regarding this request was received from McCann's until January 1996 when McCann's stated that it would guarantee payment of the overnight stay in a hotel in New Orleans.

On November 9, 1995, Jeffcoat filed a workers' compensation claim against McCann's Seafood to recover penalties and attorneys fees resulting from McCann's refusal to guarantee timely payment for travel and hotel expenses arising from reasonable and necessary medical treatment.

The Office of Workers' Compensation Administration assessed $1,000 in penalties and $1,500 in attorneys fees.

McCann's appealed this judgment asserting that it is not liable for travel expenses until they are actually incurred. McCann's further argued that it should not have been liable for attorneys fees because its actions were reasonable under the circumstances.

According to McCann's, authorizing Jeffcoat's travel and hotel expenses in January 1996, which were originally incurred in June 1995, was not an arbitrary and capricious act because Jeffcoat's travel expenses were not due at the time authorization was requested. McCann's correctly argued that, em-

ployers are liable for mileage expenses in a workers' comp case under Louisiana law, which states:

> In addition, the employer shall be liable for the actual expenses reasonably and necessarily incurred by the employee for mileage reasonably and necessarily traveled by the employee in order to obtain the services, medicines, and prosthetic devices which the employer is required to furnish under [state law].

The Office of Workers' Compensation Administration, however, was not concerned with McCann's liability for payment. However, the administration was concerned with McCann's unwillingness to provide Jeffcoat a guarantee for timely payment of his travel expenses. In the absence of such an authorization of payment, Jeffcoat's surgery was effectively denied.

An employee may recover reasonable travel expenses—including hotel expenses that are a reasonable and necessary travel expense if there is no dispute as to the amount involved or the necessity of an employee to stay in a hotel in order to keep a doctor's appointment—in connection with medical treatment as part of the employee's medical costs.

When an employee is unable to obtain necessary medical treatment without a guarantee or an authorization of payment from his employer, the employer must furnish such authorization in advance of payment as a part of its duty to furnish medical care.

No rational basis for the delay in authorizing payment was provided. The hearing officer's finding that McCann's refusal to approve the travel expenses in a reasonable time period was arbitrary and capricious is reasonable based on the information provided in the record, said the appeals court.

McCann's argued that attorneys fees were improperly awarded because there were no claims in dispute at the time of the hearing. Jeffcoat, however, claimed that McCann's failure to timely authorize payment constituted the dispute in this claim, and thus the award is proper. The appeals court agreed, writing:

> Louisiana [law] states that failure to provide benefits presented in the workers' compensation statutes will result in the assessment of reasonable attorney fees. We have already determined that the hearing officer's decision finding McCann's failure to timely authorize Mr. Jeffcoat's travel expenses violated [state law] was reasonable. This violation constitutes a failure to provide benefits in accordance with the Workers' Compensation

statutes. Since the hearing officer's determinations concerning the dispute were proper in this case, her decision to award attorney fees was not manifestly erroneous.

In addition, the appeals court held that the attorneys fees were not excessive, as McCann's had suggested:

> Jeffcoat's attorney filed the form for a dispute workers' compensation claim, participated in a mediation conference, prepared a pretrial statement, participated in a pretrial conference, tried the case on the merits, researched and wrote an appellate brief, and wrote and sent correspondence to various parties in this case regarding the matter in dispute. The hearing officer did not abuse her discretion in awarding $1,500.00. The amount of the fees awarded were reasonable in relation to the amount and nature of the work performed.

The judgment of the hearing officer was affirmed.

Miscellaneous Costs That Aren't Covered

There are a number of costs that are not covered under an employer's workers' compensation policy. A case in point: The Colorado Court of Appeals recently ruled that child care services furnished to a workers' compensation claimant while she was hospitalized for a work-related injury are not a "compensable medical benefit."

Dana Kurziel sustained a knee injury in a work-related accident and required hospitalization. She purchased a $300 airline ticket to enable her sister to come to Colorado and watch her children while she was hospitalized. Kurziel sought temporary disability benefits and medical benefits through a workers' compensation claim. She included the $300 cost of the airline ticket in her claim. The administrative law judge found that $300 was a reasonable amount for baby-sitting services for one week and ordered the employer and its insurance company to pay Kurziel that amount. The Industrial Claim Appeals Office reversed the administrative law judge and denied the claim.

Kurziel appealed.

The appellate court said that the child care services here were not "medical" in nature because they did not relieve the symptoms or effects of the injury and were not directly associated with Kurziel's physical needs. In addition, the court said they were not "incidental" to medical treatment because such services were not provided as part of an overall home health care pro-

gram designed to treat Kurziel's condition. The court agreed that the $300 award for child care services should be set aside.

One cost that workers' compensation systems could be called upon to pick up the tab for far more often in the future, warns one attorney, is the cost associated with organ transplants.

Right now, the number of patients on waiting lists is not large, and it is not apparent that many potential recipients will turn to workers' compensation as a payment source, said Mark E. Solomons, an attorney with Arter & Hadden in Washington.

But advancing technology could change that situation, making coverage of organ transplants a "far more significant concern," said Solomons, who spoke at a session on cutting-edge developments in workers' compensation at the American Bar Assn.'s annual meeting last month.

It is a volatile issue. Solomons said that, even though transplant cases constitute only a minute portion of his total practice, he has been hung up on more times, called more names and had his character assassinated more frequently in connection with these cases than with the rest of his practice combined.

Solomons noted that the Health Care Financing Administration (HCFA) recently approved Medicare payments for heart, lung and liver transplants for insured individuals, provided that certain selection procedures are met and the transplant is performed in an approved transplant medical center.

The Medicare Act, like most workers' compensation laws, authorizes the coverage of expenses that are "reasonable or necessary." Transplants historically have been excluded from the scope of coverage because of the absence of acceptable clinical evidence on their safety and effectiveness, said Solomons.

With HCFA's determination that transplants might be a safe and effective treatment, "it surely becomes more difficult for a workers' compensation system to deny coverage for reasons that would now suffice in the case of a Medicare claim," said Solomon.

Although organ transplants in workers' comp cases are not a big issue yet, "[t]he major concern for employers, insurers and workers' compensation administrators is that advancing technology may soon change the landscape in dramatic ways," Solomons said.

If transplants are no longer the "treatment of last resort" for terminal patients but instead become a "treatment of choice" for patients who are less ill, the coverage of transplants is likely to become a more significant concern for workers' comp systems, he said.

If You Get Fired After You Make a Claim

If you are fired after suffering injuries on the job, you can sue your employer for disability discrimination, the California Supreme Court ruled in August 1998. The decision overturns 16 years of lower-court rulings and clears the way for thousands of injured workers to collect potentially large damage awards when they are fired after being injured on the job and refused reasonable accommodations to continue working.

"Employers immediately are going to have to pay more attention to how they treat workers' compensation claims in general," said Brad Seligman, an attorney for the Disability Rights Education and Defense Fund. "And they are going to have to be much more careful about taking actions that can be perceived as retaliatory."

Companies will "have to be careful about how they treat anyone who has been injured on the job," added William Quackenbush, an employment law expert who filed a brief in the case on behalf of employees. "They are not going to be able to tell that person, 'We are sorry. We couldn't wait for you to return. We filled the job.'"

Employer groups have argued that state law limits injured workers to collecting only the restricted amounts allowed under workers' compensation law if they are fired. Lower courts have generally agreed. But the Supreme Court, in a ruling written by Justice Ming W. Chin, substantially expanded the potential liability employers face in such cases. "Disability discrimination is indistinguishable in many ways from race and sex discrimination," Chin wrote for the court. If a disability affects a worker's ability to perform a job, the employer may still treat that worker differently from other employees, the court said. But the company must provide reasonable accommodations for the worker's disability. If such accommodations would make it possible for the employee to perform the job effectively, and the company fires the worker anyway, then that "discrimination based on disability, like sex and age discrimination, violates a substantial and fundamental public policy," Chin wrote.

The case could be particularly important for higher-paid workers because those with higher earnings tend to win larger jury awards for emotional distress and punitive damages, which are designed to deter future corporate misbehavior, Seligman said. Before the Supreme Court decision, workers who were fired after being injured at work could obtain a maximum of $10,000 in damages, plus their lost earnings and $250 for legal costs and expenses under state workers' compensation law, he said. Plaintiff lawyers often declined to accept such cases.

The case was brought by Theresa Dillon, who worked for four years as

an administrative secretary for the Ventura County city of Moorpark. Dillon said she suffered a knee injury at work and filed a claim for workers' compensation benefits. After she recuperated from knee surgery and tried to return to work in 1994, city officials informed her she had been fired because she could no longer kneel, squat or climb many stairs, she said.

She insisted that she could do her secretarial job if she were allowed to use a wheelchair ramp rather than the stairs. But the city refused to rehire the woman, then 36.

"It was pretty blatant [discrimination] as far as I was concerned," said Maury Mills Jr., her lawyer.

Dillon won at the trial court and in a Court of Appeals, but the Supreme Court agreed to review the case because of conflicting rulings in such disputes. Mills said Dillon had since found another job in a doctor's office, although she still suffered from problems with her knee. Dillon could pursue her discrimination claims in trial court.

The city of Moorpark planned to dispute Dillon's charges. Harold A. Bridges, representing the city, complained that the decision "has expressly changed the rules after 16 years of jurisprudence."

> **Employers now will be forced to defend terminations both before a workers' compensation board and in civil court, he said. The ruling "expands the exposure employers have when they discharge an employee," Bridges said.**

Seligman agreed, contending that workers frequently complain they were fired after filing workers' compensation claims. "In the past, there has been virtually no sanction," he said. "Now there is very serious potential liability." Even before the current ruling, workers could file a discrimination suit under federal law. But the federal rules and remedies are less beneficial to plaintiffs than those under state law, Seligman said.

Complaints about being terminated after a workplace injury have been among the most common claims in the work force, because "employers have known they could get away with this." The high court's ruling "opens the door to this large group of employees, and believe me it is large, who are treated rotten simply because they were injured on the job," Seligman said.

Seligman said the ruling was so broad that it gave any employee the right to sue for being fired after filing a workers' compensation claim. But Quackenbush said workers in such cases will still have to show a lingering disability.

Case Study: A Lingering Injury

When Joyce Bachman caught the heel of her shoe in the rim of a stool at work in 1991, she never expected the injury would follow her for the rest of her life.

In a freak accident, the 40-year-old Allentown woman broke the big toe on her left foot. In pain, she went to see a podiatrist and later an orthopedic surgeon.

"It's been downhill ever since," said Dale Bachman, her husband of almost 10 years.

Joyce Bachman now uses arm braces to walk and needs a wheelchair for distances of more than a few feet.

She can no longer drive, work, cook or stay by herself for more than a few hours. A pump implanted in the left side of her abdomen delivers a constant dose of painkilling morphine through a catheter to her spine.

Bachman alleges that late diagnosis and improper surgery have left her in constant pain and caused the spread of disabling reflex sympathetic dystrophy.

Now, Bachman is caught in another struggle she never anticipated. Her suit is one of nearly 4,000 legal cases statewide that have been frozen by what experts call the unprecedented financial collapse of two major medical malpractice insurance companies.

Since the beginning of the year, the two companies—PIC Insurance Group Inc. of Fort Washington, Montgomery County, and P.I.E. Mutual Insurance Co. of Cleveland, Ohio—have been placed in liquidation, the equivalent of a Chapter 7 bankruptcy, by state regulators.

As a result, Pennsylvania's appellate courts issued 90-day stays, stopping all activity on suits involving doctors insured by the companies until their liabilities can be determined. The shortfalls are estimated at $25 million for PIC, which at its peak insured 7,000 Pennsylvania doctors, and in excess of $270 million for P.I.E., which insured 15,000 policyholders in nine states, mostly in Ohio.

The stays, issued January 21, 1999, for PIC and February 18 for P.I.E., were ordered so that an agency taking over the cases and paying some of the claims has time to review files.

The PIC stay expired in mid-April. The P.I.E. stay is in effect until June 21 because of an additional stay that accompanied Ohio's liquidation order March 23.

According to experts, the stays are but the tip of an iceberg of consequences stemming from the two companies' demise:

People who settled lawsuits out of court, giving up their right to jury trials, may get less money than they thought. Others whose cases are pending may have to wait until the next millennium for payments.

Doctors have been left scrambling to find other insurance and to wonder about their coverage.

Experts say the sheer volume of cases and the potential for hundreds of millions of dollars in claims threaten to overwhelm the state's system for dealing with bankrupt insurance companies.

Already-backlogged civil courts are facing a scheduling nightmare.

And ultimately, the insolvencies could hit a large portion of Pennsylvania's insurance policyholders in higher rates for some types of insurance.

"It's not good at any level," said Dr. Larry Glazerman, an obstetrician-gynecologist with Valley Ob-Gyn in Allentown, and formerly insured by PIC. "It mucks up the whole system from top to bottom, from doctors to the lawyers to the judges to the patients."

The scope of the problems created by the PIC and P.I.E. insolvencies is enormous.

In seven counties in the Lehigh Valley region, at least 800 suits involving doctors insured by PIC and P.I.E. are on hold.

Many of the cases that have been on hold involve allegations of significant injury to patients and the potential for large settlements or verdicts.

In all cases, the defendants have denied negligence in court papers. In most cases, they or their attorneys declined comment for this story because the cases are pending.

Malpractice cases traditionally take a long time to resolve, lawyers say, because they often involve multiple defendants, reviewing extensive medical records and finding expert witnesses. Often, cases drag on because out-of-court settlements are not offered until cases are about to go to trial. A three-month stay in cases that on average take two to three years to resolve may not seem long. But to injured parties, the delay can take on utmost importance.

The additional delay caused by the stays means many victims will wait much longer for compensation.

When a case involves a settlement or verdict of up to $1 million, 80 percent is paid by the Pennsylvania Medical Professional Liability Catastrophe Loss Fund, also known as the CAT Fund. But the fund issues checks only once a year, on December 31. So to be eligible for a check, a case must have been settled by August 31 of that year.

The stays and rescheduling of cases could push many of them past the deadline for this year. Even if a case settles Sept. 1, plaintiffs may not receive their money from the CAT Fund until December 1999 or January 2000.

Patients may face another surprise because of Pennsylvania's system for covering the debts of insolvent insurance companies. Patients may not get all the money they were expecting in settlements.

In 1970, the state Legislature created a fund, now called the Pennsylvania Property and Casualty Insurance Guaranty Association (PIGA). The 850 to 900 insurance companies licensed in Pennsylvania are required to contribute.

> **When an insurance company fails, the fund pays claims against people who were sued while insured by that company and provides lawyers to defend them.**

When news of the insolvencies broke, lawyers speculated whether the fund would pay up to its mandated limits, one of which is $200,000 per doctor per claim.

The speculation ended March 30, when PIGA asked Commonwealth Court to find the fund has no obligation to pay its $200,000 share to Charles M. and Kelly A. Birely of Fairless Hills, Bucks County, who had agreed to settle a lawsuit for $1.1 million. They had alleged that a PIC-insured doctor, Dr. David Podrasky of Langhorne, Bucks County, caused neurological and physical injuries to their daughter, Corinne, who died at age 2.

According to the fund, it doesn't owe the Birelys $200,000 because Blue Cross already paid more than that for medical care for Corinne Birely. The fund said a 1995 law allows it to deduct from payments the amount injured parties previously received from other insurance, such as health insurance or workers' compensation.

Because this is the first time the law has been tested, the court decision could set a precedent for future cases against PIC doctors.

According to PIGA Claims Manager Stephen Perrone, PIGA gets its money by assessing members—all insurance companies writing property and casualty insurance in Pennsylvania. Forcing the industry to bear the same cost twice is unfair, he said.

The maximum the fund can assess companies per year is 2 percent of net premiums for the previous calendar year. PIGA managers expect to do that for several years to cover the two malpractice insolvencies, said Perrone.

Companies can pass that cost on to policyholders of homeowners and other non-automobile property and casualty insurance policies, PIGA said in its court action. "You and I would pay for this (insolvency situation), and will pay for this under our homeowners policy," Perrone said. The increase may not be great, but premiums are "absolutely going to go up," he said, "unless you have an insurance company that is truly a charitable organization and willing to take the hit."

The guaranty fund and the state's Insurance Department are no stranger to insolvencies. PIGA has dealt with four insolvent medical malpractice companies since 1985.

However, PIC and P.I.E. are the largest malpractice insolvencies the fund has seen in terms of the size of the expected claims. In fact, costs from PIC alone are "going to be in excess of $100 million," Perrone said.

PIGA has already estimated the cost of the PIC and P.I.E. insolvencies at roughly $375 million.

For doctors intimately involved with PIC and P.I.E. cases, the insolvencies already have caused major headaches.

Doctors are worried about their coverage. Some doctors were facing their second insurance insolvency, having switched to P.I.E. from PIC.

Doctors had other reasons to be anxious, too. Because coverage under the guaranty fund "is not seamless," Reed said, questions arose about potential gaps.

Doctors feared they may be personally liable for claims not paid in full by the guaranty fun—an issue that is still unresolved, she said.

PIGA, the CAT Fund and the Insurance Department are working with the Pennsylvania Medical Society to close gaps.

Many doctors have switched insurance companies, sometimes at increased cost. Others have moved to large physician groups affiliated with hospitals that provide malpractice insurance.

Joyce Bachman, formerly a clerk in the Lehigh County treasurer's office, yearns for the life she had before her accident.

She describes herself as having been energetic and active.

She now is confined to one floor of her two-story row home because climbing stairs is painful. Her husband does most of the household chores.

Bachman's condition has spread from her left foot up her leg and into her right leg. She has been hospitalized 18 times and has had 14 spinal blocks for pain.

The Bachmans filed suit in 1995 against Dr. Douglas Tozzoli, an Allentown podiatrist. In 1997, a second suit was filed against Dr. Steven J. Lawrence

and Orthopaedic Associates of Allentown.

The suits were consolidated earlier this year. Because Lawrence was insured by PIC, both suits were on court-ordered hold.

According to court documents, Tozzoli contended that the care he gave Bachman met accepted standards. Lawrence has not filed a formal answer to Bachman's suit. He has since left Orthopaedic Associates and practices in Lancaster. In response to a reporter's phone call, Lawrence said he had no comment.

When the Bachmans' lawyer told the couple about the stay, Dale Bachman said, "I turned white. I got a sick feeling in my stomach."

His first thought was that the case was over. To his wife, the process seems endless. "It seems like it's going on forever. Things haven't been easy," she said. "Everything has just been so complicated."

How EPL Figures into Comp Claims

Increasingly, businesses are realizing that employment practices liability (EPL) insurance is one way to help manage these risks. EPL insurance is a specialized insurance product designed to protect the corporation, its directors, officers and employees from liability for actual or alleged "wrongful acts" that are employment related.

EPL insurance can be a "stand alone" policy or might an endorsement to existing liability coverage.

EPL coverage typically is written on a "claims made" basis. That means that the insurance company is obligated to pay when a claim is made rather than when the "wrongful act" happens. The scope of EPL varies depending on the policy's definition of "wrongful acts." There is little uniformity in definitions, although most coverage includes:

- any actual or alleged wrongful dismissal;

- discharge or termination of employment;

- breach of any oral or written employment contract;

- violation of employment discrimination laws (including harassment);

- wrongful failure to employ or promote;

- wrongful discipline;

- wrongful employment-related defamation; and

- employment-related wrongful infliction of emotional distress.

Exclusions in most EPL policies are designed to prevent overlap with other types of insurance. Other exclusions might include prior and pending litigation exclusions, fine and penalty exclusions and exclusions precluding coverage for accommodation costs under acts such as the Americans with Disabilities Act (ADA).

Because the number of lawsuits claiming sexual harassment has more than doubled since 1990, employers everywhere are looking at liability insurance to protect themselves from paying huge settlements, according to New York-based Insurance Services Office Inc., the largest U.S. provider of property/casualty information services.

EPL helps protect against a host of discriminatory acts based on race, age, gender, physical handicaps, marital status, sexual orientation or national origin.

EPL insurance was created after the Civil Rights Act of 1991, which put teeth into discrimination and harassment lawsuits, allowing recovery of up to $300,000 in punitive and compensatory damages.

Before 1991, plaintiffs who proved discrimination or harassment could get only back pay, attorneys fees and potential reinstatement. Now they can recover enough to drive some uninsured companies out of business.

Federal laws put caps on how much employers can pay plaintiffs in discrimination cases.

Employers of 500 or more can be forced to pay up to $300,000 in compensatory and punitive damages, while small employers are liable for no more than $50,000.

Indiana state law defers to these federal caps, but some states, including California, don't limit damages, and this further complicates things. In California, people with discrimination suits avoid federal court in an attempt to get larger awards. In Indiana they can file suit only in federal court.

According to the Insurance Services Office, the median compensatory award for a wrongful termination claim was more than $200,000 in 1995, 45 percent higher than a year earlier.

Chapter 17

Making Claims on Professional Liability Policies

The professional liability insurance market has historically been somewhat volatile in both price and availability. Because of this, and the fact that policies generally are renewable annually and claims-made, it is unwise for a design firm to agree to a contract requirement to maintain specific levels of professional liability coverage for any extended time. The designer may not be able to comply in the future. Imagine if certain coverages suddenly became unavailable to a geotechnical engineer, for example. If she had specifically agreed by contract to carry these coverages for an extended time, she would find herself in breach of contract—through no fault of her own.

In fact, if such a situation were to be adjudicated, the court would likely find that the geotechnical consultant was required to make a "reasonable effort" to continue such coverage, or to use her "best efforts" to continue such coverage, even absent such clauses in the original contract.

Professional liability project policies offer several advantages that address many administrators' concerns. To begin with, project policies provide multi-year coverage, including the study, design, and construction or remediation period of the project, plus a post-construction discovery period. And, this coverage is guaranteed. A project policy generally is non-cancelable, except for nonpayment of premium.

The Mechanics of the Claims

In a professional liability claim, the plaintiff must credibly demonstrate that:

- a generally accepted professional standard exists;

- the defendant failed to adhere to this same generally accepted professional standard;

- the resultant negligence on the defendant's part caused economic damage to the plaintiff; and

- the damages are measurable.

The allegation of negligence in a suitability claim generally arises from the failure to recommend an investment consistent with the client's investment objectives or tolerance for risk, or it may arise from an inappropriate allocation of assets.

The burden of proof on the plaintiff is a significant one, and, absent willful misconduct on the part of the defendant, one that is very difficult to prove conclusively. Because a negligence claim is difficult to prove, it is equally difficult to defend. Thus, suitability claims are, on the one hand, expensive and defense-intensive; on the other hand, they tend to be settled either out of court or in a forum other than in formal litigation.

But as we've already noted, the starting point of such legal actions is to demonstrate both the existence of a professional standard, as well as the failure of the professional to meet that standard, to the detriment of the plaintiff.

Plaintiffs, or their attorneys if the case is accepted on contingency, still must face the stark reality of the economics of launching litigation, and against a most uncertain outcome. Who among us has not felt wronged, only to have to face the chilling effect of the significant economic, emotional and psychological costs of litigation.

These economics existed before standards and will continue to exist even when standards are put into effect.

Putting this first argument to the side for a moment, let us presume that the critics do have a point—that is, the existence of practice standards will cause plaintiffs to attempt to advance causes that they otherwise would have learned to live with. To believe that this will occur is to fail to believe in the advocacy system—if plaintiffs find it easier to litigate, likewise the defendant's burden will have been eased, as these very same standards are likely to be equally valuable to the defense.

This argument suggests that while there may be increased frequency of claims, it should be accompanied by a decrease in the average severity of all claims and by a sharper decrease in the severity of negligence claims, including those alleging lack of investment suitability.

In any claim, the quality of the practitioner's documentation is critical to providing an adequate defense. This is particularly true of both the documentation of investment objectives and tolerance for risk, and of file notes made contemporaneous to the services that gave rise to the claim—typically, because the plaintiff will not have made file notes, those offered by the defendant will constitute "best evidence."

Disclose thoroughly. In a claim setting, the first document that is typically requested by the plaintiff is the RIA's Form ADV. Make sure that it accurately reflects your practice and is in compliance with appropriate regulations. You can count on the plaintiff's attorney showing no mercy if required disclosures are inaccurate or misleading.

Professional Liability

The March 1998 federal district court decision *Lexington Insurance v. Rugg & Knopp, Inc. et al.* illustrates a good professional liability issue.

In June 1992, Rugg & Knopp was awarded a contract to design and partially construct a firefighting facility at the Salt Lake City Airport. The contract contained a stipulation requiring Rugg & Knopp to acquire "errors and omissions" insurance coverage, the premiums for which were paid by Salt Lake City.

In April 1994, Lexington issued a professional liability insurance policy to Rugg & Knopp, which provided coverage from April 14, 1994, to April 14, 1995.

In February 1995, Rugg & Knopp applied for a renewal policy, which was issued for the period April 14, 1995, to April 14, 1996. At the time of the renewal, Rugg & Knopp indicated that it was not aware of any circumstances likely to give rise to a claim against the company.

Both policies contained the following language with respect to claims-made coverage:

> The Company [Lexington] will pay on behalf of the Insured [Rugg & Knopp] all sums in excess of the deductible that the Insured shall become legally obligated to pay as damages because of claims first made against the Insured and reported to the Company during the policy period of this policy. This policy applies to actual or alleged negligent acts, errors, or omissions arising out of professional services rendered for others as designated in Item 7 of the Declarations.

For this coverage to apply, all of the following conditions must be satisfied:

1. the negligent act, error or omission arising from professional services took place subsequent to the Retroactive Date stated in the Declarations;

2. the Insured had no knowledge prior to the effective date of this policy of such actual or alleged negligent act, error, omission or circumstance likely to give rise to a claim;

3. claim is first made against the Insured during the policy period;

4. the Insured must report the claim to the Company, in writing, as otherwise provided in this policy within the policy period or within the thirty (30) day period next succeeding the expiration of the policy period.

Both policies also contained the following exclusion clause:

This policy does not provide coverage and the Company will not pay claim expenses or damages for...any claim based upon or arising out of any alleged negligent act, error, omission, or circumstance likely to give rise to a claim that an Insured had knowledge of prior to the effective date of this policy. This exclusion includes, but is not limited to, any prior claim or possible claim or circumstance referenced in the Insured's application.

Both Lexington policies also contained several reporting requirements for the inclusion of:

1. the potential claimant's name and address;

2. a description of the professional services provided or that should have been provided;

3. an explanation of the type of claim that is anticipated.

After the airport construction project began, Salt Lake City grew dissatisfied with Rugg & Knopp's work performance.

Between January and March 1995, the City informed Rugg & Knopp of several omissions in the project and claimed that the project was hindered by the daily need to clarify the contract terms.

In March, the City contacted Rugg & Knopp several times to inform the company that its original concerns were yet to be resolved and that it would make no additional payments until this request was fulfilled and that failure

to comply would result in Rugg & Knopp defaulting on its contractual obligations.

On April 21, 1995, the City again expressed its concerns regarding Rugg & Knopp's ability to complete the project and requested reimbursement for costs incurred as a result of change orders, which totaled $162,000. The City also told Rugg & Knopp that it would notify Rugg & Knopp's professional liability insurance company that it intended to make a claim relating to such matters.

On June 1, 1995, the City terminated its contract with Rugg & Knopp.

On the same date, the City notified Rugg & Knopp and Lexington that it sought compensation for claims against Rugg & Knopp related to negligent acts, errors and/or omissions arising out of the construction project.

According to Lexington, it had no duty to provide coverage for the City's claims against Rugg & Knopp because the circumstances giving rise to the claims were not reported to Lexington within the period of coverage provided by Policy 1, nor was the claim reported within the required 30 days after the policy expired. Lexington also contends that Policy 2 does not provide coverage because Rugg & Knopp gained knowledge of the City's potential claims during the period of the first policy.

Rugg & Knopp, however, contended that a claim was made against it during the period of the first policy by way of the numerous letters from the City; specifically, a March 22 letter which demanded the Rugg & Knopp correct the wrong in question. Furthermore, Rugg & Knopp argued that Lexington was not prejudiced by its delayed notice of the claim, and therefore Wisconsin law does not allow Lexington to deny coverage based on an untimely notice.

The critical issue is whether Wisconsin state law applies to claims-made policies, like the ones in the instant case.

Lexington didn't object to the magistrate judge's finding that the claims were made within the policy's coverage period. However, the company argued that the notice-prejudice requirements of the Wisconsin state law does not apply to the claims-made policies.

United States Magistrate Judge Goodstein recommended granting Rugg & Knopp's summary judgment motion.

By doing business in this state, Lexington agreed to abide by Wisconsin's statutory scheme and cannot claim ignorance to avoid an undesirable result. The company has essentially asked this court to carve out an exception for claims-made policies when there is no evidence of such exception in the statutes, comments, legislative history or Wisconsin case law.

Accordingly, the only relevant question is whether the untimely notice prejudiced Lexington. There is a rebuttable presumption of prejudice when the insured fails to give notice of the claim within one year after the time required by the policy, but the claim in this case was made to Lexington within 17 days after the expiration of the policy. Although Rugg & Knopp bear the burden to show no prejudice, Lexington has not argued and cannot show that it suffered prejudice by the delay. The case can therefore be disposed of as a matter of law.

The district court adopted the recommendation of the magistrate judge in its entirety and held that: (1) Wisconsin statutes stating that failure to give proof of loss or notice required by policy does not invalidate claim, unless the insurance company is prejudiced, applied to claims-made policies, and (2) the letter sent by City during period of renewal policy was an addendum to the claim made during initial policy.

On February 2, 1996, the Lexington Insurance Company filed suit, claiming that it had no duty to defend and indemnify Rugg & Knopp. Rugg & Knopp disagreed, claiming that the insurance policies covered the claims at issue.

Both parties agreed that Rugg & Knopp was notified of a potential claim at least as early as when it received a letter dated March 22, 1995, from the City's legal office, if not January 18, 1995, when the City informed Rugg & Knopp that it omitted phone service from the project plans.

According to the court, the City's demands correspond to the policy's definition of a claim as a demand for services.

The court also said that a March 22 letter, in which the City informed Rugg & Knopp that omissions in its drawings required the City to incur substantial costs and that Rugg & Knopp would seek compensation at a later date, constituted a claim. Therefore, because the first policy insured against all claims made between April 14, 1994, and April 14, 1995, the claims were made against Rugg & Knopp within the policy's coverage period.

The first policy also required all claims to be reported as soon as practicable, or no later than 30 days after the policy expires. Rugg & Knopp was obligated to notify Lexington of any claim no later than May 14, 1995. However, Lexington was not notified until June 1, 1995. Thus, under the terms of the first policy, Rugg & Knopp was not entitled to coverage, because it did not provide timely notice.

Under Wisconsin law, "[p]rovided notice or proof of loss is furnished as soon as reasonably possible and within one year after the time it was required by the policy, failure to furnish such notice or proof within the time required

by the policy does not invalidate or reduce a claim unless the insurance company is prejudiced thereby and it was reasonably possible to meet the time limit." In addition, "failure to give notice as required by the policy...does not bar liability under the policy if the insurer was not prejudiced by the failure, but the risk of nonpersuasion is upon the person claiming there is no prejudice."

Rugg & Knopp and the City argued that Lexington did not show how it was prejudiced by the untimely notice, and therefore, it must provide coverage for the City's claims against Rugg & Knopp. Lexington, on the other hand, argued that the notice statutes do not apply to claims-made policies.

Claims-made policies, unlike occurrence policies, are designed to limit liability to a fixed period of time. To allow coverage beyond that period would be to grant the insured more coverage than he bargained for and paid for, and to require the insurance company to provide coverage for risks not assumed.

Thus, the court proceeded on the basis that the notice provision of the statute applied to claims-made as well as occurrence policies. As the Michigan Supreme Court stated, the requirement that a claim be made during the policy period defines the scope of coverage in a claims-made policy, not the requirement that the insurance company be notified within a certain period.

Thus, the notice requirement as established in the Wisconsin statutes does not effectively eviscerate claims-made policies, as Lexington alleges.

Claims are still to be made against the insured during the policy period; the legislature has simply extended the period of notification of such claims to the insured.

The court concluded that Wisconsin law applies to the claims-made policies at issue.

Lexington may not deny coverage for the Salt Lake City Corporation's claims against Rugg & Knopp on the ground that Lexington was not given timely notice of such claims.

Educational administrators and risk managers need to know that the architects, engineers and other design professionals selected for building projects have adequate and appropriate insurance. They need proof that the basic coverages—professional liability, commercial general liability and workers' compensation—are in place. That is why most professional service contracts contain specifications that detail the insurance design firms are expected to have.

Understandably, schools want assurances that the design firms on projects have professional liability insurance with appropriate policy limits, and that coverage will be through the life of the project and a reasonable time beyond.

> Professional liability insurance is tied to the professional standard of care. Therefore, an architect or engineer would be unable to persuade a professional liability insurance company to cover any act that leads to damages, rather than just the negligent acts covered in the policy language.

To begin with, a professional liability policy covers design errors and omissions. Since the project owner usually is not a designer, and therefore incapable of making design mistakes, there can be no coverage for the owner.

Actually, payment of the claim by the insurance company generally is not predicated on the design firm's payment of the deductible. It is up to the insurance company to pay the entire loss, then look to the insured for repayment of the deductible.

Many professional liability policies are called "practice policies." Such a policy covers claims made during a policy year for all professional services performed by a design firm, subject to the retroactive date. It is a practical impossibility to have a practice policy with varying deductibles for each contract.

The administrator chooses the amount of coverage, and the policy limits are dedicated to the project. And, in nearly all cases, the policy covers the entire design team, even uninsured or underinsured subconsultants. This gives the administrator more flexibility in choosing consultants.

Financial Planners as Liable Professionals

The drafters of the practice standards—the Certified Financial Planner Board of Practice Standards—appear to acknowledge the concerns of practitioners that the practice standards may result in a change in the liability climate. In Standard 1, the CFP Board notes: Conduct inconsistent with a standard in and of itself is not intended to give rise to a cause of action nor to create any presumption that a legal duty has been breached. The standards are designed to provide CFP designees a structure for identifying and implying expectations regarding the professional practice of personal financial planning. They are not designated to be a basis for legal liability.

In 1993, a New York Stock Exchange company had filed for bankruptcy resulting from the misappropriation of funds by the officers of the company. Within the first two weeks following the bankruptcy filing, four claims involving investments in the company were filed against four different registered reps of the same broker/dealer alleging lack of investment suitability. In

no case was there a defensible assessment of the client's investment objectives or tolerance for risk. The claims could not be easily defended because there was little apparent justification of the choice of the investment in the first place.

Three years later, long after this series of four claims had been settled, we were having a discussion with a financial planner who also had recommended this same investment to his client. He patiently explained to us the efforts to document the client's objectives at the time that the investment had been made.

He also pointed out that the client had, in the engaging documents, explicitly acknowledged the inherent risk that the client could not assume away, no matter how well or poorly an investment performed.

As a result, the policyholder asserted that it was highly unlikely that a claim would be filed. No claim was ever filed. In later years we came to learn that several of our other policyholders had had a similar exposure to this same security. No other claim involving this investment was ever filed by those of our policyholders who were financial planners.

This series of claims, as well as the lack of any claims reported by those financial planners who had placed the identical investment, lead us to an important conclusion: The difference between financial planners and other similarly situated financial advisory professionals was the process of financial planning itself, together with the resultant documents identifying the client's investment objectives, tolerance for risk and, most importantly, the meeting of the minds between professional and client.

> **These three elements of documentation are all important when something goes wrong, as it surely always will. These same elements are the very subject of the practice standards soon implemented.**

In defending a claim, the documents crucial to the providing of a defense include:

- assessment of investment objectives;

- assessment of client tolerance for risk; and

- file notes made contemporaneous to the alleged wrongful act.

The existence of these documents and, in fact, the financial planning process itself, already distinguish the financial planning professional from other financial advisory professionals. These standards serve to reflect practices already widely applied by many practitioners.

Covering Claims...and Legal Costs

In late 1997, the California Supreme Court, often at the vanguard of insurance law, issued back-to-back opinions allowing an insurance company to recover defense costs from its policyholder if the company proves that, more likely than not, the defense costs were incurred solely in defending against a claim, or even a part of a claim, that was not even potentially covered under the policy.

The two cases—*Jerry H. Buss et al. v. Superior Court of Los Angeles* and *Aerojet-General Corp. vs. Transport Indemnity Co.*—illustrate two common reimbursement scenarios that policyholders must understand and anticipate. In *Buss*, the policyholder, Jerry Buss, owned several professional sports teams, including the Los Angeles Lakers. He was sued under 27 causes of action by a company providing advertising services. Buss's insurance company, Transamerica Insurance Co., agreed to defend Buss based solely on one cause of action for defamation, reserving its rights to obtain reimbursement of defense costs as to the other 26 non-covered claims. Buss eventually settled the lawsuit for $8.5 million, but Transamerica refused to contribute.

Transamerica, which had paid over $1 million to defend Buss, then sought reimbursement of all defense costs except for some $21,000 to $56,000, which it believed was the only amount attributable to defending the defamation cause of action. The California Supreme Court ruled that Transamerica had the right to go after Buss to recover defense costs incurred solely in defending the 26 non-covered causes of action. Thus, the policyholder, Buss, was left facing a reimbursement claim of nearly the entire $1 million spent to defend the underlying lawsuit.

Aerojet presented a different scenario by which a policyholder may be forced to pay for its own defense. There, the policyholder tendered to its insurance companies' suits claiming contamination of property through the operation of manufacturing plants. The companies sought a declaration that they did not owe a duty to fund Aerojet's entire defense based on the presence of deductibles or retained limits in several of Aerojet's policies. The California Supreme Court ruled that the companies had a duty to defend the entirety of claims against Aerojet but could recover defense costs:

> to the extent they can prove that the defense costs were incurred solely in defending non-covered claims or parts of claims. The potentially non-covered claims or parts of claims [are] principally related to contamination occurring outside the policy period. Aerojet will have to reimburse the insurers to

the extent they prove that defense costs were incurred solely in defending such non-covered claims or parts of claims.

Rulings such as in *Buss* and *Aerojet* will likely result in more significant disputes between insurance companies and policyholders on the issue of who ultimately pays for defense costs. A policyholder, happy to learn that an insurance company has agreed to defend a lawsuit, may be extremely displeased to learn months or often years later that the company is seeking to have some or nearly all of the substantial defense costs thrown back on the policyholder.

If the policyholder is unwilling to submit to the company's demand for reimbursement of defense costs, the policyholder may become the target of a further legal action by the insurance company to recover those defense costs. The policyholder's displeasure would, no doubt, be magnified where the company is demanding reimbursement of defense costs incurred by counsel of its choice, who could have steered the underlying lawsuit in a direction favoring the insurance company's later reimbursement claim.

Does the claim carry the potential for a later reimbursement dispute? The policyholder first needs to determine whether the insurance company has the right to later assert a claim for reimbursement of defense costs. This will hinge on at least four factors:

- Does the complaint allege any claims or parts of claims that are not covered by the policy? If not, then there is no basis for the insurance company to seek reimbursement.

- Does the applicable law allow a company to defend a lawsuit but later force the policyholder to bear some or all of the defense costs? In other words, the policyholder must determine whether the company has the right to seek reimbursement of defense costs in the first place.

- Has the insurance company promptly and specifically reserved the right to later seek reimbursement of defense costs? If not, the company may have waived the right to do so. However, caution must be exercised because some jurisdictions might allow a company to assert a claim to recover defense costs despite the absence of a prompt and specific reservation of that right.

- Is the insurance company promptly and fully providing a defense? Some jurisdictions will allow an insurance company to recover defense costs from the policyholder only if the company provided a prompt and full defense.

What is the risk and extent of a potential reimbursement claim? To properly assess the risk and extent of a later reimbursement claim, a thorough legal analysis of the coverage afforded the third-party claims (and parts of claims) must be performed. Questions to address include:

- Are there any claims (or parts of claims) that are clearly outside the scope of coverage? If so, to what extent do the non-covered claims predominate the covered claims? The policyholder should consider whether it would be advisable either to defend itself or to negotiate up front a reasonable defense-cost sharing agreement.

- Do the covered and non-covered claims involve the same factual issues? For example, has the third-party claimant alleged that the policyholder's misconduct was negligent (in one cause of action) and intentional (in another cause of action)? Does the defense against contract and tort claims hinge on proof of essentially the same facts? The more the covered and non-covered claims implicate the same factual issues, the more likely the insured person will succeed in defeating the insurance company's reimbursement claim, since the company will have considerable difficulty demonstrating that any portion of the defense costs was incurred solely because of the non-covered claims.

- Should the policyholder cut a deal on reimbursement? Assuming that the applicable law affords the company the right to seek reimbursement of defense costs, the policyholder should consider whether it makes sense to try to make a deal to share defense costs. For example, after a third-party claim has been asserted, the policyholder could explore an agreement with the insurance company establishing a dollar cap, percentage cap or other formula for sharing defense costs.

> **The cap or formula would vary depending on the nature of the claims alleged in the underlying lawsuit, including the relative importance of the covered vs. non-covered claims and the extent to which such claims are factually intertwined.**

A defense cost sharing agreement could inure to the benefit of both sides by decreasing the uncertainty and risk of an unliquidated reimbursement claim,

avoiding the cost of litigating the reimbursement claim down the road, allowing the policyholder and insurance company to defend the third-party claim with a united front, and avoiding disputes over conflicts of interest in the retention of defense counsel.

Settling Professional Liability Claims

Loss experience demonstrates that well over half of all reported claims eventually close with only a small payment or no payment to the claimant.

This proposition runs somewhat counter to conventional wisdom. The insurance-buying public tends to believe that it purchases insurance to protect accumulated assets against the erosion of some unanticipated adverse judgment. The data suggests that an equally valid reason for buying professional liability insurance is to protect against the expense of providing a defense for a claim that perhaps never should have been brought in the first place. While as a professional you may well assume that the quality of your practice is above reproach, you need not have been negligent to be named as a defendant in a lawsuit. The incidence of claims is a function of human dissatisfaction, not necessarily the result of the defendant's negligence.

We can draw an important set of related conclusions:

- Claims historically have arisen from several different causes of loss.

- Claims representing 69 percent of the number of claims and 71 percent of the loss amounts will be unaffected by the implementation of standards.

- Causes of loss that will not be affected by standards include disclosure, fraud, procedural and tax claims, since such claims will continue to occur whether or not the standards are followed.

Thus, approximately one-third of the numbers of claims and the amount of losses are attributable to allegations of lack of investment suitability. Frequency or severity may or may not change as a consequence of soon-to-be implemented standards. We must look more deeply into the anatomy of a negligence claim in order to assess how standards will affect either the frequency or severity of such claims.

The January 1999 federal district court decision *Mothe Funeral Homes and Boyd Mothe v. Travelers Casualty and Surety Co. f/k/a Aetna Casualty and Surety Co.* dealt with a specific professional liability claim settlement issue.

Cheryl Hindelang Chatelain was covered by two burial policies issued by Mothe Life Insurance (MLI) which provided that burial would be performed by Mothe Funeral Homes, Inc. (MFHI).

Upon the death of Chatelain on November 14, 1996, disputes arose as to the terms of the burial policy. Chatelain's husband and father requested alterations to the burial agreement, specifically substitution of a wooden casket for the one described in the burial policy. MFHI denied their requests.

On November 13, 1997, Chatelain's husband Michael and father Alvin Hindelang filed suit against MFHI, Mothe Life Insurance Co. and Boyd Mothe, Jr. in the U.S. District Court for the Eastern District of Louisiana to settle the disputes regarding the terms of the burial policy.

Michael Chatelain and Hindelang alleged the following: MLI intentionally and/or negligently misrepresented the benefits provided by the policy; MLI's tying of the purchase of the casket to the agreement to provide funeral services constituted violations of anti-trust and unfair trade practices laws and the laws of the State of Louisiana; Boyd Mothe, Jr. was aware of the dispute over the substitution of the casket and the claim for benefits under the several burial policies; and as a result of the intentional and/or negligent conduct of Boyd Mothe, Jr., MLI and MFH, they suffered damages including but not limited to emotional distress, mental and psychological pain and suffering, damages for breach of contract, and other damages including penalties, attorneys fees, treble damages, interest from date of notice of claim, etc.

MFHI and Mothe filed a motion for summary judgment, seeking declaratory judgment and damages regarding, inter alia, the duty of Travelers Casualty & Surety Company to provide a defense for MFHI and Mothe. Travelers refused to defend, alleging that the disputes were not covered under the "occurrences" clause in the Commercial General Liability (CGL) Policy, which excludes coverage for damages "expected or intended by the insured."

The issue is whether Travelers owes a duty to defend MFHI and Mothe in the underlying action, not whether Travelers necessarily owes coverage for the alleged violations.

Travelers issued a Funeral Director's Professional and Commercial General Liability policy to MFHI for the policy period of June 1, 1996, to June 1, 1997.

The CGL policy provides as follows:

1. Insuring Agreement

a. We will pay for those sums that the "insured" becomes legally obligated to pay as damages because of "bodily injury"

or "property damage" to which this insurance applies. We will have the right and duty to defend any "suit" seeking those damages.

b. This insurance applies to "bodily injury" and "property damage" only if:

(1) The "bodily injury" or "property damage" is caused by an "occurrence" that takes place in the "coverage territory";

(2) Exclusions:

This insurance does not apply to:

a. "Bodily injury" or "property damage" expected or intended from the standpoint of the "insured."

V. Definitions

9. "Occurrence" means an accident, including continuous or repeated exposure to substantially the same general harmful conditions.

The Funeral Director's Professional Liability policy is an endorsement to the original policy. In bold letters across the top of the document is the warning: "Commercial General Liability" "this endorsement changes the policy. Please read it carefully." The endorsement changes the CGL coverage with respect to the operations as funeral director as follows:

1. Section 1—Coverage A. Bodily Injury and Property Damage Liability Insuring Agreement is amended by adding the following:

a. This insurance applies to damages because of:

(1) "bodily injury" or "property damage" due to a professional error or mistake made by you or on your behalf:

Funeral Directors Professional Liability (Endorsement) at 1 (emphasis added).

The coverage provided by the endorsement is not limited to "bodily injury" or "property damage" that results from an "occurrence."

The insurance contract also contained an endorsement, which stated that the endorsement "changes the policy." This endorsement provided coverage for civil rights violations with no limitation to unintentional violations. Travelers unsuccessfully argued that the definition of "occurrence" in its Com-

mercial General Liability policy necessarily limited the coverage provided in the endorsement to unintentional acts.

The contract provides coverage for "personal injury" or "property damage" and limits that coverage to "occurrences" which the policy defines as accidents. The "Funeral Director's Professional Liability" endorsement does not limit coverage to "occurrences." At the very least, the provisions of the Funeral Director's Professional Liability endorsement are ambiguous, and whether the definition of "occurrences" in the CGL policy also applies to the endorsement cannot be readily ascertained. As such, the endorsement must be construed against Travelers and in favor of MFHI and Mothe.

Consistent with the court's ruling in *Bayou Fleet*, the court held that the Funeral Director's Professional Liability endorsement is controlling, and coverage for "bodily injury" or "property damage" due to a professional error or mistake made by a funeral director or made on his behalf is not limited to "occurrences." The suit against MFHI and Mothe is covered by the Funeral Director's Professional Liability endorsement, and, consequently, Travelers must provide a defense to MFHI and Mothe in that action.

The Commercial General Liability Coverage Form provides:

> a. We will pay those sums that the "insured" becomes legally obligated to pay as damages because of "bodily injury" or "property damage" to which this insurance applies. We will have the right and duty to defend any "suit" seeking those damages. We may at our discretion investigate any "occurrence" and settle any claim or "suit" that may result.

> II. The "Occurrences" Clause

> A. Intentional Acts v. Intentional Damages

A duty to defend is also implicated by the Commercial General Liability policy. The policy does not exclude coverage for intentional acts when the damages are non-intentional.

Travelers denied coverage and refused to provide against MFHI, Mothe Life Insurance Co. and Boyd Mothe, Jr., arguing that the complaint alleged intentional acts, which would be excluded from coverage via the "occurrence" clause. However, the complaint does not allege that the damages which resulted were intentional on the part of Mothe Funeral Homes or Boyd Mothe, Jr. Therefore, coverage for allegations of intentional conduct are not excluded by the policy, and Travelers had a duty to defend.

The complaint against Mothe Funeral Homes and Boyd Mothe, Jr. also alleged a cause of action in negligence. According to the court, the negligence

allegations are covered under the policy, and, thus, Travelers had a duty to defend those claims. And this duty would then also obligate Travelers to defend the other claims as well.

MFHI & Mothe's motion for summary judgment was granted. Travelers owed a duty to defend.

MFHI & Mothe's motion for summary judgment was remanded to the 24th Judicial District Court for the Parish of Jefferson, State of Louisiana, for determination of the indemnification and damages issues.

Using ADR to Settle Liability Problems

The use of alternative dispute resolution in general liability insurance cases has more than doubled since 1991, according to a study from Insurance Services Office Inc. (ISO), New York.

Among the alternative methods gaining favor in settling insurance claims are mediation and arbitration.

The ISO study, conducted under the auspices of the National Association of Insurance Commissioners, found that the percentage of claims settled for $75,000 or more that were resolved through alternative dispute resolution, or ADR, increased from 7.1 percent in 1991 to 18.5 percent in 1997.

Christopher Guidette, director of corporate communications for ISO, an actuarial and statistical firm that provides advisory information to the insurance industry, said ADR makes sense for insurance companies. "You dispose of a case quickly," he said. "Time is money, too."

"If cases are settled in court, or out of court by an attorney, they carry a much higher loss-adjustment expense," Guidette said. And while awards from trials often are larger, he said, "[t]he added amount received in a claim can be illusory," because legal fees eat into the award. "Usually, an insurer will tell a claimant that that option (for ADR) exists."

However, Guidette said, "the plaintiff clearly can decline to do that."

"Seven of the professional liability carriers now offer a refund (of up to $25,000) on the deductible" if an arbitration clause is included in contracts.

He pointed out that there is a critical difference between mediation, which involves a non-binding conference that tries to bring the sides closer together in an attempt to reach a settlement, and arbitration.

"In arbitration, we choose a third party, usually a lawyer familiar with insurance. We literally try our case before that arbitrator," one expert said.

One of the unique aspects of arbitration is that there is no appeal, unless you can prove corruption on the part of the arbitrator.

Federal courts, and many state courts, now require mediation before a case ends up in front of a judge. "It probably behooves the plaintiff's lawyer to try to settle the vast majority of claims," he said. If lawyers can settle claims out of court, they can negotiate a decent settlement for their clients.

In New York, plaintiffs are allowed to sue in cases involving permanent or disfiguring injuries but the presence of the arbitration system keeps the vast majority of auto cases out of court. The arbitration system in New York is prompt, fair and moves the vast majority of cases quickly. But the fact that consumers can be forced into arbitration proceedings concerns the American Trial Lawyers Association of Washington (ATLA).

Richard Middleton, the ATLA's president-elect, said mandatory arbitration creates a danger of "undue pressure" and undermines a plaintiff's Seventh Amendment right to a jury trial. "Generally, we think that the civil justice system works," Middleton said. "We think that arbitration is OK only when it is voluntarily entered into by both sides of a dispute. It can be a beneficial corollary to the justice system. If people agree to go through the process, it clears the system for other cases that cannot be as amicably resolved."

Middleton, who practices law in Georgia, said anyone who is offered the option of arbitration should contact an attorney immediately, and not to go into a proceeding without legal representation.

"Most people don't even understand what [arbitration] is," he said. "I don't know how they could expect to have their rights protected if they don't understand the system. Without an attorney, no consumer will ever know their rights are being protected."

In August 1998, a report by an influential group representing the medical, legal and private arbitration professions recommended scrapping the practice of requiring mandatory arbitration of patients' health care disputes in favor of a voluntary system. The report, coming amid a national debate on managed-care industry reforms, is expected to heighten pressure on health insurance companies to change the way they resolve patient disputes. Congress is considering reforms backed by both Republicans and Democrats that would give consumers with grievances against their health plans the right to a review by an independent party. Arbitration is one form of independent review. The panel recommended that health plan members no longer be required to agree to arbitration as a condition of enrollment.

Instead, members could choose arbitration—or opt to pursue their claims in court—only after a dispute arose. The report is the result of a year-long effort by a joint committee of the American Arbitration Assn., the nation's largest dispute-resolution service; the American Bar Assn.; and the American

Medical Assn. The recommendations are expected to carry clout with regulators and legislators considering various "patients' rights" reforms. The panel also calls for other consumer protections. They include strict timetables, usually from 30 to 60 days, for health plans to answer members in disputes over emergency services, requests for medical second opinions, access to alternative medical treatments such as acupuncture, and experimental treatments. Mandatory arbitration is used by many health insurance companies, including the nation's largest HMO, Kaiser Permanente. It requires consumers to give up the right to have legal disputes resolved in a courtroom. Arbitration is a system of private justice in which disputes are resolved in hearings behind closed doors by hired arbitrators, usually retired judges.

Proponents of arbitration say the system helps unclog crowded courtrooms, providing a faster and less expensive means of resolving disputes. Critics say the system isn't always as fast or impartial as claimed, and they particularly question arbitration that is forced on patients as a condition of enrolling in a health plan.

The California Supreme Court last year blasted Kaiser's unusual, self-administered arbitration system as prone to "delay for [Kaiser's] own benefit and convenience." The court said the family of a Kaiser patient who died of lung cancer could take its case to a lower court because Kaiser had deliberately delayed arbitrating his claim, possibly to save hundreds of thousands of dollars.

In January, Kaiser announced that it would no longer administer its arbitration itself but would instead seek an independent organization to do so. A Kaiser spokeswoman said the HMO is close to selecting an administrator. The group drew a distinction between medical-treatment disputes and those in other fields, such as the purchase of stock, auto insurance or real estate, where mandatory arbitration is also used. "In every health care dispute, you are dealing with, at a minimum, someone's health. And in some cases, you are dealing with a life-or-death decision," added the spokeswoman.

Cliff Palefsky, a San Francisco lawyer who is critical of mandatory arbitration, praised the report. "Arbitration is being misrepresented to the public as an equal form of justice that is cheaper and quicker, but it is not," Palefsky said. "Mandatory arbitration is an invitation to abuse."

Conclusion

An agent should write up the particulars about a professional liability claim, along with basic information about the policyholder's coverage. The

agent should contact the insurance company's claims department and its local claims rep. The rep still will have to verify coverage from the company; but in the interim, he can contact the client and tell him or her what information to forward.

> **The process gets the claims rep involved in the claim rapidly and demonstrates our concern for the client.**

Pre-claims counseling is a free service meant to assist a policyholder who becomes aware that a client is dissatisfied, witnesses arguments between a contractor and the project owner, or has other reason to believe that he or she might be sued.

The companies typically assigns claims reps or attorneys to the incidents in an effort to keep them from actually becoming claims. Sometimes quick action, including intercession with a policyholder's disgruntled client, leads to a resolution of the dispute. Pre-claims counseling is not charged against the policyholder's deductible and does not adversely affect the client's claims history or premiums. And in yet another way, it demonstrates our concern for the client.

Chapter 18

Umbrella Liability Claims

The June 9, 1997, issue of *Newsweek* reported:

> A pair of umbrella policies for personal liability issued by two insurance companies—State Farm and Chubb Corp.—have paid most of the president's legal fees in the case, already estimated to be in excess of $1.5 million.
>
> But the insurers long ago made it clear that Robert Bennett (Clinton's attorney) does not have a blank check. They have refused, for example, to compensate the media-friendly attorney for the time he spends talking to reporters, and they (the insurance companies) would obviously prefer a quick settlement to a drawn-out trial."

In April 1998, President Clinton authorized attorneys to explore whether he can, by filing a lawsuit, force two insurance companies to pay more than $1 million of his legal bills from the Paula Jones case, a person familiar with the president's strategy said.

Such a move would put Clinton in the politically perilous position of suing an industry regulated by the federal government. The source, speaking on condition of anonymity, emphasized that the president has made no decision.

"This is an option being considered," the source said. "It's a choice that the average citizen wouldn't hesitate to make, but because of political considerations, the president cannot make it lightly."

State Farm and Chubb stopped financing Clinton's defense last September, when the judge threw out some counts of Jones's sexual harassment law-

suit. The companies, who had already picked up $1.5 million of Clinton's legal bills, maintained that his liability umbrella policies covered only certain counts. Their obligation ended when the judge dismissed those counts, the companies said.

A member of Clinton's legal team estimated Saturday that his private attorneys racked up in excess of $1 million in legal fees.

U.S. District Judge Susan Webber Wright dismissed the entire lawsuit last week.

Robert Bennett, Clinton's lead attorney, and his colleagues have since last fall worked behind the scenes to persuade the companies to restore coverage. They argue that the companies' obligation to defend Clinton extends until the final dismissal of all charges, which they say does not happen until any appeal is exhausted.

A Senate Republican has accused the White House of stockpiling attorneys at taxpayer expense to handle the president's personal legal matters.

Clinton's personal umbrella liability insurance coverage is under scrutiny as a group is taking measures to sue him on behalf of State Farm policyholders in the state of Illinois.

Judicial Watch—which describes itself as a non-partisan legal organization but which was characterized as "conservative" by various media outlets—said it plans to refile a lawsuit against President Clinton in Illinois, where State Farm is headquartered.

A derivative lawsuit—which a Judicial Watch official said is similar to a class-action suit, with one plaintiff representing many—was previously filed in May 1997 by the Washington-based group in the District of Columbia Superior Court on behalf of Thomas Flocco, a State Farm policyholder from Philadelphia who represented a group of policyholders, according to Larry Klayman, chairman and general counsel of Judicial Watch, speaking in an interview.

The suit demanded that President Clinton repay more than $1 million that State Farm had provided toward legal bills for the sexual harassment lawsuit filed in 1994 against the president by former Arkansas state employee Paula Jones.

Later in 1997, State Farm and Warren, N.J.-based Chubb Corp., the other insurance company which was paying President Clinton's legal bills, ceased making payments, Judicial Watch said.

The D.C. lawsuit was thrown out of court under a December 19, 1997, order by Judge Geoffrey M. Alprin, who dismissed the complaint on several procedural grounds, Klayman said.

However, Judicial Watch pointed out in a Dec. 26, 1997, statement, that the District of Columbia court "sustained the underlying bases of the lawsuit, which involved allegations by State Farm policyholders that the payments of legal fees and costs (which will likely increase premiums) for sexual harassment and defamation claims were not covered by the policy, that untimely notice (13 months after the suit was filed) precludes coverage, and that it is not the insurance carrier's role to defend a lawsuit merely to delay its resolution, as Bob Bennett, the president's lawyer, plainly admitted was his strategy."

Klayman told the National Underwriter that "even if there were coverage, [it wasn't] reasonable judgment to delay the case until after the [1996] election."

During the interview with the National Underwriter, Klayman also charged that "the payments [for Clinton's legal fees] were at a time when the insurance industry was looking for regulatory favors from the Clinton administration."

The suit may have been dismissed on technicalities, but the judge recognized that the claims are still "valid," even if he is "not agreeing with one side or the other," according to Klayman.

A formal demand was made by Judicial Watch in Illinois on Dec. 26,1997—where State Farm directors are based—and a formal complaint was to be filed in Illinois in either state or federal court the week of Dec. 29, 1997, Klayman said during the December 30 interview.

"We are going to proceed. We're ready to proceed," Klayman noted. "There's no dispute [Illinois is] where the jurisdiction is." He added that Flocco could not be interviewed due to the ongoing litigation.

Klayman said his organization is "extremely confident" the case will go to jury trial and to its conclusion.

"This case deals with an important principle—whether everyone should be treated equally," he said, even if he or she is the President of the United States.

The group said: "While Judicial Watch would have preferred to have the case proceed in the District of Columbia, it is pleased that the Court sustained the underlying legal bases of its complaint on behalf of the policyholders. This will streamline and accelerate the case when it is soon refiled in Illinois."

Steve Vogel, a State Farm representative, maintains the personal umbrella policy was "not in effect when the alleged sexual harassment occurred," but during the alleged defamation of character.

"State Farm is defending on alleged defamation, not alleged sexual ha-

rassment," he emphasized. "When the Arkansas court dismissed the defamation count, we believe that ended our participation in the defense."

Clinton didn't have to wait years to get the lump sum, as private citizens often do when they find themselves fighting about money with insurance giants.

He even selected his own attorney, Robert Bennett, at $495 an hour—a far cry from the $225 most insurance companies are willing to pay for legal defense. Bennett has called the inquiry into the alleged insurance policies "inside-the-Beltway silliness."

Maryland attorney Fred Joseph, whose firm handles hundreds of insurance cases, says insurance companies fight to get out of such cases. "If Joe Blow or Harry Homeowner were under a similar circumstance, I would be extremely surprised if the insurance companies would cover my legal fee, and usually, if insurance companies do cover the case, they insist on using their own lawyers."

Chubb spokesman David Duffy declined to comment about Clinton's case other than to say that decisions to represent policyholders are made on a "case-by-case" basis. But industry sources say Chubb's personal liability insurance does not cover sexual harassment claims.

State Farm spokeswoman Mary Moore says her company only is responsible for paying the legal fees under the single defamation count. That means State Farm has spent $1 million to defend a $75,000 claim. "The president is entitled to a defense just like any other citizen," Moore asserts.

Richard Giller, a Los Angeles insurance attorney who has written extensively on umbrella liability cases, concludes that if he were reviewing the case for State Farm he would recommend against paying the legal bill.

Under both Arkansas law and State Farm's standard umbrella policy, there is no duty to provide a defense for sexual harassment or civil rights violations since those offenses involve intentional misconduct.

Giller also maintains that, even granting State Farm's argument, the company still should not pay for the litigation of collateral issues, such as the recent fight in the Supreme Court about the president's immunity claim, because the funds are only to be used to stage a defense.

The decision to pony up for these issues, combined with the decision to pay the bills of one of the most expensive attorneys in the country, makes Giller wonder: "Is State Farm in control of the defense, or is it out of their control?"

Who's Likely to Have Umbrella Coverage

For the clear majority of the affluent, risk of a liability loss represents the most catastrophic potential of their property-casualty form. Unless their property coverage wades well into the multimillion dollar range, loss of a liability suit is the major exposure of one's assets. The fact that defense costs (without any cap) are paid by the company in addition to the policy's liability limits further illustrates the magnitude of potential loss. Bill Clinton's initial defense of the Paula Jones complaint is a high profile example where the liability insurance companies paid legal defense costs. For most of the affluent, not having to pay legal bills to defend themselves and not having to risk loss of assets due to a large judgment is clearly a number one priority.

Many people at or near retirement have been fortunate enough to accumulate assets well above those numbers. This money will be needed to provide for them during the "golden years." Well, if they do not have an "umbrella" liability insurance policy, their assets could be lost to someone else through a liability lawsuit and judgment.

> **An umbrella liability insurance policy sits over other liability coverages and will pay claims in excess of the underlying policies. It will also cover liabilities that existing policies do not.**

Generally, the policy is issued by your current homeowners/renter's or automobile insurance company. If you have homeowners and auto policies with liability maximums of $300,000, an insurance company will issue you a $1 million umbrella policy for around $200 a year.

The price sounds too good to be true? It really isn't. Here's why.

Umbrella liability companies require that you already to have at least $300,000 insurance on your home and on your car. The umbrella liability company now has a $300,000 deductible on your house and, more important, on your car. Most likely, if there is a claim, it will be paid by your automobile insurance company.

High-deductible insurance policies are cheap for two reasons. The first is that there are few claims. Because there are few claims, there is little administration, which lowers the issuing company's costs. Give an insurance company a product that provides a stream of premiums, low administration and few claims, and you have an eager issuer.

What do these policies cover? Typically, they will cover you and your relatives, including anyone related to you by blood, adoption or marriage.

Spouses, to be covered, must be in your household. They cover all vehicles that you own or rent, excluding recreational vehicles and aircraft.

These policies cover personal injury to others but have restrictions for communicable diseases. This is because a court ruled several years ago that someone was liable to another party for transmitting a herpes virus and that the liability policy had to pay.

Now there are exclusions for communicable diseases, bacteria, parasites, viruses, or other organisms transmitted by an insured person. There also are exclusions for most business activities, which are covered under business policies.

Personal policies do cover legal expenses.

Tricks for Denying Claims

In late 1998, two Oregon Court of Appeals rulings made it easier for insurance companies that have been sued to avoid footing a plaintiff's legal bills—to the point that a concurring judge fears it gives unscrupulous companies an upper hand.

The rulings, which interpret a 71-year-old state law in a novel way, say that an insurance company can avoid paying an aggrieved policyholder's legal fees simply by offering to pay a contested claim, even in the midst of a trial. So long as the offer is equal to or less than what a jury ultimately awards, the insurance company is off the hook—even if the offer isn't accepted.

The courts had consistently said that if an insurance company didn't pay a claim within six months and the policyholder sued, the company had to pay the policyholder's legal bills if he or she ultimately recovered an amount—by jury verdict or by settlement—greater than any offer made by the company during the six-month period.

Appeals Judge Rick Haselton, who concurred on the first ruling, thinks the decision has troubling implications, although he also believes the court had no choice but to rule as it did. In the first of the two unanimous appellate rulings issued in 1998 regarding the attorneys fees section of the state insurance code, he wrote a concurring opinion that while the court's interpretation of state law was "correct and indeed inevitable," the outcome "defies common sense."

In fact, the rulings differ radically from the way Oregon courts have read the law since it was enacted in 1927. But the appeals judges said a strict reading of the insurance code makes it clear that seven decades of decisions were

wrong. If an insurance company raises its offer at any time before a verdict, they ruled, it escapes liability for legal fees, even if more than six months have elapsed since the claim was filed.

In his concurring opinion—which he titled "Primal Scream"—Judge Haselton warned that "unscrupulous insurers can bleed their insureds dry by engaging in litigation wars of attrition—and then, by tendering eleventh-hour settlements to those few who are so tenacious or foolhardy to sustain the fight, avoid any liability for attorney fees."

Why would Judge Haselton endorse rulings that he—and others on the bench—think are dangerous? Court watchers say the appellate court was all but ordered to rule as it did by a 1993 Oregon Supreme Court decision that included instructions for how lower courts should interpret state laws.

The high court outlined three steps: First, a court must examine the "text and context" of a statute to determine lawmakers' intent. If the intent is unclear, the court must look at legislative history—the debates and hearings leading up to passage of a law—for clues. And if the court still can't figure out what lawmakers had in mind, it must use "traditional rules," many of them based on early English principles of common and natural law employed by judges when other guidance falls short.

In the two cases, policyholders received the money for which they'd filed claims, after long legal battles. But circuit court judges in both cases ruled that the insurance companies didn't have to pay their legal fees. In both cases the judge did not explain why the requests for attorneys fees was denied.

Lawyers for insurance companies say the appellate court was right. Under the old interpretation, they say, insurance companies were punished for not swiftly deciding whether to pay a claim, when in fact it sometimes takes longer than six months to figure out how much a policyholder is owed.

> **Defamation is often expressly included within the scope of umbrella coverage. Claims like sexual harassment are probably beyond the scope of coverage.**

Claims with a mixture of covered and noncovered claims are, in many states, considered sufficient to trigger a company's duty to defend. The company may reserve its right to deny coverage. In some states, the company may even reserve its rights to recover costs expended in defending the claim that is not covered.

But subject to these reservations, the insurance company generally must provide a defense.

Courts impose severe penalties on companies that are found to have breached their defense obligation. Policyholders may be awarded punitive damages. Companies may be held liable for judgments above limits. Defense determinations must be made carefully and under state laws, based upon the allegations of the complaint.

A Common Umbrella Liability Suit

The February 1997 federal appeals court decision *State Farm Fire and Casualty v. Raymond and Betty Otto* dealt with a common umbrella claim dispute.

The Ottos contended that the district court misapplied Nevada law when it declared that they could not pursue a separate uninsured motorist claim under an umbrella policy with State Farm Fire, because they signed a general release at the time of settling an uninsured motorist claim with their primary auto company, State Farm Auto.

While unloading some items from his car, Raymond Otto was struck and thrown from the impact of his own car door when another vehicle forcefully backed into the front of his car. Because he was unable to collect from the bankrupt insurance company of the driver at fault, Otto presented an uninsured motorist claim to his own auto insurance company, State Farm Mutual Automobile Insurance.

The Ottos' UM coverage through State Farm Auto included a bodily injury policy limit of $100,000 per person. The Ottos settled their UM claim with State Farm Auto for $85,000 and signed a document entitled "FULL, FINAL AND GENERAL RELEASE OF ALL CLAIMS, CONTRACTUAL, EXTRACONTRACTUAL, AND/OR ANY OTHER KIND WHATSO-EVER," which, in pertinent part, read:

> FOR THE CONSIDERATION [of $85,000], the undersigned Claimants, RAYMOND F. OTTO, SR. and BETTY J. OTTO, individually, as husband and wife, and for their representatives, agents, assigns and future heirs, do hereby fully and forever release, acquit and discharge in this full, final and general release, any and all claims (contractual, extracontractual, tort or any other kind whatsoever) against STATE FARM MUTUAL AUTOMOBILE INSURANCE COMPANY ("STATE FARM AUTO") and its agents, employees, assigns, representatives, insureds, insurers, independent contractors and all other

persons, corporate, partnership or individual, with respect to any and all claims, causes of action, litigation, or potential claims, rights, costs, expenses, demands for compensation or litigation arising out of that certain automobile accident or incident that occurred on or about July 9, 1991, at approximately 7:05 a.m. at 3375 Pinks Place, Las Vegas, Nevada....

In addition to the UM coverage in the auto policy through State Farm Auto, the Ottos also had purchased UM coverage in an umbrella policy issued through State Farm Fire and Casualty Company. As a condition of coverage under the UM provision of the umbrella policy, the Ottos were required to have underlying insurance coverage with a bodily injury policy limit of $100,000 per person. The Ottos' policy with State Farm Auto satisfied this requirement.

The Ottos filed a claim under the terms of their umbrella policy with State Farm Fire. Initially, the Ottos were asked to withdraw their claim to avoid the filing of a declaratory judgment action. When the Ottos refused, State Farm Fire filed this action.

The district court entered judgment in favor of State Farm Fire and declared:

> (1) that the release agreement with State Farm Auto unambiguously referred to "all other persons, corporate, partnership or individual," and therefore it did not matter if the Ottos did not intend State Farm Fire to be a beneficiary of the release; and (2) that because the release did not contain limiting language restricting its effect, the consideration paid by State Farm Auto served as adequate consideration for State Farm Fire's release under the agreement.

The Ottos appealed.

On appeal, the Ottos contended that the district court misapplied Nevada law when it failed to consider evidence which demonstrated that they did not intend to release State Farm Fire from UM liability under their umbrella policy when they settled their UM claim with State Farm Auto.

State Farm Fire claimed that it was entitled to summary judgment for the reasons stated by the district court, or on the separate and independent ground that the Ottos are precluded from pursuing a claim under their umbrella policy because they did not exhaust their underlying UM coverage with State Farm Auto (i.e., they settled for $85,000, as opposed to the $100,000 policy limit).

According to the record, State Farm Auto knew the Ottos did not intend

to release State Farm Fire from UM liability under the umbrella policy. In fact, State Farm Auto was aware the Ottos wanted to file a claim under their umbrella policy as early as their demand letter, which was sent more than seven months before the release was signed. Then, upon receiving an initial version of the release from State Farm Auto, the Ottos' attorney sent a letter explicitly requesting the deletion of all references to State Farm Fire and the Ottos' umbrella policy. In response to that request, State Farm Auto sent a letter dated July 9, 1993, which stated:

> We agree to accept your requested changes and will revise the release accordingly. Whether or not you previously were aware that your client had an umbrella policy, you must now realize that any coverage contained in that policy is not available to Mr. Otto since his umbrella coverage is excess coverage only and Mr. Otto's claim does not exceed the underlying policy coverage from his State Farm Auto policy. Although we originally included this reference and the reference to other possible State Farm policies in our release in order to be thorough, the references are not specifically necessary to release all claims in this case, and the references will therefore be removed pursuant to your request.

State Farm Auto said it was willing to remove any reference to State Farm Fire based on the mistaken belief that, under an umbrella policy for UM coverage, "an exhaustion requirement" would be inferred, much less permitted, under Nevada law

The appeals court held that no reasonable jury could return a verdict in favor of State Farm Fire. The decision of the district court was reversed and remanded with instructions for the district court to enter a judgment allowing the Ottos to pursue a claim under their umbrella policy.

As an alternative argument on appeal, State Farm Fire took the position that the Ottos were required to settle their claim with State Farm Auto for the full $100,000 policy limit before they could present a claim for excess UM coverage under their umbrella policy.

Not only do the terms of the Ottos' umbrella policy fail to mention any "exhaustion" requirement whatsoever, said the appeals court, but more than a year prior to the filing of this action, the Nevada Supreme Court decided that an exhaustion clause in an uninsured motorist policy "violates public policy," and explained that:

> Cases from other jurisdictions have held that "exhaustion" clauses violate public policy because they unnecessarily pro-

mote litigation costs, increase the number of trials, and unreasonably delay the recovery of underinsured motorist benefits. Specifically, these cases point out that an insured may have valid reasons for accepting less than the tortfeasor's policy limit, that an "underinsured motorist carrier" can compute its payments to the insured as if the insured had exhausted the tortfeasor's policy limit, and that if an "exhaustion clause" is in effect, the tortfeasor's carrier can force the plaintiff to go to trial by offering less than the tortfeasor's policy limit, thereby greatly increasing litigation costs and expenses and promoting delay.

Consistent with the Nevada high court's reasoning, the Ottos had legitimate reason to settle with State Farm Auto for less than the applicable $100,000 policy limit. Subsequent to that settlement, under Nevada law the Ottos were fully entitled to submit an uninsured motorist claim under their umbrella policy with State Farm Fire, but, as they themselves concede, State Farm Fire can only be held liable for damages in excess of the $100,000 auto policy limit—as opposed to damages in excess of the $85,000 settlement.

Conclusion

What to Do When all Else Fails

If the state regulators where you live treat you more like the suspect when you complain about a claim, you may be able to find some help in the private sector.

Throughout this book, we've considered the details of how various kinds of insurance claims are paid—and the things that you can do to make sure your claim is paid. Sometimes, though, a claim simply goes awry and you have no choice but to call a professional to help get your claim paid.

If you have to take the next step, you'll have done well to keep the kinds of communications and records described in the previous parts of the book. Beyond that, you'll want to keep a few important points in mind. We'll consider those now.

A Step Before Suing

Your first call doesn't have to be to a lawyer.

Public adjusters take over the management of insurance claims in the case of major property losses from fire or natural disaster. Don't waste your time here if your claims are less than $10,000.

A public adjuster's job can range from doing an inventory of damaged clothes in your closet to evaluating a bid for construction work. It also includes matching the special features of your loss to the terms of your insurance policy to get you the best settlement possible. Public adjusters are paid on a sliding percentage fee that typically starts at about 10 percent and decreases as claims increase. While the fee is often quite large, it needs to be

balanced against the probability that your adjuster will actually increase the size of your settlement.

At a major home fire, public adjusters may arrive before the fire trucks depart. Ignore the hard sell.

In most states, public adjusters must be licensed by the state. In addition, the national association has its own system of accreditation.

Calling the Lawyers

If all else has failed, you'll have no choice but call a lawyer. This really should be a choice of last resort—most of the time, the legal fees will eat into whatever settlement you finally reach. And, if there's no settlement, you'll still have the legal fees to pay.

If you must sue, keep a close eye on the proceedings.

The main legal claim that people can make when they feel their insurance claim has been wrongly denied is breach of contract. An insurance policy is a contract and the insurance company promises to pay valid claims in that contract.

After a breach of contract claim, the next most common legal claim is bad faith.

In most cases, the law assumes that both parties to a contract are held to an implied standard of good faith and fair dealing. However, in insurance disputes, that standard is usually applied only to the insurance company.

In bad faith cases, the courts determine the standards for proper claims handling procedures. Bad faith suits can seek actual and punitive damages— and they can be filed by either policyholders or third parties who've suffered an insured loss

The caveat: Bad faith claims can be tough to prove. You usually have to show fraud, deceit, malicious or willful behavior or intent on the part of the insurance company. Most courts require you to prove that the insurance company knew of, or recklessly disregarded, the lack of a reasonable basis for denying a claim.

The third common legal tool is a charge that the insurance company has violated state unfair claims settlement laws. These laws define prohibited acts in the claims process. They allow administrative penalties (usually state-sanctioned fines) and private lawsuits to recover damages against insurance companies that violate the statutes.

The standards of proof for recovery under the unfair claims practices

statutes are generally lower than those for bad faith claims because you don't usually have to show intent or malice.

Booming Lawsuits and an Industry Response

A growing number of people are suing. Litigation between policyholders and insurance companies increased steadily during the 1990s. One 1993 study estimated that property and liability insurance companies alone spend more than one billion dollars yearly in coverage litigation.

One thing that may be adding to these costs is the fact that—given the state-by-state regulation of insurance—some savvy lawyers channel the lawsuits into states with consumer-friendly laws. This practice, which lawyers call "forum shopping," increases costs dramatically.

In an effort to make regulation somewhat consistent, the National Association of Insurance Commissioners (NAIC) adopted a number of measures to increase uniformity in market conduct matters across states.

In December 1971, the NAIC added a claims settlement practices section to the existing Model Unfair Trade Practices Act. Prior to that time, the Unfair Trade Practices Act did not contain language specifically relating to insurance claims practices—so there was not explicit regulatory oversight of the claims process.

The Unfair Claims Settlement Practices section of the Unfair Trade Practices Act of 1971 delineates fourteen acts, each of which qualify as an unfair claims practice if "committed with such frequency to indicate a general business practice."

Under the 1990 model amendments to the 1971 Act, if a single violation is found to be flagrant, or in conscious disregard of the Act, fines may be increased to $25,000 per violation with a maximum fine of $250,000. The commissioner also has the authority to suspend or revoke an offending company's license if it knew, or reasonably should have known, that it was in violation of the Act.

All states have adopted some form of this amended Act or similar legislation, although the laws still vary widely from state to state.

Most state legislatures intended that the amended Unfair Claims Settlement Practices Acts of the early 1970s were designed to benefit the public in general, rather than individual claimants, and that this intent was misinterpreted by several liberal courts that allowed individuals to recover damages under the statutes.

There have been significant legislative and judicial changes recently at both the state and the national level. The NAIC revisited unfair claims settlement practices regulation in the late 1980s in light of the emerging growth of private causes of action under comparable state provisions and whether the actions were appropriate and beneficial to consumers in general.

Of particular concern was the possibility of higher insurance prices resulting from coerced settlements, high judgments against insurance companies, and increased attorney fees incurred to defend and settle claims. In 1990, the NAIC separated the claims provisions from the Model Unfair Trade Practices Act to establish free-standing Unfair Claims Settlement Acts for insurance companies.

The NAIC didn't intend for the Model Unfair Claims Settlement Act to create an increase in litigation. The objective of the Act was to promote an environment in which consumers are protected from claims practices which are inequitable in a broad sense.

But it did encourage more lawsuits.

What States Say About Insurance Lawsuits

In the late 1970s, California was at the forefront in expanding the rights of individuals to recover against insurance companies for alleged wrongdoing in claims settlement. In the landmark 1979 *Royal Globe* case, the California Supreme Court held that a single violation of the state's Unfair Claims Settlement Statute, which was knowingly committed, was sufficient to bring about a private cause of action for a third party claimant under the statute.

In that case, a third party claimant alleged that Royal Globe failed to attempt in good faith a prompt, fair and equitable settlement of a slip and fall claim—and, so, was in violation of the statute. The verdict for the claimant did two things: First, it allowed a private party to recover damages for a single violation of the California Unfair Claims statute; second, it extended this right to third party claimants.

The decision created a serious conflict of interest for companies, because they had a duty to protect their own policyholders from liability judgments, while also protecting the opposing interests of the third party claimants. The decision led to a dramatic increase in claims litigation in California—and across the country.

Recognizing that the decision went too far, the California Supreme Court reversed itself in 1988 in *Moradi-Shalal v. Fireman's Fund*, stating "devel-

opments occurring subsequent to our *Royal Globe* decision convince us that it was incorrectly decided, and that it has generated and will continue to produce inequitable results, costly multiple litigation, and unnecessary confusion unless we overrule it." A rare admission. But the rush of lawsuits had begun.

The Texas Supreme Court tried to slow the rush in its decision *Allstate v. Watson*. The court held that third parties have no private right to sue under the Texas Unfair Competition and Unfair Practices Act. Reasoning that since "a third party claimant has no contract with the insurer or the insured, has not paid any premiums, and has no basis on which to expect or demand the benefit of the contract," to allow a private cause of action under the statute for third parties would likely expose companies to suits from policyholders.

Insurance companies still have an exposure in Texas, however. Texas Insurance Code explicitly authorizes a private cause of action by "any person who has sustained actual damages caused by another's engaging in an act or practice declared in...this article to be unfair."

The Florida Unfair Claims Statute also explicitly allows for a private cause of action to be brought by any person injured by any of the listed unfair claims settlement practices; but unlike Texas, both first and third parties are eligible to seek recovery of damages, court costs and attorney fees.

Punitive damages may also be awarded under the statute, but only if the person suing can show reckless disregard or willful, wanton or malicious behavior, and that the violation was committed with such frequency as to constitute a general business practice. Before proceeding with the suit, the claimant must first give written notice of the violation to the company and the state insurance department, and may not pursue the claim if the matter is resolved within 60 days.

Another method for providing private rights indirectly is by referring to provisions of general unfair trade practices statutes. For example, the Kentucky Unfair Claims Settlement Practices Act is silent as to the availability of a private cause of action. However, Kentucky has a general statute which provides that, unless otherwise provided by another statute, "a person injured by the violation of any statute may recover from the offender such damages as he sustained." Since the unfair claims act is silent on the matter, this very broad language allows private actions by both first and third parties.

While Connecticut's Unfair Insurance Practices Act does not expressly authorize a private cause of action, courts have held that violations of the Act can form the basis for a civil action under the Unfair Trade Practices Act. The state's highest court held that a claimant must show more than a single viola-

tion of the Unfair Claims Settlement Practices Act to meet the requirement of showing a general business practice.

Similarly, while North Carolina's Unfair Claims Settlement Practices Act does not authorize a private cause of action, the North Carolina Supreme Court has held that a violation of the Act constitutes as a matter of law an unfair or deceptive trade practice in violation of its Unfair or Deceptive Trade Practices Act, and is thus enforceable by private action.

However, the person suing does have to show a pattern of general business practice.

Likewise, the state of Washington, in *Industrial Indemnity Co. of the Northwest, Inc. v. Kallevig*, held that a single violation of the Unfair Claims Settlement Practices Act may constitute a per se violation of the state Unfair Trade Practices Act, and permits a private cause of action.

New Hampshire provides for enforcement of its Unfair Claims Act only through the insurance commissioner. However, when an insurance company is found to be in violation by the commissioner, the act authorizes a civil action by any consumer injured as a result of that violation. Therefore, both first and third parties have rights to sue for damages under the statute.

Specifically, New Hampshire statute provides:

> When a supplier, in any action or proceeding brought by the insurance commissioner, has been found to be in violation of this chapter or has been ordered to cease and desist, and said finding or order has become final, any consumer claiming to be adversely affected by the act or practice giving rise to such finding or order may bring suit against said supplier to recover any damages or loss suffered because of such action or practice.

Massachusetts state law, which defines unacceptable claims acts, is silent on the existence of a private cause of action, but the general Unfair Trade Practices Act, does specifically allow a private suit for a repeated pattern of violations.

However, recent cases have found that no private right exists under the Unfair Claims Settlement statute. For example, in 1993, the courts in *Thorpe v. Mutual of Omaha* and *Pariseau v. Albany International*, stated that statutes prohibiting unfair insurance practices provided no private cause of action and were enforceable only by the insurance commissioner.

The Profile of a Good Claim Case

These are the things that the judges and the politicians have said. Obviously, the lawsuit marketplace has its own set of standards for determining whether or not a case is a good one.

In evaluating an insurance lawsuit's potential, life seems to imitate art. Lawyers usually look for the elements that would make a good John Grisham thriller. They ask questions like:

• What is the personal plight of the policyholder or claimant? How sad is the story? In the minds of the jurors, will it justify punishing the insurance company?

• What is the amount of the contract claim? Is it sufficient to justify a substantial compensatory award? Is the fact that the policyholder has been deprived of this sum justification for a significant emotional distress award?

• What amount of compensatory damages is likely to be awarded for economic loss, emotional distress and attorney fees?

• How long has the policyholder been with the insurance company? A jury will expect the company to go easier on a person who has been a policyholder for a substantial period of time. A company's refusal to do so may make the jury more likely to award punitive damages.

• What is the length of time from claim to compensation? The longer the period from the time of the initial injury to trial—or payment of what was rightly owed—the greater the potential for punitive damages.

• What is the overall perception of the insurance company? Marketing lines about good hands, good neighbors or pieces of the rock set high standards for behavior. If a company sells itself one way and then acts in another, it may be ripe for big damages.

People seeking punitive damages against their insurance carriers must prove a higher "threshold of actual malice" to succeed.

Most courts define actual malice as a company knowing a claim is proper, but willfully, maliciously and intentionally using unfair business practices to resolve the claim.

To counter the financial advantages insurance companies usually have, many insurance lawyers prefer to establish class-action lawsuits. These lawsuits assemble large groups of people who may have been ripped off by an insurance company and then proceed with one or two people's cases as examples of the general problem. Verdicts in these cases, when they come, are huge—and intended for all the aggrieved people.

Class-action claims can increase the seriousness of the case in the eyes of the court, the jury and even the insurance company itself. They also allow admission of other claims stories that can enhance the potential for punitive damages. And, finally, evidence of a systematic practice of wrongdoing makes the insurance company a ripe candidate for punitive damages.

The greater the amount of compensatory damages, the greater the potential for punitive damages. This is especially true in so-called "cap" states, where the law limits claims for emotional damage or other losses to $50,000 or $100,000. In these places, the punitive damages—often calculated as a multiple of actual damages—are the only real threat.

These measures are all dire. Without any doubt, it's best to work with an insurance company to convince them that your claim should be paid. In this book, we've considered preparations you need to make, the communications insurance companies expect, negotiating tactics that are common and the arguments that work. If you apply these in a steady, determined manner, you should be able to get more done than if you call in the lawyers immediately.

Insurance isn't dramatic, like in the movies. It's just business. If you treat it that way, you'll improve your position in any negotiation.

Good luck.

Appendix

Contacts for Consumers

State Insurance Departments

Alabama
Commissioner of Insurance
135 South Union St.
Montgomery, AL 36130
(205) 269-3591 or (205) 269-3595

Alaska Division of Insurance
P.O. Box 110805
Juneau, AK 99811
(907) 465-2515
E-mail: insurance@commerce.state.ak.us

Arizona Department of Insurance
3030 N. Third St., Suite 1100
Phoenix, AZ 85012
Phoenix Area: (602) 912-8444
Tucson Area: (520) 628-6371
Statewide: (800) 325-2548

Arkansas
Insurance Commissioner
1123 South University, Suite 400
University Tower Building
Little Rock, AR 72204
(501) 686-2900

California Department of Insurance
Consumer Services Division
300 South Spring Street
Los Angeles, CA 90013
(800) 927-HELP

Colorado Division of Insurance
Commissioner of Insurance
1560 Broadway, Suite 850
Denver, CO 80202
(303) 894-7499

Connecticut
Insurance Commissioner
P.O. Box 816
Hartford, CT 06142
(203) 297-3900

Delaware Insurance Commissioner's Office
Rodney Bldg.
841 Silver Lake Blvd.
Dover, DE 19903
(302) 739-4251 or (800) 282-8611

District of Columbia
Superintendent of Insurance
613 G St. NW, 6th Floor
Washington, DC 20001
(202) 727-8000 or (202) 727-7434

Florida Department of Insurance
200 E. Gaines St.
Tallahassee, FL 32399
(904) 922-3100 or (800) 342-2762

Georgia
Insurance Commissioner
2 Martin Luther King Jr. Dr.
Floyd Memorial Building
704 West Tower
Atlanta, GA 30334
(404) 656-2070

Hawaii
Insurance Commissioner
P.O. Box 3614
Honolulu, HI 96811
(808) 468-4644, ext. 2790, or (800) 548-5450

Idaho Department of Insurance
700 W. State St.
J.R. Williams Building, 3rd Floor
Boise, ID 83720
(208) 334-2250 or (800) 721-3272
SHIBA (Senior Health Insurance Benefits Advisors), 208-334-4350

Illinois Department of Insurance
Director of Insurance
320 W. Washington St., 4th Floor
Springfield, IL 62767
(217) 782-4515 or (217) 782-7446
E-mail: director@ins084r1.state.il.us

Indiana
Commissioner of Insurance
311 W. Washington St., Suite 300
Indianapolis, IN 46204
(317) 232-2385 or (800) 622-4461

Iowa Insurance Division
Lucas State Office Building, 6th Floor
Des Moines, IA 50319
(515) 281-5705

Kansas Insurance Department
420 SW Ninth St.
Topeka, KS 66612
(913) 296-3071 or (800) 432-2484

Kentucky Department of Insurance
P.O. Box 517
Frankfort, KY 40602
(502) 564-3630 or (800) 595-6053

Louisiana Department of Insurance

950 N. Fifth St.

Baton Rouge, LA 70804

(504) 342-5900 or (800) 259-5300 or -5301

Maine Bureau of Insurance

35 State House Station

Augusta, ME 04333

(207) 582-8707

Maryland Insurance Administration

525 St. Paul Pl.

Baltimore, MD 21202

(410) 468-2000 or (800) 492-6116

Massachusetts Office of Consumer Affairs and Business Regulation

1 Ashburton Pl.

Boston, MA 02108

(617) 727-7780

E-mail: ask@consumer.com

Massachusetts Property Underwriting Association
 (FAIR Plan): (800) 392-6108

Michigan Insurance Bureau

Commissioner of Insurance

P.O. Box 30220

Lansing, MI 48909

(517) 373-9273

**Insurance Division of the
Minnesota Department of Commerce**

133 E. Seventh St.

St. Paul, MN 55101

(612) 297-7161

Mississippi Insurance Department

 P.O. Box 79

Jackson, MS 39205

(601) 359-3569 or (800) 562-2957

Missouri Department of Insurance
P.O. Box 690
Jefferson City, MO 65102
(573) 751-4126 or (800) 726-7390

Montana
Commissioner of Insurance
126 N. Sanders
Mitchell Building, Room 270
Helena, MT 59601
(406) 444-2040 or (800) 332-6148

Nebraska Department of Insurance
941 O St., Suite 400
Lincoln, NE 68508
(402) 471-2201 or (800) 833-0920

Nevada Division of Insurance
1665 Hot Springs Rd., Suite 152
Carson City, NV 89706
(702) 687-4270 or (800) 992-0900, ext. 4270
Las Vegas Office:
2501 E. Sahara Ave., Suite 302
Las Vegas, NV 89158
(702) 486-4009 or (702) 486-4007

New Hampshire
Insurance Commissioner
169 Manchester St.
Concord, NH 03301
(603) 271-2261 or (800) 852-3416

New Jersey Department of Banking and Insurance
 P.O. Box 325
Trenton, NJ 08625
(609) 292-5360 or (800) 446-SHOP
Auto and Homeowner Insurance Shopping: (800) 446-SHOP
Reporting Insurance Fraud: (800) 373-8568
Individual Health Coverage Program Information: (800) 838-0935
Small Employer Health Benefits Program Information: (800) 263-5912

New Mexico
Superintendent of Insurance
P.O. Drawer 1269
Santa Fe, NM 87504
(505) 827-4592

New York State Insurance Department
25 Beaver St.
New York, NY 10004
Consumer Services: (212) 480-6400
Albany Office:
Empire State Plaza
Agency Building No. 1
Albany, NY 12257
Consumer Services: (518) 474-6600

North Carolina
Commissioner of Insurance
P.O. Box 26387
Raleigh, NC 27611
(919) 733-2032 or (800) 662-7777

North Dakota
Commissioner of Insurance
Capitol Building, Fifth Floor
600 East Blvd.
Bismarck, ND 58505
(701) 224-2440 or (800) 247-0560

Ohio Department of Insurance
2100 Stella Ct.
Columbus, OH 43215
(614) 644-2658 or (800) 686-1526
Ohio Senior Health Insurance Information Program: (800) 686-1578

Oklahoma Insurance Department
P.O. Box 53408
Oklahoma City, OK 71352
(405) 521-2828 or (800) 522-0071

Oregon
Insurance Commissioner
440-1 Labor and Industries Building
Salem, OR 97310
(503) 378-4271, (503) 378-4636 or (503) 378-4484
Insurance Consumer Advocate/SHIBA: (800) 722-4134
Information(503) 947-7984
Consumer Assistance Unit (503) 947-7984

Pennsylvania Insurance Department
1326 Strawberry Square
Harrisburg, PA 17120
(717) 787-2317

Rhode Island
Associate Director and Superintendent of Insurance
233 Richmond St.
Providence, RI 02903
(401) 277-2223

South Carolina Department of Insurance
P.O. Box 100105
Columbia, SC 29202
(803) 737-6140 or (800) 768-3467
Office of Consumer Services: (803)737-6150

South Dakota Division of Insurance
118 W. Capitol
Pierre, SD 57501
(605) 773-3563

Tennessee
Commissioner of Insurance
500 James Robertson Pkwy.
Nashville, TN 37243
(615) 741-2241 or (800) 252-3439

Texas Department of Insurance
333 Guadalupe
Austin, TX 78701
(512) 463-6515 or (800) 252-3439
Mail - P.O. Box 149104,
Austin 78714-9104
Report Fraud (512) 475-4989 or (512) 475-1772

Utah
Commissioner of Insurance
3110 State Office Building
Salt Lake City, UT 84114
(801) 538-3800 or (800) 439-3805
Consumer Service (801) 538-3805

Vermont Division of Insurance
Commissioner of Banking, Securities and Insurance
State Office Building
120 State St., Drawer 20
Montpelier, VT 05602
(802) 828-3301
Consumer Assistance line (802) 828-3302

Virginia
Commissioner of Insurance
1200 Jefferson Building
1220 Bank St.
Richmond, VA 23219
(804) 371-9741 or (800) 552-7945

Washington Office of the Insurance Commissioner
P.O. Box 40255
Olympia, WA 98504
(206) 753-7301 or (800) 562-6900
http://www.wa.gov/ins

West Virginia
Insurance Commissioner
2019 Washington St. East
Charleston, WV 25305
(304) 558-3394 or (800) 642-9004

Wisconsin Office of the Commissioner of Insurance
P.O. Box 7873
Madison, WI 53707
(608) 266-0103 or (800) 236-8517
E-mail: ocioci@mail.state.wi.us

Wyoming
Insurance Commissioner
Herschler Building
122 W. 25th St.
Cheyenne, WY 82002
(307) 777-7401

Nationwide Information Resources

Insurance Information Institute
110 Williams St., 4th Floor
New York, NY 10038
(212) 669-9200
National Insurance Consumer Helpline: (800) 942-4242

National Consumers League
815 15th St. NW, Suite 928
Washington, DC 20005
(202) 639-8140

National Insurance Consumer Organization
121 N. Payne St.
Alexandria, VA 22314
(703) 549-8050

U.S. Office of Consumer Affairs
Consumer Information Center
Pueblo, CO 81009
Write to Dept. 636B to receive a free booklet called *What You Should Know About Buying Life Insurance*.

National Flood Insurance Program
Federal Insurance Administration
(202) 646-4623
or
(800) 638-6620

Index

abandonment clause 86, 178
actual cash value 6-7, 78, 80-84, 118-119, 137, 156, 172-173, 186, 189
additional living expense 79, 85, 153-154, 156, 174-175
alternative dispute resolution 341
ambiguous language 20, 82, 123
annuity 207, 217, 219-225, 228-232
appraiser 7, 19, 24, 54, 84, 95, 104, 173, 179, 182
arbitration 7, 15, 31, 38, 66-67, 103-104, 107, 187, 260, 284-288, 311, 341-343

bad faith 12-17, 41, 55, 57, 66, 88, 132-133, 196, 199-200, 209, 211-213, 257, 285, 358-359
bankruptcy 236, 283, 319, 332
beneficiary 203-209, 216-217, 219, 221-222, 225-226, 228, 230, 235-236, 261, 279-280, 293, 297, 303, 353
bodily injury 29, 31, 33, 45, 51, 55, 61, 68, 73, 171, 338-340, 352-353
breach of contract 52, 61, 66, 70, 87, 122, 132-133, 211, 213, 248, 252, 260, 268, 295, 325, 338, 358
broad theft 157, 162, 166-167
burden of proof 91, 123, 326
business interruption 108

cancel 200-201, 268, 325
cancellation 113-116, 156
cash value insurance 227
catastrophe 97, 106-108, 131, 320
COBRA 278-280
collision coverage 26
comprehensive coverage 39
credit life 199

defense cost 135, 334-336, 349
deferred compensation 228
delay 1-2, 14-16, 19-21, 32, 40-41, 57, 65, 68, 76, 78, 86-88, 91, 112, 265, 274, 283-286, 314, 320, 329-330, 343, 347, 355
denial 1-2, 4, 14-18, 41, 65-66, 86-87, 93, 100, 110, 131, 133, 140-141, 189, 193-195, 199-200, 255-256, 265, 271, 273, 278, 301-303
depreciation 6, 81, 83-84, 120, 172, 186
disability 140

disability insurance 218, 239, 242, 244-247, 252-253, 255-256, 260- 263
discrimination 139-140, 142-143, 311, 317-318, 323-324
duties after loss 24, 40, 167
dwelling policies 124-125, 149-150, 153, 156, 162, 167, 183, 186

employment practices 323
endorsement 28-33, 121, 146, 149-150, 156-157, 162, 167, 184-185
endowment policies 198, 222-223
ERISA 232-233, 240-241, 244, 252-256, 261-262, 266, 272-273, 277, 285
estate planning 227, 233-234, 236
estate tax 197, 225-227, 230, 234-235, 237
exclusion 25, 27, 34, 41, 43-46, 55, 65, 89-90, 99-100, 116, 121-124, 127, 140-143, 153,
 155-156, 165-167, 184-186, 188, 194, 206, 222, 242, 247, 279, 324, 328, 339, 350
exclusive remedy 310-311
exhaustion 293, 354-355
expert witness 69, 88, 320
extrinsic evidence 14, 89-90, 240

face 148, 157, 161, 214, 219, 227, 252
fair rental value 153-154, 156
Federal Emergency Management Agency (FEMA) 100-105
fine arts rider 94-96
floater 21, 96, 164, 172, 184, 188
formal review 273
fraud 1, 3, 8-9, 19, 21-24, 40, 53, 56, 72, 75-76, 78, 89, 91-93, 96, 102-104, 132, 141,
 151, 157, 159-160, 180-182, 191, 194, 206, 211, 232, 252, 263, 268-269, 288, 294, 305,
 309-310, 337, 358

general liability 331, 338-341

health insurance 72, 219, 249, 267, 271-274, 278-281, 283-285, 321, 342-343
health maintenance organizations (HMOs) 8, 93, 281-283, 287, 296-297, 300, 303
homeowners insurance 21, 89, 94, 104, 106-107, 111, 114, 130, 134-135, 145, 149, 169, 191

in transit 165, 188
inland marine 185
insolvency 231, 322
insurable interest 86, 111-112, 178, 204-206
insurance reform 5, 10, 63
insured person 24, 29, 31, 33-34, 38, 40, 42-45, 83, 85, 91-92, 143, 155, 162-164, 166-167, 185,
 197-199, 201-208, 213-214, 216-218, 223, 226, 228-229, 233-236, 275, 336, 350
intentional act 55, 140-143, 340
interest only 206-209

joint-survivor 224-225

liability limit 27-28, 31, 37, 55, 58, 349
lifetime income 207-208, 219
line-item estimates 35
living trust 237
location 20-21, 112, 150, 153-155, 162-167, 176, 184-185, 188, 233, 278, 292, 312, 326
long term care 214-215, 252
long-term disability 239-240, 246, 249, 257, 260-262, 285
loss of fair rental value 85
loss of use 2
loss payable clause 80, 180
lump sum 201, 206-207, 217, 220, 222, 224-225, 234, 250, 348

managed care 9, 265-266, 270-271, 282-285, 287, 296-299, 302-303
Medicare 64, 262-263, 266, 291-304, 316
Medicare+Choice 296-303
Medigap 292-297
minimum guarantee 208, 220
misrepresentation 19, 92, 114, 116, 159, 174, 180-182, 189, 191-195, 209, 211-213, 268-270, 272-273

natural disaster 97, 99, 104, 106, 109, 130, 357
neglect 113, 124, 147, 155, 176, 185
negligent 327-329, 332, 336-338
negligent entrustment 48-49, 56
no-fault insurance 25, 40, 63-66, 69-76
non-life insurance 218
nonforfeiture 221
nonrenewal 113-116
notice of claim 18, 244-245, 311, 338

occurrence 58, 135, 179, 331, 338-340
off-premises 164, 188
optional coverage 6, 150
other than collision 21
outdoor structure 117
overlap 39, 51, 324

pair and set 85, 186
partial loss 7
permanent repair 110, 129
permanent residence 20
personal injury 260, 277, 340, 350
personal injury protection 9-10, 40, 56, 66
personal liability coverage 136, 149-150, 161, 179, 345, 348
personal property 21, 77-79, 112, 116, 121, 125-126, 145-146, 149-150, 153-154, 157, 160-165, 169, 172-174, 177, 185-186, 188-191, 195
policy violation 40, 92
possession 4, 86, 94, 109, 165-166, 170-174, 178-179, 183-186, 190, 196
pro-active tactics 46
proof of loss 79-80, 82, 118, 177, 179-181, 189-191, 193, 195, 244, 330
property damage 4, 28, 31, 33, 51, 53, 72-76, 85, 89, 107, 118, 140, 147, 171, 339-340
property valuation 83

reasonable and necessary coverage 67-70, 78, 313-314
reasonable expectation 26-27, 29, 39
reasonable means of prevention 113
reformation 211, 213
refund 341
refund option 224
regulatory complaints 16
regulatory reform 17
release 11, 14, 64, 269-270, 277, 284
rental car 6, 22, 59-60, 62
renter's insurance 14, 157, 161-164, 184
replacement cost 7, 81-84, 95, 118-119, 137, 156, 161, 172, 182, 186, 188
replacement value 80, 83, 130, 186
residual benefit 249-250
retirement 201, 207, 216-217, 220-223, 228-232, 258-259, 261, 266, 272, 299, 349
rider 94-96, 130, 214, 218, 251, 267, 289

set-off provision 37-38
short-term disability 246, 258, 260
Social Security 205, 239, 242, 246-247, 258-263, 301
specialized property insurance 21
specialty policy 185
stacking 10-11, 28-29
straight life option 224
structural collapse 117
structured settlement 207
subrogation 51-52, 86, 151, 178, 179
supplement 54, 149, 151, 292, 297-298, 307

temporary living cost 85
temporary repair 109, 112, 131, 176
term life 198, 200, 227
testamentary 234
theft 4, 19, 22, 25-27, 50, 78, 95-96, 121, 125-127, 149-150, 157, 161-162, 164-167, 170, 178,
 188-190, 193-195
third-party 293, 336-337
time limit 18, 79-80, 180, 244, 257, 279, 301, 331
totaled auto 7, 55
trust 42, 45, 48-50, 52, 56, 61, 121, 163, 166, 208, 227, 230, 232-237, 338

umbrella liability 345-346, 348-349, 352
umbrella policy 184
underinsured motorist 10, 15, 27-31, 40, 43
uninsured motorist 12, 14, 17, 27, 30, 32-33, 38-39, 42, 62, 324, 332, 352-355
universal life 202
up-front payment 85

valuation 7-8, 54-55, 83, 118, 233, 307
vandalism 117, 151-152, 162, 170, 190
variable annuity 220-221
variable universal life 202
viatical 214

waiver 67, 128, 151
waiver of premium 218
whole life 198, 201, 226, 252
workers' comp 305-324
wrongful dismissal 323

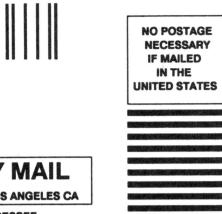

BUSINESS REPLY MAIL

FIRST-CLASS MAIL PERMIT NO. 73996 LOS ANGELES CA

POSTAGE WILL BE PAID BY ADDRESSEE

SILVER LAKE PUBLISHING
2025 HYPERION AVE
LOS ANGELES CA 90027-9849

BUSINESS REPLY MAIL

FIRST-CLASS MAIL PERMIT NO. 73996 LOS ANGELES CA

POSTAGE WILL BE PAID BY ADDRESSEE

SILVER LAKE PUBLISHING
2025 HYPERION AVE
LOS ANGELES CA 90027-9849